Also by Michael Kammen

A Machine That Would Go of Itself: The Constitution in American Culture
(1986)
Spheres of Liberty: Changing Perceptions of Liberty in American Culture (1986)
A Season of Youth: The American Revolution and the Historical Imagination
(1978)
Colonial New York: A History (1975)
People of Paradox: An Inquiry Concerning the Origins of American Civilization
(1972)
Empire and Interest: The American Colonies and the Politics of Mercantilism
(1970)
*Deputyes & Libertyes: The Origins of Representative Government in Colonial
America* (1969)
*A Rope of Sand: The Colonial Agents, British Politics, and the American Revo-
lution* (1968)

EDITOR

The Origins of the American Constitution: A Documentary History (1986)
The Past before Us: Contemporary Historical Writing in the United States (1980)
"What Is the Good of History?" Selected Letters of Carl L. Becker, 1900–1945
(1973)
The History of the Province of New-York, by William Smith, Jr. (1972)
*The Contrapuntal Civilization: Essays toward a New Understanding of the
American Experience* (1971)
Politics and Society in Colonial America: Democracy or Deference? (1967)

SELVAGES & BIASES

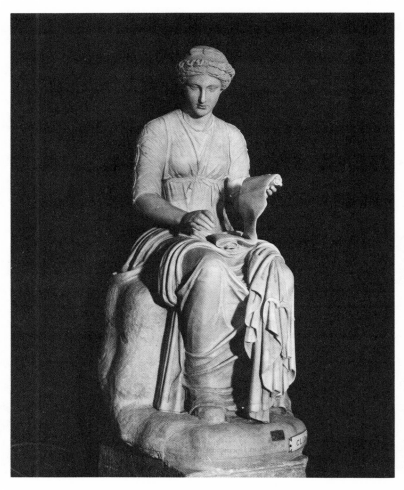

Clio, the Muse of History (marble Roman statue), from Villa di Cassio near Tivoli. Courtesy of the Vatican Museum.

Michael Kammen

SELVAGES & BIASES

The Fabric of History in American Culture

Cornell University Press

ITHACA AND LONDON

First published 1987 by Cornell University Press.

International Standard Book Number 0-8014-1924-7
Library of Congress Catalog Card Number 87-5285
Printed in the United States of America
Librarians: Library of Congress cataloging information appears on the last page of the book.

The paper in this book is acid-free and meets the guidelines for permanence and durability of the Committee on Production Guidelines for Book Longevity of the Council on Library Resources.

For Martha and John Hsu

Flowers are lovely; love is flower-like;
Friendship is a sheltering tree;
Oh the joys that came down shower-like,
Of friendship, love, and liberty,
 Ere I was old!

 S. T. Coleridge, *Youth and Age*

CONTENTS

vii

Contents

selvage, *n.* 1. the edge of woven fabric finished to prevent raveling, often in a narrow tape effect, different from the body of the fabric. 2. any similar strip or part of surplus material.

bias, *n.* 1. an oblique or diagonal line of direction, especially across a woven fabric. 2. a particular tendency or inclination, especially one which prevents unprejudiced consideration of a question.

PREFACE AND
ACKNOWLEDGMENTS

According to an old aphorism, history never repeats itself but historians often do. The point, presumably, is that repetition is undesirable, something to be avoided. If that is so, how can one justify a deliberate act of repetition: publishing a collection of essays of which all but two—the first and last—have already appeared in print?

Various responses are possible. Many of the essays surfaced initially in exotic journals or in conference proceedings and consequently have not been readily accessible, even to scholars. In 1929 Samuel Eliot Morison of Harvard wrote to a friend at Columbia that he would not attend a conference devoted to early American legal history: "I hate breaking up my week by visiting New York, and conferences never seem to me to get anywhere." Although Morison's bias may have been understandable, it seems fair to say that conferences often *do* get somewhere. Even so, tangible evidence tends to show up several years after the fact and then disappears from view faster than a rabbit running for a hedgerow.

What about the customary canard that collected essays do not make a proper book? Perhaps I should worry about the words of Dr. Oliver Wendell Holmes in 1848, when he perused a volume and proclaimed it "the oddest collection of fragments that was ever seen, . . . amorphous as a fog, unstratified as a dumpling and heterogeneous as a low priced sausage." The appropriate answer, once again, is sometimes "yes" and sometimes "no." Sometimes it happens that a writer gets

into a particular groove over a period of years and produces assorted pieces that bear the congruence of a single mind, a singular phase in time, and singularity of purpose. Hence my fondness for this assertion by Johann Georg Hamann, a statement admired by Goethe and Herder: "Everything that a man undertakes, whether it be produced in action or word or anything else, must spring from his whole united powers; all separation of powers is to be repudiated."

The problem with such aphoristic formulations, ordinarily, is that they are susceptible to exceptions. A separation of intellectual powers really *is* possible. Scholars have been known to work on unrelated projects simultaneously. During the period when these essays were written, in fact, I also pursued quite a different enthusiasm—combining American constitutional history and cultural history.

Be that as it may, the material in this book represents a major preoccupation of mine throughout the past decade: how historical inquiry (in the broadest possible sense) has been, is being, and might fruitfully be conducted in the future, with particular reference to the American scene. For self-serving reasons, obviously, I enjoy a sentence that Edmund Burke wrote about some of his own pursuits in 1775: "They have one thing to recommend them; a certain Unity of Colour, which has stood wearing for upwards of nine years; and which every day appears more and more fresh. It is indeed dyed in Grain." (Burke was referring to his "American measures," of course, not his essays.)

Diversity may be found amidst unity, however—and not merely diversity of texture, which readers should expect to see in the fabric of these essays. I also have in mind legitimate diversity of opinion— within cultures, within social groups, even within individuals. Johan Huizinga, the great Dutch historian who is the subject of Chapter 10, has always had a special appeal for me because he was "deeply convinced that human thinking vacillates between antinomies, that is, that man is constantly forced to admit the validity of seemingly opposite points of view." Recognition of that reality provides a recurrent leitmotif in Chapters 1, 2, 3, 7, 8, 10, and 11.

Otherwise, the cohesion in this collection of essays derives primarily from their common origin in a single mind reflecting upon closely related problems over a number of years. Perhaps a more varied and eccentric life would have spawned more varied and eccentric essays. I recall with some envy H. R. Trevor-Roper's delightful description of Frederick York Powell (1850–1904), the Regius Professor of Modern History at Oxford University from 1894 until his death ten years later:

His chief fame seems to be that he left the Prime Minister's offer, owing to its external similarity to an income-tax demand, unopened in an old boot, until discreet inquiries from Downing Street led to its rediscovery. During his ten years' tenure of this chair York Powell may have neglected some of those trumpery duties which have interfered with so much good work in the past; but he was the father of Icelandic studies here, the friend of Mallarmé and Rodin and J. B. Yeats and Verlaine, a universal man accidentally thrown up among our grim specialists. How he lives in everything that has been written about him by those who knew him! He contributed impartially to the *Encyclopaedia Britannica* and the *Sporting Times,* was "as well acquainted with the boxing reports of the *Licensed Victuallers' Gazette* as with the *Kalevala* or *Beowulf,*" and dedicated one of his works jointly to the Dean of Christ Church and an old fisherman at Sandgate.

My own trajectory, by comparison, follows a fairly predictable path. At the age of eight, I was given a child's picture book with brief texts titled *Presidents of Our United States* (1935), by L. A. Esler. I liked it and reread it frequently, with the result that I happened to learn by heart the names of all the presidents, in order of service. I suppose that my family found something notable about this, because my mother and father delighted in asking me in front of company to name, say, the eleventh president of the United States. When I replied "James K. Polk," they would smile with pleasure. For all *they* knew, the eleventh might have been Zachary Taylor. But the important thing, I suspect, is that their pleasure and the approval of visitors must have reinforced my own inclination to learn more about American history.

Whenever I had an opportunity in junior and senior high school, I took history courses. I did reasonably well and enjoyed them, although I now remember little except having spent a vast amount of time on the Crusades in ninth grade, and that my eleventh-grade United States history teacher was a good drillmaster.

As an undergraduate I never contemplated any major other than history. And when I completed college I never considered any career other than that of historian. Intellectually parochial and single-minded, I headed for graduate school, struggled through, and since then, more often than not, it's been scribble, scribble, scribble, eh Mr. Kammen? In my view, however, that sarcastic and rhetorical query was not merely impertinent but banal as well. Gibbon gave a more than adequate response (to which I subscribe) in his *Memoirs,* first published in 1796, two years after his death. "The love of study," he wrote, "a

passion which derives fresh vigor from enjoyment, supplies each day, each hour, with a perpetual source of independent and rational pleasure." Write on, Mr. Gibbon.

Each of the essays in this volume is introduced by a headnote that explains its provenance and, wherever appropriate, refers the reader to related works. Several of the essays were originally presented as addresses at conferences or as talks following a luncheon or dinner; in these I have deliberately retained the informal, direct voice that was appropriate to the occasion. The initial essay, which constitutes all of Part One, was written to serve as an extended introduction to the collection as a whole.

My feeling about *Selvages and Biases* is best conveyed, perhaps, by a sign that I once passed on a country road, painted in bold letters on the front of an antiques shop:

DIGNIFIED JUNK & SOME GOOD STUFF

In her preface to *London and the Outbreak of the Puritan Revolution* (Oxford, 1961), Valerie Pearl thanks, among others, the Worshipful Company of Fishmongers. My debts are less exotic yet no less numerous. Many of the colleagues and friends who hosted my visits to other universities or to conferences, and who read these essays with a candid, critical eye, are thanked following the individual pieces.

An overall expression of appreciation, however, must go to Bernhard Kendler, editor at Cornell University Press, who has waited patiently for these gleanings to get organized and has done his utmost to improve their readability; to Paul R. Baker, professor of history and director of the American Civilization Program at New York University, a generous friend who gave this project a supportive boost at a critical juncture; to my colleague Joel H. Silbey, a mine of multi-disciplinary information; to Marilyn M. Sale, managing editor at Cornell University Press, who managed the project with cheerful dispatch; to Patricia Sterling, who copyedited the manuscript with meticulous care; and to Anne Eberle, who prepared the index with equal devotion to detail.

Much of the research for these essays would not have been possible without the financial support provided by Cornell University's Colonel Return Jonathan Meigs Fund. Nina de Tar, Jackie Hubble, and Sharon Sanford did a great deal of the drudgery—entering picayune

and endless revisions on those wonderful but temperamental word processors.

Finally, a few words about the dedication of this book. At one point in his *Memoirs,* Edward Gibbon observed that "in a free conversation with books and men it would be endless to enumerate the names and characters of all who are introduced to our acquaintance; but in this general acquaintance we may select the degrees of friendship and esteem." There is no couple whose friendship could be cherished more highly than that of Martha and John Hsu. Martha's days abound with "free conversation" about books, of which I am a frequent beneficiary. John's life is suffused by music from the era that I love best—Edward Gibbon's—and John makes of that music a most glorious gift to the Cornell community. Those public virtues are simply, as they say, "for starters." Martha and John's dedications are the ones that really matter. So this book is for them, with great affection.

M.K.

Above Cayuga's Waters
September 1986

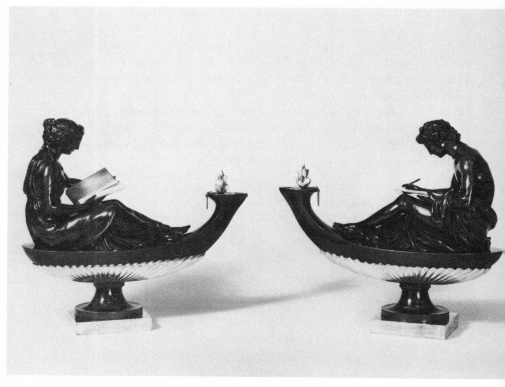

Reading and Writing: a pair of Brûle parfums (incense burners), patinated and gilt bronze, made in Paris (ca. 1780–85), and based upon models by Louis-Simon Boizot (1743–1809). The female and the male figures represent reading and writing. Taken together, they symbolize study. Private English collection.

HISTORY AS A WAY
OF LEARNING
AND KNOWING

History is what one age finds worthy of note in another.
Jacob Burckhardt

Chapter 1

Historical Knowledge
and Understanding

An abridged version of this essay was first presented at a Symposium on Social Science Paradigms held at the University of Chicago on November 15–16, 1985. I subsequently had the good fortune to offer revised renditions as the inaugural Byrne History Lecture at Vanderbilt University on March 20, 1986, and as the inaugural David M. Ellis Lecture at Hamilton College on October 6, 1986.

A few words about the title may be appropriate. My original invitation from the dean of the Division of the Social Sciences at Chicago requested a paper on "History as a Way of Knowing"—in contrast to the other two paradigms under scrutiny at the symposium, designated as "rational choice" (which is particularly in vogue among economists, sociologists, political scientists, and legal scholars) and "interpretive modes" (especially attractive to symbolic anthropologists, some political theorists, philosophers, historians, and literary critics).

Throughout this book I capitalize History when I refer to the profession or discipline and use the lower case, history, when I refer to what happened in the past. The words "historicism" and "historicist" have been invoked in so many different ways, with so many connotations (some positive, some neutral, and some pejorative), that I have not used them at all in order to avoid misunderstanding. See George W. Stocking, Jr., "On the Limits of 'Presentism' and 'Historicism' in the Historiography of the Behavioral Sciences," *Journal of the History of the Behavioral Sciences*, 1 (July 1965), 212; and Ronald H. Nash, ed., *Ideas of History* (New York, 1969), I, 265–91.

The humanist in me felt uncomfortable with the presumptive empiricism of "History as a Way of Knowing"; so I requested that my session be designated "Historical Knowledge and Understanding," a rubric more in keeping with my sense of the limits as well as the possibilities of History as a mode of "knowing." I also preferred the more modest title because I have neither credentials nor skill in the realm of epistemology.

Since then, however, I have come to believe that History does offer a distinctive way of learning and knowing, as well as a realistic means of recognizing what cannot be known with assurance—a view that was stimulated, in part, by my serving a term on the board of directors of the Social Science Research Council (1980–83). That is why, as the title for Part One of this book, I have restored a variant of the main title originally requested by Dean Edward O. Laumann and his Colloquium Committee in June 1985. As readers will discover from the essay itself, "History as a Way of Knowing" is not *necessarily* an assertive, aggressive, or even naive formulation. It can comfortably comprehend a cautious sense of the limits as well as the potential of historical knowledge.

This essay introduces and delineates on a broad canvas many of the themes that are illustrated in more particular or graphic form by the eleven chapters that follow. The *problématique* presented here in Part One is simultaneously straightforward yet perplexing: given the "state of the art" today, what are the prospects for achieving dependable historical knowledge and understanding? Is the historian's vocation on the verge of limitless horizons? Or are there significant obstructions blocking our attempts to attain clear vision—obstacles and boundaries that circumscribe the quest for truth?

I approach these issues in stages that are best summarized by a series of queries. First, do the social science disciplines face a common set of dilemmas? And if so, how is History faring by comparison with its cousins?

Second, if a common crisis does exist, what can History offer to the other disciplines, and to those policy-makers who rely upon them for guidance? In sum, how useful can History really be in an ongoing and comprehensive search for meaningful knowledge?

Third, what particular problems and handicaps does the historian inescapably confront? What noteworthy assets or advantages must he or she bring to the challenge of learning and knowing?

Fourth and last, once we have achieved historical knowledge, what are its applications? What may we confidently do with it? What is its value, tangible as well as intangible?

Obviously, these questions are sufficiently open-ended that no two historians would be likely to respond to them in quite the same way. My own approaches, I hope, are idiosyncratic without being eccentric—off my chest but not off the wall. They are inevitably idiosyncratic to the extent that I have expressed particular (even personal) visions and views. Nevertheless, I would like to think that they are fairly representative as well, because much that I have to say is rooted in and derived from the writings of colleagues who are well regarded in the guild. Although I express occasional differences with respected historians and social scientists, more often than not I borrow shamelessly from the best work that has been done in recent years, as well as from classics of historical exposition.

In that specific sense, at least, I feel much as Thomas Jefferson did about the assertions expressed in the Declaration of Independence: "To place before mankind the common sense of the subject, in terms so plain and firm as to command their assent. . . . All its authority rests then on the harmonizing sentiments of the day, whether expressed in conversation, in letters, [and] printed essays." *Dictum quod non dictum sit prius nullum est iam* ("Nothing is said today that has not been said before"). That, I suppose, must remain for others to judge.

Social Science in Crisis: A Historical Perspective

Between 1928 and 1934, give or take a bit, the social science disciplines enjoyed a burst of creativity and innovation and a surge of confidence that have not been matched since. In 1928 the sociologist L. L. Thurstone published his widely read essay "Attitudes Can Be Measured"; a year later Robert E. Park summarized what he and his disciples had been doing in Chicago for nearly a decade. Park called his essay "The City as a Social Laboratory."[1] In 1927 Wesley C. Mitchell published *Business Cycles: The Problem and Its Setting;* three years later an international group of sixteen met in Cleveland to form the Econo-

1. Thurstone, "Attitudes Can Be Measured," *American Journal of Sociology,* 33 (1928), 529–54; Park, "The City as a Social Laboratory," in T. V. Smith and Leonard D. White, eds., *Chicago: An Experiment in Social Science Research* (Chicago, 1929), 1–19.

metric Society, "An International Society for the Advancement of Economic Theory in Its Relation to Statistics and Mathematics."[2] In 1929 the anthropologist Robert H. Lowie depicted the mores of what used to be called "primitive" peoples, in the panoramic volume *Are We Civilized? Human Culture in Perspective;* in 1934 Ruth Benedict followed with her immensely influential *Patterns of Culture.* Social and cultural Anthropology, already well launched by Bronislaw Malinowski and Franz Boas, had achieved its cutting edge: cultural relativism.

In December 1929 Herbert Hoover appointed the President's Research Committee on Social Trends, co-chaired by Wesley C. Mitchell and Charles E. Merriam. In 1933 the committee's distinguished staff produced a massive report, *Recent Social Trends in the United States,* truly a triumph of cooperative work by social scientists representing many fields.[3] Meanwhile the committee's assistant director of research, Howard W. Odum—who also happened to be director of the Institute for Research in Social Science at the University of North Carolina—commissioned dozens of volumes for the American Social Science Series, which he edited, and produced *An Introduction to Social Research* with Katherine Jocher (1929) as well as *An American Epoch: Southern Portraiture in the National Picture* (1930), a blend of cultural and social analysis with a statistical base that spanned four generations.[4]

The social philosophers and theorists were not idle either. John Dewey ran off *Characters and Events* (1929) in two volumes, *Individualism, Old and New* (1930), and *Philosophy and Civilization* (1931), just like that. Even more important in its long-term influence on American social science was Karl Mannheim's *Ideology and Utopia: An Introduction to the Sociology of Knowledge,* published in Germany in 1929; an American edition appeared in 1936.

Last but assuredly not least, History was in ferment also, though innovation took different forms on opposite sides of the Atlantic. In France, Lucien Febvre and Marc Bloch established an upstart journal in

2. Erich Schneider, *Joseph A. Schumpeter: Life and Work of a Great Social Scientist* (Lincoln, Neb., 1975), 37.

3. See Barry D. Karl, *Charles E. Merriam and the Study of Politics* (Chicago, 1974), 210–20. In 1931 a second edition of Merriam's *New Aspects of Politics* (Chicago, 1925) appeared.

4. See Daniel Joseph Singal, *The War Within: From Victorian to Modernist Thought in the South, 1919–1945* (Chapel Hill, N.C., 1982), chap. 5, "Howard W. Odum and Social Science in the South."

1929. Called *Annales: Economies, Sociétés, Civilisations,* it became the vehicle for a new school of historical scholarship. Call it a school bus if you like, for it flashed its lights brightly and has been discharging and boarding pupils ever since.[5]

Meanwhile, back in the United States, a historian of culture who specialized in the Protestant Reformation, who bore the venerable name Preserved Smith, and who taught at Cornell wrote an essay (also in 1929) called "The Place of History among the Sciences." He insisted that History was akin to all of the social sciences and should utilize what they had to offer. The historian's most fundamental problem concerned the relationship of individual matters to general ones, of particulars to trends. "To lay stress on the personal," he warned, "is to make history unscientific; to omit it altogether is to make our study inhuman."[6] I don't know how many historians agreed with that assertion in 1929, but more and more have accepted some variant of it ever since. To strike such a judicious balance is essential to sound historical scholarship, and I shall elaborate the point in the third section of this essay.

Although socioeconomic considerations had increasingly been added to the historian's craft throughout the 1920s, relativism caught the fancy of many American professionals during the 1930s. The best-known statements of that persuasion would be Carl Becker's presidential address to the American Historical Association in 1931, "Everyman His Own Historian," and Charles Beard's address to the same organization two years later, "Written History as an Act of Faith."[7]

A few months after publishing his talk, Beard revealed in a letter to Carlton J. H. Hayes his desire to use classic texts in order to revitalize the teaching of social studies, especially the historical component: "Someday I want to talk to you about a plan I have for getting out the great *social* documents and teachings from the learned Thomas [Aquinas] on down as source materials for history teaching. If we had any

5. The standard account is Traian Stoianovich, *French Historical Method: The Annales Paradigm* (Ithaca, 1976).

6. Smith, "The Place of History among the Sciences," in *Essays in Intellectual History: Dedicated to James Harvey Robinson by His Former Students* (New York, 1929), 213, 217–18.

7. Becker, *Everyman His Own Historian: Essays on History and Politics* (New York, 1935), 233–55; Beard, "Written History as an Act of Faith," *American Historical Review,* 39 (1934), 219–31. See also Cushing Strout, *The Pragmatic Revolt in American History: Carl Becker and Charles Beard* (New Haven, Conn., 1958).

social ideals, then we might do something with the aid of science to realize them. Having shot holes in the old pedagogical racket, we must supply solid stuff."[8] So relativism, moral purpose, and science were altogether compatible in Beard's mind. They simply needed substantive content and social value in order to adhere, make sense, and have impact. That, too, was a sound idea, and I will return to it in the fourth section.

Obviously, the half-dozen years straddling 1930 constituted a time of great expectations and laudable achievements. New perspectives either emerged (such as relativism) or were consolidated and broadly accepted (the anthropologist's notion of an ethnographic present). Determined efforts were undertaken to make the disciplines more scientific by making them more precise. The desire for connectedness caught on, based on the premise that diverse manifestations of human behavior are ultimately related and must be studied accordingly. Hence the Social Science Research Council, formed in 1926, not only symbolized but energized the prospect of connectedness as an agenda: spawning committees, sponsoring conferences, and subsidizing fellowships.

Half a century later, social scientists know far more than they did in 1935: they have a vastly broader data base, subtler theories and means of testing them, more sophisticated techniques and technology. Nevertheless, every field seems to have been stricken by a mysterious malaise. The most appropriate analogy may be Adam and Eve eating the fruit of the tree of knowledge, thenceforward recognizing their own nakedness, and thereby losing their innocence.

Social scientists consumed and produced a lot of knowledge between, let us say, 1928 and 1978. The result seems to have been a profound loss of intellectual innocence, and 1978 is a good year from which to date it. Quentin Skinner published "The Flight from Positivism" in that year, and the *Journal of Post-Keynesian Economics* began then. I don't subscribe to the journal myself. I don't even read it. But the use of "post-" in that manner has become increasingly symptomatic of the malaise that troubles us. We appear to be doing our work in a post-structuralist, post-Weberian, and post-positivist academic universe.[9]

8. Beard to Hayes, March 4, [1934?], Hayes Papers, Butler Library, Columbia University, New York City.

9. Skinner, "The Flight from Positivism," *New York Review of Books*, June 15,

Humpty-Dumpty fell off the wall during the later 1970s. Many people felt that it was about time, and they understood (or claimed that they understood) why it had happened. But they couldn't agree about Humpty-Dumpty's proper replacement, and still can't, and therefore feel up against the wall with egg on their faces.

Two sorts of problems seem to have brought this condition about. The first is usually referred to in such terms as "intrinsic limitations" and involves various "discoveries": that subjectivity refuses to go away; that structural-functionalism presumes stability as a norm, which is ideologically naive or obtuse or both; that the ethnographic present doesn't work because it is static; and that historians fear they may impose too much order or pattern on the past, which was in reality very untidy, especially the decision-making process. And what is the most appropriate level of generalization anyway?[10] Few social scientists of my acquaintance seem to take any comfort from all that we have learned in recent years about the role of intuition, contingency, subjectivity, and dumb luck in the natural sciences.[11]

The second sort of problem is that several disciplines are not merely divided over which new paradigm ought to replace their outmoded one—a process usually called the quest for "reintegration"—but whether it is either possible or desirable to have a dominant paradigm at all. Grand theory has fallen from favor in most disciplines, and the advocates of pluralism and eclecticism are not entirely persuaded that middle-sized theories are very much better.[12] Some practitioners have

1978, pp. 26–28; Reinhard Bendix, *Force, Fate, and Freedom: On Historical Sociology* (Berkeley, Calif., 1984), 124. Some scholars may feel that 1978 is either too precise or too late a date for the transformation. They are probably right, and I won't quibble about a few years one way or another. Cf. Richard J. Bernstein, *The Restructuring of Social and Political Theory* (New York, 1976).

10. See Jerome M. Clubb, "Murray Murphey and the Possibility of Social Science History," *Social Science History*, 9 (1985), 93; Jack Goody, *The Social Organisation of the LoWiili*, 2d ed. (Oxford, 1967), iv–vii; Jan Vansina, "How the Kingdom of the Great Makoko and Certain Clapperless Bells Became Topics for Research," in L. P. Curtis, Jr., ed., *The Historian's Workshop: Original Essays by Sixteen Historians* (New York, 1970), 223, 225–26; and Arthur Schlesinger, Jr., "The Historian and History," *Foreign Affairs*, 41 (1963), 493–96.

11. See Michael Polanyi, *Personal Knowledge: Towards a Post-critical Philosophy* (Chicago, 1958); James D. Watson, *The Double Helix: A Personal Account of the Discovery of the Structure of DNA* (New York, 1968); and Thomas S. Kuhn, *The Structure of Scientific Revolutions*, 2d ed. (Chicago, 1970).

12. For a new perspective that does not yet reflect a consensus, least of all in History, cf. Quentin Skinner, ed., *The Return of Grand Theory in the Human Sciences*

been heard to mutter that only one trend seems to be clear: the social science disciplines are contemplating their navels and finding little more than lint.

The malaise that we share is most commonly referred to as a crisis, or more precisely as disciplinary crises. That usage has ramifications that would be amusing if they were not so serious. For example, each field seems to locate or refer to its crisis in the tense appropriate to its character. Soiology's crises loom somewhere in the near future: they are invariably "coming" crises.[13] Anthropology's malaise must be in the ethnographic present, of course. Clifford Geertz told us in 1985 that his discipline has "a permanent identity crisis" and suffers from "professional disquiet," and that "no one, including its practitioners, quite knows exactly what it is."[14]

Historians, needless to say, assert that their crisis began some time ago, in the more or less recent past. As Fernand Braudel (1902–85) put it: "The other social sciences know little of the crisis that our historical discipline has undergone during the last twenty or thirty years." That's not just Gallic hyperbole. Keep in mind that Braudel's favorite unit of time was the *longue durée*. A crisis that lasted much less than a quarter of a century would be an event, and Braudel didn't write about mere events if he could possibly help it. Unlike Braudel, Lee Benson is not obsessed with the *longue durée*. Benson has other sorts of obsessions. Nevertheless, he has declared emphatically that "American History-as-Discipline" is in crisis, that the crisis is "chronic," and that the essence of the crisis may be found in the "great gap between what American historians have claimed they were doing and what they actually have done and are now doing."[15]

(Cambridge, 1985). Among nine illustrative essays, the only ones directly germane to History concern Michel Foucault and "the *Annales* historians," the latter being the least appropriate chapter in the book. There is also a chapter on Thomas Kuhn, whose field is the history and philosophy of science, but primarily philosophy.

13. Lawrence Stone, "History and the Social Sciences in the Twentieth Century," in Charles F. Delzell, ed., *The Future of History* (Nashville, Tenn., 1977), 29; Alvin W. Gouldner, *The Coming Crisis of Western Sociology* (New York, 1970); Martin Shaw, "The Coming Crisis of Radical Sociology," in Robin Blackburn, ed., *Ideology in Social Science: Readings in Critical Social Theory* (New York, 1972), 32–44.

14. Geertz, "Waddling In," *Times Literary Supplement,* June 7, 1985, pp. 623–24; David Goddard, "Anthropology: The Limits of Functionalism," in Blackburn, ed., *Ideology in Social Science,* 61–75. For a droll historical perspective upon the practice of Anthropology in recent decades, see Bernard S. Cohn, "History and Anthropology: The State of Play," *Comparative Studies in Society and History,* 22 (1980), 204–8.

15. Braudel, "History and the Social Sciences," in Peter Burke, ed., *Economy and*

Once upon a time historians wrote elegant and important books about historical crises, substantive transformations in human affairs. One thinks of *La Crise de la conscience européenne, 1680–1715,* a three-volume classic by Paul Hazard (1935); or *The Crisis of the Aristocracy, 1558–1641,* by Lawrence Stone (1965); or *Crisis in Europe, 1560–1660,* edited by Trevor Aston (1965); or *The Impending Crisis, 1848–1861,* by David Potter (1976). Now, it is more common to encounter essays concerned with "The Contemporary Crisis in Intellectual History Studies."[16] The disciplines have become exceedingly self-reflexive. Consequently, it can be useful to remember that mirrors serve a different purpose from lamps. Lamps illuminate. Mirrors show you an image that may or may not be shadowy, depending upon whether a genuine source of illumination is nearby.

If we want to know why the social science disciplines are in crisis, a systematic answer would require a survey of all the crisis literature that has been generated, and much of it is extremely bitter though occasionally amusing. Here is an example that happens to concern Sociology:

> Sociologists are supposed to come in two kinds. There is the larger group, which consists of people intimately related to computers and other mathematical gadgets; these people make costly studies of very specific areas of social life; they report on these studies in barbaric English; once in a while, their findings have a bearing on this or that issue of public policy. Then there is a smaller group, consisting of people who are all in sociology by some sort of biographical mistake (they really should be in philosophy or literature); these people mostly write books about the theories of dead Germans; as far as public policy is concerned, this theorizing has no relevance at all—and a good thing it is.[17]

Society in Early Modern Europe: Essays from "Annales" (New York, 1972), 12; Benson, "Doing History as Moral Philosophy and Public Advocacy: A Practical Strategy to Lessen the Crisis in American History" (paper presented at the annual meeting of the Organization of American Historians, Detroit, Mich., April 1, 1981), 1–2, 5, 8–9.

16. By Gene Wise, *Clio,* 5 (1975), 55–71. See also Michael Zuckerman, "Myth and Method: The Current Crisis in American Historical Writing," *History Teacher,* 17 (1984), 219–45; Elizabeth Fox-Genovese and Eugene D. Genovese, "The Political Crisis of Social History: Class Struggle as Subject and Object," in *Fruits of Merchant Capital: Slavery and Bourgeois Property in the Rise and Expansion of Capitalism* (New York, 1983); and Oscar Handlin, "History: A Discipline in Crisis?" *American Scholar,* 40 (1971), 447–65.

17. Peter L. Berger, "In Praise of Particularity: The Concept of Mediating Structures," *Review of Politics,* 38 (1976), 399–400.

I will confine myself to answering the question "Whence cometh the crisis?" from a historian's vantage point. Admittedly, different historians would provide the reader with variegated explanations. Nevertheless, I do not believe that a historian's perspective is irrelevant to the other disciplines. Fernand Braudel, for example, has argued:

> The social sciences are experiencing a general crisis: they are all weighed down by their own progress, if only as a result of the accumulation of knowledge and the lack of co-operative work. . . . Whether they like it or not, all social sciences are affected directly or indirectly by the progress of the most vigorous among them. . . . All, with varying degrees of lucidity, are preoccupied with their own place in the vast body of ancient and modern [i.e., recent and not-so-recent] discovery and this at the very time when it seems that the many paths of the social sciences must converge.[18]

The intellectual mood of the later 1920s and the 1930s was upbeat, positive, constructive. In retrospect the major figures of that period seemed more concerned with what *they* hoped to achieve than with the failures of their predecessors. They still subscribed to the ancient notion that one can see farther by standing on the shoulders of giants. From that perspective, why try to reduce your progenitors to pygmies? Critical revisionism is hardly new, but it wasn't a fetish for the founders, let us say, of the Social Science Research Council.

By contrast, as Hayden White argued a decade ago, "criticism, the science of judging, has become the dominant art in the elite culture of our age."[19] A generation ago Randall Jarrell asserted that we live in an age of criticism, meaning that criticism had not merely supplanted creativity in imaginative writing but that criticism had become the dominant mode of intellectual creativity and discourse. I cannot speak for literature and literary theory, but the age of criticism has been a mixed blessing for the social sciences. If it has meant iconoclasm—the shattering of dominant paradigms and a reluctance by many to replace

18. Braudel, "History and the Social Sciences," 11.

19. White, "Structuralism and Popular Culture," *Journal of Popular Culture,* 7 (1974), 760. See also Robert E. Lane, *The Liberties of Wit: Humanism, Criticism, and the Civic Mind* (New Haven, Conn., 1961). James Reston remarked in 1958 that "this is a time for searching criticism, all right, but for criticism of the whole society" (quoted by William Appleman Williams in Henry Abelove et al., eds., *Visions of History: Interviews* [New York, 1983], 144).

them—it has also stimulated new modes of thought, a greater degree of self-awareness in our work, and a heightened sense of interconnectedness between the social sciences, the natural sciences (the exploration of sociobiology or biostatistics, for example), and the humanities (especially literary criticism and philosophy). The upbeat aspect of doing what we do in an age of criticism was summed up in the title of a volume published in 1970: *Criticism and the Growth of Knowledge*.[20]

The Situation of History among the Social Sciences

According to Jack Goody, anthropologists and sociologists have been primarily interested in the "regularities of process" and the "repetitive nature of change."[21] I suspect that their current eclectic agenda may not lend itself to a job description quite so succinct; but if the repetitive nature of change still attracts them, like moths to a candle, then they would be fascinated by a phenomenon that has been occurring for more than thirty years. The phenomenon—almost a ritual by now—is the regular appearance of an essay relentlessly called "History and the Social Sciences," or some minor variation thereof.[22] That's the repetitive part. The change part is that the essays—although repetitious in some respects—have also revealed a gradual pattern of flux. This is not the place to summarize the full trajectory of those recurrent inquiries (or pronouncements), but a brief indication of their thrust may be exceedingly instructive. Before we turn to that, however, one point should be made clear. Not all but *most* of the essayists

20. Imre Lakatos and Alan Musgrave, eds., *Criticism and the Growth of Knowledge: Proceedings of the International Colloquium in the Philosophy of Science, London, 1965* (Cambridge, 1970).
21. Goody, *Social Organisation of the LoWiili*, vi.
22. See, e.g., *The Social Sciences in Historical Study: A Report of the Committee on Historiography* (New York, 1954), esp. chap. 2, "History among the Social Sciences: Nature and Purpose of the Report"; Richard D. Challener and Maurice Lee, Jr., "History and the Social Sciences: The Problem of Communications. Notes on a Conference Held by the Social Science Research Council," *American Historical Review*, 61 (1956), 331–38; H. Stuart Hughes, "The Historian and the Social Scientist," *American Historical Review*, 66 (1960), 20–46; "Symposium on Chinese Studies and the Disciplines," *Journal of Asian Studies*, 23 (1964), 505–38; C. Vann Woodward, "History and the Third Culture," *Journal of Contemporary History*, 3 (1968), 23–35; David M. Potter, "History and the Social Sciences" (1969), in *History and American Society: Essays of David M. Potter*, ed. Don E. Fehrenbacher (New York, 1973), 39–46; and J. H. Hexter, "History and the Social Sciences," *Doing History* (Bloomington, Ind., 1971), 107–34.

have been well versed in, influenced by, and extremely sympathetic to the social sciences.

Now for the flux. In 1956 Richard Hofstadter declared: "I speak of the historian as having contacts with the social sciences rather than as being a social scientist."[23] Thirteen years later David M. Potter called for moderation—he preferred a platonic rather than an intimate relationship, if you will—yet he concluded that the "social sciences would do more than anything else to correct the shortcomings of history as it is practiced at the present time." By 1977, however, Lawrence Stone issued a skeptical plea for restraint. In 1980 Samuel P. Hays described his "predisposition as one of pursuing 'informed speculation,' a procedure which seems far closer to the real world of historical inquiry and far less pretentious than an assertion of the possibility of 'scientific explanation.'" He regarded many of the "new practitioners" of social science history as being "narrow and rigid in their views" and warned against permitting the other social sciences to determine the historian's research agenda. In 1981 Joyce Appleby began a provocative essay-review of recent works by Barrington Moore and Theda Skocpol with this question: "Has the time come to liberate ourselves from the social sciences?"[24]

The overall tendency is clear, right? Wrong. The tendency is anything but clear. The journal *Historical Methods* was founded in 1967 and is going strong. The *Journal of Interdisciplinary History,* begun a year later, is also going strong. The Social Science History Association was formed in 1974 and has been publishing a journal, *Social Science History,* since 1976. Representative essays are written by historians of extraordinary methodological sophistication; they address such issues as "Early American Historiography and Social Science History"; "The Revivalism of Narrative: A Response to Recent Criticisms of Quantitative History"; and "The Challenge of Quantitative History."[25] Moreover, the Albert J. Beveridge Prize, awarded annually by the

23. Hofstadter, "History and the Social Sciences," in Fritz Stern, ed., *The Varieties of History* (New York, 1956), 360. See also Thomas Cochran to Merle Curti, December 14, 1958, Curti Papers, box 9, State Historical Society of Wisconsin, Madison.

24. Stone, "History and the Social Sciences," 3–42; Hays, *American Political History as Social Analysis* (Knoxville, Tenn., 1980), 40–41; Appleby, "Social Science and Human Nature," *Democracy,* 1 (1981), 116.

25. By Daniel Scott Smith in *Social Science History,* 6 (1982), 267–91; J. Morgan Kousser, ibid., 8 (1984), 133–49; and Eric H. Monkkonen, *Historical Methods,* 17 (1984), 86–94.

American Historical Association to "the best book on the history of the United States, Canada, or Latin America," has for many years been bestowed upon books written by political scientists, historical geographers, literary historians, city planners, and historians of the environment and ecology, or else to members of the historical guild whose work is highly interdisciplinary.

Contradictory tendencies? That's commonly considered a sign of ambivalence, and recognizing its reality brings us that much closer to understanding History's peculiar relationship to the social sciences over the past half-century. If double drift has characterized the situation in recent years, the long-term story is equally curious: a series of liaisons, sometimes consummated and sometimes not, sometimes fulfilling and sometimes not, between Clio and damn near all the rest. In the 1920s it was History and Psychology; in the 1930s primarily Economics, followed by Sociology (especially in the 1950s and '60s) overlapped by cliometrics (enter statistics), followed by Anthropology during the 1970s.[26] The 1980s and beyond? Who can say? History and landscape as human geography, perhaps. The environment, natural and built. Material culture and iconography.[27] Many historians are

26. See, simply as examples, John A. Garraty, "Preserved Smith, Ralph Volney Harlow, and Psychology," *Journal of the History of Ideas,* 15 (1954), 456–65; Carl Becker to Merle Curti, October 12, 1935, Curti Papers, box 5; Werner J. Cahnman and Alvin Boskoff, eds., *Sociology and History: Theory and Research* (Glencoe, Ill., 1964); Edward N. Saveth, ed., *American History and the Social Sciences* (Glencoe, Ill., 1964); Richard Hofstadter and Seymour Martin Lipset, eds., *Sociology and History: Methods* (New York, 1968); Allan G. Bogue, *Clio & the Bitch Goddess: Quantification in American Political History* (Beverly Hills, Calif., 1983), esp. chap. 1, "Inside the 'Iowa School'"; Bernard S. Cohn et al., "Anthropology and History in the 1980s," *Journal of Interdisciplinary History,* 12 (1981), 227–75; and Robert Jay Lifton and Eric Olson, eds., *Explorations in Psychohistory: The Wellfleet Papers* (New York, 1974).

27. David Ward, ed., *Geographic Perspectives on America's Past: Readings on the Historical Geography of the United States* (New York, 1979); David Lowenthal and Martyn J. Bowden, eds., *Geographies of the Mind: Essays in Historical Geosophy in Honor of John Kirtland Wright* (New York, 1976); John R. Stilgoe, *Common Landscape of America, 1580–1845* (New Haven, Conn., 1982); Rhys Isaac, *The Transformation of Virginia, 1740–1790* (Chapel Hill, N.C., 1982), 11–57; Peirce F. Lewis, "Defining a Sense of Place," *Southern Quarterly,* 17 (1979), 24–46; Peirce F. Lewis, "Axioms for Reading the Landscape: Some Guides to the American Scene," in Donald W. Meinig, ed., *The Interpretation of Ordinary Landscapes* (New York, 1979), 11–32; D. W. Meinig, "The Continuous Shaping of America: A Prospectus for Geographers and Historians," *American Historical Review,* 83 (1978), 1186–1217; Henry Glassie, "Meaningful Things and Appropriate Myths: The Artifact's Place in American Studies," *Prospects,* 3 (1977), 1–49. In 1869 Jules Michelet, the French nationalist historian, declared that "without a geographic base the people, this actor of history, seem to walk on air, creating a

intellectual bigamists, but the discipline as a whole tends toward serial marriage.

Once again we must ask why? And once again an adequate answer must necessarily be multifaceted. Part of the reason will be found in the extreme heterogeneity of History as a discipline. Part will be found in its very longevity and perpetual revisionism. Part may be found by comparing History's relation to the social sciences in the United States with its relation to the social sciences in other cultures. Let's look at the variables in that sequence.

As part of the preparation for this essay, I sent a letter to 180 prominent historians, asking them a cluster of germane questions about their perceptions of the historian's craft. Using their responses along with relevant essays previously published by historians—especially pieces that are autobiographical in nature—I found that words such as *heterogeneous, diverse, idiosyncratic,* and *eclectic* frequently recurred in describing historians' ways of knowing. The word *systematic* almost never appeared. Moreover, words such as *inscrutable, polymorphous, indefinable,* and *indeterminate* were commonly invoked to characterize the past itself.[28]

It is also noteworthy that historians are most likely to be agitated by differences of opinion within their own areas of specialization and with practitioners most like themselves. Historians' attitudes toward the other social sciences are (for the most part) temperately expressed by comparison with the intensity of feeling among Machiavelli scholars, let us say, or students of the English Civil War, or experts on culture contact in early modern North America, or authorities on political behavior in mid-nineteenth-century America, or analysts of slavery as a socioeconomic institution during the antebellum period. Their polemics tend to be nasty, brutish, and long—in fact, interminable.[29] By

resemblance to those Chinese paintings where the ground is missing" (quoted in *Enrollment of the Volunteers: Thomas Couture and the Painting of History,* exhibition catalogue [Springfield, Mass., 1980], 22).

28. See Arthur Schlesinger, Jr., "On the Inscrutability of History," *Encounter,* 27 (1966), 10–17; François Furet, "Beyond the *Annales,*" *Journal of Modern History,* 55 (1983), 389–410, esp. 391–92.

29. See, e.g., Clive Holmes, "The County Community in Stuart Historiography," *Journal of British Studies,* 19 (1980), 54–73; Shepard Krech III, ed., *Indians, Animals, and the Fur Trade: A Critique of Keepers of the Game* (Athens, Ga., 1981); Don E. Fehrenbacher, "The New Political History and the Coming of the Civil War," *Pacific Historical Review,* 54 (1985), 117–42; Paul A. David et al., eds., *Reckoning with Slavery: A Critical Study in the Quantitative History of American Negro Slavery* (New York, 1976).

contrast, the overwhelming majority of historians are utterly indifferent to issues involving epistemology and the philosophy of history.[30]

When historians emerge from their trenches and look about long enough to acknowledge the existence of other trenches, they tend to divide the profession's practitioners into two types. It is highly symptomatic that they do not even agree on *which* two types are most basic. But engaging metaphors have made two sets of antinomies notably visible. One comes to us from Emmanuel Le Roy Ladurie (by way of Lawrence Stone), who refers to the fact seekers and the macrotheorists as the truffle hunters and the parachutists: "The first grub about with their noses in the dirt, searching for some minute and precious fact; the second float down from the clouds, surveying the whole panorama of the countryside, but from too great a height to see anything in detail very clearly."[31]

The other comes from Donald Kagan (by way of J. H. Hexter), who divides the guild into lumpers and splitters:

> Historians who are splitters like to point out divergences, to perceive differences, to draw distinctions. They shrink away from systems of history and from general rules, and carry around in their heads lists of exceptions to almost any rule they are likely to encounter. They do not mind untidiness and accident in the past; they rather like them. Lumpers do not like accidents; they would prefer to have them vanish. They tend to ascribe apparent accidents not to the untidiness of the past itself but to the untidiness of the record of the past or to the untidiness of mind of splitting historians who are willing to leave the temple of Clio a shambles. Instead of noting differences, lumpers note likenesses; instead of separateness, connection. The lumping historian wants to put the past into boxes, all of it, and not too many boxes at that, and then to tie all the boxes together into one nice shapely bundle. The latter operation turns out to be quite easy, since any practiced lumper will have so selected his boxes in the first place that they will fit together in a seemly way.[32]

A proliferation of antinomies is just one manifestation of the pluralism that we encounter when we ask historians how they know what

30. For a characteristic statement, see Bernard Bailyn, "The Problems of the Working Historian: A Comment," in Sidney Hook, ed., *Philosophy and History: A Symposium* (New York, 1963), 92–101.

31. Quoted in Stone, "History and the Social Sciences," 7.

32. Quoted in Hexter, *On Historians: Reappraisals of Some of the Makers of Modern History* (Cambridge, Mass., 1979), 241–42.

17

they know. A second reason why historians perpetually seek new liaisons is that most of them assume that History will always be rewritten from a fresh perspective. Hence the inclination by some to find fresh gimmicks. Hence also the recurring appeal of narrative history, even now, after a century of analytical and "scientific" history in various guises. Carl Becker expressed this point of view most engagingly in a letter to Charles Homer Haskins:

> History is as old as civilization, and older, while the other social studies are relatively new. I thought there must be some fundamental reason in the nature of the human creature for his persistent interest in stories, whether true or false, of his past, his heroes, etc. . . . The only condition in which I can conceive that historical research and writing would become futile is in [the] case, extremely unlikely, that the past of mankind should really be completely presented in "definitive contributions." If they were really definitive, there would seemingly be no further need of research. Some members of our guild seem to find the idea that each generation has to rewrite its history disillusioning. I confess I don't find it so at all.[33]

A third factor will be found in the varied ways that History is situated among the social sciences from one nation to the next (perhaps, I should add, from one university to the next). Ever since the mid-1950s, historical studies have been the linchpin of the social sciences in France, exercising institutional hegemony through the Ecole des Hautes Etudes en Sciences Sociales.[34] The tendency in Great Britain has been superbly summarized by Gareth Stedman Jones:

> If England from the 1950s, once again and somewhat paradoxically, became the focus of ambitious attempts to plot its development upon global economic and sociological grids, the process was further aided by the emergence of new conceptions of history on the part of historians themselves. What came to be known as *social history* derived from a variety of sources—from new ways of posing historical questions pioneered by the *Annales* and *Past and Present,* from the critique of economistic versions of

33. Becker to Haskins, February 19, 1932, Haskins Papers, Seeley G. Mudd Manuscript Library, Princeton University, Princeton, N.J.

34. See Jacques Revel, "Histoire et sciences sociales: Les Paradigmes des *Annales,*" *Annales: Economies, Sociétés, Civilisations,* 34 (1979), 1360–76; Stoianovich, *French Historical Method,* passim; Bernard Bailyn, review of *French Historical Method* in *Journal of Economic History,* 37 (1977), 1028–34; and Furet, "Beyond the *Annales,*" 389–90. Cf., however, Claude Lévi-Strauss, *La Pensée sauvage* (Paris, 1964), chap. 9, "Histoire et dialectique."

Marxism which developed after 1956, and from a growing interest in the methods and preoccupations of sociology and anthropology. What came to characterize this new idea of social history at its most expansive was a totalizing ambition which would both displace the narrow concerns of traditional practitioners and make history central to the understanding of modern society and politics.[35]

Not since the days of Frederick Jackson Turner, Charles A. Beard, and to a lesser degree Vernon L. Parrington—that is to say, not since the 1920s and 1930s—have historical issues in the United States been a political and methodological battleground for any unit of society larger than several segments of academe.[36] Unlike their French counterparts, American intellectuals have not played a particularly prominent role in public affairs. Unlike the Germans, we did not have two scary skeletons in the closet that made historical knowledge an absolute requisite for self-understanding and national identity.[37] Unlike the British, meanwhile, we have had a series of prominent public figures, from Harry S Truman to Ronald Reagan, who have misread, distorted, or trivialized the national past for self-serving purposes or for the vindication of misguided policies, foreign and domestic.[38]

To clinch the case for comparisons, for cultural relativism, and for the interconnectedness of social science, social reality, and a historical approach that is sensitive to language as culture, permit me to invoke Gareth Stedman Jones once more.

It may not be possible for a historian to ask what sort of substantive reality "the working class" as such might have possessed outside the particular historical idioms in which it has been ascribed meaning. But it

35. Jones, *Languages of Class: Studies in English Working Class History, 1832–1982* (Cambridge, 1983), 5–6. For a fine example of feathers flying, see Harold Perkin, " 'The Condescension of Posterity': The Recent Historiography of the English Working Class," *Social Science History*, 3 (1978), 87–101.

36. See Richard Hofstadter, *The Progressive Historians: Turner, Beard, Parrington* (New York, 1968).

37. See Klaus Epstein, "German War Aims in the First World War," *World Politics*, 15 (1962), 163–85; John A. Moses, *The Politics of Illusion: The Fischer Controversy in German Historiography* (London, 1975); Fritz Fischer, *World Power or Decline: The Controversy over Germany's Aims in the First World War* (London, 1975); and Gordon A. Craig, *The Germans* (New York, 1982), chaps. 2–3.

38. See Ernest R. May, *"Lessons" of the Past: The Use and Misuse of History in American Foreign Policy* (New York, 1973); and Charles A. Miller, *The Supreme Court and the Uses of History* (Cambridge, Mass., 1969).

certainly is possible to investigate how the historical picture changes, once certain of the assumptions informing these idioms are no longer presupposed.

Some of the most deeply entrenched of these assumptions have clustered around the notion of class. In a country like the United States, it has never been possible for historians simply to infer class as a political force from class as a structural position within productive relations. In England, on the other hand, such equations between social and political forces have been only too easy to make both because much of modern English political history has generally been thought to coincide with class alignments and because, at the level of everyday speech, one of the peculiarities of England has been the pervasiveness of the employment of diverse forms of class vocabulary. Unlike Germany, languages of class in England never faced serious rivalry from a pre-existing language of estates; unlike France and America, republican vocabulary and notions of citizenship never became more than a minor current, whether as part of everyday speech or as analytic categories; unlike the countries of southern Europe, vocabularies of class did not accompany, but long preceded, the arrival of social democratic parties and were never exclusively identified with them. In fact, in England more than in any other country, the word "class" has acted as a congested point of intersection between many competing, overlapping or simply differing forms of discourse—political, economic, religious and cultural—right across the political spectrum.[39]

It should be all too obvious that there is a need not only for comparative history—for which numerous calls have been issued[40]—but for comparative historiography and a comparative perspective on social science as well.

Those activities, when they are attempted at all, are undertaken most thoughtfully by scholars who, because of training, accident, or sheer curiosity, work in multidisciplinary modes and possess particular sensitivity to variations in time and space. As W. H. B. Court, the British economic historian, put it: "Living as they do in different societies, [men] make their decisions according to different schemes of values and according to the habits and the structures of the society they

39. Jones, *Languages of Class*, 1–2.
40. See Raymond Grew, "The Case for Comparing Histories," *American Historical Review*, 85 (1980), 763–78; Alette Olin Hill and Boyd H. Hill, Jr., "Marc Bloch and Comparative History," ibid., 828–57; and Raymond Grew, "The Comparative Weakness of American History," *Journal of Interdisciplinary History*, 16 (1985), 87–116.

find themselves living in."[41] The work that develops from that assumption leads to relativism, albeit a more explicit and clearly delineated form of relativism than the modest and agnostic variety that Becker and Beard believed to be inevitable.

Jan Vansina, an ethnographic historian, has made a particularly helpful suggestion—difficult to accomplish in practice yet worth trying again and again: "One cannot compare two societies or two cultures except by first making abstract models of each of them and then constructing a model which covers certain features of both. In other words, one had to generalize and abstract for the whole of a culture, not just for one feature or another."[42]

It is possible to point to various instances where historically oriented social scientists have made attractive proposals and unexceptionable claims. Robert W. Fogel, for example, believes that the current generation of cliometricians recognizes that "behavioral models must be place- and time-specific to be useful in historical research."[43] Unfortunately, at least from the vantage point of a curious (meaning nosy) historian who periodically tries to poke his proboscis into the tents of adjacent departments, the number of truly successful examples in which social scientists have fulfilled Fogel's formula is strikingly small. Nowhere is this fact more evident than in economic history, where the fiascoes[44] seem to outnumber the successes.[45]

The same is true of Sociology, where the historical work of Charles Tilly, Robert K. Merton, Neil J. Smelser, and Reinhard Bendix com-

41. Court is quoted in Robert M. Solow, "Economic History and Economics," *American Economic Review,* 75 (1985), 329–30. For a subsequent critique of reductionist tendencies in several disciplines, developed by a multidisciplinary practitioner, see Cohn, "History and Anthropology," esp. 216–21.

42. Vansina, "Kingdom of the Great Makoko," 234; see also Vansina, "Cultures through Time," in Raoul Naroll and Ronald Cohen, eds., *A Handbook of Method in Cultural Anthropology* (Garden City, N.Y., 1970), 165–79.

43. Fogel and G. R. Elton, *Which Road to the Past? Two Views of History* (New Haven, Conn., 1983), 67–68.

44. See Robert William Fogel and Stanley L. Engerman, *Time on the Cross: The Economics of American Negro Slavery,* 2 vols. (Boston, 1974); and Herbert G. Gutman, *Slavery and the Numbers Game: A Critique of "Time on the Cross"* (Urbana, Ill., 1975).

45. See Simon Kuznets, *Population Redistribution and Economic Growth: United States, 1879–1950* (Philadelphia, 1957); Lance E. Davis, *American Economic Growth: An Economist's History of the United States* (New York, 1972); and esp. William N. Parker and Eric L. Jones, *European Peasants and Their Markets: Essays in Agrarian Economic History* (Princeton, N.J., 1975), and Parker, *Europe, America, and the Wider World: Essays on the Economic History of Western Capitalism* (Cambridge, 1984), vol. 1, *Europe and the World Economy.*

mands considerable respect in my guild (despite some well-informed revisionism),[46] whereas the earnest efforts of Seymour Martin Lipset, David C. McClelland, and Kai T. Erikson have held up less well. The biggest objections to those works of the second sort involve problems of periodization, the incomplete or highly selective use of evidence, and what Stephan Thernstrom has called (in a lengthy critique of work by W. Lloyd Warner and his collaborators) "the pitfalls of ahistorical social science."[47]

A comparable pattern exists in Anthropology, where Marshall Sahlins, Sidney W. Mintz, and James A. Boon have utilized diverse ways of achieving "local knowledge" that is well informed by sensitivity to time and place without neglecting powerful thrusts at conceptualization and generalization.[48] Although it has become increasingly difficult to generalize about what anthropologists do and how they do it, the notion of an ethnographic present remains highly problematic for many; and the trendy work of most symbolic anthropologists continues to be appallingly ahistorical and consequently static, deficient in terms of such critical factors as process, dialectic, instability, and discontinuity.[49]

46. See Charles Tilly, *The Vendée* (Cambridge, Mass., 1964); Tilly with Louise and Richard Tilly, *The Rebellious Century, 1830–1930* (Cambridge, Mass., 1975); Robert K. Merton, *Science, Technology, and Society in Seventeenth Century England* (1938; rev. ed., New York, 1970); A. Rupert Hall, "Merton Revisited: or Science and Society in the Seventeenth Century," *History of Science*, 2 (1963), 1–16; and Neil J. Smelser, *Social Change in the Industrial Revolution: An Application of Theory to the British Cotton Industry* (Chicago, 1959).

47. Thernstrom, *Poverty and Progress: Social Mobility in a Nineteenth-Century City* (Cambridge, Mass., 1964), 225–39. See Lipset, *The First New Nation: The United States in Historical and Comparative Perspective* (New York, 1963); McClelland, *The Achieving Society* (Princeton, N.J., 1961); and cf. Erikson, *Wayward Puritans: A Study in the Sociology of Deviance* (New York, 1966), with Paul Boyer and Stephen Nissenbaum, *Salem Possessed: The Social Origins of Witchcraft* (Cambridge, Mass., 1974), and John Putnam Demos, *Entertaining Satan: Witchcraft and the Culture of Early New England* (New York, 1982).

48. Sahlins, *Islands of History* (Chicago, 1985); Mintz, *Sweetness and Power: The Place of Sugar in Modern History* (New York, 1985); Boon, *The Anthropological Romance of Bali, 1597–1972: Dynamic Perspectives in Marriage and Caste, Politics, and Religion* (Cambridge, 1977).

49. See, once again, the preface to the second edition of Goody, *Social Organization of the LoWiili*; Jan Vansina, "History in the Field," in D. G. Jongmans and P. C. W. Gutkind, eds., *Anthropologists in the Field* (Assen, the Netherlands, 1967), 102–15; Vansina, "Kingdom of the Great Makoko," 231; Marshall Sahlins, *Islands of History* (Chicago, 1985), xviii; Victor W. Turner, *The Ritual Process: Structure and Anti-Structure* (Chicago, 1969); and Raymond Firth, *Symbols: Public and Private* (Ithaca, 1973).

Finally, there is Political Science, a discipline with which History shares common origins but in which the historical approach has steadily lost ground to behavioralists, post-behavioralist model-builders, and those (such as Philip E. Converse) who persist in believing that participation in the political process is fundamentally unchanging. Judicious innovators such as V. O. Key, Jr., tempered a lifelong interest in political behavior and motivation with keen awareness of the historical dimension: of dynamic changes as well as of inertia as an entrenched force resisting change yet powerfully affecting public opinion, voting, and the higher levels of competition for power.[50]

Walter Dean Burnham, who studied with Key, remains committed to a historical approach. The word "changing" in his seminal essay "The Changing Shape of the American Political Universe" (1965) is indicative of an outlook that has won him more allies among historians than among members of his own guild. His assertion that "sociological and historical contexts profoundly shape both political consciousness and political behavior" elicits nods of assent from colleagues yet little in the way of overt commitment. Nelson W. Polsby and Theodore J. Lowi exemplify the beleaguered few who still pay attention to the evolution of particular political institutions. They remain a minority, though not without influence.[51]

Unfortunately, some of their like-minded brethren who utilize historical case studies either explore microcosms so exotic that few in the profession pay them any mind or else misread their information and offer misinterpretations that give the historical approach a tainted reputation among political scientists.[52]

50. See David B. Truman, "Disillusion and Regeneration: The Quest for a Discipline," *American Political Science Review,* 59 (1965), 865–73; Key, *Public Opinion and American Democracy* (New York, 1961); and esp. Key and Frank Munger, "Social Determinism and Electoral Decision: The Case of Indiana," in Eugene Burdick and Arthur J. Brodbeck, eds., *American Voting Behavior* (Glencoe, Ill., 1959), 281–99: "Recognition of the time dimension of 'decision' suggests the plausibility of an analytical model built on the assumption that political groupings manage to exist, as majorities or minorities, over long periods of time" (pp. 287–88).

51. Burnham, *The Current Crisis in American Politics* (New York, 1982), esp. chap. 1; Polsby, *Political Innovation in America: The Politics of Policy Initiation* (New Haven, Conn., 1984); Lowi, *At the Pleasure of the Mayor: Patronage and Power in New York City, 1898–1958* (Glencoe, Ill., 1954); Lowi, *The Personal President: Power Invested, Promise Unfulfilled* (Ithaca, 1985).

52. See Benjamin R. Barber, *The Death of Communal Liberty: A History of Freedom in a Swiss Mountain Canton* (Princeton, N.J., 1974); James Sterling Young, *The Washington Community, 1800–1828* (New York, 1966); Allan G. Bogue and Mark Paul Marlaire,

Available evidence indicates that Fernand Braudel was both fair and accurate in his seemingly harsh assessment.

> The social sciences do not seem much inclined to undertake the search for lost time. Not that they can be formally convicted for always failing to accept history or time as necessary dimensions of their studies. Indeed, superficially they welcome us; the "diachronic" analysis involving history is never absent from their theories.
>
> But we must agree that, having made such devious acknowledgments, the social sciences, from inclination, instinctively, or even as a result of training, always tend to put aside the historical explanation; they elude it by two practically contrary procedures: the one stresses the "event" or "actuality" to excess, being an empirical type of sociology scornful of all history, limited to the data provided by immediate enquiry; the other simply goes right beyond time, devising, under the heading of "science of communication," a mathematical formulation of what are in fact non-temporal structures.[53]

Writing in 1979, Daniel Bell suggested that "in the last decade, many sociologists, finding [Talcott Parsons's] concepts too abstract, have returned to history."[54] Some, perhaps. Kenneth J. Arrow, a Nobel laureate in Economics, provides an even better target for Braudel's critique. Insofar as Arrow finds historical information valuable at all, he would use it to test economic theory and explain how theories have evolved.[55] Most historians would argue that Arrow is proceeding in precisely the wrong direction. After the evidence has

"Of Mess and Men: The Boardinghouse and Congressional Voting, 1821–1842," *American Journal of Political Science,* 19 (1975), 207–30; and Michael Nelson, "The Washington Community Revisited," *Virginia Quarterly Review,* 61 (1985), 189–210. Lord Clarendon once accused Thomas Hobbes of seeking to impose abstract, "geometrical" models on society instead of taking advantage of the empirical lessons of history; he urged Hobbes, even at the age of eighty-eight, to sit in Parliament and correct the illusions bred by "his too peremptory adhering to some Philosophical Notions, and even Rules of Geometry" (Edward Hyde, Earl of Clarendon, *A Brief View of the Dangerous and Pernicious Errors . . . in Mr. Hobbes' book entitled Leviathan* [Oxford, 1676], 322).

53. Braudel, "History and the Social Sciences," 21–22. See also Edward Muir, *Civic Ritual in Renaissance Venice* (Princeton, N.J., 1981), 58–59.

54. Bell, "Talcott Parsons: Nobody's Theories Were Bigger," *Bulletin of the American Academy of Arts and Sciences,* 33 (December 1979), 7–11.

55. Arrow, "Economic History: A Necessary though Not Sufficient Condition for an Economist," *American Economic Review,* 75 (1985), 320–23, esp. 322.

been assembled, examined, and sifted, then and only then is it appropriate to explore whether theory can help us understand why or how a phenomenon occurred.[56]

Arrow's paper is quite helpful in clarifying several major differences between History and her sister disciplines. Arrow speaks about the value of comparisons, for example, but what he and most other social scientists really hope to find when they make comparisons are either similarities or regularized patterns of variance.[57] The historian thinks about comparisons (when he or she thinks about them at all) with a somewhat more open mind. If anything, the historian is more likely to hope for contrast than for similarity, not in order to reinforce our presumed obsession with particularity but because we find diversity more interesting—both for its own sake and for the challenge that it presents to our explanatory mission. I don't think I will let any cat out of any bag if I concede that most historians are impressed by the diversity to be found in cultures, in social processes, and in patterns of causation. One of the risks inherent in the historical way of knowing is a propensity to commit the fallacy of retrospective determinism. Looking back and describing what happened may make the occurrence and its consequences seem inevitable. A comparative historical perspective can help to avoid that pitfall.[58]

A truly cosmopolitan historian ought to be especially sensitive to variations in space and time. That historian is also more likely than other social scientists to recognize whatever inappropriate analogies are made, false precedents invoked, or inaccurate "norms" presumed as the background for contemporary tendencies. A few concrete exam-

56. For a pointed critique of Arrow's ahistorical analysis of the economic development of the medical profession in the United States, see Paul Starr, *The Social Transformation of American Medicine* (New York, 1982), 225–27.

57. Goody notes that anthropologists and sociologists are primarily interested "in the regularities of process rather than in the chronological record. [Theirs] is an approach that tends to stress equilibrium mechanisms or the repetitive nature of change" (*Social Organisation of the LoWiili*, vi). The historian is equally interested in repetitive change (what Emmanuel Le Roy Ladurie has called "motionless history") and aberrant or determinative changes. The former category describes what happens to most people most of the time. It is important because it helps us to appreciate what "normal" life for ordinary folk has been like. The latter category describes unusual occurrences that often alter the life patterns of polities or societies. Full understanding of the human experience requires a comprehension of both.

58. See Reinhard Bendix and Guenther Roth, *Scholarship and Partisanship: Essays on Max Weber* (Berkeley, Calif., 1971), pt. B, "Comparative Studies of Authority and Legitimation."

ples may help to clarify both the claim I am making and the blame I am dispensing. We all tended to assume the relative absence of physical mobility in pre-industrial societies until historical demographers such as Peter Laslett and E. A. Wrigley exploded that myth.[59] Sociologists were inclined to posit the extended family unit as normative prior to industrialization and the nuclear family as normative after the onset of industrialization. That view, too, has been shattered by social historians who have worked intensively on family life in early modern times.[60] During the mid-1960s Daniel Patrick Moynihan made major policy recommendations based upon a theory he developed concerning the pathology and predominance of female-headed Afro-American families, a phenomenon that he assumed had its genesis in slavery. Herbert Gutman, John Blassingame, and Eugene Genovese have demonstrated the inaccuracy of Moynihan's presumption and the inadequate sequence of his historical inferences. Despite its harshness, chattel slavery simply did not cause the black family to disintegrate.[61]

I hasten to add that the pattern is not always so neat and sweet: the social scientist posits a naive dynamic of change based upon ignorance of anything that happened more than two generations ago. Along comes the sage historian with twenty-twenty hindsight to set the record straight and save social science from its own nearsighted self. Alas, historians have also been indicted. Oscar Handlin's influential book *The Uprooted* (1951) is built around a cluster of assumptions concerning the nurturing stability of a known world left behind and the terrifying chaos of an inhospitable, unstable, anxiety-ridden New World. A younger generation of social historians who specialize in

59. See Wrigley and R. S. Schofield, *The Population History of England, 1541–1871* (Cambridge, Mass., 1981), esp. 219–28, for migration rates by quinquennium along with annual net migration rates from the later sixteenth to the later seventeenth century. See also Laslett and John Harrison, "Clayworth and Cogenhoe," in H. E. Bell and R. L. Ollard, eds., *Historical Essays, 1660–1750, Presented to David Ogg* (London, 1963), 157–84; and Darrett B. Rutman and Anita H. Rutman, *A Place in Time: Middlesex County, Virginia, 1650–1750* (New York, 1984), esp. I, 22–25, 252.

60. See Peter Laslett, ed., *Household and Family in Past Time: Comparative Studies in the Size and Structure of the Domestic Group over the Last Three Centuries . . .* (Cambridge, 1972); Kenneth W. Wachter et al., eds., *Statistical Studies of Historical Social Structure* (New York, 1978); and Philip J. Greven, Jr., *Four Generations: Population, Land, and Family in Colonial Andover, Massachusetts* (Ithaca, 1970), 97–99.

61. Gutman, *The Black Family in Slavery and Freedom, 1750–1925* (New York, 1976); Blassingame, *The Slave Community: Plantation Life in the Antebellum South* (New York, 1972); Genovese, *Roll, Jordan, Roll: The World the Slaves Made* (New York, 1974). For yet another and quite different illustration, see S. C. Humphreys, "History, Economics, and Anthropology: The Work of Karl Polanyi," *History and Theory*, 8 (1969), 165–212; and M. I. Finley, *The Use and Abuse of History* (New York, 1975), 117.

immigration and in urban and family life have demonstrated—ethnic group by ethnic group—the instability and chaos that drove immigrants from their homes and the rewards of diligence, a sense of community, social mobility, and freedom that awaited them elsewhere.[62]

I willingly concede that we historians commit many of the same sins that other social scientists do, and face some peculiar problems of our own as well. We misuse and overuse certain word-concepts when they become trendy—such as *modernization, watershed,* and *dependency*—to the point where the words cease to be meaningful and become tired clichés. (Perhaps clichés are always "tired.") This is especially true of the secular use of such clinical concepts as *paranoia, anxiety, alienated, marginalized, transference, traumatic,* and—especially during the 1960s and '70s—*identity crisis.* Individuals, communities, professions, societies, and eventually entire nations seemed to be undergoing crises of identity before our very eyes, until the whole notion became tendentious and collapsed, to be replaced by more profound ways of describing cultural dysfunction, such as *malaise, narcissistic,* and *hegemonic.* Today's buzzwords become tomorrow's vapidities. The pattern is not really harmful, as a rule, except that sometimes we deceive ourselves into believing that we have *explained* something when in reality we have barely *described* it. Give a lay historian a technical concept, and he thinks he's Archimedes with a lever or a screw. All he needs is a place to stand . . .

Actually, however, despite the constraints of national parochialism, despite excessive specialization and professional fragmentation, despite the infuriating incompleteness of their sources, historians have long been aware of their own limitations and the ways in which those failings compound their inability to "know" the past. As James Schouler, a Boston lawyer and genteel historian, wrote to Albert Bushnell Hart a century ago: "No one who writes history can feel wholly satisfied with what he has done, if his mind and his task are progressing." Just months before his death in 1935, the great Egyptologist James Henry Breasted lamented that "we are like some frontiersman in the night holding up a torch over a dark stream and imagining that the circle of

62. See Rudolph J. Vecoli, "*Contadini* in Chicago: A Critique of *The Uprooted*," *Journal of American History,* 51 (1964), 404–17; Jay P. Dolan, *The Immigrant Church: New York's Irish and German Catholics, 1815–1865* (Baltimore, Md., 1975); Josef J. Barton, *Peasants and Strangers: Italians, Rumanians, and Slovaks in an American City, 1890–1950* (Cambridge, Mass., 1975); and Lynn Hollen Lees, *Exiles of Erin: Irish Migrants in Victorian London* (Ithaca, 1979), esp. 17–19.

its hurrying current revealed by the torchlight is all there is to the stream."[63]

One of the delightful ironies of historical scholarship, however—I find it stimulating rather than discouraging—is that historians are most likely to advance their discipline when they generalize boldly, become very provocative, and are then proven dead wrong. Everyone knows about Frederick Jackson Turner's seminal essay "The Significance of the Frontier in American History" (1893), or Charles Beard's *Economic Interpretation of the Constitution* (1913), or R. H. Tawney's *Religion and the Rise of Capitalism* (1926), or Carl Becker's *Heavenly City of the Eighteenth-Century Philosophers* (1932). Although Turner deserves to be considered a good social scientist, the others really were somewhat indifferent social scientists. They were men with ideas, men of deep commitments (even though Becker's deepest commitment was to detachment), and they were, above all, our "model-builders." Their models consisted of clustered premises, well argued but not well supported. As Becker liked to admit, he had plunged in without fear and without research.

My discipline has had no Newtons and Einsteins to offer general theories that historians then spend half a century testing empirically and ultimately ascertain to be correct, or at least partially so. When historians systematically scrutinize one another's theories, they frequently find them wrong; quite often they write nasty books and essays in order to say so, make a reputation, and (they believe) clear the air.[64] As Hugh Trevor-Roper has put it, "the past is littered with the débris of ambitious historical systems."[65]

63. Schouler to Hart, November 27, 1886, Hart Papers, box 19, Harvard University Archives, Pusey Library, Cambridge, Mass.; Charles Breasted, *Pioneer to the Past: The Story of James Henry Breasted, Archaeologist* (Chicago, 1943), x. For a remarkably similar observation made by Robert C. Binkley during the 1930s, see Stephen J. Tonsor, "Myth, History, and the Problem of Desacralized Time," *Continuity: A Journal of History*, nos. 4/5 (Spring/Fall 1982), 25.

64. For a choice example, see Walter Prescott Webb, *The Great Plains* (Boston, 1931), and the savage demolition, sponsored by the Social Science Research Council, by Fred A. Shannon, *An Appraisal of Walter Prescott Webb's "The Great Plains": A Study in Institutions and Environment* (New York, 1940). Shannon's act of intellectual manslaughter drew blood, lots of it, and historians seem to have been stimulated by the gore. In 1944 the Research Appraisal Committee of the Social Science Research Council looked around for other works by American historians that could serve as sacrificial lambs to advance the cause of historical truth. See Merle Curti to Dixon Ryan Fox, January 2, 1944, and Fox to Curti, January 6, 1944, Fox Papers, Schaffer Library, Union College, Schenectady, N.Y.

65. Trevor-Roper, "The Past and the Present: History and Sociology," *Past &*

If he is correct, then where does that leave historians with respect to theory and method, not to mention "systems"? There is no clear-cut answer because there is no consensus. Jerome Clubb would like to place "theory development at the center of the [historian's] enterprise." Leonard Krieger, however, reached quite the opposite conclusion, and I suspect that if we put the question for a vote to the 15,000 members of the American Historical Association, Krieger's outlook would be the more acceptable. Here is what he wrote in 1957: "The absolutely distinctive element in the historian's operation consists precisely in this effort to describe and explain movements of men through time which are unanalyzable by any system of fixed methods and general hypotheses." Herbert Butterfield, who did not hesitate to make some very bold generalizations himself, nonetheless sneered at the excessively cerebral historian who "sits on his mountain top" taking "short cuts through the complexity of the past."[66]

Is there any predominant pattern to be found in the historian's use of theories and concepts borrowed from the social sciences? Having taken the pulse of 180 historians during the second half of 1985, and having read a bit (more systematically than stochastically, I hope), I will venture the following. Most practicing historians today freely admit to using concepts in some fashion. Some work with theories, attempting to apply or test them with data from the past. The more complex or abstract the theory, the fewer historians you are likely to find hovering around it. Metahistory, whatever its intellectual and cultural significance may be in the history of ideas, is regarded by few current practitioners as an authentic way of knowing. Rather it is a way of believing that one knows something very big and systematic, in the manner of Sir Isaiah Berlin's now venerable hedgehog.[67]

It is true that some devotees in the subdiscipline of intellectual history are attracted to the work of social theorists such as Michel Foucault,

Present, no. 42 (February 1969), 9. He adds that History "is not a science: it is an art in whose method several sciences are subsumed without making it thereby itself scientific."

66. Clubb, "Murphey and the Possibility of Social Science History," 102; Krieger, "The Horizons of History," *American Historical Review,* 63 (1957), 71–72; Maurice Cowling, "Herbert Butterfield, 1900–1979," *Proceedings of the British Academy,* 65 (1979), 597.

67. See Hayden White, *Metahistory: The Historical Imagination in Nineteenth-Century Europe* (Baltimore, Md., 1973); and Berlin, *The Hedgehog and the Fox: An Essay on Tolstoy's View of History* (New York, 1953).

Jürgen Habermas, Mikhail Bakhtin, and Paul Ricoeur.[68] But such practitioners pick and choose what helps them to explain an intellectual phenomenon, much as Richard Hofstadter did with concepts borrowed from Sociology and social psychology. Hofstadter turned to the social sciences for "speculative richness," and more specifically for concepts concerning social status, social stratification and mobility, generational differences, the sociology of knowledge and of the professions, and forms of mass culture.[69]

What I have just said is familiar to any American historian. What I am about to say is unknown, a bit of a shocker but also a highly apropos reminder of the role of contingency in human affairs—a consideration that even historians often neglect. One of Hofstadter's works, *The American Political Tradition and the Men Who Made It* (1948), has an introduction that is well known and made the book exceedingly influential for a generation; in it, he asserts that American politicians, irrespective of party or ideological persuasion, have shared a common commitment to "the sanctity of private property, the right of the individual to dispose of and invest it, the value of opportunity, and the natural evolution of self-interest and self-assertion, within broad legal limits, into a beneficent social order" (p. viii). In a letter to a respected colleague in 1968, however, Hofstadter admitted that he had added the introduction "as an afterthought, at the publishers' suggestion. They felt it needed a little something to pull it together. I had not thought of myself as writing a book with a central thesis, but when I went back I thought that this perception of consensus was one of the things that was in the book."[70]

Although we have often heard it said that we do not know what we think until we write—therefore we write—it is reassuring to learn that a master of my craft did not entirely know what he had written until someone else required him to reread it with care! The lessons of this episode are self-evident. First, historians feel comfortable making in-

68. See Dominick LaCapra, *Rethinking Intellectual History: Texts, Contexts, Language* (Ithaca, 1983); LaCapra, *History & Criticism* (Ithaca, 1985); and Hayden White, *Tropics of Discourse: Essays in Cultural Criticism* (Baltimore, Md., 1978).

69. Arthur M. Schlesinger, Jr., "Richard Hofstadter," in Marcus Cunliffe and Robin W. Winks, eds., *Pastmasters: Some Essays on American Historians* (New York, 1969), 294–95. See also Stanley Elkins and Eric McKitrick, "Richard Hofstadter: A Progress," in Elkins and McKitrick, eds., *The Hofstadter Aegis: A Memorial* (New York, 1974), 300–367.

70. Hofstadter to Arthur Schlesinger, Jr., March 1, 1968, Hofstadter Papers, Butler Library, Columbia University, New York City.

terpretive or explanatory statements on a modest scale but shy away from mega-generalizations. Second, historians (even the social scientific types) depend a great deal on intuition (or educated guesses) but are likely to leave the broader implications of their work implicit. Third, it can be risky to categorize historians into schools, such as the "consensus school." Some of us fall into schools unknowingly; others are too hastily pigeonholed (I know non-Marxists who sound like Marxists, and Marxists who don't); and some of us simply change our minds, repudiating what we once believed as a natural consequence of intellectual growth. Another statement from Hofstadter's candid and autobiographical letter is illuminating: "I agree now with most of what you say about the limitations of the consensus idea. I think it had a certain value as a corrective of some of the Progressive simplifications, but it does appear to me now that we have to go back to conflict as the center of our story. I have written about this in the closing chapter of my forthcoming book, and some of it amounts to a partial recantation."[71]

An innovative British social historian, equally self-aware, has undergone a comparable shift that is particularly germane: the intellectual odyssey of Gareth Stedman Jones has caused him to move in the direction of combining hermeneutics with history as the optimal way of knowing.

> I began with the strong conviction both of the inadequacy of simple empiricist approaches to nineteenth and twentieth century history and of the inability of conventional Marxism or other prevalent forms of social theory satisfactorily to illuminate the actual course of events. My initial ambition was to arrive at a more fruitful juncture between history and social theory. I hoped that the combination of a non-empiricist approach to history and a skeptical relation to received social theory might become the distinguishing trait of a new type of history. As I originally conceived the problem, partial or wishful depictions of the "social" had led to the inability to explain the political, cultural or ideological in the light of it. My scepticism did not extend to the character of social determination in itself. But as my preoccupation with this theme developed . . . I found myself obliged to redefine the problem: in short, to dissociate the ambition of a theoretically informed history from any simple prejudgment about the determining role of the "social." In particular, I became in-

71. Ibid. The book he refers to is *The Progressive Historians*, chap. 12, "Conflict and Consensus in American History."

creasingly critical of the prevalent treatment of the "social" as something outside of, and logically—and often, though not necessarily, chronologically—prior to its articulation through language.[72]

Increasing numbers of historians find themselves given to this kind of confession-*cum*-pronouncement. And that is symptomatic of the swift and significant changes that have been occurring in History during the 1980s. In 1981 John Higham speculated that practicing historians (as opposed to philosophers of history) had never been very theoretical to begin with, but that "a decline in theory" had taken place *pari passu* with "an improvement in practice." A glance at some issues of the *American Historical Review* in the mid-1980s suggests that theoretical explorations are making a comeback, highly visible if not yet "hegemonic."[73]

When we speak of the role of theory in historical scholarship, we are forced to recognize just how centripetally variable this discipline is. It is obviously still possible to write masterworks in which theory (as opposed to explanation) really does not figure at all. I can cite as examples *The Armada,* by Garrett Mattingly (1959); *Florence in the Forgotten Centuries, 1527–1800: A History of Florence and the Florentines,* by Eric Cochrane (1973); *Emperor of China: Self-portrait of K'ang-hsi,* by Jonathan D. Spence (1974); and *Peasants into Frenchmen: The Modernization of Rural France, 1870–1914,* by Eugen Weber (1976).

It would also be possible to rattle off a list of books as diverse as they are distinguished, however, each one representative of the historical mode of knowing and each one far better than it would have been had the author not borrowed conceptually or methodologically from the social sciences. Among works not previously referred to, I have in mind Oscar Handlin, *Boston's Immigrants: A Study in Acculturation* (1941); David M. Potter, *People of Plenty: Economic Abundance and the American Character* (1954); Robert H. Wiebe, *The Search for Order, 1877–1920* (1967); Alfred D. Chandler, Jr., *The Visible Hand: The Managerial Revolution in American Business* (1977); and finally, just to demonstrate that I am not entirely parochial, Marc Bloch's masterpiece, *Feudal Society* (1940).

72. Jones, *Languages of Class,* 7.
73. See Higham's review of Michael Kammen, ed., *The Past before Us: Contemporary Historical Writing in the United States* (Ithaca, 1980), in *American Historical Review,* 86 (1981), 807–9, and 90 (1985), esp. the essays by Thomas L. Haskell, T. J. Jackson Lears, and John Patrick Diggins.

The honor roll could be much longer. My point is simply that social science has contributed much to the historical mode of knowing, yet it remains possible to write superb history without understanding the difference between a random walk and a Rice index of cohesion. It is also possible to write history rather poorly from *either* perspective. Of the two possibilities, however, bad history that has been shaped in some way by social science is more pernicious because it looks so authoritative to the uninitiated.

It may be useful here to note the first sentence of the constitution of the Social Science History Association, formed in 1974: "The major purpose of the Social Science History Association is to improve the quality of historical explanation in every manner possible, but particularly by encouraging the selective use and adaptation in historical teaching and research of relevant theories and methods from related disciplines, particularly the social sciences." We must mark the diversity of opinion among historians about the relative merits of borrowed methods and theories. "Methods," in this frame of reference, really means statistical methods and the use of computers. I will venture to say that few historians are hostile to the selective and careful application of theory; that historians in general share more of an interest in some level of theory than in quantitative techniques of analysis; and that a mini-debate is now taking place among historians most strongly committed to a social science approach over the question, Just how proficient does the historian have to be at numerical prestidigitation? Samuel P. Hays, to cite only one prominent practitioner, has expressed concern at the tendency "to select problems for investigation on the basis of the availability of quantitative data capable of intensive statistical manipulation, rather than on the basis of their conceptual importance. . . . Concern with quantitative technique alone has tended to freeze the historical imagination as firmly as presidential history or biography did in years past."[74]

The new skepticism that one encounters in my guild pertaining to matters of method reduces to this: there is a serious risk that method may become (and for some scholars has already become) an end in itself. A danger also exists that familiarity with (or partisanship on behalf of) a given method may determine the selection of projects to be researched or may shape the way in which a historical problem is

74. *Social Science History,* 1 (1976); Hays, *American Political History as Social Analysis,* 39–40.

approached. Although the word "scientific" had various connotations half a century ago, being more precise by measuring had fundamental importance for scholars such as Joseph A. Schumpeter and Howard W. Odum. Today, perhaps *because* our techniques of social measurement have been so improved, being "scientific" (to most historians, at least) means finding the appropriate blend of evidence, analytical skills, and means of applying them in order to achieve maximum explanatory power. The quality of the questions we ask and the significance of the historical problems we pose are absolutely critical. A cautionary note is now being sounded that "knowing" social science (that is, theories and methods) is no substitute for knowing history. From my perspective, social science without a historical dimension resembles those larger-than-life yet ludicrous caricatures on parade floats: superficially grand but lacking in substance and all too easily shredded.

The contrasting views of History offered in a book published in 1983 by Robert W. Fogel and G. R. Elton make for interesting if highly predictable reading. Fogel has long been in the vanguard of cliometrics, and Elton is an unreformed and unapologetic advocate of History as an autonomous way of knowing. If we want to see where things are headed in the 1980s and to get a clear fix on History as a way of knowing, then it may be more instructive to compare Fogel's views with those of a historian who has been far more sympathetic to the social sciences than G. R. Elton. Whereas Fogel, for example, says that "cliometricians want the study of history to be based on explicit models of human behavior," Joyce Appleby declares that "there are two dubious propositions that undergird the social scientific search for truth: the idea that human behavior is sufficiently uniform to understand through abstract generalizations, and the assumption that the number of influences playing upon society is small enough to be comprehended within a single analytical framework. If these assumptions are not true, then their acceptance in our society . . . becomes a question of culture."[75]

Fogel has offered what I regard as an untenable dichotomy between two contrasting approaches, which he designates as "historical imagination" versus "behavioral modeling." Every thoughtful member of my guild values "historical imagination," but almost all of us regard that as just one among the many qualities essential to achieving sound

75. Fogel and Elton, *Which Road to the Past?* 25; Appleby, "Social Science and Human Nature," 121–22.

historical knowledge. The old question whether History is an art or a science is passé because the question is *mal posé*. Good history must combine humane science and high art. Perhaps I can best epitomize the shift that has occurred in this way. Once upon a time, the key word in the phrase "social science" was *science*.[76] Now it is *social*. The historical approach hopes to be precise, but the quest for a science of society is giving way to a search for context, contingency, and change in the story of human experience.

Context, Contingency, and Change

It is unfortunate that the most strident claims on behalf of History as a distinctive way of knowing have been made by scholars least sympathetic to the social sciences.[77] As we have seen, History cannot be autonomous. Thinking in such parochial terms is not intellectually fruitful or fulfilling. To peruse the correspondence of Richard Hofstadter, for example, and to read the extraordinary analysis of his *Anti-intellectualism in American Life* written by David Riesman in 1963, or Daniel Bell's equally trenchant response to *The Progressive Historians* in 1968, is to sense the true meaning of that weary phrase "community of scholars." They agreed and they disagreed, but Riesman and Bell entered the historian's world view; and by doing so with critical empathy, they must have expanded Hofstadter's ken of the cognitive horizon, even though he may not have altered a sentence in consequence.[78]

However much we all share an interest in human behavior and a common desire to explain it, the fact remains that certain considerations are particularly important to historians—that is, receive greater

76. See Roy F. Nichols, "History and the Science of Society: The Problem of Synthesis," in *The Social Sciences at Mid-Century: Essays in Honor of Guy Stanton Ford* (Minneapolis, Minn., 1952), 84–94; Nichols, *A Historian's Progress* (New York, 1968), chap. 6, "Among the Behavioral Scientists"; Lionel Trilling, "The Sense of the Past" (1942) in *The Liberal Imagination: Essays on Literature and Society* (1950; Garden City, N.Y., 1953), esp. 178, 183.

77. See, e.g., G. R. Elton, "The Historian's Social Function," *Transactions of the Royal Historical Society*, 5th ser., 27 (1977), esp. 199–201.

78. Riesman to Hofstadter, July 9, 1963, and Bell to Hofstadter, February 19, 1968, Hofstadter Papers. See also Hofstadter to David M. Potter, June 12 and July 2, 1963, and Potter to Hofstadter, July 8, 1963, ibid., concerning Hofstadter's use of social science concepts in *The Age of Reform* (1955) and *The Radical Right*, ed. Daniel Bell (1963).

emphasis in our work—and therefore constitute the most distinctive attributes of our craft.

The first of these I call a scrupulous attention to context. This is scarcely a newly discovered virtue. One of the many accomplishments of John Clive's magnificent *Macaulay* is his demonstration of Macaulay's sensitivity to whatever historical "situation" was germane, an emphasis that Professor Clive has since repeated on a smaller canvas in elucidating Alexis de Tocqueville's *Ancien Régime*.[79] The importance and meaning of context are sufficiently self-evident that we need not linger over them. This is what J. H. Hexter so admires in the work of a master such as Garrett Mattingly. In Mattingly's books, Hexter says, "the detail stood out from a complexly patterned background. He did not amputate the subjects he wrote about from the larger society to which they belonged, Latin Christendom mainly in the age of the Renaissance." It is what the great legal historian F. W. Maitland meant when he referred to "the interdependence of human affairs, for example the interdependence of political, religious and economic phenomena." Maitland then added, in his naughty yet winning way, "It seems to me that the people who have learnt that lesson are not the sociologists but the historians."[80] He wrote that in 1899, however, and surely Sociology has improved since then.

Because the historian believes that context can be known and indeed *must* be elaborated, he or she constantly seeks new or more appropriate means of accomplishing that end. The *Annalistes'* notion of *histoire totale* has by now given context the status of an almost limitless compulsion. We have found with many topics that, if the reader's patience and the publisher's purse permit, it is possible to be exhaustively thorough. Don Fehrenbacher has called for a new type of narrative history, "not story-telling narrative, but 'thick' narrative, which examines the

79. Clive, *Macaulay: The Shaping of the Historian* (New York, 1973), 73–74, 116, 118, 123; Clive, "Why Read the Great 19th-Century Historians?" *American Scholar*, 48 (1978–79), 39.

80. Hexter, "Garrett Mattingly, Historian," in *Doing History*, 158–59; Maitland, "The Body Politic," in *The Collected Papers of Frederic William Maitland*, ed. H. A. L. Fisher (Cambridge, 1911), III, 293. For a splendid example of History as the discipline of context, see Lawrence W. Levine, "The Historian and the Culture Gap," in Curtis, ed., *The Historian's Workshop*, 317. By examining a situation in the most scrupulously historical manner, Levine (then a Ph.D. candidate) was able to explain a letter written by William Jennings Bryan which had often been quoted but was misunderstood and consequently misused. See also Maris A. Vinovskis, *The Origins of Public High Schools: A Re-examination of the Beverly High School Controversy* (Madison, Wis., 1985).

complex tissues of change as it proceeds along a chronological course." Nonhistorians may very well say, "But isn't that what historians are supposed to do?" The answer in one word is "yes," but it is not easy and has not commonly been done well. Dom David Knowles's magisterial trilogy, *The Religious Orders in England* (1948–59), has been called "primarily a narrative history, in the grand manner, one of the few to emerge in its generation."[81]

One virtue of "thick narrative," apart from its ample attention to context, is that it facilitates the historian's task of truly integrating narrative with analysis. Hexter has observed that "in the best writing of history, analysis and narrative do not stand over against each other in opposition and contradiction; nor do they merely supplement each other mechanically. They are organically integrated with each other." He concedes, however, that the art of integration is difficult and often gets botched. I would add that the challenge of blending narrative with analysis has caused the historian considerable difficulty ever since the 1870s, when Bishop William Stubbs wrestled with the problem. Halfway through the first volume of his *Constitutional History of England,* Stubbs wrote to E. A. Freeman in 1873, "I am getting on with my book, but find myself stumped everywhere with the necessity of combining synthesis and analysis—and am subsiding into sandwiches—first a political outline, then a constitutional diagram."[82]

The solution to Stubbs's problem may take myriad forms, necessarily appropriate to each author's topic and available evidence. Thus we may consider as "thick narrative" such varied works as Allan Nevins's *Ordeal of the Union* (1947–71); Hajo Holborn's *History of Modern Germany* (1959–69); Arthur Schlesinger, Jr.'s *Age of Roosevelt* (1957–); Constance McLaughlin Green's two-volume "biography" of *Washington, D.C.* (1962–63); David M. Potter's *Impending Crisis, 1848–1861* (1976); and Anthony F. C. Wallace's *Rockdale: The Growth of an American Village in the Early Industrial Revolution* (1978).

Why are these contextually rich works so satisfying? It is not merely because every meaningful precinct, person, or decision has been accounted for and integrated. Far more important, every pertinent variable has been considered. Perhaps one of the ways in which the historical approach differs from other social science paradigms lies in our

81. Fehrenbacher, "The New Political History," 129; C. N. L. Brooke, "David Knowles, 1896–1974," *Proceedings of the British Academy,* 61 (1975), 454.
82. Hexter, *Doing History,* 170; J. G. Edwards, *William Stubbs* (London, 1952), 8–9.

disregard for Ockham's razor. The elegance of being economical in the use of evidence and explanatory postulates has much less appeal for the historian than for most social scientists. We mistrust scholars who ride a thesis too hard, and we feel more comfortable instead with multicausal explanations. We expect to encounter them and develop strategies for dealing with them. Quite often, in fact, it is deviations and aberrations that call attention to the historical problems that we revel in trying to resolve.[83]

Thick narrative is also an effective means of delineating change, which ranks alongside context as an essential attribute of the historian's vocation. To be concerned with change over time inevitably requires us to be sensitive to rates of change, to continuities, and even to what Le Roy Ladurie has called motionless time, or "history that stands still," a phenomenon far more common in antiquity and the premodern epoch than since the eighteenth century.[84] Fernand Braudel has described very well our concern with the variability of change:

> The other social sciences know little of the crisis that our historical discipline has undergone during the last twenty or thirty years; they tend to misunderstand our work, and in so doing also misunderstand an aspect of social reality that history serves well but does not always make properly known—that is, social time, or those multiple and contradictory forms of time affecting the life of man, which are not only the substance of the past but also the stuff of present-day social life. In the debate that is developing between all the social sciences this is yet another cogent argument for the importance and use of history or rather of the time-dialectic exhibited in the work and sustained observation of historians. Nothing, in our opinion, comes closer to the heart of social reality than this lively, intimate, constantly recurring opposition between the instant and the long-term. Whether we are dealing with the past or present, a clear awareness of the plurality of social time is indispensable to a common methodology of the social sciences.[85]

83. See, e.g., Charles Gibson, "Conquest, Capitulation, and Indian Treaties," *American Historical Review*, 83 (1978), 1–15; Joyce O. Appleby, *Economic Thought and Ideology in Seventeenth-Century England* (Princeton, N.J., 1978), ix; George M. Fredrickson, *White Supremacy: A Comparative Study in American and South African History* (New York, 1981), 107; and for the emphasis placed by *Annalistes* upon *histoire problème*, see J. H. Hexter, "Fernand Braudel and the *Monde Braudellien* . . . ," in *On Historians*, 105–6, 140, 144.

84. See Alexander Gerschenkron, *Continuity in History, and Other Essays* (Cambridge, Mass., 1968); Siegfried Giedion, *The Eternal Present: A Contribution on Constancy and Change*, 2 vols. (New York, 1962–64); Le Roy Ladurie, "History That Stands Still," in *The Mind and Method of the Historian* (Chicago, 1981), 1–27.

85. Braudel, "History and the Social Sciences," 12–13.

I concede that some historians have been harsh and unfair in declaring (as Trevor-Roper did) that social scientists "construct and admire their models in the workshop only and do not test them by running them through the dimension of time." I nevertheless contend that no other discipline than History takes as a primary responsibility, as the very essence of its mission, the effort to account for how things got from Time One to Time Two. Hence the impact of two influential essays by the late Perry Miller, "From Edwards to Emerson" and "From the Covenant to the Revival." Hence our attraction to agents of major historical change, such as the printing press. Hence the high value that we place upon works that describe and explain in scrupulous detail what happened to Old World customs and institutions after they made the momentous ocean passage.[86]

The historian's preoccupation with change is not a well-guarded secret. I cannot improve upon this assertion, made by Leonard Krieger almost thirty years ago, concerning the fundamental role of change in human affairs:

> It is a commonplace that time has two dimensions. In one sense it is a regular sequence, reducible to quantitative measure, and in this reduced form it has been usable by science. In another sense, however, it is an irregular process, defined by the events which occur arbitrarily within it. In the latter sense, time becomes a primary, irreducible category, change becomes its measure, and the historian becomes its knower. The historian assumes that when men are static—and under this assumption they are static when considered in their constant postures, their repetitive activity, or their finished creations—they are generalizable and can be comprehended by the means which the behavioral sciences and the humanities have predicated for stable or recurrent objects and have applied to situations and completed events. But he assumes too that when men act to change their situation or to create something new, they move through specific, unpredictable, evanescent crystallizations of actions and reactions which can be served only by a discipline working under the sovereign aegis of time. For the humanities and the behavioral sciences alike,

86. Trevor-Roper, "The Past and the Present," 12; Miller, "From Edwards to Emerson," in *Errand into the Wilderness* (Cambridge, Mass., 1956), 184–203; Miller, "From the Covenant to the Revival," in *Nature's Nation* (Cambridge, Mass., 1967), 90–120; Elizabeth L. Eisenstein, *The Printing Press as an Agent of Change: Communications and Cultural Transformations in Early Modern Europe,* 2 vols. (Cambridge, 1979); Sumner Chilton Powell, *Puritan Village: The Formation of a New England Town* (Middletown, Conn., 1963); David Grayson Allen, *In English Ways: The Movement of Societies and the Transferal of English Local Law and Custom to Massachusetts Bay in the Seventeenth Century* (Chapel Hill, N.C., 1981).

the essence of change consists in the fixed relationship between the termini of the change: for the humanities, men's actions are related to the beginning and end products of human creation; for the behavioral sciences, men's actions are converted into situations through the analysis of the stable factors in action, and the situations are then connected by laws or theories of change.[87]

One of the most notable developments within my discipline during the 1970s and '80s is the variety of ways in which historians have sought to understand, describe, and connect the multifarious facets of change in the human experience. Members of the *Annales* school have rediscovered the "event," redefining it by broadening its implications far beyond what French scholars understood the term to mean less than a generation ago. Thus François Furet has called the French Revolution "a blessed event for historicist history [*histoire historisante*], almost custom-made, punctuated by unavoidable dates, and admirably suited to narrative." Furet continues, his argument growing more complex and provocative:

> The Revolution is not so much a topic in modern history as one of its chief manifestations, in that it embodies a mode of change and human action that is fundamental to its significance. While it is true that, from its very outbreak, the Revolution has occupied a central position in the historical imagination, all the histories of the Revolution deal with a topic far vaster than the history of the Revolution—they are actually constructing a meaning for time itself. That is probably why history-as-a-social-science has dealt so cautiously with this historical object. It does not know how to tackle such a short period, how to grapple with a cascade of events so difficult to simplify, and how to avoid a practically spontaneous chronological—that is, narrative—approach. . . .
>
> For the social dimension of the event has been absorbed, whittled down, smothered by its political dimension. The social history of the Revolution does not consist in describing or analyzing the changes that took place in French society during those years in order to measure the relation between the political and institutional upheaval and the actual fabric of society. That relation is taken for granted as being wholly deducible from political history.

With these concerns in mind, we can readily appreciate Furet's desire

87. Krieger, "The Horizons of History," 71.

to reinterpret the French Revolution as an "event" of quite a different sort than his predecessors had described.[88]

Historians have found flexible and fruitful ways of utilizing the concept of a generation: as a means, for example, of illuminating the intellectual context of a major event, such as World War I, and explaining why different and overlapping age cohorts responded in diverse ways to the same event.[89] Historians have also improved their capacity to understand the relationships between units of time. For members of the *Annales* school that meant units of varying duration; but we now pay closer attention to matters of sequence as well. Henry Adams, one of the most thoughtful American writers on epistemological matters, remarked with contempt that "historians undertake to arrange sequences,—called stories, or histories—assuming in silence a relation of cause and effect. These assumptions, hidden in the depths of dusty libraries, have been astounding, but commonly unconscious and childlike; so much so, that if any captious critic were to drag them to light, historians would probably reply, with one voice, that they had never supposed themselves required to know what they were talking about."[90]

I am persuaded that human experience and social action can best be viewed in terms of sequences that vary in duration, depending upon the object of study. That is why we now differentiate between manifest events (such as a presidential election), of which contemporaries were fully aware, and latent events (such as the growth of literacy or the decline of fertility since the eighteenth century), of which contemporaries were only partially aware and which can be fully comprehended only in retrospect.[91] It is a long way, intellectually as well as

88. Furet, "Beyond the *Annales*," 399–400. See also Furet, *Interpreting the French Revolution* (Cambridge, 1981); and the interview with Herbert Gutman in Abelove et al., *Visions of History*, 191, in which Gutman urged intensive study of pivotal events that took place in 1892.

89. Alan B. Spitzer, "The Historical Problem of Generations," *American Historical Review*, 78 (1973), 1353–85; Robert Wohl, *The Generation of 1914* (Cambridge, Mass., 1979).

90. *The Education of Henry Adams* (1918), ed. Ernest Samuels (Boston, 1973), 382.

91. See Bernard Bailyn, "The Challenge of Modern Historiography," *American Historical Review*, 87 (1982), 9–11; Charles Tilly, ed., *Historical Studies of Changing Fertility* (Princeton, N.J., 1978); and Braudel, "History and the Social Sciences," 16, for a valuable enumeration of latent events that became visible when historians expanded the units of time within which they worked.

chronologically, from Henry Adams's cynicism to Erik Erikson's observation: "Maybe it is time to study political sequences as psychological continuities rather than as accidental fatalities."[92]

Even if it is, however, the historian must always have a special concern for accidental fatalities, or for the role of contingency in human affairs—the variable least loved by other social scientists yet one that makes the historian's vocation endlessly fascinating and challenging. When Charles Beard read Lionel Trilling's essay "The Sense of the Past" in 1942, he exulted and dashed off a spontaneous note to Trilling: "So few recognize the imponderables of history and realize that we must and can grasp firmly 'at' them, elusive as they are."[93]

Although our inclination to acknowledge the role of fortuitous, accidental, and conditional factors has increased during the past twenty years, it would be worth speculating why British historians seem to have been sensitized earlier to the importance of contingency than historians in the United States. Richard Pares said it all in 1935: "Historians must never give up the struggle to make sense of history, but they must also guard against making too much sense. They must allow most of all for vagueness and uncertainty." G. R. Elton, in echoing that sentiment emphatically in 1976, concluded that "History is skeptical"; seven years later, in his friendly duel with Robert Fogel, Elton insisted once again that the historical enterprise is "uncertain, contingent, and inconclusive."[94]

Although Henry Adams declared history "incoherent" in his *Education,* a best seller in 1918–19, for many years Americans were more disposed than Adams to infuse their vision of the past with purpose. A belief in the intervention of Providence, the Manifest Destiny of a Redeemer Nation, and the parochial vision of American exceptional-

92. Erikson, *Insight and Responsibility: Lectures on the Ethical Implications of Psychoanalytic Insight* (New York, 1964), 205. See also Andrew Abbott, "Sequences of Social Events: Concepts and Methods for the Analysis of Order in Social Processes," *Historical Methods,* 16 (1983), 129–47; and Christopher Ehret and Merrick Posnansky, eds., *The Archaeological and Linguistic Reconstruction of African History* (Berkeley, Calif., 1982), which indicates how well archaeological and linguistic data can be correlated when they deal with complex and long-term sequences.

93. Beard to Trilling, July 10, 1942, Trilling Papers, Butler Library, Columbia University, New York City. Quoted with the permission of Mrs. Diana Trilling.

94. Pares, review of Arthur P. Newton's *European Nations in the West Indies (1493–1688)* in *English Historical Review,* 50 (1935), 523; Elton, "The Historian's Social Function," 204, 206, 210; Fogel and Elton, *Which Road to the Past?* 100, 108. See also Trevor-Roper, "The Past and the Present," 4, 10–11.

ism all needed to recede before contingency could emerge, front and center, as a factor seriously to be reckoned with. In 1963, following two years of watching policy being "made" by the Kennedy administration, Arthur Schlesinger, Jr., published a confessional in which he lamented that the historian "often imputes pattern and design to a process which, in its nature, is organic not mechanical." He cogently argued that "the passion for tidiness is the historian's occupational disease. Yet the really hard cases tend to be inherently untidy." Since then, variations on this theme have been sounded increasingly in the United States; the fortunate consequence has been a diminished imperative to overorganize, to make everything fit together, and to explain imponderables.[95]

There is a minor irony in this trend. Surely, enhanced sensitivity to the role of contingency ought to make the discipline less susceptible to deterministic explanations of any kind. Be that as it may, the Marxist approach to history, which had so few advocates in the United States a generation ago, has many more today; and some of them produce work of the highest quality and importance. Equally curious, the appeal of Marxism has gained ground despite the sharp decline in metahistorical systems of explanation.[96]

It has happened also despite the fact that Marxist historians confront an awkward problem: namely, how to reconcile or rationalize the gap between theoretical expectations and historical realities. Two possible explanations come to mind. One is that contemporary Marxism is considerably more sophisticated than its schematic and rigid antecedents. The other? Perhaps Marxist historians in the United States, at least some of them, are Marxist in that protean, enigmatic sense that one so often encounters in western Europe and Latin America. I once asked a distinguished Italian historian at the University of Bologna, "Why are you a Marxist and what is Marxist about the history that you teach and write?" He responded wryly, "We are *all* 'Marxists,' just as you are all 'liberals.'"

My difficulty with devout Marxist history (as opposed to a sensible emphasis upon socioeconomic factors) is the same difficulty that I have

95. *Education of Henry Adams,* 301; Schlesinger, "The Historian and History," 494–95; Fehrenbacher, "The New Political History," 140.

96. See Abelove et al., *Visions of History,* a collection of thirteen interviews with radical historians; and Lee Benson, "Changing Social Science to Change the World: A Discussion Paper," *Social Science History,* 2 (1978), 427–41, with the responses on pp. 442–48 and in 3 (1979), 227–44.

with true believers in behavioralism, environmentalism, and even rationalism (that is, the belief that man is normally a rational being): they all share the common and unacceptable denominator of determinism. I believe that freedom of the will is possible and is regularly exercised. I do not believe in the universal regularity of human behavior. I do believe in cultural relativism, with the corollary that diverse cultures, even when affected by similar conditions, are propelled through different trajectories with variable consequences for their members. I believe that grand theories based upon the presumed existence of vast impersonal forces have rather limited utility for purposes of conceptualization and are likely to be reified in risky ways. I believe, along with many others, that nonrationality is more than an occasional aberration in human thought and behavior.[97]

If the obverse of determinism is contingency, then I must be some kind of a "contingentist,"—but not a congenital contingentist. It wasn't my destiny to be one. Rather, experience has turned me in that direction. I like the familiar line from Alexander Pope's *Moral Essays,* too rarely quoted along with the line that immediately precedes it:

> 'Tis education forms the common mind:
> Just as the twig is bent, the tree's inclined.

Along with contingency and nonrationality, there is at least one other major constraint upon historical knowledge: the sheer perversity of our primary sources. Not all of them, and not all of the time, but often enough—especially in the qualitative evidence that we have at first hand: personal testimony, as it were—with the consequence that compensatory measures and caution are required. I have made a collection of such deviltries, and perhaps a few pertinent illustrations will clarify the nature of the problem.

In 1958, when R. H. Tawney, the brilliant economic historian and activist in the British Labour party, completed his volume *Business and Politics under James I* after twenty years of intermittent toil, he said to

97. For the company that keeps me, see Marc Bloch, *Feudal Society* (Chicago, 1964), I, 73; David M. Potter, "Rejection of the Prevailing American Society," in *History and American Society,* 364–66; Arthur Schlesinger, Jr., "The Historian," *Proceedings of the Massachusetts Historical Society,* 91 (1979), 95; C. Vann Woodward, *American Counterpoint: Slavery and Racism in the North-South Dialogue* (Boston, 1971), 36; and Edward A. Purcell, Jr., *The Crisis of Democratic Theory: Scientific Naturalism & the Problem of Value* (Lexington, Ky., 1973), 93, 99.

his housekeeper, "Lucy, I think this is my masterpiece." Simultaneously, however, he wrote to John U. Nef, "I am ashamed of it, and wish that I had never begun it." Tawney's biographer admits that "the contradiction cannot be resolved."[98] In Charles Breasted's engrossing biography of his father, he notes a peculiar discrepancy between the cheerful and self-confident letters that the young founder of Egyptology in America wrote home from Germany while he pursued his doctorate there, and Professor James Henry Breasted's gloomy memories of his student days in Berlin forty years later. Although that sort of discrepancy is not altogether rare, it can be partially explained, at least, by a combination of changes in political and personal circumstances. We have also learned that Henry Adams deliberately falsified, for aesthetic reasons, the account given in his *Education* of events in London during the American Civil War of which he had so much personal knowledge.[99]

Because the historian especially cherishes firsthand, eyewitness accounts, I am going to relate two personal anecdotes. I suspect that every reader can recall comparable episodes. In July 1979 my wife and I attended a large party. During the course of the evening we had separate conversations with an American ophthalmologist who had recently returned, reluctantly, after several years of practice in Israel. Each of us asked him how and why his decision had been made. When we quite accidentally compared notes, we found that he had given us very different answers. He told my wife that he could not afford to relocate permanently in Israel: his salary would be lower there and his taxes much higher. He told *me,* on the other hand, that the practice of medicine in Israel frustrated him because the sociology of it was so old-fashioned—too many tea breaks and the like, combined with a system of socialized medicine that offered the support staff little incentive to work hard.

98. Ross Terrill, *R. H. Tawney and His Times: Socialism as Fellowship* (Cambridge, Mass., 1973), 104. In 1941 the University of Chicago asked Tawney to participate in a symposium entitled "The Place of Ethics in the Social Sciences," planned as part of the university's fiftieth anniversary celebration. Tawney always enjoyed visiting Chicago but was horrified by the prospect that he might be photographed with a Rockefeller. In 1941 it happened. Tawney, a devoted socialist, was mortified, yet five minutes later he got into a limousine and drove off to lunch with Henry Luce on one side and Marshall Field on the other. One of the Rockefellers was heard to mutter: "The man is mad."

99. Breasted, *Pioneer to the Past,* 34; Lee Clark Mitchell, "'But This Was History': Henry Adams' 'Education' in London Diplomacy," *New England Quarterly,* 52 (1979), 358–76.

In purely human terms I have no difficulty understanding what happened. When asked a personal question at a social gathering, one doesn't ordinarily make a speech, outlining points one, two, and three. One gives an answer that is honest though not necessarily complete. Moreover, if asked the very same question twice, one is quite likely, in order to avoid boredom, to say something different the second time. The variant answers are not incompatible. The good doctor did not lie to his friends. He simply gave a partial answer to each person. For a historian, however, that was a chastening experience. If our knowledge of motives, causes, and events in our own time, involving people we know personally, can be so fragmentary, accidental, and capricious, then how in heaven's name can we possibly hope to know fully what happened, and why, a century or a millennium ago?

Several weeks after that dinner my wife and I were doing yard work in front of our home. Two Cornell students came bicycling along our road at a vigorous pace. The second one, a female, closed her hand-brakes too hard, went over her handlebars, and crumpled on the road, her bike landing on top of her. She suffered lacerations to the forehead, a mild concussion, and a lot of bruises. In response to our telephone call, the police and an ambulance service arrived promptly and handled the crisis efficiently.

After the ambulance took the injured bicyclist (accompanied by her friend) to the emergency room of our local hospital, the police officer asked us what had happened. Even though we had both witnessed the event, we could not agree on one critical aspect of the accident. My wife felt certain that the male bicyclist, riding about twelve feet ahead of his friend, had abruptly signaled to her that he intended to make a right-hand turn. My wife had seen him make that signal (I had not) and inferred that the young woman must have panicked at having to make a sharp turn on such short notice and thus tried to slow down too quickly. When the young man returned the next day, we asked him whether he had signaled a turn or not. He said no. But whatever the explanation of his friend's mishap, my point is simply that two witnesses who were perhaps thirty and thirty-five yards away from the accident had seen different things.[100]

100. For a remarkably comparable episode involving Mr. and Mrs. James Truslow Adams, see *Rotarian*, 56 (January 1940), 14. That discrepancy involved the Adamses' contradictory perceptions of the Duke of Windsor's physical appearance and health. For an example that is quite different in nature and highly problematic for historians, see the interview with Linda Gordon in Abelove et al., *Visions of History*, 79–83.

Obviously, these are two inconsequential events, but the implications for "knowing" seem significant to me. Suppose that dinner party had involved Woodrow Wilson on the eve of America's entry into World War I. Suppose several persons had asked him an identical question about German maritime policies and he had given each one a partial answer, for the same understandable reasons. Suppose the inquirers did not subsequently compare notes, and suppose that only one of them kept a journal assiduously. Then suppose that a historian came along fifty years later, found the journal, and said, "Aha, this is what *really* caused Wilson to make that particular decision at that particular time." There is no source that a historian values more than an eyewitness account by someone presumed to have no reason to falsify the record. Nevertheless, the record may still be seriously misleading because it is incomplete.

Should I, as a result of my experiences as a historian and as an ordinary observer, abandon all hope of ever knowing anything about earlier times? No. I follow Max Weber in believing that we learn more about the past from historical analysis of constellations (or configurations) of phenomena than we do from any pretense at either precise verifiability or deductive reasoning. When Jan Vansina did historical ethnography among the Kuba peoples of the central Congo, he encountered many versions of the history of the kingdom, variations in historical accounts of the same "events," and even differences in the rendering of cultural norms. How could he make sense of these inconsistencies? His solution was to watch for the greatest common denominator: "that on which all informants present can agree." The historian must use whatever evidence is available—however little or much—with critical discernment. But the likelihood of "knowing" something is improved when clusters of data are available and can be carefully sifted. Moreover, *configurations* of data can be analyzed with much more assurance than isolated particles. As H. J. Habakkuk has written: "The influences which are relevant to [economic] development combine in many different ways, and each has a different effect according to the combination in which it appears."[101]

101. Vansina, "History in the Field," 105, 109; Habakkuk, *American and British Technology in the Nineteenth Century: The Search for Labour-Saving Inventions* (Cambridge, 1962), 3. See also Walker Percy, *The Message in the Bottle* (New York, 1975), 22: "There is a secret about the scientific method which every scientist knows and takes as a matter of course, but which the layman does not know. . . . The secret is this: Science cannot utter a single word about an individual molecule, thing, or creature in so far as it is an individual but only in so far as it is like other individuals."

Much as I am attracted to Habakkuk's comparative approach and cultural relativism, I am equally impressed by the knowledge and explanatory thrust that can be achieved when we have intense concentrations of information pertaining to a historical problem that is specific in time and place. John M. Allswang, for example, produced in 1971 a pioneering work in American political history and urban geography, *A House for All Peoples: Ethnic Politics in Chicago, 1890–1936*. He was the first historian to isolate at the precinct level a large sample of highly concentrated ethnic units. He achieved this by means of an innovative mapping process that matched census tracts with voting precincts. For ecological data at the precinct level, Allswang utilized unpublished 1920 and 1930 census material compiled by several social scientists at the University of Chicago early in the 1930s. Chicago school census data provided the basis for estimates of ethnic composition by wards during the period 1890–1916. The result is an unusually sophisticated monograph that relates ethnicity in voting to the rise of the New Deal Democratic coalition by showing that Czechs, Poles, Lithuanians, Italians, Germans, Swedes, Yugoslavians, blacks, and Jews either became disenchanted with their traditional Republican affiliation or else entered the political process for the first time during the 1920s.[102]

The sort of work done by Allswang and others who locate "thick" statistical data may seem a peculiar response to the historian's dilemma that I described a moment ago. I am persuaded, however, that concentrations of information that are exclusively qualitative can compensate in just the same way for the unreliability of individual bits of impressionistic evidence. Theodore Zeldin's two-volume masterpiece on France from 1848 until 1945 is really a massive mosaic composed of thousands upon thousands of mutually reinforcing pieces of particular information.[103]

Robert Fogel has conceded that cliometricians "tend to be disdainful of efforts to reconstruct the motives and feelings of long-dead individuals."[104] That is a dangerous form of disdain because it omits not

102. For a comparable example of what can be "known" from densely clustered information pertaining to a historical problem that is time- and place-specific, see John Modell, *The Economics and Politics of Racial Accommodation: The Japanese of Los Angeles, 1900–1942* (Urbana, Ill., 1977).

103. Zeldin, *France, 1848–1945*, 2 vols. (New York, 1973–77), reprinted in five softcover volumes titled *Ambition and Love, Intellect and Pride, Taste and Corruption, Politics and Anger, Anxiety and Hypocrisy*.

104. Fogel and Elton, *Which Road to the Past?* 64.

merely so many aspects of the human experience but so many of the most fascinating aspects. Consequently, historians have expanded their inquiries into just such areas. I deliberately use the word "expanded" because the quest itself is hardly new. Johan Huizinga's brilliant book *The Waning of the Middle Ages* (1924) came to be written, in part, because Huizinga noticed a prevalence of weeping in the art and literature of France and the Low Countries during the fourteenth and fifteenth centuries.

In 1982 Zeldin issued an intriguing manifesto for "personal history and the history of the emotions." Zeldin happens to be aggressively hostile toward the social sciences. He regards them as conceptually bankrupt, insists that historians should stop testing useless hypotheses, and urges that scientists not be allowed to determine historians' agendas.[105] One need not be so alienated from social science as Zeldin in order to write the history of human emotions. That social theory and psychology can be helpful in this endeavor has been demonstrated by John P. Demos, Robert Jay Lifton, Peter Gay, Philip Greven, and many others.[106] Although none of their works is flawless, I am attracted to them as exemplars of historical knowledge because they cope with problems inherent in qualitative evidence by using it in thick clusters, so that the unreliability of particular sources need not undermine the entire enterprise. Writing "personal history" at the level of an individual or just a few individuals is a more precarious undertaking. Nevertheless, recent examples show just how informative such work can be, despite its vulnerability to critical scrutiny.[107]

All of which brings us at last to the particularity of most historical evidence, a fact of life that historians accept as a given, yet one that troubles many social scientists and has implications not fully recog-

105. Zeldin, "Personal History and the History of the Emotions," *Journal of Social History,* 15 (1982), 339–47. See also William J. Bouwsma, "Anxiety and the Formation of Early Modern Culture," in Barbara Malament, ed., *After the Reformation: Essays in Honor of J. H. Hexter* (Philadelphia, 1980), 215–46; Lawrence Stone, *The Family, Sex and Marriage in England, 1500–1800* (New York, 1977).

106. See Demos, *Entertaining Satan;* Gay, *The Bourgeois Experience: Victoria to Freud* (New York, 1984); Greven, *The Protestant Temperament: Patterns of Child-Rearing, Religious Experience, and the Self in Early America* (New York, 1977).

107. See, e.g., Carlo Ginzburg, *The Cheese and the Worms: The Cosmos of a Sixteenth-Century Miller* (Baltimore, Md., 1980); Robert Darnton, *The Great Cat Massacre and Other Episodes in French Cultural History* (New York, 1984), esp. chaps. 2 and 6; Michael Zuckerman, "William Byrd's Family," *Perspectives in American History,* 12 (1979), 255–311; and Theodore Rosengarten, *Tombee: Portrait of a Cotton Planter* (New York, 1986).

nized by members of both groups. The historian is supposedly more interested in particulars, more respectful of their individual integrity, and more adept at recovering them. Yet I have conceded that particulars can be just as difficult to "know" with assurance as any other type of evidence, perhaps more so. Therefore what the historian "knows" best are really configurations of particulars: a voting trend, a social mood at a certain moment in time; a pattern of urban crime or of peasant fertility, and so forth. If one accepts that the acquisition of knowledge is necessarily a selective process, then the knowledge (in depth) of types can be vitally important and frequently "validating."[108]

The study of types, however intrinsically fascinating they may be, is a means of getting at patterns. Once we have "got" them, the task remains to test and refine our understanding of them. For precisely that reason, historians in recent decades have been increasingly attracted to a form of the particular known as the case study. There are those who love particulars for themselves alone. Such people are likely to say of a community study, for example, that it "reads like a novel." Well, some do and some don't. But no one can deny that the transcendent value of historical case studies—the most particular form of historical exposition except for biography—has been to explode tenuous generalizations and pave the way for reassessment. That has been the "case" with the Turner thesis, as well as with our assumptions about Jacksonian democracy and about the social impact of industrialization, the Horatio Alger myth, and the relationship between class, status, and power in nineteenth-century America.[109]

"Case study" has become the most tell-tale phrase in the realm of historical revisionism—invariably a warning that social science applied

108. For outstanding examples, see Wohl, *The Generation of 1914;* Eileen Power, *Medieval People* (1924; Garden City, N.Y., 1956); John L. Thomas, *Alternative America: Henry George, Edward Bellamy, and the Adversary Tradition* (Cambridge, Mass., 1983); and Laurence R. Veysey, *The Communal Experience: Anarchist and Mystical Counter-Cultures in America* (New York, 1973).

109. See Merle Curti et al., *The Making of an American Community: A Case Study of Democracy in a Frontier Community* [Trempeleau County, Wis.], (Stanford, Calif., 1959); Lee Benson, *The Concept of Jacksonian Democracy: New York as a Test Case* (Princeton, N.J., 1961); Alan Dawley, *Class and Community: The Industrial Revolution in Lynn* (Cambridge, Mass., 1976); Paul G. Faler, *Mechanics and Manufacturers in the Early Industrial Revolution: Lynn, Massachusetts, 1780–1860* (Albany, N.Y., 1981); and Herbert G. Gutman, *Work, Culture, and Society in Industrializing America: Essays in American Working-Class and Social History* (New York, 1976), esp. chaps. 4 and 5, which use Paterson, N.J., as a case study in several different ways.

in depth is about to help one historian give another one a bloody nose. It is noteworthy that each monograph cited in the preceding footnote was influenced by social science methods or theory or both. It is no coincidence that a number of anthropologists, sociologists, and political scientists have been calling for scrutiny of smaller units of scale. To know well, obviously, requires precision; and it is easier to be precise at the parish or precinct level, or in terms of villages and "ritual areas," than with larger units of social organization. Anthropologists have what they like to call the "not-in-*my*-village" syndrome, and they are every bit as adroit in the use of case studies to test conventional orthodoxies as historical revisionists are.[110]

I will make one last point about the value or potential value of particular knowledge in general, and especially historical particulars, as a way of knowing. I concede that it is not an easy point to make either clearly or persuasively. Both Bronislaw Malinowski (1884–1942) and the great Italian historian Federico Chabod (1901–60) believed that they could find the universal in the particular. That belief enabled each one to generalize well beyond the Trobriand Islands, or Italy since the time of Machiavelli. What makes this leap so tricky, however, is that few of us still believe, as David Hume did, that the chief use of history is to "discover the constant and universal principles of human nature." Where does that leave those of us who are more sympathetic to Herder's relativism than to Hume's universalism?[111]

The answer may lie in Federico Chabod's pursuit of specific historical problems in which he perceived universal importance. As A. William Salomone has written in his penetrating study of Chabod: "From beginning to end, all of his professional writing seems to have been predicated upon the assumption that selective and intensive concentration through the monograph on a particular historical problem of 'universal' significance is the ideal structure within which the search for historical truth must be conducted in the twentieth century."[112]

110. See Goody, *Social Organisation of the LoWiili*, iv; Clifford Geertz, *Local Knowledge: Further Essays in Interpretive Anthropology* (New York, 1983), chap. 8; and William Sheridan Allen, *The Nazi Seizure of Power: The Experience of a Single German Town, 1930–1935* (Chicago, 1965).

111. Malinowski, *Magic, Science, and Religion and Other Essays* (1948; Garden City, N.Y., 1954), 10; Forrest McDonald, "Conservative Scholarship and the Problem of Myth," *Continuity: A Journal of History*, nos. 4/5 (Spring/Fall 1982), 55; G. A. Wells, *Herder and After: A Study in the Development of Sociology* (The Hague, 1959).

112. Salomone, "Federico Chabod: Portrait of a Master Historian," in Hans A. Schmitt, ed., *Historians of Modern Europe* (Baton Rouge, La., 1971), 278–79.

There is no perfect formula for finding the universal in the particular. Chabod set his brilliant study of Italian nationalism and imperialism during the late nineteenth and early twentieth centuries against the larger context of nationalism and imperialism generally. When Dom David Knowles wrote about English friars in medieval times, he "set the English material firmly in the context of a great continental movement." By doing so, Knowles also found the universal in the particular: his chapter on the friars thereby became "an admirable introduction to the history of the friars in general." Michael Walzer became fascinated by Puritanism as an early form of political radicalism and as a set of human choices that in several respects seemed strange, even disturbing. From *The Revolution of the Saints,* specific as it is in time and in place, we learn various lessons about the contradictory tendencies of movements that mingle radical change with resistance to change.[113]

To find the universal in the particular requires unusual sensitivity to context, and that brings us back to where we began—in this section at least. Perhaps clear connections between the two help to make somewhat more meaningful these words by Max Weber: "Our aim is the understanding of the characteristic uniqueness of the reality in which we move. We wish to understand, on the one hand, the relationships and the cultural significance of individual events in their contemporary manifestations and, on the other, the causes of their being historically so and not otherwise."[114]

"What Is the Good of History?"

Although historians are not alone in raising this question from time to time, non-historians (and students fulfilling a college requirement) ordinarily ask it with venom in their voices if not hostility in their

113. Brooke, "David Knowles," 469; Walzer, *The Revolution of the Saints: A Study in the Origins of Radical Politics* (Cambridge, Mass., 1965). For some other examples of the diverse ways that historians find the universal in the particular, see Louis Chevalier, *Laboring Classes and Dangerous Classes in Paris during the First Half of the Nineteenth Century* (1958; New York, 1973); Klaus Epstein, *Matthias Erzberger and the Dilemma of German Democracy* (Princeton, N.J., 1959), esp. chap. 2; Maeva Marcus, *Truman and the Steel Seizure Case: The Limits of Presidential Power* (New York, 1977); Mary P. Ryan, *Cradle of the Middle Class: The Family in Oneida County, New York, 1790–1865* (New York, 1981); Rutman and Rutman, *A Place in Time,* I, 25–35, 247–49.

114. Weber, *The Methodology of the Social Sciences* (Glencoe, Ill., 1949), 72. On April

hearts. Even when historians raise it, they often lack an answer that is either complete or compelling. Be that as it may, from Langlois and Seignobos to Bloch and Becker, they do ask it.[115] Their answers, when they respond at all, are as idiosyncratic and heterogeneous as you might expect. At best, however, they add a dimension to our comprehension of history as a way of knowing. Consequently, I want to round out these reflections by indicating some of the ways that historians have answered the question, and then finish up with my own response, for whatever it is worth.

First, a general observation about a curious figure in the carpet. Many of the most eloquent and elaborate statements concerning the value of historical knowledge have come from individuals with little enthusiasm for the past. Indeed, we have such statements from people like Thomas Jefferson, who are far better known for their concern about the potential tyranny that the past might exercise over the present.[116] In contrast, some of the most whimsical or skeptical utterances about the value of historical knowledge have tended to come from individuals who cherish inquiry about the past for its own sake and accept the past on its own terms (rather than searching for a "usable past"). F. W. Maitland, for example, summed up in eleven words the feelings of so many for whom History has been a calling: "Life is short and history the longest of all the arts." Benjamin Rush, an admirable gentleman who was far closer to the Jeffersonian cast of mind, declared in 1786 that "the science of government, whether it relates to constitutions or laws, can only be advanced by a careful selection of facts, and these are to be found chiefly in History." Lord Acton waxed eloquent on the matter more than once, though he managed to sound more like an "applied historian" than one who simply loved historical information for its own sake and for the moral lessons it provided: "The science of politics is the one science that is deposited by the stream of history, like the grains of gold in the sand of a river; and the knowl-

23, 1926, George M. Trevelyan wrote Charles Homer Haskins to thank him for sending an essay on medieval intellectual history: "It has that knack of illuminating general propositions from particular instances which is the hall mark of the first-rate in history" (Haskins Papers, box 17).

115. Becker to William E. Dodd, January 27, 1932, in *"What Is the Good of History?" Selected Letters of Carl L. Becker, 1900–1945*, ed. Michael Kammen (Ithaca, 1973), 156; Bloch, *The Historian's Craft* (1941; Manchester, 1954), 3.

116. Jefferson, *Notes on the State of Virginia* (1781), in *Writings of Thomas Jefferson*, ed. Andrew A. Lipscomb (Washington, D.C., 1903), II, 206–7; Daniel J. Boorstin, *The Lost World of Thomas Jefferson* (New York, 1948), 218.

edge of the past, the record of truths revealed by experience, is eminently practical, as an instrument of action and a power that goes to the making of the future."[117]

The ironies inherent in this paradoxical configuration are so disarming that we ought to glance through it again. No one seems to say quite what you might except. Lord Macaulay, whose commitment to History was very strong, liked the light and casual touch: "The effect of historical reading is analogous, in many respects, to that produced by foreign travel. The student, like the tourist, is transported into a new state of society. He sees new fashions. He hears new modes of expression." In Confucian philosophy, on the other hand, the meaning of history blends profound truths with assumptions that many of us would find utterly unacceptable.

> History, indeed (and history becomes the core of Confucianists' intellectual life), is conceived largely as a record of right and wrong conduct and their respective consequences. The historical emphasis is not on process, but on incident; the *pastness* of the past (the sense, with all its potentialities for relativism, that the past is not present) and the *becomingness* of the past (the sense that it is constantly dissolving into the present) are not prominently savored. Confucius establishes this feeling for the paradigm in history, beyond time, since his genius is for moral judgment, a type of absolute, and it resists the relativities of passing time and change in the human condition.[118]

And then we come to Machiavelli, who managed to embrace it all. He read history and utilized what it taught him in order to satisfy his own intellectual hunger. He also perceived that we are *bound* to learn lessons from historical knowledge. Meanwhile, he assumed that someone out "there" must need or want what we learn; therefore we should choose to explicate meaningful things. Here is just one eloquent formulation of Machiavelli's intense fascination with the past for the sake of personal pleasure as well as public realities:

117. Maitland, "The Body Politic," in *Collected Papers,* III, 294; Rush, *A Plan for the Establishment of Public Schools and the Diffusion of Knowledge* . . . (1786), in Frederick Rudolph, ed., *Essays on Education in the Early Republic* (Cambridge, Mass., 1965), 19; Acton's "Inaugural Lecture on the Study of History" (June 1895), in his *Lectures on Modern History* (London, 1906), 1–2.

118. Thomas Babington Macaulay, "History" (May 1828), in *The Works of Lord Macaulay: Essays* (n.p., 1900), I, 232; Joseph R. Levenson, "The Genesis of *Confucian China and Its Modern Fate,*" in Curtis, ed., *The Historian's Workshop,* 287.

On the coming of evening, I return to my house and enter my study; and at the door I take off the day's clothing, covered with mud and dust, and put on garments regal and courtly; and reclothed appropriately, I enter the ancient courts of ancient men, where, received by them with affection, I feed on that food which only is mine and which I was born for, where I am not ashamed to speak with them and to ask them the reason for their actions; and they in their kindness answer me; and for four hours of time I do not feel boredom, I forget every trouble, I do not dread poverty, I am not frightened by death; entirely I give myself over to them.

And because Dante says it does not produce knowledge when we hear but do not remember, I have noted everything in their conversation which has profited me, and have composed a little work *On Princedoms,* where I go as deeply as I can into considerations on this subject, debating what a princedom is, of what kinds they are, how they are gained, how they are kept, why they are lost. And if ever you can find any of my fantasies pleasing, this one should not displease you; and by a prince, and especially by a new prince, it ought to be welcomed.[119]

If you were to put Carl Becker's rhetorical question to me—"What is the good of history?"—I would have to respond in three stages, each of them (inevitably) complex. First, history helps us to achieve self-knowledge and thereby a clearer sense of identity. Second, it helps us to acquire moral knowledge and thereby enables us to make sensibly informed value judgments. Third, it improves our understanding of the actual relationship between past and present, as well as the potential relationship between present and future.

The first of these is complex because it operates at so many levels. An entire civilization may depend upon historical consciousness as its most vital mode of self-understanding.[120] The same is true of nations, regardless of whether they are modern and have a highly sophisticated

119. Machiavelli to Francesco Vettori, December 10, 1513, from Florence, in *The Letters of Machiavelli,* ed. Allan Gilbert (New York, 1961), 142–43. Machiavelli was reading Livy's *History* at the time.

120. See Gerhard Masur, "Distinctive Traits of Western Civilization: Through the Eyes of Western Historians," *American Historical Review,* 67 (1962), 591–608; Levenson, "The Genesis of *Confucian China*," 286. Gilberto Freyre regarded Brazil more as a civilization than "merely" as a nation: see *The Masters and the Slaves: A Study in the Development of Brazilian Civilization* (New York, 1946); *The Mansions and the Shanties: The Making of Modern Brazil* (New York, 1963); *New World in the Tropics: The Culture of Modern Brazil* (New York, 1959); and *Order and Progress: Brazil from Monarchy to Republic* (New York, 1970).

tradition of historiography; or totally traditional, like the Kuba king-
dom of central Congo, where *shoosh* poems are repositories of history;
or in the process of transition, like Israel after independence and Iran
under the Shah.[121] What happens at this level may or may not involve
national self-deception. It depends upon the degree to which a govern-
ment deploys what Philip A. Kuhn has called "Cliotherapy, the build-
ing of self-confidence by the imaginative use of history."[122]

The level in question may also be a region, such as Brittany in
France or the American South.[123] It may be sectarian, such as the Jews
or the Mormons.[124] It may involve a community,[125] a professional
discipline,[126] or an obscure individual.[127]

There have been, I might add, a few unusually retrospective indi-
viduals whose way of thinking and knowing was so profoundly his-
torical that for us to "know" *them* fully requires us to understand, if

121. See Alan Macfarlane, *The Origins of English Individualism: The Family, Property,
and Social Transition* (Oxford, 1978); Vansina, "History in the Field," 104–5, 108;
Bloch, *Feudal Society*, I, 88–102; Bernard Lewis, *History—Remembered, Recovered, In-
vented* (Princeton, N.J., 1975), esp. p. 10.

122. Kuhn, "China: Excerpts from a Historian's Journal," *University of Chicago
Magazine*, Spring 1975, p. 28. See also Donald Denoon and Adam Kuper, "Nationalist
Historians in Search of a Nation: The 'New Historiography' in Dar Es Salaam," *African
Affairs*, 69 (1970), 329–49.

123. Pierre Jakez Hélias, *The Horse of Pride: Life in a Breton Village* (New Haven,
Conn., 1978); W. J. Cash, *The Mind of the South* (New York, 1941).

124. Salo W. Baron, *A Social and Religious History of the Jews*, 19 vols. (New York,
1952–83); Richard L. Bushman, *Joseph Smith and the Beginnings of Mormonism* (Urbana,
Ill., 1985); David Brion Davis, "Secrets of the Mormons," *New York Review of Books*,
August 15, 1985, pp. 15–19.

125. E.g., Robert Weible, "Lowell: Building a New Appreciation for Historical
Place," *Public Historian*, 6 (1984), 27–38; Blake McKelvey, *Rochester: The Water-Power
City, 1812–1854* (Cambridge, Mass., 1945), *Rochester: The Flower City, 1855–1890*
(Cambridge, Mass., 1949), *Rochester: The Quest for Equality, 1890–1925* (Cambridge,
Mass., 1956), and *Rochester: An Emerging Metropolis, 1925–1961* (Rochester, N.Y.,
1961).

126. E.g., John King Fairbank, *Chinabound: A Fifty-Year Memoir* (New York, 1982);
B. F. Skinner, *Particulars of My Life* (New York, 1976), and *The Shaping of a Behaviorist*
(New York, 1979).

127. See the attractive statement by Jacques Barzun quoted in Wendell Holmes
Stephenson, *Southern History in the Making: Pioneer Historians of the South* (Baton Rouge,
La., 1964), 241; and "A Connecticut Yankee in Nineteenth-Century New York," ed.
Carol Kammen, *Ithaca Journal*, August 3, 1985, p. 9, and August 10, 1985, p. 12. The
latter presents an autobiographical sketch written by an obscure woman, Mary Ann
Elderkin Clark Jackson, shortly before her death in 1855. She used history and geneal-
ogy as a way of establishing continuity and mobility and identity despite flux; she used
family history to achieve a sense of connectedness through time and space and to help
clarify her own identity.

not actually know, the history that they knew. The pre-eminent examples that come to mind are Nathaniel Hawthorne and Leopold von Ranke. The case for them has been brilliantly made in recent years.[128] It may well be that the same holds true of Cotton Mather, Thomas Hutchinson, Sir Walter Scott, James Fenimore Cooper, Ellen Glasgow, Willa Cather, and William Butler Yeats, whose poetry is both a meditation upon Irish history and a way of knowing it anew.

The second stage in my response has to do with the acquisition of moral insights in order to make sensibly informed value judgments. Social scientists in general, with some significant exceptions, seek to be "morally neutral." The phrase "value-free" has been with us for decades if not generations. When the phrase has become controversial, the issue has not usually hinged upon whether "value-free" social science is desirable but whether it is possible.[129]

Historians seem to ride a roller coaster on this issue. Lord Acton, R. H. Tawney, and David Knowles (members of sequential generations) did not hesitate to ask what moral lessons their historical inquiries might yield and impart.[130] During the half-century from the 1920s to the 1970s, however, especially in the United States, most historians felt reluctant to moralize, and some wrote passionately in opposition to doing so: making value judgments was unprofessional, unscientific, and usurped a role reserved to God.[131]

In the 1970s and 1980s, historians have increasingly emphasized their concern with humane values and the imperative that moral judgments ought to have a legitimate, explicitly acknowledged role in their work. One is likely to encounter that perspective equally at both ends of the

128. Michael J. Colacurcio, *The Province of Piety: Moral History in Hawthorne's Early Tales* (Cambridge, Mass., 1984); Leonard Krieger, *Ranke: The Meaning of History* (Chicago, 1977). See also Wesley Morris, *Toward a New Historicism* (Princeton, N.J., 1972).

129. See Fogel and Elton, *Which Road to the Past?* 62, 64; but cf. Bendix, *Force, Fate, and Freedom,* 28: "We must seek the moral justification of our (historicist) search for knowledge in the quality of the questions we ask as much as in the conscientious way we answer them"; and Joyce Appleby, "Value and Society," in Jack P. Greene and J. R. Pole, eds., *Colonial British America: Essays in the New History of the Early Modern Era* (Baltimore, Md., 1984), 290–316.

130. See Gareth Stedman Jones, "History: The Poverty of Empiricism," in Blackburn, ed., *Ideology in Social Science,* 97–98; Terrill, *R. H. Tawney,* 102–3; and Brooke, "David Knowles," 473.

131. Michael Kammen, "The Historian's Vocation and the State of the Discipline in the United States," in Kammen, ed., *The Past before Us,* 23–24; Michael Oakeshott, "The Activity of Being an Historian," in *Rationalism in Politics and Other Essays* (New York, 1962), 141, 162–64.

ideological spectrum and among historians of all age groups.[132] In a 1985 autobiographical essay, Lawrence Stone explained that he had learned early on as a professional "that history can be a moral as well as a scholarly enterprise, and that it ought not, and indeed cannot, be disassociated from a vision of the contemporary world and how it should be ordered."[133]

If such statements seem excessively *ex cathedra,* then we may turn to the work of E. P. Thompson, who has shown in the most historical way possible that moral impulses give rise to social and political action. The historian of such impulses writes history that is inescapably moralistic. History that attempts to be value-free is likely to be less interesting without being any more "scientific." I remain intrigued by Nietzsche's definition of historical knowledge. It is, he wrote, "the capacity for divining quickly the order of the rank of the valuation according to which a people, a community, or an individual has lived."[134]

We may agree to disagree about the validity of passing judgment on people who lived long ago or far away according to values utterly foreign to our own. I do not see, however, how anyone can deny the legitimacy of writing the history of human values in times past. Done scrupulously, that mode of knowing is bound to illuminate our own present as well as the evanescent past.

I can think of no bramble bush more thorny than the difficult problem of relating past and present. It is not incumbent upon all historians to do so. It is more or less appropriate, depending upon the subject under investigation. It is more or less desirable, depending upon the

132. John Higham, "Beyond Consensus: The Historian as Moral Critic," *American Historical Review,* 67 (1962), 609–25; Hexter, *Doing History,* 132–33, 172; Gordon Wright, "History as a Moral Science," *American Historical Review,* 81 (1976), 1–11; Carl Degler, "Remaking American History," *Journal of American History,* 67 (1980), 23–24; James Turner, "Recovering the Uses of History," *Yale Review,* 70 (1981), 221–33; Fred Matthews, "'Hobbesian Populism': Interpretive Paradigms and Moral Vision in American Historiography," *Yale Review,* 72 (1985), 97, 108.

133. Stone, "A Life of Learning," *American Council of Learned Societies Newsletter,* 36 (1985), 8.

134. E. P. Thompson, "The Moral Economy of the English Crowd in the Eighteenth Century," *Past & Present,* no. 50 (February 1971), 76–136; Julius Kirshner, *Pursuing Honor While Avoiding Sin: The Monte Delle Doti of Florence* (Milan, 1978), 30–59. Nietzsche is quoted in Trilling, "The Sense of the Past," 190. For an excellent example involving the history of ethical codes developed by working-class people in their places of work, see the interview with David Montgomery in Abelove et al., *Visions of History,* 179.

temperament of the individual historian. Once upon a time, early in this century, James Harvey Robinson made a formidable reputation by proselytizing for the "New History." The correspondence of Andrew C. McLaughlin, a prominent historian at that time, is peppered with useful illustrations of the intellectual chaos caused by Robinson and his gang. In 1908, for instance, Professor Lucy M. Salmon of Vassar wrote to "Andy Mac," after he had invited her to participate in a forum at the next meeting of the American Historical Association:

> What I really wish to talk about is the connection between the present and the past. I have been more, rather than less, troubled by the apparently current idea that history is to be taught as if everything began yesterday and we have only to learn how things are today. Mr. Robinson, for example, came up to lecture to our students studying mdiaeval history and told them in several ways that mediaeval history was a period to get through with,—that only the modern times were worth while.[135]

Robinson's letters to McLaughlin indicate that Lucy Salmon had not distorted his views one whit; and early in 1909 Robinson's distinguished Columbia colleague, James T. Shotwell, wrote McLaughlin to describe the course that he planned to offer that summer at Chicago. It would "deal with social problems, intellectual and scientific movements as well as with certain phases of the political history,—those in particular which have been of vital importance in the formation of the Europe of today."[136]

There has never been a consensus among astute historians concerning the meaning of history and historical knowledge for those living in the present. F. W. Maitland felt strongly that a historian should not be judged by the relevance of his work to his own time; we need not investigate the past in order to serve present exigencies, even though the living might very well learn from the experiences of the dead. In 1896 Maitland wrote to Albert Venn Dicey:

> I have not for many years past believed in what calls itself historical jurisprudence. The only direct utility of legal history (I say nothing of its thrilling interest) lies in the lesson that each generation has an enormous

135. Salmon to McLaughlin, October 17, 1908, McLaughlin Papers, box 1, Special Collections, Regenstein Library, University of Chicago.

136. Robinson to McLaughlin, October 19, 1908, and Shotwell to McLaughlin, January 9, 1909, McLaughlin Papers.

power of shaping its own law. I don't think that the study of legal history would make men fatalists; I doubt it would make them conservatives. I am sure that it would free them from superstitions and teach them that they have free hands. I get more and more wrapped up in the middle ages, but the only utilitarian justification that I ever urge *in foro conscientiae* is that, if history is to do its liberating work, it must be as true to fact as it can possibly make itself; and true to fact it will not be if it begins to think what lessons it can teach.[137]

A generation later Herbert Butterfield issued his influential warning against *The Whig Interpretation of History* (1931); and Charles Beard, of all people, explained to a respected colleague that "as to the 'lessons' of history, I must leave them for you to formulate. I swear that I cannot enumerate them with the best of wishes on my part."[138] More recently, that sort of agnosticism has waned and been replaced by diverse discourses concerning the uses of historical knowledge and the serious business of understanding our relationship to the past. Some wax eloquent (though remaining discreetly cautious) about the value of history to statesmen and policy-makers.[139] Others with a psycho-historical perspective talk in neo-Freudian terms about the "authority of the past"—the past as determinative permanency, burden, even neurosis—and argue that understanding the past is the optimum way to reduce its tyranny over the present, for groups of people as well as for individuals.[140]

At times I cannot help feeling that if the neo-Freudians are correct in contending that the past exercises authority over us, then the present is equally problematic because it is so ephemeral and our information about it so fragmentary. Knowing the future—despite the intriguing

137. Quoted in C. H. S. Fifoot, *Frederic William Maitland: A Life* (Cambridge, Mass., 1971), 143.

138. Beard to August C. Krey, [July 1933?], Krey Papers, box 103b, University of Minnesota Archives, Minneapolis.

139. See Schlesinger, "On the Inscrutability of History," 17; Schlesinger, "The Historian and History," 496–97; David F. Trask, "A Reflection on Historians and Policymakers," *History Teacher*, 11 (1978), 219–26; and Robert G. Stakenas and David B. Mock, "Context Evaluation: The Use of History in Policy Analysis," *Public Historian*, 7 (1985), 43–56.

140. Philip Rieff, "Freud and the Authority of the Past," in Lifton and Olson, eds., *Explorations in Psychohistory*, 78. See also the foreword by Wolfgang Schluchter to Bendix, *Force, Fate, and Freedom*, xiv.

but bizarre business of futurology—is hopeless. Perhaps that is why Friedrich Schlegel called the historian "a prophet in reverse" (*Athenaeum,* 1798–1800). I don't accept that charming epithet, but I do believe that history is a powerful, often reliable, necessary, and distinctive way of knowing.

Over the past three generations or so, historians (a great many of them, at least) have moved from the quest for a "usable past" to a profound respect for the "pastness of the past." On the whole, that has been a salutary swing, although I do not believe that we ought to discard entirely a judicious concern for usable pasts. Only once, however, have I encountered a statement by a historian describing his work in which a prudent concept of usable pastness was linked with absolute acceptance of the pastness of the past. It appeared in Joseph R. Levenson's retrospective meditation on his remarkable trilogy, *Confucian China and Its Modern Fate* (1958–65):

> I wrote the history of how something *became* history, as modern men became modern in making their past *past,* while keeping it, or restoring it, as theirs. Values rejected for the present, as *"historically significant,"* came to be accepted for a past that was *"historically significant."* Historical relativism, conservative and revolutionary historicism, the very different ways (Confucian and Marxist, for example) in which men can be historically-minded—these began to come through to me as not only attitudes toward history. They were the very stuff of the history toward which I was conceiving an attitude.[141]

Permit me to end on a personal note. For reasons that may have become clear in the course of this essay, I do not consider myself a social scientist—certainly not an orthodox one and perhaps not even a deviant one. If you hold to too many heresies, you ought to sit with some other congregation. Neither am I comfortable with the traditional label of humanist, however, because that might imply that I have nothing to learn from the social sciences, and that most assuredly is not the case. Then what am I? In what congregation do I belong? First an explanation about my vocational identity, and then a credo suitable to my sense of affiliation.

Once, following a lecture given by Michel Foucault at the Collège

141. Levenson, "The Genesis of *Confucian China,*" 281.

de France, some very critical questions were asked, and the discussion became exceedingly heated. Finally, someone asked Foucault, "What is your intellectual authority for these assertions, these interpretations? What are you, anyway? Are you a historian? A philosopher? Or something else? How can you legitimize your conclusions?"

Foucault responded simply and with his customary quiet dignity, "I am a reader."[142] The French *lecteur* does not translate very well, but presumably Foucault meant a privileged reader. There are ordinary readers and there are privileged readers. Given his intelligence, erudition, and sensitivity, Foucault must clearly be described as a privileged reader.

Although I am very fond of that story, I am less eager than Foucault to disaffiliate. Therefore, if someone asked me, "What are you?" I would respond a bit less simply by saying that I am a reader and a historian.

As for my credo, it offers little more than candid skepticism. History may or may not be an assured way of knowing. I have found it a satisfactory as well as a satisfying way of knowing. But like so many professional colleagues, I am not comfortable with the positivistic implication that somehow I can "know" anything definitively.

For me the process of knowing involves large dollops of context, contingency, and change. Ultimately, it may be the *process* rather than the product that matters most. That is why I am a reader first and a historian second. The name of the process, needless to say, is learning; and that is why, along with several members of my guild, I believe that history is not so much a mode of knowing, perhaps, as it is a way of learning.[143] For me it happens to be the way of learning *nonpareil*.

I am grateful to my assigned discussants at the University of Chicago Symposium, Bernard Cohn (Anthropology and History) and Julius Kirshner (History), for their thoughtful assessments. I am also indebted to Paul K. Conkin, Samuel T. McSeveney, Lewis Perry, and Matthew Ramsey for making my stay at Vanderbilt so stimulating; and to David R. Millar as well as Carol and David M. Ellis themselves for ensuring that my visit to Hamilton would be congenial.

142. Narrated to me by Michel de Certeau on October 12, 1984.
143. See Bruce Kuklick, "History as a Way of Learning," *American Quarterly,* 22 (1970), 609–28; William Appleman Williams, *History as a Way of Learning: New Viewpoints* (New York, 1973), 5–21.

Finally, a number of colleagues and friends provided very helpful feedback on this rather sprawling and awkwardly ambitious piece. To thank them does not implicate them in my own sins of omission and commission. But thank them I must, because they responded most generously and thoughtfully: Allan G. and Margaret R. Bogue, Paul Boyer, Paul K. Conkin, Dominick LaCapra, Peter D. McClelland, R. Laurence Moore, and Robert J. Smith.

An Emblem of Mortality by Charles Yardley Turner (oil on wood panel, 1888). Turner studied in Baltimore, New York, Paris, and the Netherlands (particularly Dordrecht) before settling in New York City, where he taught at the Art Students League and at the National Academy of Design. The large volume that the old man has set aside in order to contemplate the skull is most likely the 1643 Amsterdam edition of the Bible that Turner kept in his studio. Courtesy, National Academy of Design, New York.

PATTERNS OF MEANING IN THE HISTORIAN'S CRAFT

Advice to Persons About to Write History—Don't.
 Lord Acton to Bishop Mandell Creighton, April 5, 1887

On Knowing the Past

Have we recently reached a critical juncture in our relationship to History? Abundant signs say yes. To judge by rising museum attendance, increasing book sales, successful television programs, and historical-preservation activities, nostalgia is surely in the saddle.

Nostalgia would seem to be a mindless if not a headless horseman, however, because newspaper surveys reveal a woeful ignorance of the national past by Americans with above-average educational backgrounds.

For several years now, large and well-established professional groups such as the American Historical Association, the Organization of American Historians, and the National Council for the Social Studies have sought measures that might stimulate historical interest in the schools and enhance historical understanding among laymen. They have met with limited (or, at best, mixed) success.

This problem exemplifies a more general American ambivalence about the past—an ambivalence that has been visible for three cen-

turies. Americans who are policy-makers and opinion-makers, for example, have had a strangely ambiguous relationship to history.

Let us look at three of the most interesting Americans in our pantheon: Thomas Jefferson, Ralph Waldo Emerson, and Henry Ford. Associated with each is a provocative statement about our need to be released from the burdens of an oppressive or meaningless past. Each statement is actually more complex than a one-line excerpt can reveal, but at least the one-liners serve to jog our memories:

> The earth belongs in usufruct to the living . . . the dead have neither powers nor rights over it. (Jefferson to James Madison, September 6, 1789)

> Our age is retrospective. . . . It writes biographies, histories, and criticism. The foregoing generations beheld God and nature face to face, we, through their eyes. . . . Why should not we have a poetry and philosophy of insight and not of tradition, and a religion by revelation to us, and not the history of theirs? (Emerson, "Nature," 1836)

> History is more or less bunk. (Ford in a newspaper interview, 1916)

The problem with taking any of these pithy remarks too seriously is that they are not only misguided as declarations, in my opinion, but not even representative of the three men who uttered them.

Consider the fact that Jefferson, in his 1781 *Notes on the State of Virginia,* the only book he ever wrote and a classic of American thought, pleaded for the necessary centrality of History in the curriculum of secondary-school students. "History, by apprizing them of the past, will enable them to judge of the future; it will avail them of the experience of other times and other nations; it will qualify them as judges of the actions and designs of men."

Consider the fact that Emerson wrote an 1841 essay called "History" in which he declared: "Man is explicable by nothing less than all his history. . . . There is a relation between the hours of our life and the centuries of time."

And consider the fact that emblazoned on an iron sign in front of Greenfield Village and the Henry Ford Museum in Dearborn, Michigan, are these words from a Henry Ford grown wiser than the 1916 curmudgeon: "The farther you look back, the farther you can see ahead."

How are we supposed to make sense of such contradictory utterances?

First, of course, we must recognize that their views were as variable as ours. All lived long lives, witnessed and participated in the making of history, and changed their minds on certain key matters from time to time.

Second, we should appreciate that they distinguished between the desirability of knowing history and the imperative that we not be prisoners of the past.

Third, we must recognize that there is a tension contained within the cliché that we ought to learn from the lessons of the past. Do we learn from the so-called wisdom of the past, or do we profit from the follies of the past? Jefferson made that distinction and preferred the second alternative.

One reason why Americans may frequently recite the negative statements of Jefferson, Emerson, and Ford and prefer to neglect their affirmations of historical study is that we have been—most of us, most of the time—an optimistic and opportunistic people. We want to believe that "it" will all work out for the best.

The problem is that history shows us that "it" doesn't always. History, real history, isn't chock-full of happy endings.

Listen to Walter Lippmann back in 1914: "Modern men are afraid of the past. It is a record of human achievement, but its other face is human defeat." How right he was—all the more reason why we must know and understand the past. We have at least as much to learn from our defeats as from our achievements.

Why, then, should we really want to know the past? Here are a few reasons that I find most compelling:

• To make us more cognizant of human differences and similarities, over time and through space.

• To help us appreciate far more fully than we do the nonrational and irrational elements in our behavior: what James Boswell called, in 1763, "the unaccountable nature of the human mind."

• To enhance our awareness of the complexity of historical causation—the unanticipated intertwining of opinion and events—and their consequences for our understanding of that whirlwind we call social change.

• To acknowledge more fully and critically than we do the consequences of what is at stake when powerful people interpret history for partisan purposes on the basis of insufficient or inaccurate information about the past.

• To avoid the tendency to ascribe equal value to all relationships

and events. Worse than no memory at all is the undiscriminating memory that cannot differentiate between important and inconsequential experiences.

It is the historian's vocation to provide society with a discriminating memory.

Chapter 3

Vanitas and the
Historian's Vocation

In 1982, when *Reviews in American History* celebrated its tenth anniversary, Stanley I. Kutler and Stanley N. Katz, the editors, devoted a special issue to the theme of "The Promise of American History: Progress and Prospects." They invited me to contribute an essay, and what follows is one that I had been contemplating for many years. It first appeared in *Reviews in American History,* 10 (December 1982), 1–27, an issue simultaneously published as a separate soft-cover book titled *The Promise of American History*—and is reprinted here in slightly edited form with the journal's permission.

The appearance of this essay elicited more spontaneous reactions than anything else I have ever written, including books. One scholar summed up the tone of much of the correspondence that came in: "It speaks to my condition."

In 1958, when I started graduate study (with special concentration in early American history), to read the weighty works of Charles McLean Andrews was *de rigueur*. Before taking our general examinations, my fellow students and I staggered through the colossal *Colonial Period of American History* (1934–38; four volumes, 1,651 pages), *The Colonial Background of the American Revolution* (1924), and more—much more. Following my "generals," when I began to explore a dissertation topic concerning Anglo-American history on the eve of the Revolution, I became acquainted with Andrews's great *Guides* to manuscript mate-

rials for the history of the United States before 1783 (located in the British Library, the Public Record Office, and other English archives), published in three volumes (1908–14). Subsequently, I read the *Festschrift* published in 1931 to honor Andrews, plus his posthumous "testament," titled "On the Writing of Colonial History" (1944), and the fine biographical study by A. S. Eisenstadt (1956).

To a young and impressionable graduate student, lacking much confidence that he could ever complete a doctoral program, Charles McLean Andrews seemed legendary, an intellectual giant no longer living yet larger than life nonetheless—academic or otherwise. Merely to gaze at his photograph, published as the frontispiece in Eisenstadt's study, was daunting: a three-quarter view of Andrews's handsome face, with dark and deep-set eyes glowering imperiously upon my ignorance of the field he had charted. Here, surely, was a self-assured historian, proud of his staggering achievements, the man himself every bit as magisterial as his work.

Imagine my intense fascination in late December 1981 when I found a letter from Andrews to Max Farrand among Farrand's papers at the Huntington Library in San Marino, California. The letter is dated November 4, 1915, and for several reasons I feel compelled to present a lengthy extract.

Dear Max:

Of course I liked your letter. Who would not have liked to have something that made him feel that what he was trying to do was worth while. Expressions of interest in oneself or ones work are so rare in New Haven that I am almost tempted to have your letter framed. I get into the habit of wondering sometimes whether it is all worth the effort and the sacrifice and the drudgery. But I always come back to the one great solace that it is all to the good, and that whatever contributes to knowledge or to life is its own reward. Then I love it and that adds to my cares, lest I be doing that which is purely selfish because I am never happier than when I am at it. I am glad you liked the paper, and I am more glad that you told me you liked it.[1] I liked it myself, and felt that it opened a lot of possible interpretations that had not been in the past a part of our thought of

1. This must refer to Andrews, "Anglo-French Commercial Rivalry, 1700–1750: The Western Phase," *American Historical Review*, 20 (1915), 539–56, 761–80, the only paper he published in 1915.

colonial history. I sometimes in my climbing think that I am looking on a new world of colonial life, and that in the past we have been living like cave men instead of searchers for the truth and the light. I keep at it, but it [is] all so slow and there is so much to know. I wonder whether I shall live out the doing of what I want to do.

Andrews had left Bryn Mawr in 1907 to succeed his mentor, Herbert Baxter Adams, at Johns Hopkins. Three years later he accepted an appointment at Yale in order to be free from administrative responsibilities, "to throw off the character of general utility-man which I have had to assume here."[2] Yet at the age of fifty-two, already a well-established scholar, and after five years at Yale, he nevertheless underwent a sustained crisis of confidence. He felt isolated and unappreciated. The letter that I have quoted may or may not supply some comfort to struggling Americanists today, but it does at least provide a parable. Andrews's candor about his crisis of confidence is wonderfully refreshing. Haven't we all felt as he did? Haven't we all suffered self-doubt? And having achieved some goal—the arduous completion of a monograph, the presentation of a new course—haven't we wondered whether it was really worth the expenditure of time and psychic strength at the expense of some other activity? Were we adequately appreciated? Was the effort itself properly understood?

Although historians have not ordinarily addressed this aspect of their vocation, others have. The "vanitas" theme became very popular in western European art during the seventeenth century, especially in Calvinist cultures. Usually there is a skull, symbol of our mortality, and in addition an extinguished candle, a neglected book or two, an empty inkpot, a discarded quill pen whose nib is dulled, or perhaps an artist's palette on which the colors have dried and hardened: see Figure 1, *Vanitas* (1623) by the Dutch artist Pieter Claesz. Not surprisingly, this motif moved westward across the Atlantic, and we have a fine New England example from about 1690 in Captain Thomas Smith's *Self-Portrait* (Figure 2).[3] His hand rests upon a skull, which in turn is imposed upon a poem by Smith.

2. Quoted in A. S. Eisenstadt, *Charles McLean Andrews: A Study in American Historical Writing* (New York, 1956), 145.

3. See Joseph Allard, "The Painted Sermon: The Self-Portrait of Thomas Smith," *Journal of American Studies,* 10 (1976), 341–48.

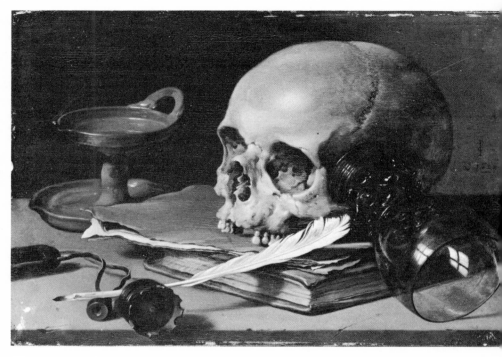

Figure 1. Vanitas, by Pieter Claesz (oil on wood, 1623). The Metropolitan Museum of Art, Rogers Fund, 1949 (49.107).

Why why should I the World be minding
therin a World of Evils Finding.
 Then Farwell World: Farwell thy Jarres
 thy Joies thy Toies thy Wiles thy Warrs
Truth Sounds Retreat: I am not Sorye.
 The Eternall Drawes to him my heart
 By Faith (which can thy Force Subvert)
To Crowne me (after Grace) with Glory.

It may have been easier in some respects for pious Puritans living in an age of faith to abjure good works and personal creativity as paths to immortality. For professional historians living in a more secular century, however, and especially for those inclined toward disbelief or doubt, the problem becomes more complex, sometimes even agonizing. Is there a more poignant pair of sentences in all of contemporary

Figure 2. Self Portrait, by Thomas Smith (oil on canvas, ca. 1690). Courtesy, Worcester Art Museum, Worcester, Massachusetts.

American historical writing than these, composed by Richard Hofstadter while dying of cancer? Hofstadter refers to Jonathan Edwards's call to the presidency of the College of New Jersey (Princeton): "He accepted the invitation, but shortly after reaching Princeton he was inoculated against smallpox, took the inoculation badly, and died before he could take up his duties. At the end he was puzzled by the irrationality of it all—that God should have called him to this role and then left him no time to fill it."[4]

4. Richard Hofstadter, *America at 1750: A Social Portrait* (New York, 1971), 242.

Hofstadter's example is unusually sad and admittedly not typical. Although he died prematurely, having sketched in merely the background of a vast projected canvas, his work achieved recognition from the outset; he was richly and justly honored throughout his career, and at the end he had the satisfaction of knowing that his contribution and influence were enormous. What about those who had less cause for confidence? What about those whose achievements were considerable but who were not sanguine by temperament?

- Moses Coit Tyler wrote to his sister shortly before his death in 1900: "Much of the things I have toiled for in life now appear to me, as I approach the period of old age, to be mere froth and scum."[5]

- William E. Dodd wrote to Erich Marcks, his former teacher in Leipzig, on April 27, 1915: "In the field of history-writing there is no fame any more . . . since Gibbon. To write a good book may win one the approval of a few good friends and some others, but in ten years the best book has to be rewritten."[6]

- When J. Franklin Jameson, director of the Department of Historical Research at the Carnegie Institution, discovered in 1927 that he would soon be put to pasture and that the whole apparatus he had labored to build would be allowed to lapse, he resigned and sent a bitter letter of explanation to friends on the Council of the American Historical Association and the editorial board of the *American Historical Review:* "Whereas I had supposed I could continue my present work as long as I was fit for it, it [is] the intention of President Merriam that I should be retired at the age of seventy (September 1929). It is evidently also his intention that no successor shall be appointed; that the present workers in the Department shall be allowed to finish their present tasks . . . but that no further work in United States history shall be undertaken."[7]

- In 1959 Lewis Mumford wrote to Waldo Frank from Amenia,

5. *Moses Coit Tyler, 1835–1900: Selections from His Letters and Diaries,* ed. Jessica Tyler Austen (Garden City, N.Y., 1911), 325. See also James Ford Rhodes to John T. Morse, August 29, 1918, Morse Papers, Massachusetts Historical Society, Boston.

6. Quoted in Robert Dallek, *Democrat and Diplomat: The Life of William E. Dodd* (New York, 1968), 79.

7. Jameson to Evarts B. Greene, November 9, 1927, Greene Papers, Butler Library, Columbia University, New York City. In 1980, when Marshall McLuhan reached the age of sixty-eight, the University of Toronto dismantled his Center for Culture and Technology and refused to postpone his retirement. See *New York Times,* June 22, 1980.

New York: "As for the difficult time you've been going through, dear Brother, I know many of the same symptoms, too: above all how important it is, no matter how self-rewarding one's work may be, to have some response from the world outside, from a public, however stupid, from editors, however grubbing. The difference between having it and not having it is like the difference between swimming in salt water or in fresh water; for in the latter one must work to keep one's head above water. And it's no consolation for either of us to remember that we have already made our mark and left a large opus: that may be true, but each day and year has its own demands and its own rewards; and there is a flavor in the last autumn fruits that is its own excuse for being and that one should be able to share with others."[8]

Clearly there is a leitmotif here, and such profoundly personal as well as touching observations warrant extended exegesis. One obstacle (among many) is that analysis or generalizations—whether psycho-biographical or collective in nature—are exceedingly hazardous. To begin, not all historians are alike, obviously, or react in the same ways. Moreover, even those historians whom we believe we know well often turn out to be rather more complicated than anyone has hitherto imagined. Let me offer two illustrations pertaining to Frederick Jackson Turner, each one from correspondence previously unused (to the best of my knowledge) by those scholars engaged in the Turner canon and "industry."

First, let us consider the Turner who so admired social scientists and wanted historians to form intellectual alliances with them. In 1914 he wrote to George Lincoln Burr, the Cornell medievalist:

I have never given so much thought to the underlying meaning and content of history as perhaps I ought. I know I haven't thought it out as you have, and if I come anywhere near what you approve of as the right conception of what history means in my own experiments, I shall be more than content, and you seem to honor me by saying that the thing to try to do is what is meant by the treatment of the *individual* element. . . . I merely have felt that history had a right to deal with large mass statistics,

8. Mumford to Frank, August 29, 1959, Frank Papers, box 85, University of Pennsylvania Library, Philadelphia. See Paul Goldberger's excellent review of Mumford's *Sketches from Life: The Early Years* (New York, 1982), in *New York Times Book Review*, May 16, 1982, pp. 13, 41.

tendencies, etc., as well as [i.e., in addition to] the *event* and the individual psychology. I dislike to yield good territory to sociologists, political scientists, etc., on which the historian may raise good crops.[9]

Here Turner certainly does not disdain the methods of social science, but he clearly believed that history had something special to offer that the other social sciences could not. He anticipated Fernand Braudel's minimization of *l'histoire événementielle* as well as E. P. Thompson's insistence that ours is the "discipline of historical context."[10]

Second, there is the Turner who bears the double burden of environmental determinism *and* American "exceptionalism." Once again, I find him not entirely guilty of the unsophisticated, chauvinistic naiveté with which he is commonly charged. Nevertheless—and this is why the matter is so pertinent to the theme of this essay—near the end of his distinguished career he was accused of intellectual parochialism by one of his oldest and dearest friends, Charles Homer Haskins. In 1925 Turner defended his views to Haskins:

> Just what you have in mind when you suggest that I look into French and German sectionalism because I would modify my "dogmatic negative" I don't know. On page 267 I point out that: "Unlike such countries as France and Germany the United States has the problem of the clash of economic interests closely associated with regional geography *on a huge scale*. Over areas equal to all France or to all Germany either the agricultural or the manufacturing types are here in decided ascendancy."
>
> I am hardly ignorant of the fact of sections in European countries, but unless I am mistaken they are not comparable in France or Germany with this large scale sectionalization of economic interests which make the American problem distinctive, areas equal or greater than a nation in Europe have preponderating economic interests of the same kind. This seems to me different from that *intra*-national sectionalization of interests in such a country as Germany; it is more like the subdivisions in a section such as New England or the South, or the North Central States.
>
> I should not bother·you with this if I were not unwilling that you should think me dogmatic. Is it dogmatic to say that the United States is vastly larger in area than France? or that our sections affected by an

9. Turner to Burr, September 5, 1914, from Darby, Montana, Burr Papers, box 11, Department of Manuscripts and University Archives, Cornell University Library, Ithaca, N.Y.

10. See E. P. Thompson, "Anthropology and the Discipline of Historical Context," *Midland History*, 3 (1972), 41–55.

economic interest are so large that they raise a special problem in the relation between sections and the contests of economic interest?[11]

What matters here is not whether Frederick Jackson Turner was substantively right or wrong. Rather, the significant issue involves that delicate relationship between the power to persuade and professional self-esteem. Turner and Haskins had been graduate students together at Johns Hopkins in the late 1880s and early 1890s. Subsequently, they had been colleagues at the University of Wisconsin (where they even taught a seminar together), and later they were colleagues at Harvard.[12] Now, after more than thirty-five years of close contact and communication, Turner could not make Haskins comprehend and accept as valid a concept that dominated his professional work during the second half of his career. Surely that inability must have been a source of disappointment if not despair. At the age of sixty-four, Turner may be forgiven his frustration, his recognition of the fruits of vanitas in his chosen vocation.

I

Our understanding of mankind's quest for fame stretches as far back as our knowledge of public culture itself. Chancellor Robert R. Livingston of New York (1746–1813) called it "the culture of laurels," a phrase I cannot improve upon. Jacob Burckhardt compiled abundant evidence that such a culture flourished during the Italian Renaissance.[13] The iconography of that epoch demonstrates the point equally well, as we can see in Figure 3, the *Triumph of Fame,* painted in the mid-fifteenth century by a Florentine known only as the Master of Fucecchio. Just as Burckhardt differentiated between the Renaissance sense

11. Turner to Haskins, May 6, 1925, Haskins Papers, Seeley G. Mudd Manuscript Library, Princeton University, Princeton, N.J. This discussion concerns one of Turner's most famous essays, "The Significance of the Section in American History," published in *Wisconsin Magazine of History,* March 1925, and reprinted in Turner, *The Significance of Sections in American History* (New York, 1932), where the quotation appears on p. 36.

12. For details of their relationship, see Ray Allen Billington, *Frederick Jackson Turner: Historian, Scholar, Teacher* (New York, 1973), 59, 66, 70–71, 95–96, 126, 180, 227, 243, 297, 310, 316, 320.

13. See Jacob Burckhardt, *The Civilization of the Renaissance in Italy* (New York, 1958), 152, 404, 428.

Figure 3. Triumph of Fame, the birthplate of Lorenzo de Medici, by the Master of Fucecchio (fifteenth-century Florentine). Courtesy of The New-York Historical Society, New York City.

of honor and the passion for fame, so we must acknowledge a fine distinction between vanitas and the passion for fame. I rather suspect, by the way, that the sardonic Calvinist view of vanitas in the seventeenth century was, at least in part, a reaction against the partially pagan, partially Roman Catholic "culture of laurels" that had flourished during the fifteenth and sixteenth centuries.

Be that as it may, the professionalization of historical scholarship in the United States brought with it, as a personal sort of epiphenomenon, the curiously contrapuntal relationship between a passion for fame and the acknowledgment of vanitas. Brooks Adams declared in 1915 that man's "greatest enemy is always his own vanity and self

esteem," and in 1952 Felix Frankfurter reminded Mark Howe, the legal historian, of James B. Thayer's remark: "It is good for people to praise you, provided you don't inhale it."[14] *Pari passu,* however, we have Albert Bushnell Hart puffing to Harvard's President A. Lawrence Lowell in 1922: "I hope it may be remembered for righteousness that next after Henry Adams and Henry Cabot Lodge, Channing and I have the honor of introducing on a considerable scale the study of special topics in American history."[15] One might proliferate such illustrations, but unfortunately they are all too familiar.

The memorable point, moreover, is not that historians boast of their accomplishments but rather that those accomplishments are, for the most part, so swiftly forgotten by all but a handful of disciples. On the basis of my (admittedly random) reading, it seems to me that perhaps three or four "modern" historians may be said to have achieved widespread, enduring, and therefore genuine fame in the United States: Edward Gibbon, Thomas Babington Macaulay, Francis Parkman, and Henry Adams. (Others may undoubtedly be added, but even in the cases of Frederick Jackson Turner, Charles Beard, and Carl Becker, for example, their reputations now seem as precarious as their influence once was pervasive.) Historians of genius, such as William Hickling Prescott, Henry Adams, and Charles Francis Adams, Jr., idolized Gibbon. The enigmatic Henry said so in so many words in his *Education.* The more phlegmatic C.F.A., Jr., considered Gibbon "an orb of the first order" and his work "the most delightful of all books." Prescott cited Gibbon in his commonplace book early in 1822, once again as a cicerone in a letter of advice to his son written in 1843, and above all in 1857 when he explained to a friend how he had become a historian: "I had early conceived a strong passion for historical writing, to which perhaps the reading of Gibbon's *Autobiography* has contributed not a little. I proposed to make myself a historian in the best sense of the

14. Brooks Adams is quoted in Frederic Cople Jaher, "The Boston Brahmins in the Age of Industrial Capitalism," in Jaher, ed., *The Age of Industrialism in America: Essays in Social Structure and Cultural Values* (New York, 1968), 208; Frankfurter to Howe, November 4, 1952, Howe Papers, 2–10, Harvard Law School Library, Cambridge, Mass.

15. Hart to Lowell, February 17, 1922, Hart papers, Harvard University Archives, Pusey Library, Cambridge, Mass. For a striking example of a historian summarizing his entire lifetime's achievement, there is an extraordinary letter from Curtis P. Nettels (1898–1981) to Carl Bridenbaugh, May 6, 1980. (I am indebted to Professor Bridenbaugh for sharing this letter with me.)

term, and hoped to produce something that Posterity would not willingly let die." Vanitas and the historian's vocation—but in Prescott's case, he had the rare qualities requisite to fulfill his aspiration.[16]

Macaulay served explicitly as a model for John Bach McMaster, James Ford Rhodes, Charles Francis Adams, Jr., and above all for Theodore Roosevelt and Henry Cabot Lodge. T.R.'s feeling for Macaulay's work verged on adulation. Lodge tells us that in college "I read Macaulay and conceived for him an intense admiration; his force, his rhetoric, his sure confidence in his own judgment, his simplicity of thought, all strike a boy very vividly."[17] And finally, in 1889 T.R. sent to Francis Parkman, then sixty-six, a paean as remarkable for its forthrightness as for its comparisons: "I have always had a special admiration for you as the only one—and I may very sincerely say, the greatest—of our two or three first class historians who devoted himself to American history; and made a classic work—not merely an excellent book of references like Bancroft or Hildreth."[18]

Some readers may protest that we have also had great historians in the twentieth century. I would not dispute that for a moment, but I *would* submit that all the evidence concerning them is not yet in, and that some among the greatest have defied the injunctions of vanitas in a way that their more prudent predecessors did not. A few attributes and attitudes will illustrate my point. Perry Miller, Samuel Eliot Morison, and Charles A. Beard all cultivated *personae* as "lone wolves." In the instances of Miller and Morison, their *personae* conveyed a massive arrogance that must inevitably dilute the measure of their human stature and enduring fame.[19]

16. *The Education of Henry Adams,* ed. Ernest Samuels (Boston, 1973), 386; Edward C. Kirkland, *Charles Francis Adams, Jr., 1835–1915: The Patrician at Bay* (Cambridge, Mass., 1965), 137; *The Papers of William Hickling Prescott* (Urbana, Ill., 1964), 41, 199, 379. For Gibbon's own views on vanitas and the historian's vocation, see his *Autobiography* (Boston, 1877), 230. See also James Ford Rhodes, "The Profession of Historian," in *Historical Essays* (New York, 1909), 56, as well as his "Edward Gibbon," ibid., 107–40.

17. See Eric F. Goldman, *John Bach McMaster: American Historian* (Philadelphia, 1943), 13, 45, 48, 109, 119, 121, 124–27; Kirkland, *Adams,* 201, 209; Roosevelt to James Ford Rhodes, November 29, 1904, in *The Letters of Theodore Roosevelt,* ed. Elting E. Morison (Cambridge, Mass., 1951), IV, 1049; Henry Cabot Lodge, *Early Memories* (New York, 1913), 31, 234.

18. Roosevelt to Parkman, July 13, 1889, *Letters of Roosevelt,* I, 172–73. In 1923 the Canadian Historical Association created the Parkman Centennial Committee to plan a major public celebration in Montreal. See Lawrence J. Burpee to J. Franklin Jameson, June 27 and August 28, 1923, Jameson Papers, box 118, Library of Congress, Washington, D.C.

19. See Perry Miller, "The Plight of the Lone Wolf," *American Scholar,* 25 (1956), 445–51; Samuel Eliot Morison to Evarts B. Greene, December 16, 1929, Greene Pa-

At least Beard—whose influence was surely the broadest of the three but whose work may prove to be least enduring in value—exuded a most refreshing unpretentiousness. I have seen a great many Beard letters scattered among diverse manuscript collections and am happy to concede that my admiration, indeed affection, for him increases apace. He did not correspond with one eye on Posterity. Half the time his letters are mildly irksome because undated, but he is *always* spontaneous, always the iconoclast, always free from cant. Here is a representative sample, written to August C. Krey, the medievalist, perhaps in 1944: "What I fear most of all, AC, is becoming respectable. I love best the people who are not respectable, such as Francis of A, or Thomas à Kempis or Gene Debs or Marcus Aurelius. So if you hear that my stock is going up with the respectables, please jump on it, unload, sell it short, and call it a false alarm."[20]

Along with most of his contemporaries, however, Beard did participate in the highly questionable practice—intimately tied to the vanitas problem—of manipulative, indeed conspiratorial book reviewing. It was commonplace for authors to arrange to have their books reviewed by close friends in prominent newspapers or prestigious journals. In 1924, for example, when James M. Beck published *The Constitution of the United States: Yesterday, Today—And Tomorrow?* he asked Charles Warren whether the *International Book Review* had requested a review: "I suggested your name for this purpose to the editor, and if you receive such an invitation I hope very much that you will review it." Beck then arranged for Warren to review his book in the *Washington Post* and suggested that when he finished, "if you will send me a carbon copy of it, I will try to get it in some other newspaper or magazine."[21]

Yet another facet of the same phenomenon is the book review editor who prejudges a book, or simply wishes to savage another scholar,

pers; Bernard Bailyn, "Morison: An Appreciation," *Proceedings of the Massachusetts Historical Society,* 89 (1977), esp. 121–23.

20. Beard to Krey, March 31, [1944?], Krey Papers, folder 187, University Archives, University of Minnesota, Minneapolis.

21. Beck to Warren, September 2, November 7 and 22, 1924, Beck Papers, box 2, Seeley G. Mudd Manuscript Library, Princeton University, Princeton, N.J. See also Robert Seager, II, *Alfred Thayer Mahan: The Man and His Letters* (Annapolis, Md., 1977), 440; Philip A. Bruce to Worthington C. Ford, March 14, 1910, Ford Papers, box 7, New York Public Library (Annex), New York City; and Charles A. Beard to Arthur M. Schlesinger, July 23, 1917, Schlesinger Papers, Pusey Library, Harvard University, Cambridge, Mass.

and consequently suggests to a reviewer an acceptable or desirable line of attack. Here is Samuel Eliot Morison inviting James Truslow Adams to review Charles K. Bolton's *The Real Founders of New England* for the *New England Quarterly:* "I am sure that you will enjoy reviewing the book, which is a pretentious but a very silly one, making out that the fishermen and scattered settlers of the New England coast who didn't found anything were the 'real' founders rather than the Plymouth and Massachusetts-Bay people. . . . The book deserves to be slashed thoroughly, and of course you can do it better than any of us here who have to live with Bolton and see him every few days."[22] Bolton served as librarian (that is, director) of the Boston Athenaeum, and Adams obliged Morison with a hatchet job.

The problem may have been, as Adams explained to Allan Nevins in 1924, that he did not know "the professional ethics of such matters." But I do not find that pitiful whimper persuasive—partly because the correspondence in which these requests appear is often marked "confidential," and partly because an implicit debate over the ethics of book reviewing had been under way *at least* since 1913, when J. Franklin Jameson made the following observation:

> [Albert Bushnell] Hart's doctrine that no book should be severely reviewed in the *American Historical Review* if written by a man having an established historical reputation, or one of the best historical jobs, or relations of close friendship with the members of the Board of Editors, does not commend itself to me. If the *Review* had from the beginning been managed on those principles, its reviews would now be thought as worthless as, for instance, Hart's recommendations of his young men notoriously are.[23]

In 1909 Hart had declared, in his presidential address to the American Historical Association, that "critical historians are more or less cannibals: they live by destroying each others' conclusions." That has happened on occasion, perhaps; but too often the criteria of critical reviewing have been blurry at best, mushy at worst, and a "buddy system" continues to exist in certain quarters. I feel a certain affinity and affection for two sentences that James Parton wrote to George

22. Morison to Adams, October 1, 1929, also November 7, 1929, James Truslow Adams Papers, Butler Library, Columbia University, New York City.
23. Adams to Nevins, October 23, 1924, Adams Papers; Jameson to George Lincoln Burr, October 26, 1913, Burr Papers, box 11.

Bancroft back in 1867: "There is a time to forebear, and there is a time to hit out from the shoulder. As a general thing, we are too mild and forgiving. We are so afraid of being savage, that we are apt to be soft."[24]

I should like to make one last point about the quest for fame among American historians in the twentieth century, a point as simple as it is obvious: namely, that ambition may often result in a form of self-imprisonment, with psychological consequences that I cannot begin to fathom. In one sense, our chosen vocation makes us very privileged people. Bernard DeVoto observed in 1930, "My profession requires me to read all the books that explain America to itself."[25] I empathize with that remark; more than that, I can identify with it. And attempting to fulfill it can be a highly pleasurable experience.

In yet another sense, however, our chosen vocation can become a compulsion, a form of entrapment. In 1948 Irving Brant asked Douglass Adair, "Did you notice Dumas Malone's conjecture in the Times Book section that the whole biography [of Jefferson] would run to six volumes? That would surely be a life sentence. He assumed, I suppose, that the remainder of it would be marked by the same detailed attention to political methods and events, which won't be the case."[26] Ha! Not only did Malone turn out to be prescient and Brant wrong, but obviously Brant could not foresee his own "life sentence": that he too would eventually devote six volumes and almost three decades to James Madison. The historian's vocation has its major and its minor ironies. This one strikes me as being particularly choice.

II

All of which brings us to a critical and unavoidable tension—sometimes creative, sometimes highly destructive—and that is the histo-

24. Hart, "Imagination in History," *American Historical Review,* 15 (1910), 234–35; Parton to Bancroft, June 4, 1867, quoted in Milton E. Flower, *James Parton: The Father of Modern Biography* (Durham, N.C., 1951), 201.

25. DeVoto, "The Centennial of Mormonism" (1930), in *Forays and Rebuttals* (Boston, 1936), 81. In addition to Wallace Stegner's wonderful *The Uneasy Chair: A Biography of Bernard DeVoto* (Garden City, N.Y., 1974), see Thomas Reed Powell's marvelous one-page sketch of DeVoto, dated November 15, 1936, in Powell Papers, A-2, Harvard Law School Library, Cambridge, Mass.

26. Brant to Adair, March 3, 1948, Brant Papers, box 16, Library of Congress, Washington, D.C.

rian's vocation itself as a historical *problématique*. This tension, or issue, is profoundly important for many reasons, but I shall consider only two. The lesser (given the focus of this essay) concerns the confusion, hence the need for an explicit distinction, between history perceived as *what happened* in the past and History perceived as the artificial *product* of a particular vocation, calling, or craft. Even the most thoughtful Americans have tended to conflate the two. When John Adams wrote, in 1789, "My experience has very much diminished my faith in the veracity of History," I think he had the second definition in mind. When he asked Mercy Otis Warren rhetorically, in 1814, "What are we to think of history when, in less than forty years, such diversities appear in the memories of living persons, who were witnesses?" I suspect that he had the first definition in mind, but perhaps not exclusively.[27]

There is less ambiguity in a marvelous letter written by his great-grandson Henry Adams in 1908: "If you are in vein for an illustration of the law of growth from unity to multiplicity, do my favorite task! Read St. Augustine's Confessions, then read Rousseau's; then try to bring us together on one string. No Chinese puzzle is so amusing . . . history is one long muddle of eyes and fangs."[28] This wry remark seems resonant with the first definition (though I would not want to stake my reputation, such as it is, on that contention).

Why is this distinction even noteworthy in our context? Because we historians have a noble public obligation that might be described as "explaining a culture to itself" (more on that in the next section); because we take a fair amount of guff from shrewd gadflies who have at least one foot in the guild and one tongue in the cheek (quoth Henry Adams: "He knew no history; he knew only a few historians");[29] *and* because we take even more guff, figuratively speaking, from smart men and women outside the guild who have certain expectations about what we can do, ought to do, and do do.

My illustration, *toute seule,* is taken from Paul Freund's remarks at a

27. Adams to Jeremy Belknap, July 24, 1789, in *Collections of the Massachusetts Historical Society,* 6th series, vol. 4 (Boston, 1891), 438; Adams to Warren, February 2, 1814, ibid., 5th series, vol. 4 (Boston, 1878), 505. For Herman Melville's cynical view of History, see *Billy Budd, Sailor (An Inside Narrative)* (Chicago, 1962), 130–31.

28. Adams to Worthington C. Ford, April 10, 1908, Ford Papers. For memorable comments on the historian's vocation, however, see *The Education of Henry Adams,* 36, 382, 395.

29. *The Education of Henry Adams,* 293.

dinner in honor of Justice Felix Frankfurter, held af the Somerset Club in Boston on June 14, 1956. The kinds of questions Frankfurter "puts to himself and to us cannot be answered by mere judges and lawyers alone," Freund observed. "Whence come our notions of right and justice? Do they come from history? Do they come from historians— which is not the same thing, and by how much not the same thing? Do they come from ourselves distilling history through the filter of our own necessities, our own aspirations? Do they come from ourselves seeking perhaps to transcend history, to apprehend truths beyond and above history?"[30]

Now then, what is the larger reason why the issue with which I began this section seems so important? Answer: A cluster of problems essentially internal to the profession—problems so hazardous that acknowledgment of them, more often than not, evokes shrill cynicism. In search of succinctness, I shall enumerate seven exemplars of the historian's vocation as historical *problématique*.

1. Historical scholarship is highly subject to trends and fads. Not so bad as some disciplines—such as literary criticism—to be sure, but bad enough. Garrett Mattingly said it all in 1959:

> In my more pessimistic moments I am sometimes inclined to imagine that the historical profession, instead of moving steadily forward through experience and self-criticism to deeper understanding and steadier, more penetrating vision, just swings aimlessly back and forth with the tides of fashion, like the ladies' garment industry. Even before the turn of the century, though history was emphatically still part politics, and international politics perhaps its most reputable branch, the deeper thinkers were in revolt against narrative, and exhorting their colleagues to break its drowsy spell. Already a growing faction of social and economic historians were telling each other that the occupants of the more famous and better paid chairs were incapable of seeing beneath the surface to the real currents of history. Before long, some of them already occupants of those coveted chairs, the vanguard were saying loudly that military and diplomatic history were idle and frivolous when they were not positively immoral, and that even political history was no better unless it exposed the molding of movements and institutions by the vast impersonal forces

30. A copy of Freund's remarks may be found in the Howe Papers, 2–12 (the Freund-Howe folder). See also Frankfurter's fascinating letter to Zechariah Chafee, Jr., July 9, 1954, Chafee Papers, 4–17, Harvard Law School Library, Cambridge, Mass. For a much more hostile view from someone entirely outside the guild, see Edward Albee, *Who's Afraid of Virginia Woolf? A Play* (New York, 1963), 64, 68.

of social change. By the 1920's this fashion in history was everywhere triumphant, but already its champions could feel their heels being trodden on by hungry young men who despised materialism and positivism, Darwin and Dewey and Marx, and flaunted the *mystiques* of *élans vitals* and autonomously developing systems of ideas. Their turn came, and for the past fourteen years the dominant fashion has been some form of what we seem determined to call "intellectual history." . . . I have no guess as to how long the present phase may last or what will follow, but like women's fashions, fashions in history have only a limited number of ways to go. Perhaps military and diplomatic history may come back again, especially if the cold war ever thaws, and war and diplomacy cease to be such painful subjects.[31]

2. Even those historians capable of the highest methodological innovation and sophistication somehow tend to ignore their own prescriptions when the time comes for them to put theory into practice. L. Pearce Williams provides a case in point in his essay-review of two books by Thomas S. Kuhn, *The Essential Tension: Selected Studies in Scientific Tradition and Change* (1977) and *Black-Body Theory and the Quantum Discontinuity, 1894–1912* (1978).

There is some irony in the fact that *The essential tension* and the work on quantum theory have appeared in the same year. The essential tension in the work of Thomas Kuhn seems to be between his philosophical views which have created so much stir, and his actual practice as a historian. To follow his philosophy is to force historical evidence into a theoretical framework, which is about as unhistorical as one can get. On the other hand, to read Kuhn, the historian, is to see the philosophical structure vanish before one's eyes, like smoke.[32]

Similar criticisms have been leveled at Keith Thomas because of the discrepancy between his essays on anthropological history and his *Religion and the Decline of Magic* (1971); and at Quentin Skinner because of apparent discrepancies between his advocacy of new approaches to the history of ideas and the reality, however awesome, of his *The Foundations of Modern Political Thought: The Renaissance* and *The Age of Reformation* (1978) in two volumes.

31. Mattingly, "Some Revisions of the Political History of the Renaissance," in Tinsley Helton, ed., *The Renaissance* (Madison, Wis., 1961), 9.
32. Williams, "The Essential Thomas Kuhn," *History of Science*, 18 (1980), 74. See also K. R. Minogue, "Method in Intellectual History: Quentin Skinner's Foundations," *Philosophy*, 56 (1981), 533–52.

3. One hates to confess it publicly, but historians are quite capable of thinking and behaving unhistorically. In 1915, for example, John D. Bassett of Smith College wrote to Lyon G. Tyler of William and Mary: "I am preparing a short account of the early Virginia historians and wish to ask if you will tell me how to get at all that has been said in behalf of Capt. John Smith. . . . There is no difficulty in finding things against him; but I have usually been on his side and I wish to find the evidence to support my intuitions."33

In October 1920 Worthington C. Ford read to the Massachusetts Historical Society a letter in which Charles Sumner "blackguarded his own divorced wife and the Hooper family in general." After the meeting James Ford Rhodes and Henry Cabot Lodge forced Ford to destroy the Sumner letter "in the interests of propriety."34

In 1925 Lyon G. Tyler sent a polite inquiry to his old friend Philip A. Bruce, the most distinguished historian of Virginia, asking for evidence to support Bruce's claim that Pocahontas had died of small-pox. Bruce responded thus: "As soon as I received a copy of my colonial history [vol. I Hist. of Virginia] from Lewis and Company, I gathered up all the notes of authorities on which the statements in that history were based; piled them up in the road back of my house; and set the whole mass off with a match. In asserting as I did that Pocahontas died of the smallpox, I am sure that I had some authority for it, but I cannot now say where this authority is to be found."35

Recent illustrations abound, most of them far more subtle and cere-bral than mere acts of physical destruction; but the length of this essay (not to mention the prohibitive cost of libel suits) prevents me . . .

4. Historians have not been very successful in handling the problem posed by interpretations considered ideologically unpopular at any given moment. It is a great tribute to David M. Potter's subtlety as a scholar (and humanity as a person) that radicals did not revile him on account of his conservative political views. But consider the fate of Richard Hildreth in the mid-nineteenth century, or Hermann E. Von Holst in the late nineteenth century, or Charles A. Beard during the second quarter of the twentieth century. Let us recall, too, that John Adams's *Defence of the American Constitutions* (1787–88) was used against him in fiercely partisan ways during the presidential election of

33. Bassett to Tyler, January 5, 1915, Tyler Papers, group 5, box 4, Swem Library, College of William and Mary, Williamsburg, Va.
34. Robert Cruden, *James Ford Rhodes: The Man, the Historian, and His Work* (Cleveland, 1961), 64–65.
35. Bruce to Tyler, July 15, 1925, Tyler Papers, group 5, box 4.

1796. According to Merrill Peterson, however, this did not bother Adams because "it caused the book to be read by more people during six months than would otherwise read it in a hundred years."[36]

5. Historians seem to be hopelessly split over the relative merits and handicaps of sociopolitical activism. Nor do I find the slightest correlation between engagement or detachment on the one hand and the quality of a historian's work on the other. Let J. H. Hexter speak for those superb historians—like Johan Huizinga, Dom David Knowles, Perry Miller, Carl Becker, and Richard Cobb—who were, or are, comparatively distanced from public affairs.

> For a small part of my day I live under a comfortable rule of bland intellectual irresponsibility vis-à-vis the Great Issues of the Contemporary World, a rule that permits me to go off half-cocked with only slight and occasional compunction. But during most of my day—that portion of it that I spend in dealing with the Great and Not-So-Great Issues of the World between 1450 and 1650—I live under an altogether different rule. The commandments of that rule are:
> 1. Do not go off half-cocked.
> 2. Get the story straight.
> 3. Keep prejudices about present-day issues out of this area.[37]

Now let Henry Glassie speak for other fine historians—like Pieter Geyl, Richard Hofstadter, Natalie Zemon Davis, Robert Jay Lifton, and Martin Duberman—who have been activists. "If you cannot enter passionately into the life of your own times, you cannot enter compassionately into the life of the past. If the past is used to escape the present, the past will escape you." It is important to note, moreover, that advocates of activism ordinarily do not differentiate between the

36. Peterson, *Adams and Jefferson: A Revolutionary Dialogue* (Athens, Ga., 1976), 63. For Beard, see his letters to Arthur M. Schlesinger, May 14 and July 23, 1917, *Schlesinger Papers;* and Howard K. Beale, ed., *Charles A. Beard: An Appraisal* (Lexington, Ky., 1954), 250–52. For the fascinating case of Karl Lamprecht in Germany, see Georg G. Iggers, *New Directions in European Historiography* (Middletown, Conn., 1975), 25, 28.

37. Hexter, "The Historian and His Day," in *Reappraisals in History: New Views on History and Society in Early Modern Europe* (New York, 1963), 7–8. For the fierce split in the Mississippi Valley Historical Association (1950–55) over the appropriateness of social reform activities within a professional association, see Ray Allen Billington, "From Association to Organization: The OAH in the Bad Old Days," *Journal of American History,* 65 (1978), 75–84; and Thomas D. Clark, "Our Roots Flourished in the Valley," ibid., esp. 93–96.

historian's public vocation and his or her private obligations of conscience as a citizen. As Lifton has argued, "such things as ethical and political commitments are necessary rather than antithetical to scholarly work. Nowhere is this more true than in the study of psychohistory."[38]

6. The point is frequently made that historical writing in the United States has for quite some time proceeded along two separate channels: academic and popular. A few scholars, such as T. H. Von Laue, have pleaded that "history is, or ought to be, written not for the profession but for a public of educated, thoughtful, and intelligent citizens who turn to history for light amidst the baffling or frightening darknesses in their lives and times."[39] Despite such appeals, the process (or phenomenon) of professional specialization quickens, and scholars increasingly prefer the company of their "own kind" at well-focused subdisciplinary meetings. God help the well-meaning but unwitting amateur who poaches . . . because Clio doesn't seem likely to be sympathetic.[40]

Freelance historians, in their turn, have tended to be stridently anti-academic. As James Truslow Adams wrote to Allan Nevins in 1925:

A university life is a life to a great extent apart from the main currents, particularly in a small place. Your contacts are with immature youth,

38. Glassie, "Meaningful Things and Appropriate Myths: The Artifact's Place in American Studies," *Prospects*, 3 (1977), 29; Lifton, *History and Human Survival: Essays on the Young and Old, Survivors and the Dead, Peace and War, and on Contemporary Psychohistory* (New York, 1971), 16. Closely related to this issue is the whole question of writing "instant" or contemporary history. For an eloquent affirmation of its validity, see Arthur M. Schlesinger, Jr., "The Historian," *Proceedings of the Massachusetts Historical Society*, 91 (1979), 86–97. For a strong statement in opposition, see Woodrow Wilson to Edward S. Corwin, August 30, 1918, Corwin Papers, Seeley G. Mudd Manuscript Library, Princeton University, Princeton, N.J.

39. Von Laue, "Is There a Crisis in the Writing of History?" *Bucknell Review*, 14 (December 1966), 1–15. See the very interesting praise for John Fiske in James M. Beck's letter to David Jayne Hill, September 3, 1924, Beck Papers, box 1.

40. For the genesis and development of this trend, see J. Franklin Jameson to Worthington C. Ford, April 20, 1910, Ford Papers, box 7; Clarence W. Alvord's remarks in the *Annual Report of the American Historical Association for 1914* (Washington, D.C., 1916), I, 312–13; George Wilson Pierson to Mary Mapes, November 30, 1965, John Dos Passos Papers, 5950-ac, box 1, University of Virginia Library, Charlottesville. Part of the problem lay in scholarly mistrust of what Becker, Corwin, and others of their generation called, always with pejorative implications, "fine writing." See Corwin's symptomatic review of Albert J. Beveridge's *John Marshall*, vols. 1–2, in *Mississippi Valley Historical Review*, 4 (1917), 116–18.

with your fellow faculty members, and books. Yet in history you have to write of the active life, of all types of men. . . . One day up at Columbia, [Dixon Ryan] Fox and some others were talking . . . and the general opinion was that at present more and better historical writing was being done by men with no academic connection than by those who had such.[41]

I cannot say with assurance whether Fox and his friends may have been "putting Adams on" or whether Adams heard what he wanted to hear in the way that he wanted to hear it, but I do know that the rest of Adams's sentiments have been harshly echoed from his day to ours by Albert J. Beveridge, Kenneth Roberts, Walter D. Edmonds, Claude G. Bowers, James T. Flexner, Barbara Tuchman, and many others.

7. The final problem in this litany is multifaceted and can best be introduced by paraphrasing the toughest question that Helen Vendler poses to, and about, poets: What sort of poem will you write when you are old and gray? Or, in her words: "What will this poet of plenty write when he becomes a poet of deprivation?" At the simplest level of analysis the issue is not new, and the responses seem to be as varied as the temperaments of historians. When Gibbon finished his first three volumes, he seriously considered stopping. The fall of the Roman Empire in the West constituted a discrete unit, so for almost a year he diverted himself by reading classical texts. Then, however, he tells us that "in the luxury of freedom I began to wish for the daily task, the active pursuit, which gave a value to every book and an object to every inquiry." Gibbon then immersed himself in the age of Justinian. Three more volumes.[42]

There have not been many Gibbons, however, and the correspondence of American historians in the twentieth century reveals a plaintive refrain.

- Max Farrand (1922): "You are quite right that it is high time I was publishing another book. . . . But with my many engagements I feel as if I should have to do as Turner threatened at one time, namely, to declare intellectual bankruptcy."[43]
- Edward S. Corwin (1944): "Like yourself, I can't turn off as much work as once I could. . . . So I hesitate to swear on the Bible that I

41. Adams to Nevins, September 20, 1925, Adams Papers. See also Rhodes, "The Profession of Historian," 66.
42. Gibbon, *Autobiography,* 210.
43. Farrand to Ferris Greenslet, May 3, 1922, Greenslet Papers, Houghton Library, Harvard University, Cambridge, Mass.

will do what you ask—finish off a systematic work on American constitutional development. My present inclination is toward a rather more limited assignment, a constitutional history of the Presidency."[44]

By contrast, however, we have a charming letter from Charles Beard in which he regrets that he never met Lord Acton, an *érudit* with an encyclopedic mind who published very little. "I believe that no man of my time *knew* more than Acton. He knew too much to write." Later, in the same letter, Beard added an observation that is richly self-revealing: "It is better to be wrong about something important than right about trivialities."[45] Beard himself, of course, remained prodigiously productive throughout his lifetime. Samuel Eliot Morison intensified his workload in his declining years. At the age of seventy-six he noted wistfully: "Knowing that death will break my pen, I now work almost the year round, praying to be spared to write what is in me to write."[46] Vanitas and the historian's dogged determination.

A second aspect of this problem involves the knotty issue of intellectual generosity versus selfish careerism. I could recite an honor roll of talented historians who did not fulfill their own calling because they compulsively helped others to do so. Take the example of George Lincoln Burr. J. Franklin Jameson wrote this of Burr in 1926:

> I have always longed—all of us have always longed—that he should produce either or both of two great books, one on the history of witchcraft and one on the history of toleration, but I am pretty well convinced that he never will. He will always devote himself to doing the work of others, or work which others impose upon him. I rather resent his occupation with these matters of Henry C. Lea and President [Andrew Dickson] White, but if he were not doing them, he would be doing what the Tompkins County Historical Society or the Literary Club of McGrawville asked him to do, and if that is the case, he might as well be answering worthwhile questions for deserving historical scholars like you and me. The world does not contain a more unselfish man, but it is

44. Corwin to Oliver Peter Field, August 7, 1944, also Philip Brown to Corwin, August 16, 1944, Corwin Papers, box 3; Henry Steele Commager to Allan Nevins, December 13, [1966?], Nevins Papers, box 88, Butler Library, Columbia University, New York City.

45. Beard to August C. Krey, January 30, [1934?], Krey Papers, folder 103b. See also Gertrude Himmelfarb, *Victorian Minds* (New York, 1968), 168–69.

46. Quoted in Bailyn, "Morison: An Appreciation," 120–21.

perhaps a pity for the world that the unselfishness and the wonderful learning have not been entrusted to two separate individuals.[47]

Stark contrasts are easily come by. In 1939, when Arthur O. Lovejoy asked Gilbert Chinard to serve as editor-in-chief of the newly founded *Journal of the History of Ideas,* Chinard replied that he "could not possibly assume the responsibility. For too long I have wasted my time reading other people's efforts. I have come to the point when I must make a choice: either give up my own work or concentrate more on it. The choice is made."[48] I do not mean to tarnish Chinard's well-deserved reputation, and perhaps his decision best served scholarship (as well as himself). But the contrast between Burr and Chinard is highly symptomatic. Everyone could supply his or her own surrogate examples.

A third facet of this problem involves the need—felt by some, but by no means all—for coming to terms with forebears and with followers. The former is much the easier task of the two, I believe, and has resulted in some distinguished contributions to scholarship. One thinks immediately of *The Progressive Historians* (1968) by Hofstadter, or John Hope Franklin's biography of George Washington Williams (1985), or the anticipated study of Arnold Toynbee by William H. McNeill. Coming to terms with successors is rather more difficult because Young Turks can be exceedingly cruel in torturing (if not actually killing) their fathers. During the 1940s and '50s, Big Bill Broonzy often discovered that younger blacks in his audience did not care for his music. "This ain't slavery no more," he was told, "so why don't you learn to play something else? . . . the way you play and sing about mules, cotton, corn, levee camps and gang songs. Them days, Big Bill, is gone for ever."[49] For intergenerational misunderstanding among historians in our own time, perhaps it will suffice to cite Jacques Barzun's *Clio and the Doctors: Psycho-History, Quanto-History & History* (1974) and the response it elicited. The problem with *epigoni* is that their work, however flawed, can make us feel very inadequate. They may do much for the vocation but precious little for *vanitas*.

47. Jameson to Austin P. Evans, August 10, 1926, Burr Papers, box 16.
48. Chinard to Lovejoy, February 19, 1939, Chinard Papers, Eisenhower Library, Johns Hopkins University, Baltimore, Md.
49. Quoted in Lawrence W. Levine, *Black Culture and Black Consciousness: Afro-American Folk Thought from Slavery to Freedom* (New York, 1977), 217.

III

Now that we have peered through problems and frustrations at some length, perhaps we should direct our attention to matters of consolation and aspiration. Despite the obvious obstacles—methodological as well as philosophical—mine is not a counsel of despair. Jean Starobinski has taught us that History was gradually redefined, and came to be re-understood, during the third quarter of the eighteenth century. I suspect that the same may be true of the past twenty years,[50] and of the decade ahead, with profound consequences for such questions as—why try? why continue? why write History at all in the face not of our physical finitude (which after all is an old story) but in view of the ephemeral character of our labors, our audience, and the transitory nature of our profession?

Many people who heard Carl Becker deliver his presidential address to the American Historical Association, "Everyman His Own Historian," misunderstood his mood and his message. He spent the early months of 1932 trying to explain himself, as in this letter to Charles Homer Haskins:

> I gather from some things I have heard that there are people who had the impression that I was preaching the futility of historical research. Nothing could be farther from the truth, since the address is the outcome of a long process of muddled thinking, from many years back, in the effort to find a satisfactory answer to those who ask, "What is the good of history?" . . . The only condition in which I can conceive that historical research and writing would become futile is in [the] case, extremely unlikely, that the past of mankind should really be completely presented in "definitive contributions." If they were really definitive, there would seemingly be no further need of research. Some members of our guild seem to find the idea that each generation has to rewrite its history disillusioning. I confess I don't find it so at all.[51]

50. See Starobinski, "From the Decline of Erudition to the Decline of Nations: Gibbon's Response to French Thought," in G. W. Bowersock et al., eds., *Edward Gibbon and the Decline and Fall of the Roman Empire* (Cambridge, Mass., 1977), 139–57, esp. 139–41; Michael Kammen, ed., *The Past before Us: Contemporary Historical Writing in the United States* (Ithaca, 1980); and Bernard Bailyn, "The Challenge of Modern Historiography," *American Historical Review*, 87 (1982), 1–24.

51. Becker to Haskins, February 19, 1932, Haskins Papers. I found this marvelous letter ten years after I believed that I had completed an exhaustive canvass in preparing and editing *"What Is the Good of History?" Selected Letters of Carl L. Becker, 1900–1945*

Nor do I, so I want to wind down by suggesting nine reasons why. What follows is less a creed, perhaps, than a gabby rationalization of what I have been doing for the past twenty-five years and would like to be doing for the next twenty-five. If someone handed me a million dollars, with no strings attached, I would cheerfully accept; but I don't believe that it would alter my life in any significant way. I cannot conceive of myself in pursuit of any other vocation, nor can I imagine desisting from the only one I've ever had. Recall, for a moment, the fate of Diedrich Knickerbocker as described by Washington Irving: "His history [of early New York] being published, he had no longer any business to occupy his thoughts, or any scheme to excite his hopes and anticipations. This, to a busy mind like his, was a truly deplorable situation. . . . There would have been great danger of his taking to politics, or drinking,—both which pernicious vices we daily see men driven to by mere spleen and idleness."[52]

Well then, what can historians realistically hope to do, and why should they?

1. First, humankind cannot begin to anticipate what sorts of knowledge may be found useful or interesting centuries hence. John Adams knew all about vanitas but misperceived the value of maintaining a historical record of his own time. In 1802 he began his autobiography with these words: "As the Lives of Phylosophers, Statesmen or Historians written by them selves have generally been suspected of Vanity, and therefore few People have been able to read them without disgust; there is no reason to expect that any Sketches I may leave of my own Times would be received by the Public with any favour, or read by individuals with much interest."[53] To judge by the ecstatic responses of John F. Kennedy, Bernard Bailyn, and Edmund S. Morgan, Adams could not have been more wrong. Thank God for his perpetual-motion pen, his historical perspective, and his vanitas.[54]

(Ithaca, 1973). In some respects the patrician scholars who wrote two and three generations ago were intellectually less arrogant than their modern successors. On February 25, 1914, Charles Francis Adams, Jr., wrote to James Ford Rhodes that "in my opinion all history, including my own, needs to be rewritten once in ten years" (quoted in Kirkland, *Adams,* 208). See also Rhodes, "The Profession of Historian," 75.

52. Irving, *Knickerbocker's History of New York* (1809; New York, 1894), I, 18–19.

53. *Diary and Autobiography of John Adams,* ed. L. H. Butterfield (Cambridge, Mass., 1961), III, 253. See also Manton Marble to Worthington C. Ford, September 12, [1906?], Ford Papers.

54. See Kennedy's review, *American Historical Review,* 68 (1963), 478–80; Bailyn,

2. Moreover, we pay too little heed to a truism uttered by William A. Dunning way back in 1913: namely, that time and again a major "influence on the sequence of human affairs has been exercised, not by what really happened, but by what men erroneously believed to have happened." There is no more compelling argument for the serious study of historical myths, misperceptions, and misunderstandings.[55]

3. I am utterly persuaded by E. P. Thompson's argument that "the discipline of history is, above all, the discipline of context; each fact can be given meaning only within an ensemble of other meanings." Elsewhere he has insisted that "we cannot understand class unless we see it as a social and cultural formation, arising from processes which can only be studied as they work themselves out over a considerable historical period."[56] To fulfill these imperatives with absolute respect for the particularity of people and the specific integrity of varied social institutions and modes of thought requires the patience of a plodding historian. Rarely, very rarely, does the so-called historical anthropologist or historical sociologist do the job as we do it. Nor should they be expected to. They have other goals in mind. But if we, whose vocation is the discipline of context, do not discover and amplify those contexts, it will never be done properly.

4. We all know that social memory is at least as fallible as individual memories, and pluralistic as well. Even more daunting, there is abundant evidence that historians' memories are just as imperfect as any other.[57] Nevertheless, historians *en bloc*—the historian's vocation acting collectively and interacting critically—can aspire to Leonard Krieger's maxim that "by its very nature, history is not the mere memory of humanity but the reformation of its memory." As Carl Becker put it in 1932, "Critical history is simply the instinctive and

"Butterfield's Adams: Notes for a Sketch," *William and Mary Quarterly*, 19 (1962), 238–56; and Morgan, "John Adams and the Puritan Tradition," *New England Quarterly*, 34 (1961), 518–29.

55. Dunning, "Truth in History," *American Historical Review*, 19 (1914), 217–29. See also Albert J. Beveridge to Edward S. Corwin, February 9, 1918: "The more I study history, the clearer it becomes to me that too little account is taken by historians of the human conditions under which men do things" (Beveridge Papers, box 212, Library of Congress, Washington, D.C.).

56. Thompson, "Anthropology and the Discipline of Historical Context," 45, and *The Making of the English Working Class* (New York, 1963), 11.

57. See the wonderful speech by Neil McKendrick, "J. H. Plumb: A Valedictory Tribute," in McKendrick, ed., *Historical Perspectives: Studies in English Thought and Society in Honour of J. H. Plumb* (London, 1974), 8.

necessary exercise of memory, but of memory tested and fortified by reliable sources."[58] There are additional complexities, and Becker goes on to discuss them, but I can live and work quite comfortably within the framework of his maxim.

5. It may well be that a chastened sense of *vanitas* and the historian's vocation has been at least partially responsible for a growing interest, during the past fifteen years, in the history of failure. I have in mind diverse studies and different forms of failure. Bernard Bailyn's *The Ordeal of Thomas Hutchinson* (1974), for example, or Gerald H. Meaker's marvelous study *The Revolutionary Left in Spain, 1914–1923* (1974), or Charles Gibson's subtle craftsmanship in his presidential address to the American Historical Association (1977).[59]

We also have books about the *sense* of failure, about shattered dreams and utopias, that have enriched immeasurably our understanding of individuals, communities, and what we might call coherent psychological moments in time. I am thinking of Pauline Maier's *The Old Revolutionaries: Political Lives in the Age of Samuel Adams* (1980), or Joseph J. Ellis, *After the Revolution: Profiles of Early American Culture* (1979), or William Dusinberre, *Henry Adams: The Myth of Failure* (1979). We can profit from an observation made by Denis Donoghue: "We are likely to find that much American literature achieves its vitality by a conscientious labour to transform the mere state of failure into the artistic success of forms and pageants: it learns a style not from a despair but from an apparent failure." Donoghue concludes this provocative essay by asking, "Do we not feel that American literature thrives upon the conditions of failure and that it would lose its character, if not its soul, were it given the conditions of success?"[60] Wiser heads than mine will perceive some penetrating explanation, but I find it more than a minor puzzle that historical literature in the United States has, until quite recently, moved predominantly along a very

58. Krieger, "The Horizons of History," *American Historical Review*, 63 (1957), 73; Becker to William E. Dodd, January 27, 1932, in Kammen, *"What Is the Good of History?"* 157.

59. Gibson, "Conquest, Capitulation, and Indian Treaties," *American Historical Review*, 83 (1978), 8. See also Alfred D. Chandler, Jr., "Industrial Revolutions and Institutional Arrangements," *Bulletin of the American Academy of Arts and Sciences,* 33 (May 1980), 50.

60. Donoghue, "The American Style of Failure," in *The Sovereign Ghost: Studies in Imagination* (Berkeley, Calif., 1976), 104, 126.

different sort of channel from that of imaginative literature (novels, romances, short stories, poems, journals, and so forth).

6. We do History—at least most of us ought to, and some actually do—to fulfill a sense of obligation to various sorts of communities. Burckhardt loved and admired the Florentine historians because "what they most desired was that their view of the course of events should have as wide and deep a practical effect as possible. . . . Like the ancients, they were citizens who wrote for citizens."[61] Burckhardt, we know, ceased at an early age to write very much so that he could devote himself fully to teaching and the responsibilities of citizenship in his beloved Basel. Such a pattern has never been common, either in the Old World or in the New. It constitutes a kind of ideal of which *some* are aware, and to which a very few, like George Lincoln Burr and William G. McLoughlin, are actively committed.[62]

7. Teaching plays a part in our vocation. Indeed for many historians it is the principal part. In the context of our vanitas theme, teaching has to be considered a mixed blessing. Haven't we all had students (even serious students) come to see us in order to discuss their inadequate performance on an exam? Often they show me their class notes, perhaps to affirm that they really were there when such-and-such a topic was presented, or to demonstrate that "I really know it even though I couldn't quite get it all down on paper." More often than not, when I glance over their class notes, I am horrified to discover the transmogrification of a point that I had made with stunning lucidity (I thought) into a garbled mess—what Eeyore might have called "a Confused Noise." We are fortunate to have Burckhardt's *Force and Freedom: Reflections on History* (1943), based upon his students' lecture notes. But I would much prefer that we had it firsthand, that he had written it out himself. Heaven help me if my erstwhile students ever publish *my* classroom lectures—and I have been blessed with some very fine students![63]

61. Burckhardt, *The Civilization of the Renaissance in Italy*, 250–51. Schlesinger quotes Theodor Mommsen's reflection upon his political entanglements: "In doing so I may have erred and made mistakes, but the worst mistake would have been to avoid my duties as a citizen, lest they interfere with my obligations as a scholar" ("The Historian," 93).

62. See Albert J. Beveridge to Edward S. Corwin, June 9, 1922, Corwin Papers, box 2.

63. I have the following story from a year-long eyewitness and participant. Some

On the other hand, our students can be an immense source of pride, an extension of our very egos. And when that happens, our self-esteem is served most admirably. Henry Adams's impact as a teacher has been well documented.[64] In the papers of Edward S. Corwin, who taught American constitutional law and history at Princeton from 1911 until 1946, letters from former students testify to his enormous influence and to the satisfaction that he must have derived from following the careers of Thurman Arnold and others who became distinguished lawyers, judges, professors of law, and government officials. I cannot resist just one fine example, dated 1937:

> A little more than a quarter of a century ago (what a long time a fraction of a century seems), I asked you a question at one of our weekly meetings when we were wading through Madison's Notes, item by item, the answer to which I have never forgotten. I asked you in substance this: "It must be a great bore to you to be going through this subject with me. What help can it be to your research to hear me asking stupid questions?" Your answer in substance was: "A specialist can easily get into an intellectual rut. You have a virgin mind, at work in a virgin field. You are likely to "pop" me a question that will set my mind going. You wouldn't be aware at the time that you had set up a chain of thought, but that can happen."[65]

time ago, one of the most distinguished historians of the United States (still active) would come into class carrying lecture notes that were visibly yellow-brown around the edges. After a few lackluster performances, graduate students began to interrupt the professor with stimulating questions. His answers were invariably fresh, knowledgeable, and immensely interesting. As soon as he had answered one question, another would come forth, and another, and another. I am also told that some of his finest lectures occurred just after the latest *Journal of Southern History* or *Mississippi Valley Historical Review* had arrived, because fresh articles caused him to improvise and rethink his views on various topics. Was the professor aware of his students' strategy? One never knows, but I suspect that he was. As between answering a question and puzzling out the hieroglyphics that one scratched twenty years earlier . . . it's really no contest.

64. See Stewart Mitchell, "Henry Adams and Some of His Students," *Proceedings of the Massachusetts Historical Society,* 66 (1942), 294–310; and Henry Adams to Charles W. Eliot, March 2, 1877, in *Henry Adams and His Friends: A Collection of His Unpublished Letters,* ed. Harold Dean Cater (Boston, 1947), 80–81.

65. Thompson Bradshaw to Corwin, March 2, 1937, Corwin Papers, box 2. See also Thurman Arnold to Corwin, March 27, 1932, and October 5, 1936, ibid., box 1; William L. Underwood to Corwin, February 13 and April 2, 1936, and William B. Slade to Corwin, March 21, 1937, ibid., box 2.

Herbert Levi Osgood of Columbia, dry-as-dust institutional historian though he may have been, profoundly influenced Dwight Morrow. We could compile a vast list, but the point is an elementary one: most teachers have no idea how long a shadow they cast; if they did, their euphoria might supply enough psychic energy to warm their homes for weeks on end. True, we turn our students off, too, but the less said about that the better.[66]

My final few points follow directly from this one but are rather more personal in nature in the sense that they primarily concern what the pursuit of History does for the historian rather than what it does for society, community, or individuals.

8. We do History, vanitas to the contrary notwithstanding, for pure pleasure, for the excitement of the hunt, for satisfactions that are as palpably sensuous as they are cerebral.

Item: "I am simply one who loves the past and is diligent in investigating it."[67]

Item: "You ask if there were reasons of environment, education or temperament which led me to write so much about the [American] Revolution. I suppose there were. As near as I know them they were a natural fondness from boyhood for history, a training in practising law which compelled me to give authorities and evidence for every statement. I acquired a contempt for any one who wandered from the record and had a contempt for myself whenever I did. . . . Then also historical investigation, the hunt for facts and actualities is very much like a rabbit or a quail hunt, of which I have done a good deal. Both are full of surprises, disappointments, excitements, successes. If the history was as invigorating as the quail hunt it would be a perfect sport."[68]

Item: "In his analytic function he [the historian] is the rationalist, perhaps even the scientist. In his empathic function he is the artist, and it is research as art that redeems the drudgery of data-gathering.

66. Hence, in my view, all the more irony in that bizarre exchange of letters, called "The Relevance of History," between David H. Donald, Edward L. Keenan, and Blanche Wissen Cook, printed in the *American Historical Association Newsletter,* 15 (December 1977), 3–6.

67. *The Analects of Confucius,* quoted in Frances FitzGerald, *Fire in the Lake: The Vietnamese and the Americans in Vietnam* (New York, 1973), 15.

68. Sydney George Fisher to Arthur M. Schlesinger, July 31, 1922, Schlesinger Papers, box 2.

"This form of art is as exigent as any other. It requires its practitioner to enter into the past, to meet people who are very much alive yet different from him in ways that he can imperfectly apprehend, to view them objectively for what they were, and then to portray them in all their vitality. This is so large an assignment that his reach, he knows, will exceed his grasp; and why should it not? Just as the subject matter of research fascinates him because he will never be able to do it full justice, so does the art of research. The requirements of that art are too stringent for his comfort: they deny him the illusion that he has nothing more to learn, and keep him always reaching for what he cannot quite grasp. His own particular creativity is therefore at full stretch, and that is perhaps as near to pure joy as an academic can come."[69]

9. My final point is virtually banal, even though great glosses could be composed about it. We historians, as a guild, will almost always enjoy the last word. When the fancy-Dan journalists and instant-historians are done, when the jurists and novelists have kept faith with the imperatives of equity and imagination, we will second-guess them and our predecessors and even ourselves. The last word may indeed never be spoken; there can always be another. But with the passage of time, as history becomes History, the *latest* word will most likely be said (or written) by a historian.[70]

The rest is silence, save one sentence by William James in order to convey, perhaps, the sense of an ending: "I am finite once for all, and all the categories of my sympathy are knit up with the finite world *as such,* and with things that have a history."[71] I think he's playing my song.

———

I appreciate the careful readings that this essay received in manuscript form from David A. Hollinger and R. Laurence Moore, as well as the enthusiastic and cooperative efforts of Stanley I. Kutler, who prodded me to write it in the first place.

69. William B. Willcox, "The Psychiatrist, the Historian, and General Clinton: The Excitement of Historical Research" (1967), reprinted in Robin W. Winks, ed., *The Historian as Detective: Essays on Evidence* (New York, 1969), 512.

70. For a marvelous analysis that is germane, see Carl Becker, *Everyman His Own Historian: Essays on History and Politics* (Chicago, 1966), 247–48.

71. William James, *A Pluralistic Universe: Hibbert Lectures on the Current Situation in Philosophy* (1909; New York, 1943), 48.

Without meaning to slight any of the other scholars who wrote to me following its publication, I want to thank the following for their particularly gracious and thoughtful responses: Paul Baker, Merle Curti, Carl Degler, Joseph J. Ellis, Felix Gilbert, John Higham, Anne Firor Scott, Fritz Stern, Robert Wiebe, and James Harvey Young.

Chapter 4

Clio and the Changing Fashions: Some Patterns in Current American Historiography

This piece, which first appeared in the *American Scholar,* 44 (Summer 1975), 484–96 is the earliest statement of my interest in historiography as a serious source (and form) of cultural history. A related and complementary essay, "The Current State of History," appeared in the *New York Times Book Review* that same year, on Sunday, June 29, 1975.

The genesis of both essays was quite fortuitous. In 1974 I served on a three-person jury to determine the winner of the National Book Award in History (since then renamed the American Book Award). That meant reading a diverse lot of books from *all* fields of history—a broadening and chastening experience that obliged me to think comprehensively about the "state of the art," so to speak.

Since then I have not been willing or able to read quite so widely, year after year. Nevertheless, several harmless addictions seem to have become permanent as a consequence of that "jury duty": (1) a desire to sample at least the *best* works being written in subfields of History outside my own; (2) curiosity about trends in the state of the art, which simultaneously seems ever-changing yet moving ahead very slowly; and (3) a strong belief that historical literature is an essential litmus of social values and cultural change.

Precisely because the field *does* change, however, an essay of this sort becomes, in one sense, "dated" rather soon after publication. Upon rereading it, however, I am pleased by the accuracy of many

of my predictions. Nor am I surprised that I had no inkling at all of other tendencies that would develop a decade later, such as the renaissance of military history.

For at least a partial update, see my introduction to Kammen, ed., *The Past before Us: Contemporary Historical Writing in the United States* (Ithaca, 1980), 19–46, titled "The Historian's Vocation and the State of the Discipline in the United States."

As the general mood of the mid-1970s is very much altered from what it was at the end of the 1960s, so too the contours of historical thought and scholarship during the past six years have been strikingly different from those of the decade 1960–69. C. Vann Woodward perceived in 1969 a "growing anti-historical bias in contemporary culture,"[1] but by the early months of 1974 the number one best seller in fiction was Gore Vidal's *Burr,* while in nonfiction it was Alistair Cooke's *America.* Can the change be understood simply as a shift from cynical realism and "relevance" to nostalgic escapism? In part, perhaps. But it must also be understood against a background of aroused public curiosity about our national origins, as well as historians' deepening sensitivity to what Edmund Burke once called "the causes of our present discontents."

We might fruitfully begin by comparing two compilations of the most significant books about American history published during the past fifteen years. The first list is derived from a broad and careful survey of practicing historians, who were asked which books they personally rated highest in quality, which had the greatest scholarly impact, and which were most widely used in the classroom.[2] Their top sixteen choices, all published between 1960 and 1968, appear as one of the two accompanying lists.

We do not yet have a comparable survey based upon similarly circulated questionnaires for the period 1969–74. I have, however, polled a substantial number of representative historians, and the result is a suggestive compilation of sixteen books that are at least *among* the most significant works about American history published during the last half-dozen years.

1. Woodward, "The Future of the Past," *American Historical Review,* 75 (1970), 717–21.
2. Cornelius Eringaard, "Historians' History, 1960–1969" (Ed.D. diss., Ball State University, 1972). See also John E. Johnson, "Historians' Histories, 1950–1959" (Ed.D. diss., Ball State University, 1972).

Patterns of Meaning

Certain continuities in the two lists are readily apparent. Books that attempt broad-gauge synthesis and reinterpretation appear on both. Racial tensions and the institution of slavery remain cynosures. Methodological innovation continues to be appreciated, as are books shaped by particular ideologies, political or personal. Yet the differences between the two lists are much more striking than the similarities and deserving of attention.

Significant Books in American History Published 1960–68

C. Vann Woodward, *The Burden of Southern History* (1960).

Eric L. McKitrick, *Andrew Johnson and Reconstruction* (1960).

William Appleman Williams, *The Contours of American History* (1961).

Lee Benson, *The Concept of Jacksonian Democracy: New York as a Test Case* (1961).

David H. Donald, *Charles Sumner and the Coming of the Civil War* (1961).

Richard Hofstadter, *Anti-Intellectualism in American Life* (1962).

Gabriel Kolko, *The Triumph of Conservatism: A Reinterpretation of American History, 1900–1916* (1963).

William E. Leuchtenburg, *Franklin D. Roosevelt and the New Deal* (1963).

Walter LaFeber, *The New Empire: An Interpretation of American Expansion, 1860–1898* (1963).

Stephan Thernstrom, *Poverty and Progress: Social Mobility in a Nineteenth-Century City* (1964).

Daniel Boorstin, *The Americans: The National Experience* (1965).

Eugene D. Genovese, *The Political Economy of Slavery: Studies in the Economy and Society of the Slave South* (1965).

Kenneth M. Stampp, *The Era of Reconstruction, 1865–1877* (1965).

Bernard Bailyn, *The Ideological Origins of the American Revolution* (1965, 1967).

Robert Wiebe, *The Search for Order, 1877–1920* (1967).

Winthrop D. Jordan, *White over Black: American Attitudes toward the Negro, 1550–1812* (1968).

Significant Books in American History Published 1969–74

Gordon Wood, *The Creation of the American Republic, 1776–1787* (1969).

Philip Curtin, *The Atlantic Slave Trade: A Census* (1969).

Kenneth Lockridge, *A New England Town: The First Hundred Years, Dedham, Massachusetts, 1636–1736* (1970).

Philip Greven, Jr., *Four Generations: Population, Land, and Family in Colonial Andover, Massachusetts* (1970).

John Demos, *A Little Commonwealth: Family Life in Plymouth Colony* (1970).

Carl Degler, *Neither Black nor White: Slavery and Race Relations in Brazil and the United States* (1971).

Gabriel and Joyce Kolko, *The Limits of Power: The World and United States Foreign Policy, 1945–1954* (1972).

James Lemon, *The Best Poor Man's Country: A Geographical Study of Early Southeastern Pennsylvania* (1972).

Martin Duberman, *Black Mountain: An Exploration in Community* (1972).

David M. Potter, *History and American Society* (1973).

Richard Slotkin, *Regeneration through Violence: The Mythology of the American Frontier, 1600–1860* (1973).

Daniel Boorstin, *The Americans: The Democratic Experience* (1973).

Stephan Thernstrom, *The Other Bostonians: Poverty and Progress in the American Metropolis, 1880–1970* (1973).

Robert W. Fogel and Stanley Engerman, *Time on the Cross: The Economics of American Negro Slavery* (1974).

Eugene D. Genovese, *Roll, Jordan, Roll: The World the Slaves Made* (1974).

Paul Boyer and Stephen Nissenbaum, *Salem Possessed: The Social Origins of Witchcraft* (1974).

To begin with, there appears to have been a declining concern with traditional political history—the narratives of public institutions, officials, and their competition for power. This trend is accompanied by a notable awakening of interest in social history, but social history that no longer means what it meant to G. M. Trevelyan half a century ago: "the history of a people with the politics left out." In contemporary historiography, social history has come to focus on the examination of changes in social structure, mobility, bonds of community, social order and dis-order, intergenerational relationships, the history of the family, and childhood. Even the so-called "new political history," with its emphasis upon ethnoreligious allegiances and demographic descriptions of localities as a means of explaining voting behavior or partisan conflict, has become, in effect, a subcategory of social history. Richard L. McCormick has written, "The most unfavorable thing there is to say about the ethno-cultural school is that its members have not pursued their own fine insights far enough. Unless political history becomes a subdivision of social history, it is important to specify precisely how cultural identifications become politically salient, and to face squarely the question of what, if anything, mobilizing voters has to do with making policies."[3]

Although both cultural and intellectual history (the history of ideas)

3. McCormick, "Ethno-Cultural Interpretations of Nineteenth-Century American Voting Behavior," *Political Science Quarterly*, 89 (1974), 377.

remain popular, these modes of inquiry—so widely pursued and characteristic of the quarter-century following World War II—may very well have peaked in 1968 and 1969 with the appearance of two stunning volumes: Winthrop D. Jordan's *White over Black,* a brilliant history of the origins of racial prejudice, and Gordon Wood's fine *The Creation of the American Republic,* an examination of emerging American political theory between the Declaration of Independence and the Constitution. Since 1969, creative energies of the kind that were once channeled into the dissection of determinative attitudes and ideas have been applied to the history of American society.

One special feature of this shift has been the blossoming and legitimizing of the case study as a respectable, indeed a historiographically avant-garde, endeavor. For more than a century, the writing of local and family history was considered the domain of antiquarians, genealogists, filiopietists, and retired admirals. Now, dozens of Ph.D. dissertations are done each year on this town, that county, or families in general and in particular. The telescope having given way to the microscope, American historians are examining smaller units of society in greater detail than ever before.

A growing interest in "material history," in historical archaeology, in the history of objects and architecture has also arisen, both as an expression of cultural aspiration and as a symptom of cultural change. "Forgotten institutions, buried artifacts, and outgrown experiences are included in these books" says Neil Harris in the preface to his widely used series, *The American Culture,* "along with some of the sights and sounds that reflected the changing character of American life."

Increased attention to the history of native Americans and of Indian-white relations has been salutary, too, both because of the relative neglect these areas of inquiry have traditionally suffered and because of the interdisciplinary advances that have made possible a more sophisticated approach to them. During the last five years historians seem suddenly to have discovered anthropology as well as ethnohistory and now borrow, shamelessly yet effectively, from the conceptual cupboards of these disciplines. The works of Claude Lévi-Strauss and Clifford Geertz are most frequently cited, especially Geertz's influential essay "Ideology as a Cultural System."[4]

4. See Geertz, *The Interpretation of Cultures: Selected Essays* (New York, 1973), chap. 8.

This growing tendency to borrow concepts and techniques, both from the social sciences and from literary criticism and art history, reveals a rising self-consciousness about the philosophy of history and, even more, about the problems of historical methodology. A highly vocal cluster of people within the profession now exists whose principal interest is the study of methodology itself. As Gene Wise, a leader of this group, put it in his book, *American Historical Explanations* (1973), "a historical explanation is distinguished not so much by its content as by its form."[5] Cecil F. Tate, another member, believes that "danger" lies in "unstated and unexamined methodological assumptions"; and so he has produced a book, *The Search for Method in American Studies* (1974), designed to make implicit procedures more systematic.[6]

Interestingly, two of the most controversial issues among historians during the early and mid-1960s—whether or not psychological criteria and quantitative methods should be applied to historical scholarship—are now largely passé. They have become so partly because their advocates are getting less strident in their claims and partly because a new generation of historians has come of age, with the special stock of computers and couches already available when needed. In much of recent historical scholarship, computer hardware and psychiatric furniture are taken for granted.

In this connection, Robert W. Fogel, the best known among contemporary cliometricians, made an extraordinary statement. "The writing of *Time on the Cross*," he confessed, "has been a chastening experience for us. . . . We have come to recognize that history is, and very likely will remain, primarily a humanistic discipline. We now believe that the issue raised by historical quantifiers is not whether history can be transformed into social science but the realm of usefulness of social science methods in a humanistic discipline."[7]

Such statements are disarming enough to most inveterate opponents of innovation and are compounded by whispers that we have always made quantitative and psychological judgments about the past anyway. Fogel has also asserted, "Mathematics has long been an intrinsic

5. Wise, *American Historical Explanations: A Strategy for Grounded Inquiry* (Homewood, Ill., 1973), viii.
6. Tate, *The Search for a Method in American Studies* (Minneapolis, Minn., 1973), 4.
7. Fogel, "The Limits of Quantitative Methods in History," *American Historical Review*, 80 (1975), 342.

feature of historical analysis, but its use has been covert and subliminal. That is because many issues that turn crucially on quantitative dimensions are disguised by words; they are not apparent because they are put forward in words instead of in numbers or equations."[8]

Putting the case for psychohistory, Erik H. Erikson has remarked in *Dimensions of a New Identity:*

> Psychohistory, essentially, is the study of individual and collective life with the combined methods of psychoanalysis and history. In spite of, or because of, the very special and conflicting demands made on the practitioners of these two fields, bridgeheads must be built on each side in order to make a true span possible. But the completed bridge should permit unimpeded two-way traffic; and once this is done, history will be simply history again, but now a history aware of the fact that it has always indulged in a covert and circuitous traffic with psychology which can now be direct, overt, and aware.[9]

It is ironic, then, that the most recent and eloquent opposition to psychohistory and quantification comes from a very distinguished historian of culture who also agrees that practitioners have always used these techniques. But Jacques Barzun's *Clio and the Doctors* (1974) contends that when the psychohistorian attempts to explain a personality like Hitler's, he adds little to what we knew when we merely described that personality in detail, and that psychohistory is problematic because it is mechanistic and deterministic: "Events and agents lose their individuality and become illustrations of certain automatisms."[10]

Barzun raises some important issues in his challenge to the "doctors." He suggests that in psychobiography there is a tendency toward selective concentration upon certain personal facts to the neglect of others; that the authors of such works rely upon materials that are incomplete, and upon methods—such as symbol and analogy—that are indirect; that minds may be understood through other means than depth psychology; and that psychohistory lacks methodological rigor because so often it involves "little more than the use of a suggestive comparison."

8. Ibid., 330.
9. Erikson, *Dimensions of a New Identity: The 1973 Jefferson Lectures in the Humanities* (New York, 1974), 13.
10. Barzun, *Clio and the Doctors: Psycho-History, Quanto-History, and History* (Chicago, 1974), 23.

Ultimately, however, Professor Barzun may spoil his brief by revealing what could be regarded as old-fashioned prejudices about what written history is, or ought to be, at its best. He seems to prefer the narrative mode, which he is entitled to do; but he also assumes that the historian's task is to tell *what* happened, even more than to explain why it happened or what its effects might have been.

He has a rather romantic notion, at least in my view, of the "genuine" historian's *modus operandi:* that the "common" historian doesn't have much of a problem with bias, that his facts and "truths" are readily ascertainable, and that his "actual" events are utterly different in kind from numerical or psychological phenomena. Barzun believes that a historical fact derived from a literary source is more reliable than one drawn from a census, a parish register, or a voting record—a belief that perplexed me until he permitted his own (apparently elitist) angle of vision to appear. Barzun is explicitly contemptuous of "the laborious search through archives for the deeds of the many. The mass age needs mass premises and conclusions."

What may be bothering a few intransigent doyens, then, is that the practice (if not the nature) of historical scholarship is, very simply, changing. Explicit value judgments, which were anathema back in the days of so-called "scientific" and "objective" History, are now very much in vogue. Indeed, it is the historians closest to the social sciences—the cliometricians, the diplomatists and historians of United States foreign policy, the historians of warfare and of race—who are most commonly given to moralizing in their work and who, as a part of their explicitly ideological approach, contend that the historian has an important role to play as moral critic.

As in the social sciences, moreover, articles in learned historical journals have gained as much influence as full-scale books, and often more. The second list of significant books, 1969–74, is somewhat misleading in that it camouflages the extraordinary contribution made by briefer but nonetheless truly seminal essays published during this period: by John Higham on the phasing of historical thought in America; by Ann Douglas and Carroll Smith-Rosenberg in women's history; by John Shy on the social implications of military history; by Herbert Gutman on the laboring classes in nineteenth-century America; by Samuel P. Hays on the political dimensions of social change since the 1880s; and by Edmund S. Morgan on the work ethic and economic growth during the first generation at Jamestown. These pieces represent some of the most exciting work being done in the

profession today. The layman, unfortunately, can get at them conveniently only in anthologies stitched together for use in college courses, and by then the essays are already four or five years old. Like good wine, they keep well enough. The problem is that our tastes tend to vacillate periodically.

The practice of historical scholarship is changing in yet another way: collaboration is becoming far more common than it once was. *Time on the Cross,* by Robert Fogel and Stanley Engerman, is only the most sensational example. A better book, perhaps, and one likely to be of more enduring value, is *Strikes in France, 1830–1968* (1974), by Edward Shorter and Charles Tilly, an impressive study of industrial conflict and the organization of workers based upon computer analyses of more than 100,000 strikes. The collaboration of these authors, like that of Paul Boyer and Stephen Nissenbaum in their innovative inquiry into the social origins of witchcraft, suggests that two heads are sometimes more than twice as good as one alone: "There remain no chapters, no paragraphs, hardly a sentence even, that one or the other of us would be able to claim as his 'property.' We would like to consider the book the product of an exploration into the possibilities of cooperative scholarship, an attempt to reduce somewhat the intellectual and emotional toll so often exacted by solitary academic labor. *Salem Possessed* would probably never have been written except as a collaboration; in any case, we believe it to be a better book than either of us could have produced alone."[11]

More than ever before, historians are becoming aware of their interdependence, and of their dependence upon computers, special resources, and even, in some instances, students. It is increasingly difficult, certainly, to imagine a great work being written in a prison cell, the way Fernand Braudel wrote his masterpiece, *The Mediterranean World in the Age of Philip II* (1949), in a German jail during World War II; or the great Belgian historian Henri Pirenne produced his stunning history of early Europe under similar circumstaces during World War I. Such "splendid isolation" seems literally (as well as figuratively) a thing of the past. For better or worse, historians now seem to require a great deal in the way of special resources and support services.

Paradoxically, historians may very well be on the verge of regaining the broad reading public that they enjoyed in this country between the

11. Boyer and Nissenbaum, *Salem Possessed: The Social Origins of Witchcraft* (Cambridge, Mass., 1974), xiv.

1850s and the 1920s. Now that the novel is into lean days, if not in fact an impoverished genre, history may well supplant it as the major written source of entertainment, instruction, and artistic satisfaction. In his famous essay "The Art of Fiction" (1884), Henry James saw fiction displacing history as *the* absorbing diversion. It is possible to envision the reverse now happening—note, as an instance, Norman Mailer's subtitle to *The Armies of the Night* (1968), "History as a Novel: The Novel as History"—and this for many reasons:

First, the rapidity of social change in our time seems to increase our hunger for historical knowledge. Indeed, the rapidity of change conflates past-into-present so swiftly that life itself seems to be a "becoming," and thereby the very stuff of history.

Second, the truth of modern life often seems stranger than fiction anyway, and our experiences of the past decade have made contemporary history seem unusually susceptible to moral criticism, which was, of course, a traditional function of the novel.

Third, History, like fiction, can be a form of social documentation; but it surpasses the novel in helping us to distinguish *explicitly* between ephemeral phenomena, on the one hand, and enduring or consequential phenomena, on the other. Increasingly, we seem to require assistance in separating tradition from trash, necessary artifacts from superficial artifices.

Fourth, the legitimizing of local studies once again gives historical writing those identifiable particularities of time, place, and persons that have long been the benchmarks of fiction.

And finally, as America finishes its fourth full century of history, we are less vulnerable than ever before to the old caustic charge that we have no history. Rather, like Walt Whitman, we have by now embraced it all: innocence and guilt, homogeneity and diversity, a colonial condition and an imperial status, the primitive and the post-industrial, cultural creativity and destructiveness, grandeur and tragedy.

What, then, lies on the horizon for American historiography? What will the near future of historical writing be like? Several of the basic tendencies of the past decade will surely continue to be influential.

Books about intellectual paradigms, modes and models of thought, what the French call the history of *mentalités,* are likely to continue to appear, still under the tremendous impact of such works as *The Structure of Scientific Revolutions,* by Thomas S. Kuhn, and *The Machine in the Garden,* by Leo Marx. Books about social structure, class, upward and downward mobility, intergenerational relationships, and family

history will also continue to be fashionable. Books about economic growth and decline, as well as about the implications of both, will rise in importance—especially if our current recession deepens into something worse. The works of four of our best urban and business historians, senior scholars of great originality—works not so well known to the general public as they should be—figure to gain a broader readership: Alfred D. Chandler's *Strategy and Structure: Chapters in the History of the Industrial Enterprise* (1962); Thomas C. Cochran's *Business in American Life: A History* (1972); James Willard Hurst's *Law and Economic Growth* (1964), and *The Legitimacy of the Business Corporation* (1970); and Sam Bass Warner, Jr.'s *The Urban Wilderness: A History of the American City* (1972), among others.

Although the New Left revisionists of the 1960s now seem to have shot their bolt, sensitive historians will continue to use the past as a means of offering critiques of the present, and vice versa. History, as Martin Duberman has urged, will be written from more personal perspectives.[12] Such perspectives will undoubtedly be especially strong in ethnic and labor history, popular culture, and the history of blacks, American Indians, and women.

As for techniques of investigation and exposition, a growing use of and respect for oral history can be foreseen. Merle Miller's *Plain Speaking: An Oral Biography of Harry S. Truman* (1973) has added immeasurably to our understanding of that man, just as *All God's Dangers: The Life of Nate Shaw,* by Theodore Rosengarten (1974), has contributed an exciting new dimension to black, agricultural, and southern history during the middle third of this century.

Closer scrutiny of iconographic evidence can also be expected, with historians paying more and more attention to paintings, portraits, cartoons, photographic archives, urban plans, and film history. What is called the history of human geography—environmental history, demography, man's changing relationship to the land- and seascapes—will receive added attention, too, although it is important to note here that half a century ago Frederick Jackson Turner established many of the ground rules for writing about human geography. True, he failed to go very far beyond the ground rules himself, so that many of his heirs are not even aware of what they owe to his legacy. One of the telling criticisms voiced by older scholars like Jacques Barzun is that

12. See Duberman, *Black Mountain: An Exploration in Community* (New York, 1972), 12–14.

the Young Turks are so often oblivious to their distinguished prede-
cessors. Just as Turner anticipated the new historical geographers, and
Charles A. Beard four decades ago anticipated the New Left critique of
United States foreign policy, so Marcus W. Jernegan, Marcus Lee
Hansen, Theodore Blegen, and Oscar Handlin wrote the "history of
the inarticulate" back in the 1930s and 1940s—before it came to be so
called and, one might add, so fashionable.

One final thought on new directions. Comparative history is begin-
ning to come into its own: the cross-cultural examination of slave
systems, revolutions, peasant societies, political elites, bureaucracies,
and the process of modernization provide a few examples. As the
works of foreign historians become better known in this country—
such as those of E. J. Hobsbawm, Alan MacFarlane, George Rudé, and
J. G. A. Pocock—our national history will be written within less
parochial boundaries and from less provincial perspectives.

Even the question of our national character—so eagerly discussed
during the 1940s and 1950s but discarded, by and large, after that—is
apparently being revitalized. David M. Potter, one of the most original
and stimulating American historians of the post–World War II genera-
tion, helped to keep a small fire burning during the 1960s with his
provocative essays on "American Women and the American Char-
acter," "The Quest for the National Character," and several other
related themes.[13] But those who have done the most to rejuvenate
interest in the national character historically considered are Daniel Bell
and Erik H. Erikson, a sociologist and a psychiatrist. In 1968 Bell
published a little essay entitled "National Character Revisited: A Pro-
posal for Renegotiating the Concept," which concluded with these
summary remarks:

> If one is to distinguish between personality configuration and the values,
> styles, and imagoes of a country as influences which in one way or
> another shape individual responses, then the idea of modal personality
> types can serve as the ground for the dimension of *character* in the idea of
> national character. But if one also seeks to maintain the idea of the *nation*
> as a meaningful unit of a sociocultural pattern, then one cannot eschew
> the examination of the national creed, imagoes, style, and consciousness
> as components of the cultural pattern. It is in this effort, perhaps, by

13. See *History and American Society: Essays of David M. Potter,* ed. Don E. Fehren-
bacher (New York, 1973), chaps. 11 and 13.

searching out the interplay between personality and the components I have sought to specify, that we might yet be able to find some viable meaning in the ambiguous phrase "national character."[14]

Since then, several interpretive works seeking to explore our national origins and explain our distinctive attributes have appeared, most notably Neil Harris's eight-volume series, *The American Culture* (1970–73), my own *People of Paradox: An Inquiry Concerning the Origins of American Civilization* (1972), and Richard Slotkin's *Regeneration through Violence: The Mythology of the American Frontier, 1600–1860* (1973).

Do we have a usable past? More than three centuries ago, in 1672, the Reverend Thomas Shepard wrote this to his son, who had just been admitted to Harvard College: "Read some Histories often, which (they say) make men wise, as Poets make witty; both which are pleasant things in the midst of more difficult studies."[15] And at the close of the American Revolution, when Thomas Jefferson set out to devise a model curriculum for schools in a republican society, he placed historical studies at the very core of that curriculum: "History, by apprizing them of the past, will enable them to judge of the future; it will avail them of the experience of other times and other nations; it will qualify them as judges of the actions and designs of men; it will enable them to know ambition under every disguise it may assume; and knowing it, to defeat its views."[16]

In the subsequent two centuries, however, we somehow seem to have lost faith and to have become a present-minded nation of cynics. Henry James left the United States for England because, among other things, he felt so poignantly the lack of a usable past here. In 1918 Van Wyck Brooks, the critic and historian of American culture, contended that we desperately needed a new and usable past.

It just might be a sign of the times that we have not heard much of that phrase, "a usable past," in recent years. By 1969, following a decade of overuse, it had become a cliché, more banal than benign; today we are more likely to be told that we must respect "the pastness

14. Bell, "National Character Revisited: A Proposal for Renegotiating the Concept," in *The Winding Passage: Essays and Sociological Journeys, 1960–1980* (Cambridge, Mass., 1980), 183.

15. Perry Miller and Thomas H. Johnson, eds., *The Puritans* (New York, 1938), 717.

16. Jefferson, *Notes on the State of Virginia* (1781), in *The Writings of Thomas Jefferson*, ed. Andrew A. Lipscomb (Washington, D.C., 1903), II, 206–7.

of the past," which means to accept the past on its own terms rather than to transmogrify it into our own contemporary frame of reference.[17] A proper respect for the integrity of lives and times gone by is a major step toward true historical understanding. So also is the realization that we must not attempt to make *too much sense* of the past. It was, after all, as nonrational at times as is the present.

"What seest thou else," asks Prospero in *The Tempest*, "in the dark backward and abysm of time?" Our proper answer ought to be, not ourselves but our forebears. Clio may change *her* clothes, but those quaint people in the family photograph album cannot change theirs. By allowing them to retain their special identity, we are more likely to discover our own—and, in the bargain, our destinies as well.

17. Cf. Warren I. Susman, "History and the American Intellectual: Uses of a Usable Past," *American Quarterly,* 16 (1964), 243–63; and Aileen Kraditor, "American Radical Historians on Their Heritage," *Past & Present,* no. 56 (August 1972), 136–53.

Chapter 5

Extending the Reach of American Cultural History: A Retrospective Glance and a Prospectus

The Organization of American Historians held its seventy-sixth annual meeting on April 6–9, 1983, in Cincinnati, Ohio. The program committee, believing that the discipline faced a crisis of over-specialization and fragmentation, selected as the theme for that meeting "The Reuniting of Historical Explanation: Themes, Concepts, and Agenda," and solicited a cluster of special sessions in order to develop thinking and discussion along those lines. This essay evolved from an invitation by the program committee to prepare an extended paper on the culture concept as a means of reintegration.

I presented a revised version on May 25, 1983, in Kiel, West Germany, at the annual meeting of the German Association for American Studies. That organization then published it in its quarterly journal, *Amerikastudien/American Studies,* 29 (1984), 19–42, and the slightly modified version appears here with permission.

This essay has been stimulated by inquiries about cultural history and the concept of culture as a possible basis for the reintegration of American historiography. I have organized the paper into three sections. The first is quite literally historical: the *problématique* of American cultural history as a thrice-told tale (at the very least). The second is intended as suggestive: what could be some of the basic components of a newly expanded cultural history? And the third is tentatively

prescriptive: what might be the larger consequences of an approach to cultural history that is dynamic and multidimensional, even imperialistic in terms of the intellectual turf it seeks to influence?

Perhaps I should explain what I mean by "reintegration." I do not have in mind some monolithic new line of interpretation (in the manner of Charles A. Beard and Vernon L. Parrington) on which everything can be strung. Nor do I expect to discover a central theme or even a neat and close-knit set of central themes to which all Americans have resonated. I do have in mind, especially for purposes of teaching and future research, a viable response to the question that so many of us have been asking in recent years: how do the disparate pieces of the current and rather confounding historiographical puzzle fit together?[1]

The decade between the early 1820s and the early 1830s provides a useful example. We now have some splendid work for these years in the fields of labor history, women's history, the social history of religion, and the history of technology. We also have fresh material on corruption, crime, and the countervailing quest for social control. And we have important information on ideological aspects of the decade, notably the growing attractiveness of evangelical Christianity to people who were affluent rather than "socially dispossessed." I am increasingly persuaded that a fresh value system developed during the 1820s in conjunction with (and perhaps as a rationalization for) the hierarchical control required by industrialization. Some of the explanatory concepts that appeared then are industrial morality, Christian capitalism, communal industrialism, and moral order.[2]

1. See Paul Conkin, "Intellectual History: Past, Present, and Future," in Charles F. Delzell, ed., *The Future of History* (Nashville, Tenn., 1977), 111–33. On pp. 125 and 132 n.2, Conkin uses "cultural history" in referring to "the history of the fine arts and for attempts to gauge the spirit of an age or to locate a complex group of mental traits in a population." For developments from Marc Bloch, Lucien Febvre, and Robert Mandrou to Philippe Ariès, Norbert Elias, and Michel Foucault, see Patrick H. Hutton, "The History of Mentalities: The New Map of Cultural History," *History and Theory,* 20 (1981), 237–59.

2. For just a few examples, see Anthony F. C. Wallace, *Rockdale: The Growth of an American Village in the Early Industrial Revolution* (New York, 1978); Paul G. Faler, *Mechanics and Manufacturers in the Early Industrial Revolution: Lynn, Massachusetts, 1780–1860* (Albany, N.Y., 1981); Thomas Dublin, *Women at Work: The Transformation of Work and Community in Lowell, Massachusetts, 1826–1860* (New York, 1979); Paul E. Johnson, *A Shopkeeper's Millennium: Society and Revivals in Rochester, New York, 1815–1837* (New York, 1978); and Richard L. McCormick, "Scandal and Reform: A Framework for the Study of Political Corruption in the Nineteenth-Century United States, and a Case Study of the 1820s" (paper prepared for discussion at the Shelby Cullom Davis Center for Historical Studies, Princeton University, February 1982).

The linkages that we must make between different sorts of mono-
graphs concerning the 1820s, and the value system that takes shape as
we do so, fits very well with Marshall Sahlins's analysis of what he
calls symbolic reason: "It takes as the distinctive quality of man not
that he must live in a material world . . . but that he does so according
to a meaningful scheme of his own devising, in which capacity man-
kind is unique."[3] Those connections, and the transformational nature
of the 1820s that we discover as a result of making them, are what I
understand by the term "re-integration."

I

I shall start with some material that may be least familiar: namely,
the origins of American cultural history in general and the search for
synthesis in particular. It is, surprisingly, a rather old story. For a full
generation after 1907, Max Farrand (of Yale, then the Commonwealth
Fund, and finally the Huntington Library) was obsessed by the chal-
lenge of broadening what seemed to be the narrowness and increasing
fragmentation of historical knowledge about the United States. What
placed this bee in his bonnet was an assignment to write an essay-
review of all twenty-seven volumes of the American Nation Series.[4]
Thereafter, his correspondence frequently refers to the need for new
courses, new texts, and new research that would coherently add the
strands of social and intellectual history to the well-established sub-
disciplines of political, military, and constitutional history. It is clear
from Farrand's letters that what he had in mind, we would call cultural
history.[5]

3. Sahlins, *Culture and Practical Reason* (Chicago, 1976), viii. Sahlins, an an-
thropologist at the University of Chicago, seems to be more widely read among social
scientists in France than in the United States, though he certainly has been influential
within his own discipline here.
4. Farrand, "The American Nation: A History," *American Historical Review*, 13
(1908), 591–95.
5. See Farrand to the publisher Frank Hall Scott, January 4, 1910, to whom he
proposed a series of volumes on "religious thought, education (including the develop-
ment of new subjects and new methods in our universities), philosophy and psychol-
ogy, literature, economics, political thought, philanthropy and social reform, the me-
chanical inventions, and fine arts" (Farrand Papers, Huntington Library, San Marino,
Calif.). See also Farrand to Carl R. Fish, February 8, 1910; Farrand to Franklin S. Hoyt,
January 3, 1912; Farrand to Allen Johnson, January 19, 1921; Arthur M. Schlesinger to
Farrand, March 7, 1924, all in Farrand Papers.

Late in 1917, for example, after reading the proofs of *Colonial Folk-ways,* by Charles McLean Andrews, he wrote an enthusiastic letter to his new colleague.

> I am convinced that while there is a great deal of work to be done in the political and constitutional field, and in the economic and industrial field, also, it is in the main the filling in of outlines already pretty definitely established. The opening for new work seems to me to be largest in what I am coming more and more to term "the inner life" of the people of the United States. So little has been done in that field that it is impossible to establish proportions. I should be inclined to lay the first emphasis on the religious, shading off into the intellectual, which immediately leads one into literature which has already been pretty well covered. Then I am inclined to think would come the social life, which would include sports and amusements, and somewhere is going to come in the description of what might be termed scientific achievements: developments in the realm of science, both pure and allied, developments in medicine, etc.

Farrand concluded with a line (which he frequently repeated) that shoots through the intervening years like a strong-shafted arrow: "The interpretative mind will sometime bring order out of chaos."[6] Collectively, we stand today like so many St. Sebastians, filled with Farrand's arrows. Like St. Sebastian, we wear a benign smile but not much else. Like St. Sebastian also, we feel rather helpless about bringing order out of chaos. We have not *sought* intellectual martyrdom so much as we have inherited it. Nonetheless, it's a mickle messy, not to mention demoralizing.

Andrews answered Farrand by agreeing "most heartily that we have got to do a lot of preliminary work, gathering a mass of information on all aspects of our history before the synthetic task is begun." Having said that much, Andrews expressed a desire to hear just exactly what Farrand meant by "coherency," and then he posed a series of troublesome questions:

> What are we aiming at? Have we a clear-cut and logical purpose, that is scientific in method and treatment and at the same time possessed of a definite object, or are we simply aiming to tell the story, balance the different factors, make attempts to estimate the relative importance of the different parts, a notoriously difficult task, and in general add to the sum

6. Ibid., Farrand to Andrews, December 31, 1917.

of human knowledge? I know what I want to do for colonial history, as far as its purely colonial aspects are concerned, but I am not clear in my mind as to what I want to do for colonial history in its relation to the history of the United States.[7]

A search for synthesis recurs in the publications as well as the private correspondence of American historians throughout the 1920s, '30s, and '40s. In 1927 it annoyed James C. Malin that too few authors "are aware that there is any problem involved or any reconstruction necessary." During the 1930s, social history seemed destined to emerge as the likely core of any "reconstruction" that might take place. Dixon Ryan Fox declared in 1930 "that the concept of social evolution . . . offers an available scheme on which to bring an immense number of seemingly discrete facts into an understandable relation." Not everyone was sympathetic, however. Avery Craven commented in 1934:

What has happened in the field of history is the realization that the story of the past cannot be told unless the whole complexity is at least grasped. The great problem so far, has arisen from the fact that with the study into the varied expressions of life in a period, men have been inclined to include everything they had found and have called such inclusion "social history." What really needs to be done is to study every expression of life in a period, catch something of the larger patterns and then have the courage to include everything necessary to the larger patterns but to exclude those things which are only interesting and incidental. . . . In other words, it seems to me that the only men who are going to be able to handle the complexity of materials are not those trained by men who are simply stupefied by the abundance of new facts but by mature men who have faced and realized the enormous problem of complexity and who have been able to wade through facts and still retain something of an understanding such as Turner had of the American pattern.[8]

7. Andrews to Farrand, January 3, 1918. For a parallel lack of synthesis in the field of Anglo-American literature, ca. 1920, see Phyllis Franklin, "English Studies in America: Reflections on the Development of a Discipline," *American Quarterly,* 30 (1978), 27.

8. See James G. Randall, "The Interrelation of Social and Constitutional History," *American Historical Review,* 35 (1929), 1–13; Fox, "A Synthetic Principle in American Social History," ibid. (1930), 256–66; William T. Hutchinson, "The Significance of the Constitution of the United States in the Teaching of American History," *Historian,* 13 (1950), 8; Malin to Max Farrand, January 27, 1927, and Craven to Farrand, November 27, 1934, Farrand Papers; and Thomas Reed Powell to James Phinney Baxter III, February 7, 1938, Powell Papers A-3, Harvard Law School Library, Cambridge, Mass.

During the 1920s and '30s, Van Wyck Brooks, Constance Rourke, Max Farrand, George Wilson Pierson, and others began to find kindred spirits for whom cultural history rather than social history might serve as the quintessential common denominator. The problem, of course, lay in defining exactly what one meant by culture and cultural history. Eager inquiries were dispatched, and the replies just as eagerly consumed. "Would it be too much trouble," Farrand asked James C. Malin, "to tell me a little about what you are doing on 'the cultural side' of the *Interpretation?*"

I am delighted to know that you are working in that field. I, too, have been working at that for a number of years, but only recently have I been able to put any time upon it, and I am expecting to devote the rest of my working years to that special field. Constituted as you and I apparently are, you will understand that I have felt obliged to get a broad sweep of various aspects, and I have already completed a superficial survey of the development of religious thought, of education, of the literature, of reading, and of political thought. I have a start made on the development and application of science, something on the development of art, very little on the development of sport and of the theater, and almost nothing on the development of philosophy. These are only sufficient to give me a general sweep of those aspects, but they seem to suffice to let me fit in peculiar manifestations at particular times into the general scheme, and there are astounding correlations, so it is possible apparently to fit them into a general sketch of development. Were you aware of the fact that students of history, and especially American history, all over the country are turning in this same direction? It is really a remarkable manifestation.

A few months later Farrand confessed to Malin, "I have not advanced so far on the cultural side as my somewhat ambitious outline may have indicated. We are all fumbling around in this fascinating, but complex subject, and you are quite right that the greatest difficulty is in weaving the results of our studies into the fabric of the course so that it becomes an indispensable part of it." By 1939 Constance Rourke had

Powell was recommending Max Lerner for a position in history and political science at Williams College. "I am skeptic enough to doubt whether [Lerner] will ever find a satisfactory synthesis," Powell wrote, "but the search for such a synthesis is of tremendous value both to the searcher and to students who come in contact with him as a teacher." Lerner published his synthesis twenty years later, *America as a Civilization: Life and Thought in the United States Today* (New York, 1957).

a history of American culture under way with a "strong but not ex-
clusive emphasis upon folk or popular arts." She felt that she had "hit
upon a form of treatment which permits a broad synthesis of ample
and complex materials." She then learned that Van Wyck Brooks
himself was preparing a multivolume history of American culture but
assured him that "our approaches are in contrast, and that neither in
any way repeats or infringes upon the other."9

If Rourke and Brooks, who were sympathetic souls in so many
ways, could not agree about the proper content, emphasis, or integrat-
ing mechanisms for a comprehensive history of American culture, we
should not be surprised to find a lack of definitional consensus among
historians, anthropologists, and social scientists generally. Raymond
Williams has described the complex etymology of "culture" as well as
ambiguities inherent in its current usage. Therefore, I invoke with a
certain affection this confession made by A. Lawrence Lowell in 1934:
"I have been entrusted with the difficult task of speaking about
culture. But there is nothing in the world more elusive. One cannot
analyze it, for its components are infinite. One cannot describe it, for it
is a Protean in shape. An attempt to encompass its meaning in words is
like trying to seize the air in the hand, when one finds that it is every-
where except within one's grasp."10

As those who are interested in the culture concept know, Alfred
Kroeber and Clyde Kluckhohn put together a substantial compendium
of definitions and usages, including twenty-two that are historical in
the sense that they emphasize social heritage or tradition.11 More re-
cently, James Axtell has offered a composite definition that not only
serves quite well, but implicitly suggests why the concept of culture
seems rather a likely candidate to provide a new amalgam for co-
herence in American historical scholarship.

9. Farrand to Malin, April 9, 1924, and June 24, 1924, Farrand Papers; Rourke to
Brooks, March 30, 1939, Brooks Papers, University of Pennsylvania Library, Phila-
delphia; Pierson to Farrand, November 20, 1940, Farrand Papers. Rourke did not live
to complete her ambitious project, and after her premature death Brooks faithfully
prepared the fragment essays for publication as *The Roots of American Culture* (New
York, 1942).
10. Williams, *Keywords: A Vocabulary of Culture and Society* (New York, 1976), 76–
82; A. L. Kroeber and Clyde Kluckhohn, *Culture: A Critical Review of Concepts and
Definitions* (Cambridge, Mass., 1952), 4 n.5.
11. Kroeber and Kluckhohn, *Culture*, 47–49. See also Sideny W. Mintz, "Culture:
An Anthropological View," *Yale Review*, 71 (1982), 501, 512.

Culture is an idealized pattern of meanings, values, and norms differentially shared by the members of a society, which can be inferred from the non-instinctive behavior of the group and from the symbolic products of their actions, including material artifacts, language, and social institutions. The task of the ethnohistorian is to determine just what the patterns are in a particular society over time and how the individual parts— whether actions, beliefs, or artifacts—together constitute the functional whole.[12]

I am quite comfortable with that definition, and I feel no need to elaborate upon it as a formula for reintegration. Why? First, because serious historians of American culture have recently been rather conscientious about defining what they mean by cultural history. The examples of Daniel Walker Howe and Alan Trachtenberg, added to Axtell's, suggest a remarkable degree of congruence among current practitioners.[13] I may be nearsighted, but I don't believe that definitional problems are the most pressing issue on our present agenda.

Why else? Well, on the one hand I do not share the nihilistic atomism of Murray G. Murphey: "It is clear that the grand synthesis, as developed by men such as [Perry] Miller, simply cannot be applied to so complex an entity as modern society; whether or not there was a New England mind in the seventeenth century, there is no American mind today. An inventory of American beliefs today would yield not a system but a mass of inconsistent fragments."[14]

But on the other hand, it gives me pause—it should give us all pause—that so many disciplines, and not History alone, have been obliged during the past generation (for reasons of intellectual integrity) to abandon holistic theories and tidy syntheses. As Daniel Bell observed in his retrospective glance at the social sciences,

12. Axtell, *The European and the Indian: Essays in the Ethnohistory of Colonial North America* (New York, 1981), 6. Axtell italicizes the first sentence of this useful definition. See also John William Ward, "History and the Concept of Culture," in *Red, White, and Blue: Men, Books, and Ideas in American Culture* (New York, 1969), 6–9.

13. See Howe, "Victorian Culture in America," in Howe, ed., *Victorian America* (Philadelphia, 1976), 5; and Trachtenberg, *The Incorporation of America: Culture and Society in the Gilded Age* (New York, 1982), 9, 143. For both of these authors, noncultural phenomena such as political behavior, technological change, and "modernization" become epiphenomenal to culture as the ultimate explanatory context.

14. Murphey, "The Place of Beliefs in Modern Culture," in John Higham and Paul K. Conkin, eds., *New Directions in American Intellectual History* (Baltimore, Md., 1979), 164.

if complexity has been the stone of stumbling in the cognitive fields, simplicity has been the undoing of some of the sociological theories. One reason why the large field of "culture and personality" has almost completely evaporated has been the difficulty, in large and complex societies . . . of identifying cultural patterns in metaphorical and holistic terms. What strikes one, in looking at any society, is the contrasting patterns that seemingly exist at the same time, or succeed each other so as to question the stability of a culture pattern.[15]

I am a pluralist and a pragmatist. Although I consider myself a cultural historian, it seems futile to argue that a cultural "paradigm" is in all cases preferable, let us say, to a social history "paradigm,"[16] especially when cultural historians cannot even agree among themselves which cultural "paradigm" should be *primus inter pares*. During the past decade or so, historians influenced by Clifford Geertz, Victor Turner, Mary Douglas, Sir Edmund Leach, Robert Redfield, and others have informally vied with one another by putting forward various conceptual models that might be just the right one for History: not too ethnographic and not too abstract but *just* right; not too communitarian and not too pluralistic but *just* right; not too macro and not too micro but *just* right.[17]

15. Bell, *The Social Sciences since the Second World War* (New Brunswick, N.J., 1982), 48–49; Cecil F. Tate, *The Search for a Method in American Studies* (Minneapolis, Minn., 1973), esp. chap. 1, "Holism and Myth in American Studies." Cf. the approach in Michael Kammen, *People of Paradox: An Inquiry Concerning the Origins of American Civilization* (New York, 1972), esp. chap. 4.

16. Ever since Thomas S. Kuhn published *The Structure of Scientific Revolutions* (Chicago, 1962), "paradigm" has become a buzzword. Some scholars are now repelled by its trendiness and refer to it pejoratively, but I believe that they are overreacting. The word-concept "paradigm" has an honorable lineage that goes back to Burckhardt, at least. Therefore, cultural historians, above all, should feel comfortable using it. See Jacob Burckhardt, *Force and Freedom: Reflections on History* (New York, 1943), 219. Burckhardt prepared those lectures in 1869–71.

17. See Ronald G. Walters, "Signs of the Times: Clifford Geertz and Historians," *Social Research,* 47 (1980), 537–56; Giles Gunn, "The Semiotics of Culture and the Interpretation of Literature: Clifford Geertz and the Moral Imagination," *Studies in the Literary Imagination,* 12 (1979), 109–28; and Bernard S. Cohn, John W. Adams, Natalie Z. Davis, and Carlo Ginzburg, "Anthropology and History in the 1980s," *Journal of Interdisciplinary History,* 12 (1981), 227–78. It seems noteworthy that a rising interest among scholars in cultural anthropology has coincided with complaints about cultural disintegration within society at large. See Mortimer J. Adler, "The Disappearance of Culture," *Newsweek,* August 21, 1978, p. 15; Harold Bloom, "A Speculation upon American Jewish Culture," *Judaism,* 31 (1982), 266–67; and T. S. Eliot, *Notes towards the Definition of Culture* (London, 1948), 19, 93.

I yield to no one in my enjoyment of good Anthropology. It is my favorite discipline outside of History, and some of my own recent work has been influenced by explanatory concepts borrowed from Anthropology.[18] Nevertheless, I feel compelled to offer a few caveats. The first is a gut apprehension: namely, that Clio can be a rather fickle *femme,* and that she most certainly isn't monogamous. History's flirtation with Sociology—during the 1950s and '60s almost an infatuation in some quarters[19]—led to disillusionment and subsequent disengagement for some scholars; the same process now seems to be happening between certain historians and the work of Erik H. Erikson; so I see no reason why it might not occur, eventually, between History and Anthropology as well.[20] Anthropologists have been quite critical of significant work by historians; we, in turn, are sometimes disturbed by the insufficient sensitivity to historical dimensions and particularity of time and place shown by even the most distinguished anthropologists.

Although Geertz is immensely insightful and valuable for definitional purposes (for example, what do we mean by "ideology"?), and despite Turner's fecundity in dealing with symbolic codes that are

18. See Michael Kammen, *A Season of Youth: The American Revolution and the Historical Imagination* (New York, 1978), esp. 189–90, 201; and Kammen, "Echoes and Reverberations: Reflections on the Language of Politics and Patterns of Political Literature in Revolutionary and Republican America," in Jan Fergus, ed., *Literature and Society: The Lawrence Henry Gipson Symposium, 1978* (Bethlehem, Pa., 1981), esp. 26 and n.44.

19. See Richard Hofstadter and Seymour Martin Lipset, eds., *Sociology and History: Methods* (New York, 1968); and the interesting letter from Sumner Chilton Powell to Mark Howe, Jr., September 1, 1956, Howe Papers, box 4, Harvard Law School Library, Cambridge, Mass. Powell had just completed a draft of *Puritan Village* (1963) and explained that "Sorokin's *Cultural & Social Dynamics* was quite inspiring. I'd never read it, but I certainly thanked him, after finishing that mammoth tome, for his concept of methodology. I saw just what I'd been overlooking: that I was trying to make a random narrative, when I simply did not have the necessary data." Powell perceived that he merely had to put his 650 town "orders" into "various categories of 'social problems' and *then* organize the English background on that basis—so simple!"

20. See Thomas Bender, *Community and Social Change in America* (New Brunswick, N.J., 1978), esp. 3–43; Emery Battis, *Saints and Sectaries: Anne Hutchinson and the Antinomian Controversy in the Massachusetts Bay Colony* (Chapel Hill, N.C., 1962), 284–85; David Potter to Seymour M. Lipset, June 16, 1964, and Potter to Allan Nevins, June 17, 1964, Nevins Papers, box 88, Butler Library, Columbia University, New York City; Howard I. Kushner, "Pathology and Adjustment in Psychohistory: A Critique of the Erikson Model," *Psychocultural Review,* 1 (1977), 493–506; Michael Kammen, "Changing Perceptions of the Life Cycle in American Thought and Culture," chap. 8 below, esp. 210–221; and Hildred Geertz, "An Anthropology of Religion and Magic," *Journal of Interdisciplinary History,* 6 (1975), 71–89.

central to our historical materials, I cannot help feeling that some of the anthropologists who are most historical in orientation, and whose work has great potential value for historians, have been relatively neglected. *Configurations of Culture Growth* by Alfred L. Kroeber, for example, attempted to cast historical cultures and events "into organized relief, by an attitude which consciously recognizes pattern-growth configurations in their space-time relations as well as in their value relations."[21] Kroeber was especially interested in the *historical* development of diverse cultures. Although he watched for patterns and typologies, he remained cautious about forcing his material into rigid categories, and he concluded with neither laws nor predictions. As he wrote to an editor (referring to himself in the third person), "the author . . . is extending his observation . . . beyond the conventional preoccupation of his profession with the primitives to the larger manifestations of high civilization. The book therefore deals with the materials of culture history, but is novel in that it is not so much a narrative of what happened as a sociological examination of how, and to what degree, the major achievements of human civilization repeat themselves."[22]

I would like to suggest that if the culture concept does become a versatile tool for historians in the decades ahead, we would be well advised to pay at least as much attention to those like Kroeber, Ruth Benedict, Robert Redfield, and Robert H. Lowie, whose understanding of the concept was comprehensive, as we do to those who are more specialized in symbolic, legal, linguistic, medical, or economic anthropology. Narrower specialisms (if I may use the English phrase) will always be helpful in our monographic work. For the task of reintegration, however, we must turn to broad-gauge theorists of cultural change, cultural relativism, and what Ruth Benedict called "configurational anthropology."[23]

21. Kroeber, *Configurations of Culture Growth* (Berkeley, Calif., 1944), 846. See also Melville J. Herskovits, *Man and His Works: The Science of Cultural Anthropology* (New York, 1948), esp. chaps. 28, 32, 34; George M. Foster, "What Is Folk Culture?" *American Anthropologist,* 55 (1953), 159–73; and Conrad M. Arensberg and Solon T. Kimball, *Culture and Community* (New York, 1965). It seems obvious that different sorts of anthropological theory will be better suited to one phase of American history than to another. The Redfield-Foster category of "folk culture," for example, used by them to describe societies that are more than primitive but not yet industrialized, is much more applicable to the first half of American history than to the second.

22. Quoted in Theodora Kroeber, *Alfred Kroeber: A Personal Configuration* (Berkeley, Calif., 1970), 170.

23. E.g., Benedict, *Patterns of Culture* (Boston, 1934), 214–15, 217; Redfield, *The*

It seems quite clear that no single discipline, however rich in terms of theory and methodology, can begin to fulfill all of History's needs if reintegration is to take place and a new paradigm appear. (I might add, parenthetically, that waiting for *the* new paradigm will require more cigarettes than waiting for Godot and greater good will than waiting for the Messiah. Those who assume that once-upon-a-time a Beardian synthesis truly prevailed have either forgotten or never knew how many serious historians refused to accept that synthesis even in its so-called heyday.[24] Similarly, it is interesting to note an observation made privately by Richard Hofstadter not long before his death: "It is certainly true that some historians have here and there used consensus as a helpful way of putting problems into focus, but I think there never was a consensus school, and that the whole idea has in any case been overdone."[25])

I will scarcely surprise anyone if I suggest that a new configuration along cultural lines will require (1) fresh and more thorough attention to the study of folklore, an approach that has been adopted quite fruitfully by such sophisticated *Annalistes* as Jacques Le Goff, the medievalist, and Emmanuel Le Roy Ladurie;[26] (2) even deeper, more penetrating studies of historical myths, for as Nietzsche noted, "only a horizon ringed about with myths can unify a culture";[27] (3) greater use

Little Community, and *Peasant Society and Culture* (Chicago, 1962); Julian H. Steward, *Theory of Culture Change: The Methodology of Multilinear Evolution* (Urbana, Ill., 1955); Robert Plant Armstrong, *Wellspring: On the Myth and Source of Culture* (Berkeley, Calif., 1975); and Robert F. Murphy, *The Dialectics of Social Life: Alarms and Excursions in Anthropological Theory* (New York, 1971), a survey of social rather than cultural anthropology.

24. See, e.g., Allen Johnson to Max Farrand, March 7, 1918, Farrand Papers; Samuel Eliot Morison to Allan Nevins, May 18, 1948, Nevins Papers (professional); and C. Vann Woodward to Richard Hofstadter, August 9, 1967, Hofstadter Papers, Butler Library, Columbia University, New York City.

25. Hofstadter to Bernard Bailyn, April 13, 1970 (uncatalogued), Hofstadter Papers.

26. See Le Goff, *La Naissance du Purgatoire* (Paris, 1981); and Le Roy Ladurie, *Love, Death and Money in the Pays D'Oc* (New York, 1982). Both of these French historians rely upon Stith Thompson's *Motif-Index of Folk-Literature: A Classification of Narrative Elements in Folk Tales, Ballads, Myths, Fables, Medieval Romances, Exempla, Fabliaux, Jest Books, and Local Legends,* 6 vols. (Bloomington, Ind., 1932–36). See also Jan H. Brunvand, *The Study of American Folklore: An Introduction* (New York, 1968); and Alan Dundes, "The American Concept of Folklore," *Journal of the Folklore Institute,* 3 (1966), 226–49.

27. Nietzsche, *The Birth of Tragedy* (1872; Garden City, N.Y., 1956), 136; Ernst Cassirer, *The Philosophy of Symbolic Forms,* 3 vols. (New Haven, Conn., 1953–57), esp. vol. 2, *Mythical Thought* (1955); William H. McNeill, "Make Mine Myth," *New York*

of and interconnections with the study of material culture, the decorative arts, iconography, film, and the history of architecture;[28] (4) what remains least utilized in my opinion, the study of cultural geography and the changing American landscape;[29] and (5) greater awareness of the contention by Akira Iriye, in his 1978 presidential address to the Society for Historians of American Foreign Relations, that nations ought to be regarded as cultural systems and that "international relations are interactions among cultural systems." Iriye recognized the assumption among his colleagues that "in order to understand American diplomacy, one must know something about American culture"; but he went on to acknowledge that "problems immediately arise, however, when one asks what, specifically, the relationship is between a given cultural system and its external behavior." I hope I am mistaken, but I am not aware that Iriye's provocative paper has received much attention from non-specialists in U.S. diplomatic history. It certainly has been ignored by most historians of American culture.[30]

Having invoked the obvious, I shall conclude this section by returning to the repetitious: that is, my insistence that cultural history and a cultural approach to history in general have been prominent on our agenda for a very long time. Scholars in medieval and early modern European history began moving in this direction during the early years of the twentieth century.[31] Following World War II the word "cul-

Times, December 28, 1981. For an example of what can be done with previously unutilized materials in American cultural history, see Barbara MacDonald Powell, "'The Most Celebrated Encampment': The Valley Forge Experience in American Culture, 1777–1983" (Ph.D. diss., Cornell University, 1983).

28. See Jules David Prown, "Mind in Matter: An Introduction to Material Culture Theory and Method," *Winterthur Portfolio,* 17 (1982), 1–19; Henry Glassie, "Meaningful Things and Appropriate Myths: The Artifact's Place in American Studies," *Prospects: An Annual of American Cultural Studies,* 3 (1977), 1–44; and *American Quarterly,* 31 (1979), a special issue "Film and American Studies."

29. See Peirce F. Lewis, "Axioms for Reading the Landscape: Some Guides to the American Scene," in *The Interpretation of Ordinary Landscapes,* ed. D. W. Meinig (New York, 1979), 11–32; John Brinckerhoff Jackson, *The Necessity for Ruins and Other Topics* (Amherst, Mass., 1980); James R. Gibson, ed., *European Settlement and Development in North America: Essays on Geographical Change in Honour and Memory of Andrew Hill Clark* (Toronto, 1978); *American Quarterly,* 33 (1981), a special issue devoted to "American Culture and the American Frontier."

30. Iriye, "Culture and Power: International Relations as Intercultural Relations," *Diplomatic History,* 3 (1979), 115–16. The remarkable book in which Iriye exemplifies his thesis is *Power and Culture: The Japanese-American War, 1941–1945* (Cambridge, Mass., 1981).

31. See T. Kroeber, *Kroeber,* 45; Preserved Smith to Charles Homer Haskins, April

ture" started to appear in our vocabulary with increasing frequency, and the concept itself swiftly became an academic buzzword of sorts.[32]

Nevertheless, I would suggest that the concept has had an erratic history among Americanists during the past generation. In 1950, for example, a fine conference was held at Brown University on "Approaches to American Studies." A statement circulated in advance by the program committee observed that "cultural anthropology, with its broad outlook on society, can suggest fields of inquiry and methods of approach that will be new to most students of American society."[33] It was more than two decades, however, before tangible results began to be seen; and *The State of American History,* edited by Herbert Bass in 1970, contained twenty essays yet none on cultural history. *Prospects: An Annual of American Cultural Studies* began to appear in December 1975. The editor's note proclaimed "a very real need for a multi-disciplinary journal that explores all aspects of American civilization." We have had a *Journal of Popular Culture* since 1967, and a *Journal of American Culture* since 1978. But so much for historical context and *déjà vu.* Let's turn to some of the basic components of a freshly integrated cultural history.

II

It is a weary truism by now that explanatory devices purporting to comprehend everything usually end up explaining little or nothing. True enough, yet I remain persuaded that a cultural approach to the whole of American history promises rich dividends if our goal is reintegration. Let us look for a moment at what may, perhaps, be our two largest subfields: political and social history. Anyone who doubts that politics, to be fully understood, must be viewed in cultural context, need only look at John Brewer's brilliantly revisionist book, *Party Ideology and Popular Politics at the Accession of George III* (1976), especially his three chapters on the press during the 1760s; on person-

5, 1929, and Carl Stephenson to Haskins, November 6, 1930, Haskins Papers, boxes 16 and 17, Seeley G. Mudd Manuscript Library, Princeton University, Princeton, N.J.; and Caroline F. Ware, ed., *The Cultural Approach to History* (New York, 1940).

32. See Williams, *Keywords,* 10.

33. "Approaches to American Studies: A Conference to Be Held at Brown University, November 3–4, 1950," Howe Papers, box 4 (E. S. Morgan folder).

ality, propaganda, and ritual (about Wilkes and the Wilkites); and on party ideology and public unrest.[34]

Similarly the "new social history," however rich its demographic underpinnings, does not become fully meaningful without explanatory mechanisms. When we look for the "how" and the "why," more often than not an explanation emerges in cultural terms. For example, in his valuable essay "Social Change and Cultural Conflict in Virginia: Lunenburg County, 1746 to 1774," Richard Beeman starts with a description of social structure, and then of social change. The essay really coheres in the final third, however, when he turns to an analysis of cultural divergence within the county and utilizes the distinction between "structural relationships" and "communitas" to explain and make meaningful the social data with which he began.[35] As Clifford Geertz has remarked, "social events do have causes and social institutions effects; but it just may be that the road to discovering what we assert in asserting this lies less through postulating forces and measuring them than through noting expressions and inspecting them."[36]

Geertz's phrase "noting expressions" has a rather broadly inclusive meaning. I would like to elaborate upon it by noting six topics in cultural history that not only warrant investigation but whose exploration could move like a searchlight across conventional subdisciplines and perhaps illuminate all sorts of hitherto dark corners and shadowy areas.

(1) We urgently need an American equivalent of Raymond Williams's seminal book *Keywords;* his etymologies are almost entirely British. Recent work by David D. Hall and Michael McGiffert, for

34. See also Günther Lottes, "Popular Culture and the Early Modern State in 16th Century Germany," in Steven L. Kaplan, ed., *Understanding Popular Culture: Europe from the Middle Ages to the Nineteenth Century* (Berlin, 1984), 147–88; and Eliot, *Notes towards the Definition of Culture*, chap. 5, "A Note on Culture and Politics."

35. *William and Mary Quarterly*, 35 (1978), 455–76. See also David Brion Davis, "Some Recent Directions in American Cultural History," *American Historical Review*, 73 (1968), esp. 705–6; Carl N. Degler, *Neither Black nor White: Slavery and Race Relations in Brazil and the United States* (New York, 1971), 47, 88–89, 92, 204, 224, 244, 247–48; Wallace, *Rockdale*, esp. 477–85; and Martin J. Wiener, *English Culture and the Decline of the Industrial Spirit, 1850–1980* (Cambridge, 1981), esp. x, 3–5.

36. Geertz, "Blurred Genres: The Refiguration of Social Thought," *American Scholar*, 49 (1980), 178. For a useful way of distinguishing between social and cultural history, see E. H. Gombrich, *In Search of Cultural History* (Oxford, 1969), 41. For a thoughtful set of suggestions for new linkages between social and cultural history, see Harry S. Stout, "Culture, Structure, and the 'New' History: A Critique and an Agenda," *Computers and the Humanities*, 9 (1975), esp. 221–27.

instance, has given us reason to regard such phrases as "troubled and unquieted" in a new and highly nuanced way. The significance of fear and uncertainty in the seventeenth century were scarcely unknown to scholars before 1972, but I would submit that we have now been sensitized to "unsettled" spirits as a determinative feature in the foreground of the human landscape in Puritan New England, and with manifest behavioral consequences.[37] Comparable explorations should be made (for the eighteenth and nineteenth centuries) of such word-concepts as *virtue, benevolence, useful* and *utility, improvement, prosperity, visionary, perfection, efficient, communication, enterprise, improvisation, consolidation, energy, discipline, remembrance, memory, economy, empire, creation, disorder,* and *anxiety.* In several instances I believe that the result would be a revisionist monograph of considerable significance, not merely about the American language but about the role that language has played as both symptom and determinant of thought and behavior.[38]

(2) The history of public opinion, and of attitudes toward public opinion in the United States, has not yet been written. We all may have our favorite passages, ranging from James Madison's seminal essay of 1791 to Tocqueville's famous chapter "The Power Exercised by the Majority in America over Thought" to Walter Lippmann's *Public Opinion* (1922). But what about the interstices, the permutations, the development of public opinion polls during the 1930s and '40s, the touching moments—such as that in 1809 when Joseph S. Buckminster expressed deep anxiety because the pernicious impact of "this secret influence of the public opinion, though not easily described, has been felt and lamented by many of us who were educated in the present generation."[39]

(3) When are we going to have a major work on the cultural impact

37. *God's Plot: The Paradoxes of Puritan Piety: Being the Autobiography and Journal of Thomas Shepard,* ed. Michael McGiffert (Amherst, Mass., 1972), 3, 9, 19; Hall, "The Mental World of Samuel Sewall," *Proceedings of the Massachusetts Historical Society,* 92 (1980), 21–44.

38. Cf. Quentin Skinner, "The Idea of a Cultural Lexicon," *Essays in Criticism,* 29 (1979), 205–24. See also "A Dictionary of Cracker Barrel English," *New York Times,* September 5, 1982, p. E9; and Marc Bloch, *The Historian's Craft* (Manchester, 1954), 158.

39. Quoted in Emory Elliott, *Revolutionary Writers: Literature and Authority in the New Republic, 1725–1810* (New York, 1982), 52–53. For examples from the 1820s and '30s, see Perry Miller, *The Life of the Mind in America from the Revolution to the Civil War* (New York, 1965), 68, 85.

of fires and related catastrophes in the United States? Nine major fires occurred in New York City between 1791 and 1836. In 1829 alone there were 151 lesser fires there. The Crystal Palace burned down in 1858, and P. T. Barnum's American Museum in New York City was devastated in 1865, 1868, and again in 1872.[40] General Sherman set fire to Atlanta in 1864, and in April 1865 citizens of Richmond set fire to warehouses of tobacco and cotton so that they would not fall into Union hands. Robert E. Lee's records all perished in that blaze. Among utopian communities, Brook Farm burned in 1846; the North American Phalanx (Monmouth County, New Jersey) in 1856; and in the Puget Sound area the Equality Colony in 1906 and Helicon Home Colony one year later. Everyone knows about the raging infernos in Chicago (1871) and Boston (1872); but the massive fire of 1871 in Peshtigo, Wisconsin, a logging town, killed more than five times as many people as the notorious Chicago fire.[41] In 1903 a capsized stage-light ignited some scenery at the Iroquois Theater in Chicago. Before the fire could be brought under control, 602 people had been killed—compared with 250 in the more famous blaze of October 8, 1871.

What intrigues me—however lugubrious the fascination may be—is the *cultural* response to these and many other fires. We have Anne Bradstreet and her poem "Upon the Burning of Our House" (1666) to compare with John P. Marquand's great-aunt Mary Curzon, whose favorite topic was a stupendous fire at Newburyport in 1811: "The Fire" that destroyed her grandfather's house, his wharf, and one of his brigs, the *George Washington,* which had been docked at the wharf. We can contrast both with Matthew Josephson's anxious account of the fire at his New York apartment in 1930, when he lost many of his possessions and almost his life. For Bradstreet, Aunt Mary Curzon, and Josephson, as for Henry James, fires remained vivid memories: pivotal points in their lives and family histories, but even more, stimuli for imaginative literature.[42] In several of his stories Nathaniel Haw-

40. See Neil Harris, *Humbug: The Art of P. T. Barnum* (Boston, 1973), 155, 169, 172, 241–42, 270. See also the catalogue of the 1980 University Hospital Antiques Show, Philadelphia, an exhibit organized around the theme of fire fighting in the United States. For a different approach, see Stephen J. Pyne, *Fire in America: A Cultural History of Wildland and Rural Fire* (Princeton, N.J., 1982).

41. The Peshtigo Fire Museum was established in 1962. The American Museum of Fire Fighting in Hudson, New York, has extensive collections and is a neglected resource for American cultural historians.

42. Stephen Birmingham, *The Late John Marquand* (Philadelphia, 1972), 25; Joseph-

thorne seems to have examined the notion of fire as an agent of obliter-
ation and cleansing. "Earth's Holocaust" (1844) is a fable about a vast
prairie bonfire that destroys remnants of the past, and in *The House of
the Seven Gables* (1851) Holgrave finds utility in fire because it elimi-
nates needless vestiges of time.[43]

Aleksandr Borisovich Lakier, who visited the United States in 1857
and became the first Russian to write a serious account of America,
was so fascinated by fire fighting here that one Russian reviewer of his
book decided that the American national character must be most fully
expressed by mutual cooperation in fighting fires. Recall that Mark
Twain has Hank Morgan declare that "fires interested me consider-
ably, because I was getting a good deal of an insurance business start-
ed, and was also training some horses and building some steam fire-
engines, with an eye to a paid fire department by and by."[44] Fires have
had vast commercial consequences. They have brought about the re-
organization of neighborhoods—even whole urban areas. They have
destroyed structures but unified the human congregations that utilized
those structures, often resuscitating in the process a spirit of communi-
ty that had been sacrificed to social heterogeneity, factionalism, or
physical decay.[45]

son, *Life among the Surrealists: A Memoir* (New York, 1962), 376–84; Edmund Wilson,
Patriotic Gore: Studies in the Literature of the American Civil War (New York, 1962), 654.
For severe fires as momentous events in the personal lives of American historians, see
John W. Burgess, "Remarks to be Read at the 50th Anniversary of the Foundation of
the School of Political Science," October 14, 1930, p. 11, typescript in Burgess Papers,
Butler Library, Columbia University, New York City; Howard Mumford Jones, *An
Autobiography* (Madison, Wis., 1979), 4; *In and Out of the Ivory Tower: The Autobiogra-
phy of William L. Langer* (New York, 1977), 23, 35.

43. Alan S. Wheelock, "The Burden of the Past," *Essex Institute Historical Collections*,
110 (1974), 109; Hawthorne, *The House of the Seven Gables* (Boston, 1900), 267. For the
terrible prairie fires of 1871, "popularized" in a sense by Currier and Ives, see John
Brinckerhoff Jackson, *American Space: The Centennial Years, 1865–1876* (New York,
1972), 45.

44. Arnold Schrier and Joyce Story, eds., *A Russian Looks at America: The Journey of
Aleksandr Borisovich Lakier in 1857* (Chicago, 1979), xxxvi–xxxvii; Twain, *A Connecticut
Yankee in King Arthur's Court* (1889), in *The Family Mark Twain* (New York, n.d.), 803–
4.

45. See, e.g., the silver barrel-form pitcher made in Boston in 1811 to commemo-
rate Isaac Harris's successful effort to save the Old South Church from burning on
December 29, 1810. The congregation presented the pitcher to Harris on January 29,
1811 (Museum of Fine Arts, acc. no. 13.560). There is also *The Burning of the Opera
House* (1887), oil on canvas by Nickolaus Wirig of Rock Island, Illinois; this work may
have been commissioned as a parade banner or as a presentation piece for the Wide

Fires convert all sorts of artifacts laden with past associations into memories to be romanticized. Even the fires themselves become romanticized. One needs only to glance at some of the popular lithographs and stone engravings of the nineteenth century: *Awful Conflagration of the Steam Boat* Lexington, *in Long Island Sound* (a Currier and Ives), or *The Great Conemaugh Valley Disaster & Fire at Johnstown, Pa.,* a tragedy that took place on May 31, 1889.[46]

(4) I am aware of only one inquiry into the American propensity for precise calculation, even though it seems to run like a silver thread from Robert Keayne, the Puritan merchant who quantified and calibrated everything, to Ezra Stiles, scholar of the American Enlightenment and minister to the Second Congregational Church in Newport, Rhode Island. Edmund S. Morgan tells us that on February 7, 1767, as Stiles

> watched the people passing up and down the Parade (Newport's public square), he boldly estimated the population of the world from beginning to end at an average of eight hundred million persons per generation. If there were 150 generations from the creation to the day of judgment, a number he considered reasonably probable, this would mean a total of one hundred and twenty billion souls to be judged; and since he was toying with omniscience, he went on to guess that ninety billion of these would be saved, of whom two-thirds would be infants, for he still repudiated the traditional New England belief on this matter and consigned to glory all who died in infancy. There would thus be ninety billion on Christ's right hand and thirty billion on his left, "An immense and awful Assembly," he concluded.[47]

Awake Hose, Hook, & Ladder Company (Abby Aldrich Rockefeller Folk Art Center, Williamsburg, Va.). And Edward Hopper, *Under Control* (ca. 1907–10), gouache on illustration board, shows three firemen holding a firehose (at the Whitney Museum, New York City, from the Kennedy Galleries, 1979).

46. The New York Public Library, Fifth Avenue at 42nd Street, has an extraordinary collection of prints pertaining to fires and fire fighting in the nineteenth century. See also Harry T. Peters, *America on Stone* (Garden City, N.Y., 1931), plates 38, 50, 67, 87, 93, 121, 144; and the spectacular painting by John Krimmel and Samuel Jones, *The Conflagration of the Masonic Hall, Chestnut Street, Philadelphia which occured* [sic] *on the Night of the 9th of March, 1819,* in *Antiques*, 119 (1981), 982.

47. See *The Apologia of Robert Keayne . . . The Self-Portrait of a Puritan Merchant,* ed., Bernard Bailyn (New York, 1965); and Morgan, *The Gentle Puritan: A Life of Ezra Stiles, 1727–1795* (New Haven, Conn., 1962), 141–42. Stiles also devoted a great deal of time to drawing up "family constitutions," really precise rules to guide the destiny of each family into eternity (pp. 162–63). See also Patricia Cline Cohen, *A Calculating People: The Spread of Numeracy in Early America* (Chicago, 1983), an admirable book.

Thomas Jefferson loved nothing so much as exquisite calculations, whether it was the precise amount of human labor required to bury Dabney Carr, his young brother-in-law; or the annual rainfall during a seven-year period (47.5 inches); or the comparative efficiency of wheelbarrows with one and with two wheels; or his attempt in 1813 to prove by logarithms that the United States could not afford banks.[48] Samuel George Morton (1799–1851), who became the foremost American craniologist, was fascinated by the so-called cephalic index; he measured who knows how many hundreds of skulls and published his *Crania Americana* in 1839.[49] For iconographic evidence we may scrutinize two pictures at the Museum of Fine Arts in Boston. One by Thomas Hicks (1823–90), simply called *Calculating,* depicts a man working diligently at his account books. The second, by Eastman Johnson (1824–1906), titled *Measurement and Contemplation,* shows one chap closely observing another who is engaged in exact measurement (Figure 4).

Needless to say, Americans have not been uniquely inclined toward reckoning. Condorcet, Bentham, Frédéric LePlay, Charles Fourier, and Charles Babbage come immediately to mind. Yet a comparative study might reveal the relative extent to which these tendencies trickled down from intellectuals to more ordinary members of each society, and that in turn just might improve our understanding of the role that certain aspects of technology played in nineteenth-century American culture.[50] Moreover, the United States may well have been distinctive in terms of the pervasiveness and frequency of *millennial computation.*

48. See Garry Wills, *Inventing America: Jefferson's Declaration of Independence* (Garden City, N.Y., 1978), 119–21; Bray Hammond, *Banks and Politics in America from the Revolution to the Civil War* (Princeton, N.J., 1957), 195.

49. See Robert F. Berkhofer, Jr., *The White Man's Indian: Images of the American Indian from Columbus to the Present* (New York, 1978), 58; John Kirtland Wright, "Notes on Measuring and Counting in Early American Geography," in *Human Nature in Geography: Fourteen Papers, 1925–1965* (Cambridge, Mass., 1966), 205–49; Wallace, *Rockdale,* 196–211, 214–18, 227–39; and Karen R. Lewis and Howard Plotkin, "Truman Henry Safford, the Remarkable 'Lightning Calculator,'" *Harvard Magazine,* September–October 1982, pp. 54–56.

50. See Wiener, *English Culture and the Decline of the Industrial Spirit,* 17–19; and cf. Trachtenberg, *The Incorporation of America,* 62–63. Although I applaud Trachtenberg's fresh and significant examples, I must insist that one can find many illustrations of "the rule of calculation" long before the 1870s. For charming ruminations on Babbage, see Hugh Kenner, *The Counterfeiters: An Historical Comedy* (Bloomington, Ind., 1968), 104–16.

Figure 4. Measurement and Contemplation, by Eastman Johnson (oil on chipboard, early 1860s). Bequest of Martha C. Karolik for the M. & M. Karolik Collection of American Paintings, 1815–1865, 48.435. Courtesy, Museum of Fine Arts, Boston.

Knowing exactly when the Second Coming is going to occur can be quite useful in mobilizing disciples.

(5) During 1980–81, when I taught in Paris at the Ecole des Hautes Etudes en Sciences Sociales, it became clear after a few months that "space" as a word-concept, more particularly the differences (and the overlaps) between public and private space, has become a prominent—perhaps even the dominant—mode of analysis for various sorts of cultural historians in France. Mona Ozouf's superb study *La Fête révolutionnaire, 1789–1799* (1976) devotes a lengthy chapter to "La Fête et

l'espace," with subsections on *l'espace sans qualités* and *l'espace céré-moniel*. Arlette Farge's fresh documentary volume, *Vivre dans la rue à Paris au XVIIIe siècle* (1979), not only begins with a chapter titled "Espace privé, espace public" but devotes three chapters to the theme "s'approprier l'espace." Turning from Ozouf's cultural symbols and Farge's emphasis upon urban culture to a profound analysis of American literary texts, we have a splendid collection of essays by Pierre-Yves Petillon, *La Grand-route: Espace et écriture en Amérique* (1979).[51] I could continue with many other examples, but the point should be manifestly clear that we who hope to do cultural history in new ways have much to learn from recent French scholarship, especially from creative individuals outside the much discussed *Annales* tradition.[52]

(6) Although I cannot claim that the cultural impact of war in American history has been entirely neglected,[53] I would nonetheless contend that much remains to be done in this area and that it offers wonderful opportunities for the sort of reintegration that so many of us seek. I have suggested elsewhere that World War II was the single most important turning point in American history for institutions of higher learning and the pursuit of knowledge in the United States.[54] Similar-

51. See also Louis Marin's *Utopiques: Jeux d'espaces* (1973), esp. chap. 6, "La Ville: Espace du texte et espace dans le texte"; and Richard Marienstras, *Le Proche et le lointain* (Paris, 1982), esp. the chapter on English forests in the Elizabethan-Jacobean era. During 1980–81 both Philippe Ariès and Michele Perrot devoted their advanced seminars to notions of public and private space: Ariès in early modern history, and Perrot with the French working class during the nineteenth century. Note the observation by Bernard S. Cohn: "The ordering of space does not merely reflect social relations and social structure, but is part of the actual constitution of the sociological order" ("Anthropology and History in the 1980s," *Journal of Interdisciplinary History*, 12 [1981], 249).

52. I am fully aware of Edward T. Hall's *The Hidden Dimension* (Garden City, N.Y., 1966), esp. chaps. 4–6, 8–11, and of its influence among some social historians in the United States, as well as such essays as Robert F. Berkhofer, "Space, Time, Culture and the New Frontier," *Agricultural History*, 38 (1964), 21–30; but their focus and implications are rather different from the current orientation among cultural and social historians in France.

53. See, e.g., Charles Royster, *A Revolutionary People at War: The Continental Army and American Character, 1775–1783* (Chapel Hill, N.C., 1979); George M. Fredrickson, *The Inner Civil War: Northern Intellectuals and the Crisis of the Union* (New York, 1965); Barbara Miller Solomon, *Ancestors and Immigrants: A Changing New England Tradition* (Cambridge, Mass., 1956); Carol S. Gruber, *Mars and Minerva: World War I and the Uses of the Higher Learning in America* (Baton Rouge, La., 1976); Edmund E. Day, ed., *The Impact of the War on America* (Ithaca, 1942); and Robert Wohl, *The Generation of 1914* (Cambridge, Mass., 1979), 80, 95.

54. Kammen, "A Brave New World of Knowledge [1920–1970]" (paper prepared for the American Academy of Arts and Sciences, 1983).

ly, we have yet to elaborate historically upon a comment by Ananda K. Coomaraswamy, the great Orientalist and art historian, who noticed "the self-doubt that came over the West during and after the Great War." Or the impact of World War I upon the allegiances and sense of identity among German-Americans, the largest single ethnic group in the United States. Or the observation by R. W. B. Lewis that "the enduring effect of the war upon Edith Wharton (as upon countless other sensitive and thoughtful persons) was to give her an entirely new consciousness of history—as a writer, as an American, and as an individual human being."[55]

These are simply a few of the components that I can envision for an expanded cultural history and a reintegrated overview of the United States. What about the larger consequences (and actual dynamics) if we proceed along such paths? I'd like to speak about three sorts, or groups, of consequences. The first involves our sensitivity to region and locality, so let us call it the problem of generalization with respect to cultural diversity and geography in the United States. The second involves a vexing issue to which none of us is a stranger: the interactive relationship between high culture, so-called, and popular culture. The third has to do with the relative degree of emphasis that we give to crisis and change as opposed to continuity in American history.

III

Jacob Burckhardt, the founding father of cultural history as we know it, had nothing good to say about the United States. Typically, for example, he would refer to "people of American culture, who have to a great extent foregone history, i.e., spiritual continuity, and wish to share in the enjoyment of art and poetry merely as forms of luxury." Despite these strictures, we can benefit by rereading the edition of his lectures in which such acerbic comments appear because Burckhardt called attention to the reciprocal action of culture, religion, and

55. See Roger Lipsey, *Coomaraswamy: His Life and Work* (Princeton, N.J., 1977), 267; James Truslow Adams to Allan Nevins, October 20, 1924, Adams Papers, Butler Library, Columbia University, New York City; the *Progressive* to Arthur M. Schlesinger, May 13, 1927, Schlesinger Papers, Pusey Library, Harvard University, Cambridge, Mass.; *New York Times,* September 20, 1937, p. 19; and R. W. B. Lewis, *Edith Wharton: A Biography* (New York, 1975), 423. See also David M. Kennedy, *Over Here: The First World War and American Society* (New York, 1980).

the state. His emphasis upon "reciprocal action" among major forces in human history supplies the best corrective I have seen to mono-causal explanations or bases for historical integration.[56]

Region and Locality: The Problem of Generalization with Respect to Cultural Diversity and Geography

Insofar as a "consensus school" did emerge in the generation after 1945, one of its most myopic aspects involved the foreshortening of sectional differences in American history and culture. Perry Miller tended to assume that New England was the Massachusetts Bay Colony writ large, and that somehow America was New England written in block capitals. Carl Bridenbaugh found common patterns in the development of early American cities: hence they could become simultaneous seedbeds of rebellion.[57] Robert E. Brown believed that democracy was far more pervasive in Massachusetts, Virginia, and New York than his predecessors had realized; and Michael Kraus brought this whole homogenizing tendency to its fulfillment by writing *The Atlantic Civilization: Eighteenth-Century Origins* (1949).

During the 1970s and '80s a range of studies that collectively may be called cultural sensitized us to sectional and subregional differences. We now realize how very different the English colonies in the Caribbean were from the southern colonies on the mainland, at least during the first century of their existence. Richard Beale Davis has insisted that the South had a mind of its own. Anita and Darrett Rutman have shown that mortality rates in colonial Virginia were quite different from those in Massachusetts, with significant consequences for family structure and divergent assumptions about kin relationships. Cultural geographers like Robert D. Mitchell have augmented our understanding of subtle divergencies between western Virginia and eastern Maryland, between central Kentucky and southwestern Ohio.[58]

56. Burckhardt, *Force and Freedom*, esp. 169–94, 211–30, 241–54. The anti-American quotation appears on p. 152.

57. All of this despite the fact that Miller and Bridenbaugh both edited intercolonial travel diaries that called attention to local and regional differences, and despite the availability of Newton D. Mereness, ed., *Travels in the American Colonies* (New York, 1916). See Miller and Thomas H. Johnson, eds., *The Puritans* (New York, 1938), 425–47; and Bridenbaugh, ed., *Gentleman's Progress: The Itinerarium of Dr. Alexander Hamilton, 1744* (Chapel Hill, N.C., 1948).

58. Richard S. Dunn, *Sugar and Slaves: The Rise of the Planter Class in the English*

Moreover, we are becoming much more precise in discussing what cultural baggage was brought from Britain and what had to be discarded. We can no longer speak of "the Chesapeake" as a monolith, because we have recently learned how strikingly different its northern, western, and eastern shores had become by the early eighteenth century. Sociocultural and economic differences between Salem Village and Salem Town lie at the very heart of *Salem Possessed,* one of the most original and methodologically integrative books ever written by historians of the United States.[59] We have replaced the crude environmental determinism that lingered for more than a generation after Frederick Jackson Turner's death with far greater sensitivity to cultural variables; and *within* specific geographic contexts we have learned that any given phenomenon, such as sociopolitical instability, may be rampant at the provincial level (that is, in and around colonial capitals) yet barely visible at all in more isolated rural localities.[60]

In certain respects it has been easier to recognize cultural pluralism in *colonial* America because there seem to have been fewer variables and

West Indies, 1624–1713 (Chapel Hill, N.C., 1972); Davis, *Intellectual Life in the Colonial South, 1585–1763,* 3 vols. (Knoxville, Tenn., 1978); Rutman and Rutman, "'Now-Wives and Sons-in-Law': Parental Death in a Seventeenth-Century Virginia County," in Thad W. Tate and David L. Ammerman, eds., *The Chesapeake in the Seventeenth Century: Essays on Anglo-American Society* (Chapel Hill, N.C., 1979), 167–69, 171, 173; Mitchell, "The Formation of Early American Culture Regions: An Interpretation," in James R. Gibson, ed., *European Settlement and Development in North America,* 66–90. One cannot overestimate the contribution of Lester Cappon et al., eds., *Atlas of Early American History: The Revolutionary Era, 1760–1790* (Princeton, N.J., 1976).

59. See T. H. Breen, "Transfer of Culture: Chance and Design in Shaping Massachusetts Bay, 1630–1660," in *Puritans and Adventurers: Change and Persistence in Early America* (New York, 1980), 68–80; Aubrey C. Land, "Economic Base and Social Structure: The Northern Chesapeake in the Eighteenth Century," *Journal of Economic History,* 25 (1965), 639–54; Paul G. E. Clemens, *The Atlantic Economy and Colonial Maryland's Eastern Shore: From Tobacco to Grain* (Ithaca, 1980); Carville Earle, *The Evolution of a Tidewater Settlement System: All Hallow's Parish, Maryland, 1650–1783* (Chicago, 1975); Paul Boyer and Stephen Nissenbaum, *Salem Possessed: The Social Origins of Witchcraft* (Cambridge, Mass., 1974). See also Richard S. Dunn, "Imperial Pressures on Massachusetts and Jamaica, 1675–1700," in Alison G. Olson and Richard M. Brown, eds., *Anglo-American Political Relations, 1675–1775* (New Brunswick, N.J., 1970), 52–75; and James T. Lemon, *The Best Poor Man's Country: A Geographical Study of Early Southeastern Pennsylvania* (Baltimore, Md., 1972).

60. See Lois Green Carr and David W. Jordan, *Maryland's Revolution of Government, 1689–1692* (Ithaca, 1974); Paul R. Lucas, *Valley of Discord: Church and Society along the Connecticut River, 1636–1725* (Hanover, N.H., 1976); and Langdon G. Wright, "Local Government in Colonial New York, 1640–1710" (Ph.D. diss., Cornell University, 1974).

less clutter then. For the nineteenth and twentieth centuries we must not merely trace the proliferation of cultural pluralism but develop and utilize what Herbert J. Gans has called a taxonomy of "taste cultures" based upon a fairly complicated "social structure of taste publics and cultures."[61]

The Interactive Relationship between High Culture and Popular Culture

Once upon a time, in 1915, Van Wyck Brooks proclaimed that American culture had a Highbrow level and a Lowbrow level, but that the two made almost no contact. Somehow his formulation seemed so vivid and persuasive that it held sway for almost two full generations. Here are just a few familiar paragraphs.

> These two attitudes of mind have been phrased once for all in our ver-nacular as "Highbrow" and "Lowbrow." I have proposed these terms to. a Russian, an Englishman and a German, asking each in turn whether in his country there was anything to correspond with the conceptions im-plied in them. In each case they have been returned to me as quite Ameri-can, authentically our own, and, I should add, highly suggestive.
>
> What side of American life is not touched by this antithesis? What explanation of American life is more central or more illuminating? In everything one finds this frank acceptance of twin values which are not expected to have anything in common: on the one hand, a quite un-clouded, quite unhypocritical assumption of transcendent theory ("high ideals"), on the other a simultaneous acceptance of catchpenny realities. Between university ethics and business ethics, between American culture and American humour, between Good Government and Tammany, be-tween academic pedantry and pavement slang, there is no continuity, no genial middle ground. . . .
>
> So it is that from the beginning we find two main currents in the American mind running side by side but rarely mingling—a current of overtones and a current of undertones—and both equally unsocial: on the one hand, the transcendental current, originating in the piety of the Pu-ritans, becoming a philosophy in Jonathan Edwards, passing through Emerson, producing the fastidious refinement and aloofness of the chief American writers, and resulting in the final unreality of most contempo-

61. See Arthur Mann, *The One and the Many: Reflections on the American Identity* (Chicago, 1979), esp. 136–45; Gans, *Popular Culture and High Culture: An Analysis and Evaluation of Taste* (New York, 1974), 69, 103, 108; and Richard S. Storrs, *The Puritan Spirit* (Boston, 1890), 6–7, 67.

rary American culture; and on the other hand the current of catchpenny opportunism, originating in the practical shifts of Puritan life, becoming a philosophy in Franklin, passing through the American humorists, and resulting in the atmosphere of our contemporary business life. . . .

In fact, we have in America two publics, the cultivated public and the business public, the public of theory and the public of activity, the public that reads Maeterlinck and the public that accumulates money: the one largely feminine, the other largely masculine. Wholly incompatible in their ideals, they still pull together, as the ass and the ox must. But the ass shows no disposition to convert the ox, nor the ox the ass. They do not mitigate one another;—they are, in biological phrase, infertile with one another.[62]

By the 1950s a few perceptive cultural historians began to notice "the reciprocal flow of impulse and inspiration from popular to academic thinker; in turn influenced, without doubt, by ideas which may have originated at the top and filtered downward." During the 1960s we received some elaborations of that notion, but still the stress fell upon expressions of culture filtering *down*. As Georges Duby, a gifted French medievalist, put it, "the cultural patterns of the upper classes in society tend to become popularized, to spread and to move down, step by step, to the most deprived social groups." It did at least occur to Duby, writing in 1966, to ask whether the opposite might also be true: "Did not the descending movement of popularization have a counterpart, a reverse trend? In other words, to what extent, in the Middle Ages, did aristocratic culture (using the word in its narrowest sense) accept values or forms arising from the lowest social strata?"[63]

Gradually, during the 1980s—mostly in oral presentations at conferences on high and popular (or plebeian) culture—such words as *straddling, permeability,* and *symbiosis* have become increasingly common.[64] I feel that the filtering-*down* process has already been well

62. Reprinted in Brooks, *Three Essays on America* (1934; New York, 1970), 17–19, 78–79.

63. R. Richard Wohl, "Intellectual History: An Historian's View," *Historian,* 16 (1953), 75–76; Duby, "The Diffusion of Cultural Patterns in Feudal Society," *Past & Present,* no. 39 (April 1968), 3–4. See also Lionel Trilling, "The Sense of the Past," in *The Liberal Imagination: Essays on Literature and Society* (1950; Garden City, N.Y., 1953), 183.

64. At the Cornell Conference, "Popular Culture in Europe and America," held April 22–24, 1982, this was especially true of papers by Jacques LeGoff, H. C. Erik Midelfort, and Herbert J. Gans. See Kaplan, ed., *Understanding Popular Culture,* 19–37 and 113–45.

demonstrated by historians of American culture, and will continue to be.[65] In my own work I have found it especially easy to trace in the field of constitutional history, or what I call cultural constitutionalism.[66]

But the most interesting challenge to cultural historians in the years ahead may be found in the inverted variants of "straddling" and "permeability." When and where and under what circumstances does culture actually "trickle up," so to speak? Bernard Bailyn has supplied one fine example of "straddling" by describing an ordinary Boston shopkeeper, the son of a leather-dresser who was elaborately imbued, early on, with the same ideological perspective that we so willingly ascribe to the colonial whig elite.[67] But what about "trickle up"? A few examples may suffice.

65. See Harris, *Humbug,* 51, 80, 95–96, 100–101, 122, 125, 140, 291; and Barbara Welter, *Dimity Convictions: The American Woman in the Nineteenth Century* (Athens, Ohio, 1976), esp. chaps. 1–2, 5–7.

66. For Charles Warren's success in popularizing his three-volume *The Supreme Court in United States History* (Boston, 1922), see William B. Munro to Warren, November 20, 1922, Warren Papers, box 1, Library of Congress, Washington, D.C.; and Alexander R. Lawton, Jr., to Warren, March 22, 1923; Frank W. Stearns to Warren, August 1, 1923; C. Lee Cook to Warren, October 25, 1923; W. R. Webb to Warren, December 26, 1923; F. G. Stutz to Warren, January 19, 1924; E. L. Harvey to Warren, February 16, 1924; John E. McConnell to Warren, October 28, 1924; William Howard Taft to Warren, November 11, 1926, all in Warren Papers, box 2. For the impact of Senator Albert J. Beveridge's speeches and massive biography of Justice John Marshall, see John Eben Bleekman to Beveridge, January 14, 1920; James S. Beacom to Beveridge, July 12, 1920; Robert E. O'Malley to Beveridge, July 21, 1920 (with an important enclosure), Beveridge Papers, box 222, Library of Congress, Washington, D.C. For the impact of James M. Beck, *The Constitution of the United States* (New York, 1922), see Morton Keller, *In Defense of Yesterday: James M. Beck and the Politics of Conservatism* (New York, 1958), 159. Andrew W. Mellon, secretary of the treasury, paid for the distribution of 2,000 copies of Beck's book to public libraries throughout the United States. Eldridge R. Johnson, head of the Victor Talking Machine Company, arranged for a special edition of 10,000 copies to be sent to schools and libraries. In 1923 the National Security League distributed paperback copies, and in 1927 an abridged version appeared for use in elementary schools. Liberal ideas about the U.S. Constitution could trickle down almost as easily as conservative interpretations. See Judson King to Edward S. Corwin, April 15, 1937, Corwin Papers, box 2, Seeley G. Mudd Manuscript Library, Princeton University, Princeton, N.J. King, director of the National Popular Government League, proposed to publish a "layman's bulletin" version of *The General Welfare Clause* by J. F. Lawson: "I want to present in simple language this idea," King wrote, "that the Supreme Court has never given a direct interpretation of the welfare clause; that the clause is amply open to the construction Lawson placed upon it; and that, if the Court would frankly face the issue and give the interpretation needed in this day and age, it would clear the way for ordinary progress."

67. Bailyn, "The Index and Commentaries of Harbottle Dorr," *Proceedings of the*

- In 1924 Fred Lewis Pattee first suggested that the "cosmology," or sentimental values, contained in American dime novels had considerable impact upon the middle classes and even the elite. During the past decade we have just begun to appreciate the extent to which Pattee was right.[68]
- During the 1920s and early '30s, a composer and musicologist named John Powell, from Richmond, Virginia, collected southern folksongs and other "native" folkloric materials. By 1933 he had been invited to prepare a series of "Southern Folk-Music Programmes." These radio broadcasts caught the attention of Eleanor Roosevelt, who arranged for a special program that would emanate from the White House. Powell thanked Mrs. Roosevelt on behalf of the folk musicians for helping "to keep alive their tunes. . . . Response has come from all over the country, expressing a realization of the cultural value of our effort."[69]
- In 1936 Irving Brant, strictly a journalist at the time, published *Storm over the Constitution,* a strident critique of the Supreme Court. Thomas Corcoran told Brant subsequently that "F.D.R. took the book with him on a South American cruise and that it was a prime factor in his decision to shift from a constitutional amendment to reform of the Supreme Court."[70]

I think the time has passed when we must be apologetic about writing cultural history as a "filtering-down" process exclusively or, the reverse, when we have to make extravagant claims for the "autonomy" of working-class culture. The sorts of topics that we wish to examine can be as populist or as elitist as our sources dictate. The most

Massachusetts Historical Society, 85 (1973), 21–35. For a superb example of "straddling" and folk culture involving the funeral procession of Abraham Lincoln, see Lloyd Lewis, *Myths after Lincoln* (New York, 1941), 123–24.

68. Pattee, "A Call for a History of American Literature" (1924), in *Tradition and Jazz* (New York, 1925), 247–48. See also William Yandell Elliott, "The Constitution as the American Social Myth," in Conyers Read, ed., *The Constitution Reconsidered* (New York, 1938), 210–11.

69. John P. McConnell to John Powell, Aug. 19, 1931; John Powell to Eleanor Roosevelt, Jan. 17 and March 3, 1934, John Powell Papers, box 5a, Alderman Library, University of Virginia, Charlottesville. See also Jerre Mangione, *The Dream and the Deal: The Federal Writers' Project, 1935–1943* (Boston, 1972), 244, 247–48, 252, 353; and Jay Anderson, "Living History: Simulating Everyday Life in Living Museums," *American Quarterly,* 34 (Bibliography 1982), 303–5.

70. Brant to Virginius Dabney, March 21, 1975, Brant Papers, box 5, Library of Congress, Washington, D.C.

exciting challenge involves a combination of the two, because in historical reality they interact in complex ways. Permit me just one illustration from my interest in patterns of historical consciousness. V. S. Naipaul has written provocatively about a friend and film producer in Argentina who believes that "ordinary" people tend to delude themselves if and when they reflect upon history at all: "I think that after Marx people are very conscious of history. The decay of colonialism, the emergence of the Third World—they see themselves acting out some role in this process. This is as dangerous as having no view of history at all. It makes people very vain. They live in a kind of intellectual cocoon."[71]

The crucial point, to my way of thinking, is that no social stratum has yet cornered the market on historical self-deception. Elites do it as much and as well as workers. Elites distort history in order to maintain cultural hegemony, whereas "the folk" may warp the past in order to make their subordination more bearable or more comprehensible; or to grasp some glimmer of hope for the future.[72]

The Relative Degree of Emphasis That We Give to Crisis, Change, and Continuity in American History

Some students of American culture have recently made brilliant contributions by stressing moments of crisis and transformation—with the final years of the nineteenth century as perhaps the most dramatic case in point. Neil Harris, for example, has described "a sense of crisis" at that time owing to "an impoverished national taste, a struggling and depressed class of artists, and a debased and vulgar stock of consumer goods."[73] If we string together a sufficient number

71. Naipaul, *The Return of Eva Perón: With the Killings in Trinidad* (New York, 1980), 99.

72. See the extraordinary repression of historical memory that pervades Studs Terkel's *Hard Times: An Oral History of the Great Depression* (New York, 1970), esp. 150, 170, 358, 529–30; Paul Cowan, "Whose America Is This?" *Village Voice,* April 2, 1979, pp. 1, 11–17; and David S. Broder, *Changing of the Guard: Power and Leadership in America* (New York, 1981), 139.

73. Neil Harris, "Museums, Merchandising, and Popular Taste: The Struggle for Influence," in Ian M. G. Quimby, ed., *Material Culture and the Study of American Life* (New York, 1978), 141; Harris, "Utopian Fiction and Its Discontents," in Richard L. Bushman et al., eds., *Uprooted Americans: Essays to Honor Oscar Handlin* (Boston, 1979), 220, 236; T. J. Jackson Lears, *No Place of Grace: Antimodernism and the Transformation of American Culture, 1880–1920* (New York, 1981), esp. 30, and 5, 31, 41, 60, 96, 126, 142, 146, 155, 179, 184, 189, 203, 209, 215, 219, 225–26, 262, 290, 307.

of these cultural crises, we may eventually document and fulfill Van Wyck Brooks's cynical quip: "three hundred years of effort having bred none of the indwelling spirit of continuity."[74]

Dramatic strikes, great riots, and other popular eruptions are "attractive"—perhaps "useful" is a preferable word—to the cultural historian because such events can supply a monograph with built-in focus and cohesion. Increasingly, however, we will have to turn to descriptions of plebeian culture at its comparatively humdrum day-to-day level in order to capture the repetitious circumstances and continuities that have characterized the lives of most ordinary people at most places and in most historic times.[75] Insofar as we may dignify this approach by calling it a "technique," it can be applied equally to all strata of society; in fact, it involves little more than a return to good (and by now rather old-fashioned) cultural anthropology!

Best of all, in my view, a sensible balance between the emphasis upon cultural crises and detailed accounts of culture, broadly conceived, over the *longue durée* is most most likely to lead us toward that pluralistic view of cultural history envisioned by Sir Isaiah Berlin: pluralistic in a diachronic as well as a synchronic sense. "There is a pervasive pattern which characterizes all the activities of any given society: a common style reflected in the thought, the arts, the social institutions, the language, the ways of life and action, of an entire society. This idea is tantamount to the concept; not necessarily of one culture, but of many; with the corollary that true understanding of human history cannot be achieved without the recognition of a succession of the phases of the culture of a given society or people."[76]

The synthesis that we seek need *not* be like the elusive and legendary unicorn. It may very well be encompassed by Sir Isaiah's pluralistic

74. Brooks, "Letters and Leadership" (1918), in *Three Essays on America*, 119.

75. See Emmanuel Le Roy Ladurie, *Carnival in Romans* (New York, 1979), as compared with the same author's *The Peasants of Languedoc* (Urbana, Ill., 1974). Also cf. Alan Dawley, *Class and Community: The Industrial Revolution in Lynn* (Cambridge, Mass., 1976), with Faler, *Mechanics and Manufacturers*. See also "The Study of American Everyday Life," a special issue of *American Quarterly*, 34 (Bibliography 1982), 218–306.

76. Berlin, *Vico and Herder: Two Studies in the History of Ideas* (New York, 1976), xvii. See also Johan Huizinga, "The Task of Cultural History" (1929), quoted in Rosalie L. Colie, "Johan Huizinga and the Task of Cultural History," *American Historical Review*, 69 (1964), 625; Carl E. Schorske, *Fin-de-Siècle Vienna: Politics and Culture* (New York, 1980), xxii–xxiii; and George W. Stocking, Jr., "Franz Boas and the Culture Concept in Historical Perspective," in *Race, Culture, and Evolution: Essays in the History of Anthropology* (New York, 1968), 227–30.

vision of cultural history, a notion that goes back (at least) to Vico and Herder, has been explicitly articulated in our own century by Johan Huizinga and Carl Schorske, and will have ever more advocates and practitioners in the years ahead.

Even if it does, however, we should proceed in a manner that is better described as realistic than as optimistic. In "Cultural History as a Synthesis," written in 1956, Jacques Barzun insisted that the historian must rely on "the gift of seeing a quantity of fine points in a given relation without ever being able to demonstrate it. The historian in general can only show, not prove; persuade, not convince; and the cultural historian more than any other occupies that characteristic position." I do not know whether Barzun realized it at the time, but his observation echoed Huizinga's—published in 1929 in a very long essay titled "The Task of Cultural History"—that after all is said and done, History is the inexact discipline par excellence.[77] Despite the stunning changes and improvements that have occurred over half a century, I believe that Barzun and Huizinga remain fundamentally right.

One respected colleague, after scrutinizing this essay, speculated that the reintegration of American history in our time could only be the product of a personal vision. Mankind has had various dreams of order, including visions of the past neatly organized and properly packaged. Perceptions of a coherent past, my friend then added, are likely to be appreciated—partially for aesthetic reasons, but also because of their explanatory power—only by an "informed" audience: that is, an elite audience consisting primarily of specialists and devotees. He may be right, and he may also be less cynical than sage and candid. Martin Heidegger, after all, expressed quite forcefully his skepticism about the concept of culture as an aspect of modern metaphysics because he felt that it sidestepped certain crucial issues and conflated others. "History," he wrote in 1950, "is neither simply the object of written chronicle nor simply the fulfillment of human ac-

77. Barzun, "Cultural History as a Synthesis," in Fritz Stern, ed., *The Varieties of History, from Voltaire to the Present* (New York, 1956), 393; Huizinga, *Men and Ideas: History, the Middle Ages, the Renaissance,* trans. James S. Holmes and Hans van Marle (New York, 1959), 21. In "Thick Description: Toward an Interpretive Theory of Culture," Clifford Geertz contends that "cultural analysis is intrinsically incomplete. And, worse than that, the more deeply it goes the less complete it is. It is strange science whose most telling assertions are its most tremulously based, in which to get somewhere with the matter at hand is to intensify the suspicion, both your own and that of others, that you are not quite getting it right" (*The Interpretation of Cultures* [New York, 1973], 29).

tivity. That activity first becomes history as something destined. And it is only the destining into objectifying representation that makes the historical accessible as an object for historiography, i.e., for a science, and on this basis makes possible the current equating of the historical with that which is chronicled."[78]

Yet another concern might properly be raised, namely, that any quest for historical integration, not to mention actual synthesis, could be construed as a pseudomethodological surrogate for the substantive consensus and cultural unity that seem to be lacking in modern life itself. Should historians attempt to provide what society cannot furnish? Moreover, if historians do so, are they essentially diverting attention from critical and often divisive social issues? Isn't there a danger that holistic aspirations and facile linkages may be tantamount to a covert form of ideology—a far more clever and powerful consensus historiography than the version that dominated our guild for several decades following World War II? Some members of the profession, not to mention outsiders with a genuine interest in American history, may be justified in feeling apprehensive about any "search" for integration and, above all, suspicious of a vision of historical synthesis based primarily upon *cultural* components.

I am obliged to respect such skepticism by politically astute or ideologically oriented critics. We have learned too much from E. P. Thompson about the cultural dynamics of "opaque societies," in which dominant groups do not *fully* disclose their basic assumptions and aspirations; in which the historical sources for working-class people often seem purposefully clouded by their own design; and in which "secret traditions" may be more important than open argument or dialogue.[79]

We must also heed the extensive analyses of Pierre Bourdieu, a

78. See Heidegger, *The Question concerning Technology and Other Essays,* ed. William Lovitt (New York, 1977), 24; and Heidegger, *The End of Philosophy* (New York, 1973), chap. 3, "Recollection in Metaphysics," esp. 75, 77–78. Needless to say, Heidegger's prose is not easily accessible in either German or English. "The Question concerning Technology" has been reprinted numerous times, and in the better versions the editors' notes explain Heidegger's use of certain abstract or opaque words and phrases by referring to their appearance elsewhere in his writings. Lovitt's translation and edition is especially helpful in this respect.

79. See Thompson, *The Making of the English Working Class* (1963; New York, 1966), 484–97; Asa Briggs's discussion of Thompson and "the opaque society" in *Scientific American,* 212 (1965), 125, 128; and Thompson, *Whigs and Hunters: The Origin of the Black Act* (London, 1975) 16–17, 62–64, 99, 142, 144–45.

Figure 5. The Prince's Birthday, by Jan Steen (oil on canvas, 1660). Courtesy of the Rijksmuseum, Amsterdam, the Netherlands.

distinguished French sociologist (Collège de France), whose theory of cultural transmission links knowledge with power but not in an ob-vious or simplistic manner. Through socialization and formal educa-tion, Bourdieu argues, relatively permanent cultural values are inter-nalized. This process, in turn, affects (even structures) individual and group behavior in ways that tend to reproduce existing class rela-tionships. Consequently, in a stratified social order, dominant groups and classes have been able to shape or control the most socially es-teemed and hence "legitimate" cultural meanings. Bourdieu's analysis, which is neither conventionally nor reductively Marxist—in many respects he is closer to Weber than to Marx—suggests that symbolic meanings mediate power relations among various social groups and classes. Culture, therefore, at its most fundamental level, is not devoid

151

of political implications, but rather is an expression of such values. (Bourdieu's point may be exemplified, as well as Thompson's, in a superb scene painted by Jan Steen [1626–79] titled *The Prince's Birthday,* shown in Figure 5. A group of middling and humble folk have gathered at an inn or tavern and are using the birthday of Prince William III as a pretext to get very drunk. No prince is present, but the ritual celebration of his birthday provides an occasion—and a rationale—for manifestations of uproarious behavior in the popular culture, manifestations that will remain opaque to the prince and his elite because they are unlikely ever to witness such a gathering.)

In his brilliant study of art museums and their visitors, for example, Bourdieu acknowledges that museums have undergone a process of democratization during the past generation. Ordinary people now go to and meet at art galleries. Museums have become more successful in attracting middle- and working-class people by offering, in addition to painting and sculpture, objects of folklore or historical "souvenirs"— artifacts that stimulate social memories. Bourdieu has found that most people explain their affection for museums on aesthetic grounds and as an instinctive experience. He contends, however, that in reality museum-going is a *cultivated* taste that depends very much upon the educational system and the social transmission of cultural values. He denies the existence of an innate aesthetic sense and insists upon an achieved one that results from a lengthy cultural apprenticeship. Bourdieu concludes that the sociology of culture is crucial because it demonstrates the dynamics of social and economic inequalities; and he observes that if culture is to fulfill its prime function of providing human pleasure, even enchantment (at this point the French translates awkwardly), then we must not ignore the historical and social conditions that have facilitated the *full* possession of "culture" by some people in contrast to its partial possession by many others.[80]

After considering the caveats of Bourdieu, Thompson, and Heidegger, I conclude with at least three impressions.

1. Proposals for new approaches to cultural history may very well point toward compartmentalization rather than integration. Nev-

80. See Bourdieu and Alain Darbel, *L'Amour de l'art: Les Musées et leur public* (Paris, 1966), esp. 114, 147; Bourdieu, *Les Etudiants et leurs études* (Paris, 1964); Bourdieu, *Les Héritiers: Les Etudiants et la culture* (Paris, 1964), translated as *The Inheritors: French Students and Their Relation to Culture* (Chicago, 1979); and Bourdieu, *Reproduction in Education, Society and Culture* (London, 1977). Cf. Mintz, "Culture," 509–10.

ertheless, that should not deter us from seeking and developing new modes of inquiry, because cultural history is too important (and too much fun) not to move forward under its own steam, even if the total integration of historical knowledge remains a will-o'-the-wisp.

2. Although the caveats that I have mentioned do not *preclude* our use of the culture concept as anthropologists have developed it, they do require us to make sure that our application of the culture concept is sufficiently pluralistic: in diachronic terms (respecting the pastness of the past), in terms of the realities of social structure, and in terms—increasingly acknowledged by anthropologists during the 1980s—of the pronounced relativism that exists among and between cultures.

3. Bourdieu's acknowledgment that cultural democratization *has* occurred in our own time, and to a marked degree, suggests that neither cultural history per se nor culture as the basis for an *attempt* at integration, is *necessarily* a conservative formalization of the status quo or an imposition of consensus where none truly exists in the society at large. Scholarly synthesis does not require smoothing over differences, and any intelligent synthesis can surely take social and ideological divergences into account. Those of Charles A. Beard, Carl Becker, and Vernon L. Parrington most certainly did.

It is the oldest of clichés that we study the past, among other reasons, in order to improve our understanding of the present. In reality, however, the reverse is equally true. That is precisely why the insights of Martin Heidegger, E. P. Thompson, and Pierre Bourdieu, derived heavily from their observations of contemporary as well as historical realities, should be seen by us as flashing yellow lights rather than permanently red ones. Justice Oliver Wendell Holmes was not being *merely* ironic when he wrote, back in 1895, that "the present has a right to govern itself so far as it can; and it ought always to be remembered that historic continuity with the past is not a duty, it is only a necessity."[81]

My thanks to the following readers for their thoughtful suggestions: Paul Boyer, Barbara Welter, Lawrence A. Cremin, John P. Demos, Dominick LaCapra, R. Laurence Moore, Joel Silbey, and Daniel J. Singal.

81. Holmes, *Collected Legal Papers* (New York, 1920), 139, from a speech entitled "Learning and Science" (June 25, 1895).

Chapter 6

Challenges and Opportunities in Writing State and Local History

A preliminary version of this paper was offered on June 15, 1980, as the keynote address to the first Institute for Local Historians, sponsored by the Division of Historical and Anthropological Services of the State Education Department of New York (convened at the Conference Center of the Institute of Man and Science, Rensselaerville, New York).

A revised rendition was presented in Indianapolis on November 6, 1982, to the joint annual meeting of the Indiana Historical Society and sixty-fourth annual History Conference. The Indiana Historical Society then published the essay as a separate pamphlet in 1983.

For a related essay, see Michael Kammen, "The American Revolution Bicentennial and the Writing of Local History," *History News*, 30 (1975), 179–90.

Johan Huizinga, the great Dutch historian, traveled extensively throughout the United States in 1926. The next year he published a slender volume of reflections titled *Life and Thought in America*. Toward the end of that book, after a goodly number of acerbic comments, Huizinga tosses off this rather droll one: "The luncheon as a means of intellectual exchange has obtained an almost ritual importance in America. . . . [But] not all branches of learning lend themselves to the luncheon form; it is not right for history."[1] Unfortunate-

1. See Huizinga, *America: A Dutch Historian's Vision from Afar and Near,* trans. and

ly, however, Huizinga never explains why. The nearest thing to a hint that he offers seems to hinge upon the likelihood that alcoholic beverages may undermine intellectual clarity. The only spirits that I see on this occasion, though, are the sunny dispositions of you Hoosiers (some by nativity, some by adoption, and a few, perhaps, by default). Therefore I propose that we proceed with this luncheon, even though we risk the posthumous wrath of an austere moralist whose approbation would mean a great deal to me if I could ever earn it.

On the other hand, someone who lives in upstate New York may need to take Huizinga's lesson to heart more than happy Hoosiers do. Edmund Wilson, who spent many summers at an ancestral home in Talcottville, New York (not far from Utica), recorded in his journal on August 13, 1955, that "this kind of life, in the long run, does . . . get rather unhealthy. One evening . . . I drank a whole bottle of champagne and what was left of a bottle of Old Grand-Dad and started on a bottle of red wine—I was eating Limburger cheese and gingersnaps."[2] It is true, of course, that Wilson was not at that moment participating in a luncheon session at a conference of historians. Even so, if my own musings seem rather bizarre, you may entertain the possibility that my lucubrations were composed while emulating Edmund Wilson's mode of self-indulgence. Ithaca, where I live, is not so very far from Talcottville.

Although it is considerably farther from Ithaca to Indianapolis, in this jet age it only takes a little longer to fly from "my place" to yours than to drive from "my place" to what used to be Edmund Wilson's. Now that physical distances have shrunk, however, psychological distances—the sorts of distances that can cause misunderstanding—become ever more interesting, especially to state and local historians. As an easterner, and as a historian visiting the Middle West today, I find it fascinating to reach back to the early years of this century—1904 to be exact—when one of your own, Meredith Nicholson, pondered the dilemma of misunderstood natives in this state.

ed. Herbert H. Rowen (New York, 1972), 303; and Michael Kammen, " 'This, Here, and Soon': Johan Huizinga's *Esquisse* of American Culture," chap. 10 below.

2. Wilson, *Upstate: Records and Recollections of Northern New York* (New York, 1971), 120. But then see Wilson's curiously arch remark on p. 131: "I come to feel, when I have been here for any length of time, the *limited* character of upstate New York. It does not go back very far into the past and it does not come very far forward into the present."

The Hoosier is not so deeply wounded by the assumption in Eastern quarters that he is a wild man of the woods, as by the amiable condescension of acquaintances at the seaboard, who tell him, when he mildly remonstrates, that his abnormal sensitiveness is provincial. This is, indeed, the hardest lot, to be called a mudsill and then rebuked for talking back! There are, however, several special insults to which the citizen of Indianapolis is subjected, and these he resents with all the strength of his being. First among them is the proneness of many to confuse Indianapolis and Minneapolis. . . . Still another source of intense annoyance is the persistent fallacy that Indianapolis is situated on the Wabash River. There seems to be something funny about the name of this pleasant stream, which a large percentage of the people of Indianapolis have never seen, unless from the car window.[3]

Well, I propose that we make a pact: I promise not to call you "mudsills" if you will promise not to talk back. I won't even ask whether you are fond of upstate New York. I'll just proceed with my assignment, and you may say: mercy, mercy.

I begin by talking about the significance of state and local history, past and present, and then discuss the challenge that local history offers in the years ahead. The third section of my remarks is devoted to special opportunities that local historians now enjoy, because I strongly believe that this is a particularly good time to be involved with or "doing" state and local history. Finally, but briefly, I raise the issue: Who can write local history? Who is "qualified" to write it? My answer to this last question may surprise you a bit.

I

The writing of local history has been (and will continue to be) significant for many different reasons. I shall offer you half a dozen reasons, but I know full well that you could multiply my list with many of your own.

The first and most obvious reason has to do with the very human need for a sense of place and a natural curiosity about the particularities of one's own locale. Rudyard Kipling summed it up very well in a poem:

3. Nicholson, "Indianapolis: A City of Homes," *Atlantic Monthly,* 93 (June 1904), 836.

God gives all men all earth to love,
But since man's heart is small,
Ordains for each one spot shall prove
Beloved over all.[4]

Mark DeWolfe Howe, the Boston biographer and antiquarian, quoted those lines on the title page of a book (published in 1930) that he called a "Town Biography" of his birthplace: Bristol, Rhode Island. We tend to assume that New Englanders like Howe—many of them, at least—share the special sense of place. Perhaps, but New Englanders certainly possess no exclusive monopoly on it. Howe himself had been raised in Philadelphia and therefore provides an instance of someone's becoming "more New England than the ordinary Yankee." C. Vann Woodward and David M. Potter, distinguished twentieth-century historians, have rightly insisted that "personalism and persistent local attachments" were "evidence of the survival of an authentic folk culture in the South long after it had disappeared in urban culture elsewhere."[5]

A sense of place has also been important to our newcomers, however; consequently, the term "local history" acquires yet another aspect when we apply it to the history of immigration and ethnicity in American life. Irving Howe has written, in his masterful work called *World of Our Fathers* (1976), that while the eastern European Jews who came to the United States "seldom felt much loyalty to Russia or Poland as nations, they brought with them fierce affections for the little places they had lived in, the muddy streets, battered synagogues, remembered fields from which they had fled. The *landsmanshaft*, a lodge made up of persons coming from the same town or district in the old country, was their

4. Quoted in Helen Howe, *The Gentle Americans, 1864–1960: Biography of a Breed* (New York, 1965), 18.

5. See Potter, "The Enigma of the South," *Yale Review,* 51 (1961), 150–51; and Woodward, *American Counterpoint: Slavery and Racism in the North-South Dialogue* (Boston, 1971), 19–20. See also Allen Tate, "A Southern Mode of the Imagination," in Joseph J. Kwiat and Mary C. Turpie, eds., *Studies in American Culture: Dominant Ideas and Images* (Minneapolis, Minn., 1960), 99; Susan Elizabeth Lyman, *Lady Historian: Martha J. Lamb* (Northampton, Mass., 1969), 23; Karal A. Marling, *Wall-to-Wall America: A Cultural History of Post-Office Murals in the Great Depression* (Minneapolis, Minn., 1982), 95; Wallace H. Cathcart to Victor H. Paltsits, October 9, 1907, Paltsits Papers, box 2, New-York Historical Society, New York City; J. Franklin Jameson to Isaac J. Cox, December 4, 1909, box 117, and Rev. A. W. H. Eaton to J. Franklin Jameson, December 6, 1911, box 94, Jameson Papers, Library of Congress, Washington, D.C.

ambiguous testimony to a past they knew to be wretched yet often felt to be sweet."[6]

Since World War II these American *landsmanshaften* have published hundreds of memorial volumes, histories of the tiny towns in eastern Europe from which their members came. Although this genre of local history is little known, it too is a significant part of the literature—as pertinent to understanding this "nation of immigrants" (to use Franklin Delano Roosevelt's phrase) as it is to the history of eastern Europe per se.

It is by now a truism that immigration and continental migration have been central factors in shaping American history. Thomas Jefferson was prophetic when he wrote from Paris in 1786 that "our confederacy must be viewed as the nest from which all America, North and South is to be peopled."[7] Nevertheless, we have not fully recognized the consequences those factors have had in complicating our sense of place. Mobility has inevitably meant rootlessness for many. But those individuals, families, and communities that stayed put, on the other hand, have been responsible for a considerable amount of local and regional chauvinism. In many instances, unfortunately, local pride felt by one group is misunderstood by another—or worse, is bitterly resented. We have not significantly recognized that the efforts of local historians can be significant in creating and perpetuating social tensions in the United States.

The most dramatic example known to me involves the hegemony of New Englanders over the writing of American history—a phenomenon that persisted throughout the nineteenth century and well into the twentieth. This tendency has been resented by New Yorkers, by midwesterners, even by Californians; but nowhere has it been despised so much as in the South. Perhaps I might illustrate this point with a couple of extracts from correspondence that passed more than half a century ago between two leading southern historians. Philip Alexander Bruce, a Virginian, had just read the claim that women played a more important role in early Plymouth than in early Virginia. That claim got his bile flowing, for as he explained to Lyon G. Tyler, the retired president of the College of William and Mary,

The Pilgrims have beaten the Jamestown settlers in history, because, from the start, they had a talent for the use of the pen; and that talent has

6. Howe, *World of Our Fathers* (New York, 1976), 183–84, 189–90.

only grown more active with the progress of the years, until, by this time, the New England points of view have become the dominant ones in our national shibboleths.

Two weeks later Bruce continued his theme, and the refrain began to sound like a diatribe:

The only hope that I have that the superior claims of our prior settlement will be fully admitted lies in the certain expectation that the wealth and population, and, therefore, the importance of Virginia will grow enormously; and that with that growth, there will spring up a band of local historical scholars who will possess both the means and the literary culture to enforce on the attention of the world the superior part which Virginia played in the history of colonization.[8]

This story of regional and local rivalries for historical hegemony constitutes an important yet unwritten chapter in our cultural history. And the competition continues to this day, whether we wish to acknowledge it or not. In 1968, for example, a group based at Boston University conceived of a Committee for a New England Local History Bibliography. By 1972 the project had acquired many sponsors, a major federal grant, and a full-time staff. In 1976 the publication of huge, thorough bibliographical guides to local historical writing began to appear: Massachusetts, Maine, New Hampshire, and Vermont are "out"; Rhode Island appeared in 1983 and Connecticut in 1986; two final volumes on New England as a whole are planned for 1988–89. These books are the most useful works of their kind ever prepared. They make the available references for localities in other states look very inadequate by comparison.[9] So once again, whether we like it or not, New Englanders seem to lead the way in doing local history.

Rather than resent their leadership, however, we would do well to

7. Jefferson to Archibald Stuart, January 25, 1786, in *The Papers of Thomas Jefferson,* ed. Julian P. Boyd (Princeton, N.J., 1950–), IX, 218.

8. Bruce to Tyler, July 26 and August 10, 1925, Tyler Papers, group 5, box 4, Swem Library, College of William and Mary, Williamsburg, Va. By the mid-1920s there were even historians in New England who were critical of "the absurd worship of everything that is of New England" (see Worthington C. Ford to Lyon G. Tyler, July 7, 1924, ibid.).

9. Cf. John D. Haskell, Jr., ed., *Massachusetts: A Bibliography of Its History* (Boston, 1976), with Harold Nestler, *A Bibliography of New York State Communities: Counties, Towns, Villages* (Port Washington, N.Y., 1968).

be grateful, and to note that for more than a decade now a major preoccupation among professional historians has been to test the conventional wisdom of American history through in-depth case histories—what Bernard DeVoto used to call "post-hole digging." Most of the pioneering examples of this new genre were, predictably, studies of New England towns, especially during the colonial period; but by the later 1970s and early 1980s scholars had become interested in states, counties, and communities all over the United States and had begun asking different sorts of questions, using new methodologies, and producing works of great potential value to nonprofessional historians as well as to scholars.[10]

This body of work has helped us to appreciate several reasons why state and local history is significant. First, because we have begun to understand, as never before, just how pluralistic and decentralized American society has always been, with consequences that we scarcely envisioned a generation or two ago. As Oscar Handlin has written of the seventeenth century: "Power tended to devolve to its local sources. Whether that involved the town, as in New England, or the local powers sitting in the vestry, as in Virginia, the characteristic political organization was decentralized. Whatever acknowledgment might be given to the authority of the Crown, political institutions were decisively shaped by the necessity of defining connections to local power."[11] More often than not, the most critical decisions affecting

10. See Thomas H. Smith, "The Renascence of Local History," *Historian*, 35 (1972), 1–17; Kathleen Neils Conzen, "Community Studies, Urban History, and American Local History," in Michael Kammen, ed., *The Past before Us: Contemporary Historical Writing in the United States* (Ithaca, 1980), 270–91; Robert C. Twombly, "A Tale of Two Towns," *Reviews in American History*, 8 (1980), 161–66; Alan Dawley, *Class and Community: The Industrial Revolution in Lynn, Massachusetts* (Cambridge, Mass., 1976); Anthony F. C. Wallace, *Rockdale: The Growth of an American Village in the Early Industrial Revolution* (New York, 1978); Edward Countryman, *A People in Revolution: The American Revolution and Political Society in New York, 1760–1790* (Baltimore, Md., 1981); and Mary P. Ryan, *Cradle of the Middle Class: The Family in Oneida County, New York, 1790–1865* (New York, 1981).

11. See Handlin, "The Significance of the Seventeenth Century," in James Morton Smith, ed., *Seventeenth-Century America: Essays in Colonial History* (Chapel Hill, N.C., 1959), 5; and Edward Countryman, "'Out of Bounds of the Law': Northern Land Rioters in the Eighteenth Century," in Alfred F. Young, ed., *The American Revolution: Explorations in the History of American Radicalism* (De Kalb, Ill., 1976), 57. Norman K. Risjord, *Chesapeake Politics, 1781–1800* (New York, 1978), looks closely at politics in the Maryland House of Delegates in 1788. He finds twelve roll calls devoted to two issues of provincewide importance; the other sixty-two roll calls concerned what Risjord calls "local interests or nonpartisan social issues."

the lives of ordinary people were made by local citizens and implemented through local institutions. That is one rather obvious reason why local history has very properly become so interesting to us in recent years. (Recall the observation made by T. S. Eliot in 1948 that "a local speech on a local issue is likely to be more intelligible than one addressed to a whole nation."[12])

Another reason for the rediscovery of local history by professional historians has to do with the inescapable fact that you see different things when you use the microscope rather than the telescope. To cite just one example, historians who have examined the colonial rebellions of 1689–91 have long been impressed by the terrible instability, human conflict, and institutional disruption of those years. Detailed studies of particular counties and communities, however, have recently given us a very different perspective. Outside of the provincial capitals, life continued and sources of authority functioned—not without anxiety and, in many instances, not without changes in personnel. But the ultimate point is that people carried on; the basic web of human relationships did not disintegrate; and therefore instability was not so pervasive as historians assumed fifteen or twenty years ago. We owe this more balanced perspective to what might be called a "new particularism" in American historical writing.[13]

II

Despite these achievements, the challenge of state and local history continues to be twofold. There is the challenge for us to continue these innovations rather than resting content with the achievements of the 1970s. And there is also the challenge to spread much more widely—among the general public as well as among historians—the good news that a revolution has occurred in writing local history. Back in 1873 Friedrich Nietzsche wrote an iconoclastic essay called "The Use and Abuse of History." One passage, in particular, still stands as a tough challenge to you, to me, and to anyone who cares about the past for its own sake and wishes to respect the "pastness of the past." Listen to Nietzsche:

12. T. S. Eliot, *Notes towards the Definition of Culture* (London, 1948), 87.

13. See Lois Green Carr and David W. Jordan, *Maryland's Revolution of Government, 1689–1692* (Ithaca, 1974); and Langdon G. Wright, "Local Government in Colonial New York, 1640–1710" (Ph.D. diss., Cornell University, 1974). See also Richard Cobb, *Reactions to the French Revolution* (London, 1972), 13, 16.

History is necessary to the man of conservative and reverent nature who looks back to the origins of his existence with love and trust; through it he gives thanks for life. He is careful to preserve what survives from ancient days, and will reproduce the conditions of his own upbringing for those who come after him; thus he does life a service. The possession of his ancestors' furniture changes its meaning in his soul, for his soul is rather possessed by it. All that is small and limited, moldy and obsolete, gains a worth and inviolability of its own from the conservative and reverent soul of the antiquary migrating into it and building a secret nest there. The history of his town becomes the history of himself; he looks on the walls, the turreted gate, the town council, the fair, as an illustrated diary of his youth, and sees himself in it all—his strength, industry, desire, reason, faults, and follies. "Here one could live," he says, "as one can live here now—and will go on living; for we are tough folk, and will not be uprooted in the night." And so, with his "we," he surveys the marvelous individual life of the past and identifies himself with the spirit of the house, the family, and the city.[14]

One of the greatest challenges that local historians face, therefore, is to answer this charge of conservative antiquarianism. Part of the solution, I believe, lies in overcoming the worst excesses of ethnocentrism. When the poet Dante wrote, "My country is the whole world!" he meant that universals of human existence could be found in the microcosm of Florence, Italy. Faulkner must have felt the same way about his imaginary county in Mississippi. For so many practitioners of local history, however, the words of a distinguished contemporary French historian are pertinent and true: "The village all too often spent its time contemplating its own navel—that is for most members of the community the parish pump was the centre of their little universe."[15]

This has been a worldwide tendency throughout most of human history. Our parochialism is no more egregious than that of the Chinese, English, French, or Southeast Asian societies.[16] But what can be done about it? What *must* be done if we are to have good state and local

14. Nietzsche, *The Use and Abuse of History,* intro. Julius Kraft (Indianapolis, 1957), 17–18.

15. Emmanuel Le Roy Ladurie, *The Territory of the Historian* (Chicago, 1979), 99. See also Stanley Hoffman et al., *In Search of France: The Economy, Society, and Political System in the Twentieth Century* (Cambridge, Mass., 1963), 230–31; and Conrad M. Arensberg and Solon T. Kimball, *Culture and Community* (New York, 1965), ix–x.

16. See O. W. Wolters, *The Fall of Śrīvijaya in Malay History* (Ithaca, 1970), ix; John Clive, *Macaulay: The Shaping of the Historian* (New York, 1973), 494; and Barbara W. Tuchman, *Stilwell and the American Experience in China, 1911–1945* (New York, 1970),

history is for practitioners to read more widely than they do—to read important monographs on Newburyport, Massachusetts; Rochester, New York; Germantown, Pennsylvania; and Lunenberg County, Virginia, as well as outstanding recent studies of, say, Montaillou, France, or Vienna, Austria.[17]

The local historian should be an unashamed but discriminating borrower of concepts, methods, and contexts. Let me illustrate my point by quoting at length from an obscure little essay published in England by the Middlesex Local History Council in 1963.

> The economic historian and the local historian have much to gain from keeping an eye on each other's work. We economic historians look to local history for much of our raw material, particularly in these days when increasing attention is being devoted to economic development in particular regions. As we scan the local history journals, however, we become very aware that few of the articles we find there make use of works of economic history which might be of help in interpreting local evidence. Economic historians are getting more out of local history than local historians are getting from economic history. This seems rather an unfair bargain.
>
> Perhaps this lack of communication in one direction is most evident in the local historian's frequent reluctance to explain the timing of the events which he describes. According to him, they just happened. Yet, it is clear from the history of our own times that the moment of decision is often dictated by changes in the economic climate—movements in bank rates, for instance, or a slight increase in the level of unemployment. The same is true of the past; even truer, in fact, because financial crises were then more severe, and swings in the level of unemployment more extensive. Much has been written lately by economic historians about these ups and downs in the economic life of the country and, as a consequence, it is often now possible, by looking up a few readily-obtainable books, to

31. Among the papers of Victor Hugo Paltsits there is a letter from Dr. W. Inglis Morse, whose address in 1937 was Pansy Patch, Paradise, Nova Scotia.

17. See Stephan Thernstrom, *Poverty and Progress: Social Mobility in a Nineteenth Century City* (Cambridge, Mass., 1964); Paul E. Johnson, *A Shopkeeper's Millennium: Society and Revivals in Rochester, New York, 1815–1837* (New York, 1978); Stephanie G. Wolf, *Urban Village: Population, Community, and Family Structure in Germantown, Pennsylvania, 1683–1800* (Princeton, N.J., 1976); Richard R. Beeman, "Social Change and Cultural Conflict in Virginia: Lunenberg County, 1746 to 1774," *William and Mary Quarterly*, 35 (1978), 455–76; Emmanuel Le Roy Ladurie, *Montaillou: The Promised Land of Error* (New York, 1978); and Carl E. Schorske, *Fin-de-Siècle Vienna: Politics and Culture* (New York, 1980).

understand more about why local developments took place when they did.[18]

Yet another lesson to be learned from innovative recent work done by English historians is that understanding the relationships between centralized units of political authority and regional and local organizations is essential if we are to avoid the pitfalls of doing local history in a vacuum. My colleague Clive Holmes has expressed this point quite well in his introduction to *The Eastern Association in the English Civil War*, a book that treats the eastern counties around Cambridgeshire during the very critical years 1643–45: "The history of the Eastern Association can only be explained adequately, not by the invocation of the region's unique homogeneity however defined, but by the close analysis of the complex and tension-ridden dialogue of the three principals: the legislators at Westminster, the Association's authorities and administrators at Cambridge, and the county committees in the localities."[19]

It is my belief that state and local history, most especially, should not be regarded in isolation. We have had too much physical mobility, too much social diversity, and too many bonds between disparate places in a widespread market economy to justify isolated examinations of local history. Onondaga salt was sold all the way from New York City to upper Canada and Michigan during the antebellum period, for example; and the Oneida Indians, whose historic home was upstate New York, are to be found in diaspora near Green Bay, Wisconsin. It has become a platitude that to do local history well brings one inescapably into regionalism and regional history.[20] I do

18. T. C. Barker, "Modern Economic History and the Local Historian," *Middlesex Local History Council Bulletin*, no. 16 (November 1963), 1–3. For two important examples of what can be achieved, see Michael P. Weber and Anthony E. Boardman, "Economic Growth and Occupational Mobility in 19th-Century Urban America: A Reappraisal," *Journal of Social History*, 11 (1977), 52–74, a case study of Warren, Pennsylvania, 1870–1910; and Daniel Walkowitz, *Worker City, Company Town: Iron and Cotton-Worker Protest in Troy and Cohoes, New York, 1855–1884* (Urbana, Ill., 1978).

19. Holmes, *The Eastern Association in the Civil War* (London, 1974), 3–4.

20. See Joseph L. Love, "An Approach to Regionalism," in Richard Graham and Peter H. Smith, eds., *New Approaches to Latin American History* (Austin, 1974), 137–55; Thad W. Tate and David L. Ammerman, eds., *The Chesapeake in the Seventeenth Century: Essays on Anglo-American Society* (Chapel Hill, N.C., 1979); and Roberta Balstad Miller, *City and Hinterland: A Case Study of Urban Growth and Regional Development* (Westport, Conn., 1979), which treats Syracuse and Onondaga County, 1790–1860.

not disagree, but I would like to push the point one step further by suggesting that local history, properly conducted, can lead one simultaneously into the histories of several different regions. In 1894, for example, a violent confrontation in Hammond, Indiana, occurred because of an American Railway Union strike in support of the Pullman walkout. It would be extremely instructive to compare what happened in Hammond with simultaneous episodes in Chicago, Los Angeles, and elsewhere.

I would like to make a special plea for a mode of investigation that may sound perfectly reasonable yet has not been pursued by local historians in any systematic way. I have in mind the ubiquitous story of two communities—roughly equal in size and in resources when they were embryonic—which compete with each other to become the county seat, or to be the major commercial entrepôt, or to serve as the site for some special institution, such as a university, a hospital, or a jail. Whether it be Winchester vs. Stephensburg, Virginia, in the 1740s; or Elizabeth vs. Newark, New Jersey, in 1807; or Seneca Falls vs. Waterloo, New York, in the 1830s; or Santa Rosa vs. Sonoma, California, in the 1850s, I am talking about a competitive pattern that has recurred hundreds of times in United States history. Although we used to glorify the match race between sleek, powerful horses, and we love to read Mark Twain's account of the Mississippi River steamboat racing the fire-breathing locomotive, few historians have made it their business to tell the cutthroat saga of neighboring communities that struggled mightily for economic and political dominance.

There is an obscure essay (jointly authored because it originated as two separate papers) that ought to be required reading for every local historian. It explores the cultural dynamic of a midwestern community that has had a "mainstream" history as well as a dissenting tradition. Although most communities are probably in a similar situation, the alternative or dissenting voice tends to get muted with the passage of time. Let the authors explain:

> In this country most of the history written during the nineteenth century must have taken the form of local and county histories, produced or sponsored by local residents rather than by trained scholars. These frequently shapeless and always self-gratulant community chronicles exhibit in the main only the haziest notions of historical method or philosophical consistency. They can nevertheless reveal the sense of particular local pasts in relation to given stages of local development.

After tracing the optimistic and boosteristic versions of historical writing about Kansas City, Missouri, the authors label them the dominant tradition, "drawing its force from conceptions of what the city was supposed to *be* and what it was supposed to become." The authors then identify certain local figures who, "whatever their reasons, have found themselves drawn toward different aspects of the city's history and have shown that much of what the writen tradition takes for granted is in fact highly problematic. These divergent expressions . . . have taken the form of addresses to 'old settlers' associations, letters to editors, and unpublished reminiscences; they can be described, for contrast, as a sort of 'oral tradition.' "

The authors' conclusion is highly instructive:

> Obviously, there is more than one "past" in Kansas City. The written tradition—with its success story of prophecies redeemed, boldness vindicated, and the city itself a continuing testimony to a triumph over the wilderness—exercises an almost hypnotic influence not only over its historians but in the city's present-day publicity. . . . The conflicts between and within the traditions we have called "written" and "oral" mark a range of questions that remain open for new investigations and fresh judgment. It is quite clear that adequate local history can be written in terms of neither stereotype.[21]

III

That challenging assertion brings me to the third item on my agenda: the opportunities that lie ahead for local historians. It is perhaps disappointing to learn that there is no neat and tidy formula for everyone to follow—no prepackaged method that would be appropriate to every community. We can console ourselves, however, by recognizing that there is also no consensus among historians of the United States in general—or among historians of women, or within the so-called American Studies movement, or within the *Annales* school in France—about the one best way of doing any kind of history. The most appropriate balance between theory and description, between cultural and economic emphases, between narrative and analysis, involves issues that historians disagree about just as intensely as ever.

21. R. Richard Wohl and A. Theodore Brown, "The Usable Past: A Study of Historical Traditions in Kansas City," *Huntington Library Quarterly*, 23 (1960), 237–59.

If I were asked to recommend the classic example—or even a classic model—of American local history writing, I would be hard pressed to do so. Classic works do exist, but none of them will serve very well as an all-purpose model. What about W. Lloyd Warner's work on Newburyport, Massachusetts, or Robert and Helen Lynd's work on Muncie, Indiana? Too sociological and insufficiently historical. What about Blake McKelvey's five-volume work on Rochester, New York? Invaluable, yet old-fashioned in methodology and lacking in comparative perspective. What about I. N. P. Stokes's six-volume iconography of Manhattan Island? It is a gorgeous work, yet narrow in focus and *sui generis* in content. Very few localities have the richness of visual materials that makes such an approach possible.

Well then, what about Merle Curti's *The Making of an American Community: Democracy in a Frontier County* (1959), on Trempeleau County, Wisconsin? Based upon collaborative work and utilizing quantitative methods, it may come as close as any work that we can find to being a "classic model." Nevertheless, other communities will have types of data available that Curti lacked (and vice versa) and pose questions that Curti and his colleagues did not. Other communities will have existed for double the time span of Trempeleau County, thereby creating multigenerational opportunities as well as methodological problems. And for more urbanized localities a problem-focus quite different from the "Turner thesis" will be far more appropriate.[22]

It is essential to bear in mind the diversity of what local historians do. They tend to be "held responsible" for everything that happened in their communities; that is, they are expected to be knowledgeable about the entire story, from genesis to the present and from political history to architectural aspects. That's understandable, but it should not blind us to the fact that local historians have specialized and even should specialize. They may write the history of a local institution, such as a church, a factory, a hospital, a university, or a utopian community. They may write the history of an artifact, such as an unusual bridge, building, or market.[23] They may even write the *leg-*

22. Cf. Clyde and Sally Griffen, *Natives and Newcomers: The Ordering of Opportunity in Mid-Nineteenth-Century Poughkeepsie* (Cambridge, Mass., 1978); Ronald H. Bayor, *Neighbors in Conflict: The Irish, Germans, Jews, and Italians of New York City, 1929–1941* (Baltimore, Md., 1978); and Bruce C. Daniels, ed., *Town and County: Essays on the Structure of Local Government in the American Colonies* (Middletown, Conn., 1978).

23. See, e.g., James J. Divita, *Slaves to No One: A History of the Holy Trinity Catholic*

endary history or folklore of a locality. The story of Valley Forge, for example, as a symbolic phenomenon in American culture is almost as important as the actual encampment that occurred there during the winter of 1777–78.[24]

Two recent developments within the historical profession may be particularly reassuring to local historians. The first is a revival of interest in and respect for narrative history. For several generations now, prominent academic historians have been more interested in analyzing pieces of the past (to see how they worked) than in synthesizing what they have learned into a coherent "story." That is changing, just as abstract expressionism in art is giving way to new modes of representationalism. Most local historians, I believe, feel comfortable reading and writing narrative history. Well, these trends seem to run in a cyclical fashion, and new modes of narrative seem to be on the way "in" again.[25]

The second pertinent development is that historians have become increasingly interested in the history of failure: of losers, like the Loyalists in the American Revolution; or political movements that aborted, like socialism in Spain after World War I; or things that should have happened but didn't, such as treaties between the Hispanic colonists in the New World and native Americans.[26] Many local historians feel

Community in Indianapolis on the Diamond Jubilee of the Founding of Holy Trinity Parish (Indianapolis, Ind., 1981); J. M. Bumsted, "Revivalism and Separatism in New England: The First Society of Norwich, Connecticut, as a Case Study," *William and Mary Quarterly*, 24 (1967), 588–612; Tamara K. Hareven and Randolph Langenbach, *Amoskeag: Life and Work in an American Factory-City* (New York, 1978); Walter Muir Whitehill, *Museum of Fine Arts, Boston: A Centennial History*, 2 vols. (Cambridge, Mass., 1970); Margaret A. Erskine, *Mechanics Hall* (Worcester, Mass., 1977); and Emily Williams, *Canal Country: Utica to Binghamton* (Utica, N.Y., 1982), on the Chenango Canal.

24. See Barbara MacDonald Powell, "'The Most Celebrated Encampment': The Valley Forge Experience in American Culture, 1777–1983" (Ph.D. diss., Cornell University, 1983).

25. See Lawrence Stone, "The Revival of Narrative: Reflections on a New Old History," *Past & Present*, no. 85 (November 1979), 3–24; and Bernard Bailyn, "The Challenge of Modern Historiography," *American Historical Review*, 87 (1982), esp. 7–9, 23–24.

26. See Bernard Bailyn, *The Ordeal of Thomas Hutchinson* (Cambridge, Mass., 1974); Gerald H. Meaker, *The Revolutionary Left in Spain, 1914–1923* (Stanford, Calif., 1974); Charles Gibson, "Conquest, Capitulation, and Indian Treaties," *American Histor-*

awkward because, as they often put it, "nothing *important* ever happened in our community."[27] Does that refrain sound familiar? What if your town is not Concord, Massachusetts; or Nauvoo, Illinois; or New Harmony, Indiana; or Sante Fe, New Mexico; or Monterey, California? Take heart! Some of us have ceased to tell American history as an unbroken series of successes by famous folks. Therefore, in my own state, the towns that were *not* located along the Erie Canal, and the decline of certain Adirondack industries, and the collapse of the whaling industry from Long Island and New England ports, and even the fiscal decline of New York City are all stories with fascinating lessons for us, living as we do in an age of economic crisis and contraction.[28]

State and local history, in short, have moved beyond "boosterism." The town scandal is infinitely more interesting than complacent prosperity with a denouement that "they all lived happily ever after." Students of the past are at least as concerned about ordinary chaps as they are about elites, about rates of social change and patterns of human fertility. The decline of fertility in the Western world since the mid-nineteenth century has begun to captivate the interest of more and more historians. As the relationship between human population and food resources becomes ever more problematic, it is not even possible to say whether the decline of fertility is a story of success or of failure. It may simply be an adaptive aspect of human survival. In any case, it is a phenomenon that can be traced in most of our communities, and it should be.

ical Review, 83 (1978), 8–9; and Alfred D. Chandler, Jr., "Industrial Revolutions and Institutional Arrangements," *Bulletin of the American Academy of Arts and Sciences,* 33 (May 1980), 50.

27. See Charles Warren's letter to Mark A. DeWolfe Howe, May 31, 1938, in which Warren thanked his friend for sending a copy of *Old Bristol* and indicated that he had read the book with great interest: "You were singularly fortunate in having a town to write about which had a good deal of tradition hanging around it and which contained many rather unique individuals with marked characteristics. My old Town of Dedham was a much more prosaic place and when I was preparing my Tercentenary Address, I was astonished to find how few stories regarding individuals were extant in the Town, either in writing or by word of mouth" (Houghton Library, Harvard University, Cambridge, Mass.). But cf. Kenneth A. Lockridge, *A New England Town: The First Hundred Years, Dedham, Massachusetts, 1636–1736* (New York, 1970).

28. See, e.g., Philip L. White, *Beekmantown, N.Y.: Forest Frontier to Farm Community* (Austin, Tex., 1979); and Peter D. McClelland and Alan L. Magdovitz, *Crisis in the Making: The Political Economy of New York State since 1945* (New York, 1981).

IV

My final point has to do with the question, Who can or should write local history? My answer may be somewhat surprising, because I do not believe that one has to be a lifelong resident of Vincennes, or Crawfordsville, or Tell City in order to write its history. I do not believe that women necessarily write women's history better than men, or that blacks necessarily have an advantage in writing black history, or (for that matter) that only Americans can write about the history of the United States. Thomas S. Kuhn has told us that "almost always" the people who are responsible for dramatic innovations in the natural sciences" have been either very young or very new to the field whose paradigm they change."[29]

Let me cite just two examples in the field of local history. William Lambarde's *A Perambulation of Kent* (1576) is one of the finest local histories in the entire Anglo-American tradition. In several key respects Lambarde is the progenitor of English county history-writing. Nevertheless, he settled in Kent the very year that he wrote this famous book, and his entrance into a particular community was the cause of his undertaking the *Perambulation*.[30] Similarly, in 1835 Ralph Waldo Emerson researched and wrote his well-known bicentennial discourse about Concord, Massachusetts, because he had just moved there and was about to be married. The history he wrote helped to legitimize his status in Concord. As for age, bear in mind that Emerson was thirty-two years old when he wrote it.[31]

Well then, what lessons do I wish to derive and drive home? We should welcome the talented outsider who would write a history of our community. An "old-timer" is not the only person who can write local history. A native will not necessarily be more accurate than a

29. Kuhn, *The Structure of Scientific Revolutions,* 2d ed. (Chicago, 1970), 90.
30. See Peter Laslett, "The Gentry of Kent in 1640," in T. H. Breen, ed., *Shaping Southern Society: The Colonial Experience* (New York, 1976), 42.
31. "Historical Discourse at Concord, on the Second Centennial Anniversary of the Incorporation of the Town, September 12, 1835," in *The Complete Works of Ralph Waldo Emerson,* ed. Edward W. Emerson (Boston, 1932), XI, 27–86; Ralph L. Rusk, *The Life of Ralph Waldo Emerson* (New York, 1949), 221–23. For additional examples of important local historians with roots elsewhere, see the works of Joel Munsell and Frederic F. Van de Water, historians of Albany, New York, and Vermont, respectively, who grew up in Massachusetts and New Jersey.

newcomer, or a believer more sympathetic than a nonbeliever. A recent president of the Mormon History Association, Professor Jan Shipps of Indiana University–Purdue University in Indianapolis, is not a Mormon. She has earned the Mormons' admiration and trust, nonetheless.

I suspect that I may be preaching to the converted. In 1979, when the Indiana Historical Society commissioned a sesquicentennial history of the organization, it sought an "outsider" rather than an "insider" because it did not wish to promulgate an official history. Lana Ruegamer had been associated with your organization for less than four years, and considered herself a "nonparticipant" as well as a newcomer.[32]

V

I have spoken of challenge, of opportunities, and finally of qualifications. My views are inevitably personal—perhaps even idiosyncratic. They are the product of what I read, of conversations that I have had with other historians, and of reactions to professional situations that I have observed. I don't know that I can offer a Local Historian's Creed, but I shall conclude with three declarations of faith.

1. Local historical writing in the years ahead must find a middle ground between the old-fashioned variety that was richly anecdotal and the type of "new social history" as local case study, which deals with people as impersonal aggregates. The serious and humanistic historian must identify trends, to be sure, but should exemplify them with flesh-and-blood individuals. It's not a matter of simple human interest or of precision versus impressionism, but rather one of defining the historian's vocation as comprising narrative *plus* analysis. Narrative without analysis is a beast with a hollow head, but explanation without vivid illustration is stultifying and unsatisfying.

2. Local historical writing, for better and for worse, endures longer than any other form of historical writing. A great amount of it was produced, for example, during the 1880s. Those books are still read by members of (and visitors to) the communities they describe. I cannot

32. Ruegamer, *A History of the Indiana Historical Society, 1830–1980* (Indianapolis, 1980), v.

say the same about the "scientific" monographs written by professional historians a century ago. If I may quote Johan Huizinga once again, "there are wise historians among the amateurs of local history and dull gleaners of facts among the renowned professors of the universities." *Vanitas, Vanitas.* Write local history and you may achieve one variant of immortality.[33]

3. To do local history well, one must read broadly. A comparative perspective is essential. Nevertheless, each of our communities is a cosmos unto itself, and each one contains many, though not *all*, the universals of human experience. Henry David Thoreau put it very well in 1849: "The characteristics and pursuits of various ages and races of men are always existing in epitome in every neighborhood. The pleasures of my earliest youth have become the inheritance of other men."[34]

I hope that the pleasures of your youth and neighborhood will appear in your histories—but also your scandals. I hope that insiders as well as outsiders, old-timers as well as newcomers, will appear in your histories. I trust that the unique as well as the universal will appear, and that you will make an effort to distinguish between the two. However you write your histories, the responsibility you bear is considerable, because good, bad, or indifferent, your histories will become, as Thoreau put it, "the inheritance of other men." And women.

I am quite fond of an admonition given to young Hoagy Carmichael during World War I by Reggie Duval, the pianist from Indianapolis. "Never play anything that aint *right*," Duval remarked. "You may not make any money, but you'll never get hostile with yourself."[35] That sounds to me like very good advice—as sensible for state and local historians as it is for musicians.

I thank David V. Burns, Gayle Thornbrough, and Lana Ruegamer (respectively the president, executive secretary, and editor of publications at the Indiana Historical Society in 1982–83) for their gracious hospitality and cooperation.

33. Huizinga, "The Task of Cultural History," in *Men and Ideas: History, the Middle Ages, the Renaissance,* trans. James S. Holmes and Hans van Marle (New York, 1959), 21; J. Frank Dobie, *Some Part of Myself* (Boston, 1967), 198–99.
34. Thoreau, *A Week on the Concord and Merrimack Rivers* (1849; New York, 1961), 21–22.
35. Quoted in Carmichael, *The Stardust Road* (New York, 1946), 16–17.

It is an equal pleasure to acknowledge that my interest in state and local history has been stimulated and honed by numerous conversations on the subject with Carol Kammen, the most perceptive practitioner of local history in the state of New York.

Job Lot, Cheap, by William Harnett (1878), the first easel painting in American art to be composed entirely of books. Twenty-two books are disarrayed in a pyramid on a wooden crate. The *Cyclopedia Americana* is located just to the left of center; upside down on either side of it are the *Odyssey* and the *Arabian Nights*. Beneath the discarded books, a torn label on the crate reads: "Just Published." Harnett may very well have had in mind an essay by Washington Irving titled "The Mutability of Literature." Courtesy of the Reynolda House Museum of American Art, Winston-Salem, North Carolina.

PART THREE

THE QUEST FOR MEANING IN AMERICAN CULTURE

The past is never dead. It is not even past.

William Faulkner

History Isn't
What It Once Was

This piece first appeared on the Op-Ed page of the *New York Times,* February 2, 1985, and was reprinted in the *Richmond Times Dispatch* on February 7, 1985. Copyright © 1985 by The New York Times Company. Reprinted by permission.

A southerner wrote to me wistfully from Machipongo, Virginia, that "we used to regard January 19 as Lee-Jackson Day. Now it has been replaced by Martin Luther King Day."

With the passage of time, the past recedes from the present. It becomes more remote. Isn't that how we usually think about history (when we think about it at all)? I wonder.

I, for one, grew up thinking that way. History courses that I took during the 1950s usually stopped in 1939. Often the instructor never got beyond 1914 or 1919. Perhaps time simply ran out on the story of the past. Not enough days in the school year.

Perhaps. Most often, however, a need for distance was recognized. The recent past belongs to sociology or political science or even journalism. You can't "do" history properly until all the facts are "in," and that really takes time. The facts don't come in at the end of each day by themselves, like so many cows on a farm. They have to be searched for, more like missing sheep.

I also grew up with the notion that the distant past was more suitable as an object of historical study. How often have we heard the tale

about a group of specialists on ancient Greece, strolling tweedily through the corridor of a convention hotel en route to a session on Periclean Athens. When they passed a room filled with medievalists, they sniffed haughtily: "Journalists!"

Comparable feelings could be found among museum-goers and antique collectors. Gatherers of American decorative arts used to concentrate on the two centuries following 1630, the age of handcraftsmanship. Machine-made goods didn't qualify as antiques. They lacked prestige.

If we went to museums or collected objects, we did so to savor or possess pieces of a world that pre-existed our own. A very different world. And when the country went ga-ga over King Tut, mummies, and Egyptology early in the 1920s, part of the charm lay in the remote antiquity of all that gauze, gold, and gaudily painted wood.

So once upon a time, if you were "into" the past, earlier meant better. But that has been changing. Our newest major history museum, the Margaret Woodbury Strong Museum in Rochester, New York, emphasizes cultural history and popular taste during the century from about 1840 until 1940. The Strong Museum's inventory consists primarily of machine-made rather than handmade items. It exhibits as cultural artifacts some of the same toys I played with in the later 1930s and 1940s. My personal world is now represented in a museum. History is not receding. It's gaining on me.

Evidence of the trend has proliferated. In 1985 the world's first museum devoted to computer hardware opened in Boston. Late in 1984, a group of planners selected San Jose, California, as the site for a $95 million museum of modern technology. Exhibits will demonstrate the history and application of the scientific principles on which the electronics and biotechnical industries of the 1970s and '80s are based. In this instance, history has passed me by.

American Heritage, a popular historical magazine, decided late in 1984 thenceforth to emphasize the recent past. Roughly 75 percent of the journal is now devoted to twentieth-century history. Essays appear on Watergate, Hollywood, and the swing to suburbia.

Harcourt Brace Jovanovich, the publishing house, issued a historical calendar for 1985. The box for January 31 tells us that the first American satellite, Explorer I, was launched on that day in 1958. The box for February 7 contains a double entry: Massachusetts is admitted as the sixth state in 1788, and the Senate establishes a committee to investi-

gate the Watergate conspiracy in 1973. The old history balanced by the new. That's fine.

February 12 does *not* have a double entry, however, It does *not* mention Abraham Lincoln, arguably our greatest president. Only this: in 1955 the United States agrees to train South Vietnamese troops. And then February 20: John Glenn becomes the first American to orbit the Earth, while Lincoln is passé. Instant history has passed him by. Apparently, John Glenn is what it's all about. The right stuff is real history.

This trend is perplexing for a teacher. If more people pay attention to the past—any past—that's good, I guess. One thing may lead to another. Who knows: those who notice John Glenn on the kitchen wall today may think about Honest Abe off the wall tomorrow. Still, I can't help feeling sort of wistful about the eclipse of a past that I used to know.

It doesn't seem to be a matter of great white men being supplanted by women, minorities, and ordinary folks. More often, it's one batch of great white men being displaced by another batch of newsworthy but lesser white men. Affirmative action hasn't hurt history. Trendiness and pandering have.

Perhaps it is too soon to try to comprehend what is happening, never mind why. All that can be said with assurance and candor is that popular interest in the past is rolling relentlessly toward tomorrow. Unlike my hairline, history isn't receding. It's creeping up on us. History wasn't always that way.

Chapter 8

Changing Perceptions of the Life Cycle in American Thought and Culture

An exploratory draft of this essay was initially presented in Boston on October 30, 1977, at the biennial meeting of the American Studies Association. An abridged rendition of the version that appears here was presented on May 10, 1979, to the Massachusetts Historical Society, and the complete revision was published in the *Proceedings* of that organization, vol. 91 (Boston, 1980), 35–66. It is reprinted in much the same form, with the permission of the Society.

Iconography depicting the human life cycle is plentiful, and diverse examples have come to my attention in the period since this essay appeared. Randolph Johnston, for example, a contemporary Canadian sculptor, has cast in bronze a unique and wonderful work called *Nine Ages of Man*. A popular engraving appeared in France during the late seventeenth and early eighteenth centuries, usually hand-colored, called *Les Différents Degrés des Ages,* also a nine-stage rendering. Jean Valentin de Boullogne (French, ca. 1594–1632) painted two versions of *The Four Ages of Man*. One can be found at the National Gallery in London (no. 4919), and the other at the Vassar College Art Gallery in Poughkeepsie, New York.

Among Italian renderings, see Titian's *Three Ages of Man* (ca. 1510–15), schematized in an unconventional manner as a landscape, and located at the National Gallery of Scotland in Edinburgh; *Man's Three Ages* (sixteenth century, Venetian school), formerly attributed to Lorenzo Lotto and located in the Pitti Palace in Florence; the

four stages of man (ca. 1540) painted on the ceiling of "Saturn's Terrace" at the Palazzo Vecchio in Florence; and *Les Trois Ages de la Vie* (apparently painted in the eighteenth century by an Italian), located in the Mouton-Rothschild Museum of Wine, Medoc region, near Bordeaux, France.

For a variation on the male life cycle, presented in ten stages but applied to the vicissitudes of a famous historical personage, see *Karikatur auf Napoleons Aufstieg und Fall* (1814)—essentially the rise and fall of Napoleon from a child in Corsica to Emperor of France to exile on the island of Elba—located in the Historical Museum of Frankfurt, West Germany (Graphische Sammlung, inv. c 12108).

A seventeenth-century Japanese version is so extraordinary that I have added it to the illustrations that originally accompanied this essay. It appears as Figure 19 and came to me through the courtesy of Professor Hideo Kojima, Department of Educational Psychology, Nagoya University, Nagoya, Japan.

The Voyage of Life series by Thomas Cole turned out to be so popular during the 1840s that he painted a second set while in Rome, 1842 (oil on canvas), now owned by the National Gallery of Art in Washington, D.C. Cole's four preliminary studies (oil on wood panel) are owned by the Albany Institute of History and Art.

<div style="text-align:center">

I

</div>

The history of the life cycle in American thought is one of the most engaging subjects that I have ever encountered or explored. Essentially, it involves nothing less than a primary shift, over the past four centuries, in humankind's perception of itself. Rather than "primary shift," however, perhaps I really should say a whole *cluster* of related alterations. Either way, these changes have not been systematically traced by historians, or by anyone else for that matter. Although some of the pertinent materials are familiar—such as the *Voyage of Life* paintings done by Thomas Cole, 1839–40, and modern essays written by Erik H. Erikson on the life cycle—many of our essential sources remain obscure. More significant, the familiar and the obscure have not been brought together within a unified framework; and most important of all, an explanation of why certain symptomatic changes occurred has never been offered.

Why should such an intriguing subject be so neglected, and perhaps

so problematic? In part because the source materials are diverse and fragmentary. They are scattered intermittently over time and irregularly across many disciplines. The American genus of the quarry we are stalking first appears in the seventeenth century as a Christian allegory shaped by Calvinist theology and ends in our own time ("ends" only in the sense that our own time is as far as we can see; there will obviously continue to be perceptions of the human life cycle) as a secular taxonomy determined by our understanding of depth psychology and biology. All in all, the story we are about to examine involves a remarkable odyssey of the human spirit.

The topic is complex and elusive because no one, as yet, has established a basic chronology. Who wrote (or painted) what? And when? Which were the innovative minds? Which have been the most intense periods of interest in the human life cycle? Only by establishing such a chronology does the twisting configuration of continuity *and* change become apparent.

The subject has also been elusive because the most important persons involved, especially in the twentieth century, have been remarkably ahistorical in their perspective and in their manner of proceeding—even people like Erik H. Erikson, who are presumed to be sensitive to the past. I have found most modern writers on the life cycle incredibly myopic. They are not merely oblivious to early American poems and sermons, or to nineteenth century art pertaining to the life cycle; such lapses might be readily understood and forgiven. But the ignorance that one finds among contemporary psychologists, for example, of important work done on the life cycle just a generation ago by psychologists and anthropologists is simply appalling.

One other form of myopia has been a factor in keeping our subject obscure: namely, the myopia of "American exceptionalism" that has characterized so much of the work done in American cultural history and American Studies for the past four decades.[1] Although our delineations of the life cycle have taken some distinctive turns and forms in the United States, the subject cannot be understood in cultural isolation. Colonial views of the life cycle were derived from European perceptions. Our nineteenth-century notions continued to be shaped by new patterns of influence drawn from western and northern Europe. As a matter of fact, Old World influences upon American per-

1. See Laurence R. Veysey, "The Autonomy of American History Reconsidered," *American Quarterly*, 31 (1979), 455–77.

ceptions of the life cycle have never been stronger than they were in the period from about 1825 to 1850—which is ironic, needless to say, because that is just when Americans were most anxious to establish their cultural independence.

The irony diminishes somewhat, however, if we distinguish between the producers and consumers of cultural artifacts. By producers, in this context, I mean essayists, publishers, painters, and engravers, who *had* to know how heavily they were borrowing from Old World materials. Consumers, on the other hand, ordinarily did not realize that they were participants in a pan-Atlantic cultural phenomenon. They might have when they read Dr. Johnson's little essay "The Voyage of Life," reprinted in a New England schoolchild's reader; but they would not have when they placed upon their living room wall a popular wood-engraved illustration called THE LIFE AND AGE OF MAN: *Stages of Man's Life, from the Cradle to the Grave.* More on such anomalies anon.

Let us now establish a sense of chronology. We cannot, and need not, treat every period with equal intensity. Although Americans have persistently had *some* perception of the human life cycle, certain periods have been fertile and others fallow in terms of intellectual ingenuity and artistic creativity. We need not pay close attention to those phases when Americans were content to reiterate time-honored formulae. We can, instead, concentrate upon three periods: first, the mid-seventeenth-century origins; next, the transitional and very complex second quarter of the nineteenth century; and finally, the middle third of the twentieth century, when social scientists entirely replaced poets, clergymen, essayists, and artists as custodians and expositors of the life cycle concept.

II

That concept has a very rich, complex, and long tradition in European (as well as Asian) thought. Moreover, it seems never to have been richer or more complex than during the later Renaissance, when English North America was being colonized. The late Samuel C. Chew put together a vast compendium of verbal as well as visual materials in *The Pilgrimage of Life* (1962), a book that concentrates upon the period 1485–1642 in both Britain and continental Europe. We learn from Chew that three-, four-, five-, six-, seven-, and nine-stage concep-

tualizations of the life cycle are all to be found in the literature and art of early modern Europe. The seven-stage rendering is perhaps the best remembered. Hippocrates had used it in antiquity; a famous mosaic pavement, called *The Seven Ages of Man,* was installed in 1476 at the cathedral in Siena, Italy; and, of course, one of Shakespeare's most memorable soliloquies is that of Jaques in *As You Like It* (II, vii, 139):

> All the world's a stage,
> And all the men and women merely players:
> They have their exits and their entrances;
> And one man in his time plays many parts,
> His acts being seven ages. At first the infant,
> Mewling and puking in the nurse's arms.
> Then the whining school-boy, with his satchel
> And shining morning face, creeping like snail
> Unwillingly to school. And then the lover,
> Sighing like furnace, with a woeful ballad
> Made to his mistress' eyebrow. Then a soldier,
> Full of strange oaths, and bearded like the pard,
> Jealous in honour, sudden and quick in quarrel,
> Seeking the bubble reputation
> Even in the cannon's mouth. And then the justice,
> In fair round belly with good capon lined,
> With eyes severe and beard of formal cut,
> Full of wise saws and modern instances;
> And so he plays his part. The sixth age shifts
> Into the lean and slipper'd pantaloon,
> With spectacles on nose and pouch on side,
> His youthful hose, well saved, a world too wide
> For his shrunk shank; and his big manly voice,
> Turning again toward childish treble, pipes
> And whistles in his sound. Last scene of all,
> That ends this strange eventful history,
> Is second childishness and mere oblivion,
> Sans teeth, sans eyes, sans taste, sans every thing.

Although the seven-stage rendering may be better known today, it was no more popular in Renaissance Europe than the four-stage conceptualization. The latter would be far more influential in early American thought, and that is significant for our purposes here. I have found only occasional allusions to "the Seven Ages of Man" in American culture. It crops up, for example, in the *New Musical Banquet,* pub-

lished at Windsor, Vermont, in 1810; in *The Life and Age of Woman,* an engraving of the 1830s (see Figure 14); in M. C. [Mathew Carey?], *Excerpts from the Commonplace Book of a Septuagenarian; Reflections on Shakespeare's Seven Ages of Man,* published at Philadelphia in 1835; and, in our own time, in Ogden Nash's delicious poem "The Seven Spiritual Ages of Mrs. Marmaduke Moore."[2]

The four-stage conceptualization was very popular in Elizabethan and Jacobean England. One reason, I believe, was that a convenient analogy could be developed, in a culture that thrived upon "correspondences," between the human life cycle and the cycle of nature.[3] Thomas Tusser, for example, wrote a characteristic quatrain in 1573, "A Description of Time and the Seasons":

> The yeere I compare, as I find for a truth,
> The Spring unto childhood, the Sommer to youth,
> The Harvest to manhood, the Winter to age:
> All quickly forgot as a play on the stage.

And Sir Fulke Greville, the Jacobethan poet and politician, declared in his *Treatie of Warres* that

> States have degrees, as human bodies have,
> Spring, Summer, Autumn, Winter and the grave.

The illustration shown in Figure 6, *Time Leading the Seasons,* provides graphic evidence of the attractiveness to seventeenth-century minds in being able to conflate the human life cycle with the four seasons.

That convenient conflation was utilized by the first American writer to contemplate the life cycle explicitly: Mistress Anne Bradstreet (1612–72) of the Massachusetts Bay Colony. In 1650 she published a notable collection of poems titled *The Tenth Muse Lately Sprung Up in America,* including a 456-line composition (first written in 1643–44) called "Of the Four Ages of Man."[4] She identifies them in line 2 as

2. *The Pocket Book of Ogden Nash* (New York, 1952), 99–101.

3. See Samuel C. Chew, *The Pilgrimage of Life* (New Haven, Conn., 1962), 154–60. See also Creighton Gilbert, "When Did a Man in the Renaissance Grow Old?" *Studies in the Renaissance,* 14 (1967), 7–32; Keith Thomas, "Age and Authority in Early Modern England," *Proceedings of the British Academy,* 62 (1976), 205–48; and Robert A. Nisbet, *Social Change and History: Aspects of the Western Theory of Development* (New York, 1969).

4. The best edition is in *The Works of Anne Bradstreet,* ed. Jeannine Hensley

LE TEMPS VOLE SANS JAMAIS RETOURNER.

Sans cesse & sans retour on voit couler le Temps,
Et l'Automne, & l'Esté, l'Hiver, & le Printemps,
Mais depuis qu'une fois la saison est passée,
L'on ne la voit jamais retourner sur ses pas :
La route de nos jours est aussi compassée,
De moment à moment nous courons au trépas.

NIL

Figure 6. Time Leading the Seasons, a plate from Octavio Van Veen, *Quinti Horatii Flacci Emblemata* (Antwerp, 1612; Brussels, 1683).

186

being "Childhood and Youth, the Manly and Old Age," and she is far more concerned with the vexations of life than with its joys, with the vanities of man in this world than with his rewards. The four ages of man are related by a system of correspondences to the four elements and the so-called "humours." Just as Erik H. Erikson perceives a basic strength as well as a potential crisis in each of his eight stages, so Bradstreet presents both the best that youth can do "and then the worst in a more ugly hue."

On balance, however, her assessments are more negative than positive, more pessimistic than optimistic. Born into moral depravity, the Puritan child is beset by sins and dangers. Youth is arrogant and cruel, proud and licentious. He is inclined to "frolic" in gorgeous attire. Middle Age is a time of perilous ambition, a time of vulnerability to illness and disease—a vindictive and quarrelsome phase—but most of all, a time for hard and serious work. There are striking similarities here to Erikson's seventh stage, called adulthood, in which responsibility and caring for others are paramount, in which the mature person needs to steer away from stagnation and toward generativity. As Bradstreet put it:

> A father I, for children must provide;
> But if none, then for kindred near allied.
> If rich, I'm urged then to gather more,
> To bear a port i' th' world, and feed the poor.

Old Age takes pride in the accomplishments of a lifetime and yet recognizes the ephemeral folly of mortal achievements. Neither knowledge nor honor can forestall death.[5] Hence nostalgia, plus a modicum of wistful wisdom and a sheaf of wheat, are emblems of the elderly. This is, to be sure, a Christian life cycle; therefore, Bradstreet's last four lines juxtapose hope for eternal life against the vanities and vexations that have gone before:

(Cambridge, 1967), 51–64. The first twenty-eight lines of "Youth" most likely refer to the life of Sir Philip Sidney (1554–86), the Elizabethan soldier, statesman, and poet.

5. James Logan of Philadelphia translated Cicero's *Cato Major, or his Discourse of Old-Age* for Isaac Norris, a "neighbour then in his grand Climacteric." See Marie Elena Korey, *The Books of Isaac Norris (1701–1766) at Dickinson College* (Carlisle, Pa., 1976), 3.

> And I shall see with these same very eyes,
> My strong Redeemer coming in the skies.
> Triumph I shall o'er sin, o'er death, o'er hell,
> And in that hope I bid you all farewell.

Bradstreet used certain historical personages (such as Sir Philip Sidney) as prototypes for her characters. She could also draw upon her own experiences as a daughter, wife, and mother. Essentially, however, her quadripartite characterization was a Christian allegory, and that allegorical usage remained a powerful trope for more than two centuries. During the Great Awakening, for example, the sermons of such evangelical clergymen as Gilbert Tennent, Jonathan Edwards, William Cooper, and Ellis Gray described or referred to the life cycle much as Bradstreet had.[6] Significant changes would not begin to occur until the early nineteenth century.

The ethos of the young republic required a didactic literature for adults as well as for children, and the life cycle concept swiftly became one of the most important ingredients in that literature. At first, during the early decades of the nineteenth century, it would appear that little had changed since the days of Bradstreet and the eighteenth-century ministers. Their four-stage schematization remained dominant here, as it did in Europe. (Hegel's influential lectures on the life cycle, given in the 1820s, used the four-stage phasing.[7]) Nevertheless, a gradual shift in sensibility was under way. What was most symptomatic of that shift? The fact that the "voyage of life" metaphor, in literature and in art, displaced "the seasons" as the dominant image used to describe and explain the life cycle. "Displaced" is, in one sense, a somewhat misleading word, because the imagery of changing seasons was really incorporated into the rather more comprehensive "voyage of life" metaphor.

Even so, we can perceive a shift by the 1820s. The key document is Dr. Samuel Johnson's little essay "The Voyage of Life," which had

6. See Ross W. Beales, Jr., "In Search of the Historical Child: Miniature Adulthood and Youth in Colonial New England," *American Quarterly,* 27 (1975), 383–85; and Martha Brewster, *Poems on Divers Subjects* (New London, Conn., 1758), 3–4, 34.

7. See Jerrold Seigel, *Marx's Fate: The Shape of a Life* (Princeton, N.J., 1978), 17, 63. William Hogarth's popular series of mid-eighteenth-century engravings had included *The Four Times of the Day* (Morning, Noon, Evening, Night) and *The Four Stages of Cruelty* (the history of Tom Nero as a schoolboy, a brutal coachman, the vicious murderer of a servant girl pregnant with his child, and a corpse given to the dissector).

first appeared in *The Rambler* in 1751. It was readily available in the colonies even before the Revolution; it was tacked on, for example, at the end of the first American edition of Dr. Johnson's *Rasselas*, published in Philadelphia in 1768. In the new republic "The Voyage of Life" would be frequently reprinted in American schoolbook anthologies, such as Lindley Murray's *Sequel to the English Reader; or, Elegant Selections in Prose and Poetry*, which went through many printings during the 1820s; or Moses Severance's *The American Manual; or, New English Reader*, which was so popular during the 1830s.

Great numbers of American schoolchildren, as well as adults, read Dr. Johnson's essay: a didactic discussion of Reason, Hope, Ease, Intemperance, and Pleasure. Johnson acknowledged at the outset his own debt to Seneca (4 B.C.–65 A.D.): " 'Life,' says Seneca, 'is a voyage, in the progress of which, we are perpetually changing our scenes; we first leave childhood behind us, then youth, then the years of ripened manhood, then the more pleasing part of old age.' " The dominant imagery used by Johnson clearly emerges as a motif that must have deeply influenced the composition of Thomas Cole's four pictures called *The Voyage of Life* (Figures 7–10). Here are just a few illustrative passages from Johnson's allegorical essay. Compare them with Cole's paintings:

> he floats along the stream of time
> the whistle of winds, and the dash of waters
> the straits of Infancy
> launching out into the ocean of life
> now on the main sea, abandoned to the winds and billows
> a stream flowing through flowery islands
> full of rocks and whirlpools
> courting the gale with full sails[8]
> the current was invariable . . . it was impossible to sail against it
> the turbulence of the stream of life.

Thomas Cole was born in Lancashire, England, in 1801; emigrated to the United States in 1819; revisited England from 1829 to 1831; and

8. In the two final sets of *The Voyage of Life*, done in 1839–40 and 1842, Everyman's boat has no sails. At the Albany Institute of History and Art, however, there are four early studies (oil on wood) in which the boat in "Youth" has a very large sail; in "Manhood" that sail is being blown to tatters by a great gale. Cole made fewer changes in "Childhood" and "Old Age," but even the "duplicate" set done in 1842 differs in a number of details from the 1839–40 works.

Figure 7. The Voyage of Life: Childhood, by Thomas Cole (oil on canvas, 1839). Collection of Munson-Williams-Proctor Institute, Museum of Art, Utica, New York.

settled along the Hudson River in Catskill, New York, in 1832. We know that during the later 1820s he envisioned four pictures, to be called "Allegory of Human Life." He did not complete them until he received a suitable commission in 1839, however, and then titled his series *The Voyage of Life.* Its individual paintings correspond to Bradstreet's categories: Childhood, Youth, Manhood, and Old Age. They were publicly exhibited on several occasions and enjoyed immense popularity.[9] Cole made a duplicate set of canvases in 1842, and numerous engravings appeared after his death in 1848. These exhibitions and reproductions enjoyed considerable financial success; they inspired reviews, philo-

9. See *Cole's Pictures of the Voyage of Life, Now Exhibiting at the New Building* (New York, 1840); and Rev. Gorham D. Abbot, *Cole's Voyage of Life, a Series of Allegorical Pictures* (New York, 1860). For a poem that may have influenced Cole's conception of the allegory, see William Cullen Bryant, "The Past" (written in 1828 and first published in 1829) in *Poetical Works of William Cullen Bryant* (New York, 1893), 121.

Figure 8. The Voyage of Life: Youth, by Thomas Cole (oil on canvas, 1840). Collection of Munson-Williams-Proctor Institute, Museum of Art, Utica, New York.

sophical essays, poems, and numerous imitations in oil by amateurish contemporaries. Many a New York mansion during the Victorian era, for instance, contained a "meditation room"—really a kind of private chapel—and Cole's *Voyage of Life* series could frequently be found hanging in such rooms.[10]

Cole prepared program notes to accompany the display of his pictures, and his notes enable us to draw some contrasts with Bradstreet's earlier conception of the Four Ages of Man. In Cole's "Childhood," for example, a boat "bears a laughing infant," and luxuriant plants and spring flowers are "emblems of the joyousness of early life." Bradstreet's child, born to original sin, knows little of laughter and joyous-

10. See Esther I. Seaver, " 'The Voyage of Life': Four Paintings after Thomas Cole," *Baltimore Museum of Art News,* 18 (1955), 7–16; Edward H. Dwight and Richard J. Boyle, "Rediscovery: Thomas Cole's 'Voyage of Life,'" *Art in America,* 55 (1967), 60–63.

Figure 9. The Voyage of Life: Manhood, by Thomas Cole (oil on canvas, 1840). Collection of Munson-Williams-Proctor Institute, Museum of Art, Utica, New York.

ness. Although Cole's "Youth" contrasts less starkly with Bradstreet's, his is predictably more idealistic and romantic in its emphases. Cole's youth is inexperienced and has visions of grandeur, but he is neither arrogant nor cruel like Bradstreet's.

For Cole, "Manhood" was a time of trouble. Because "experience has taught us the realities of the world," we now are aware of sorrows; some men even contemplate "Suicide, Intemperance, and Murder." And so the landscape for this third phase is perilous: "rugged and dreary" by design. Although his "Old Age" suggests a scene of gloom, Cole nonetheless concludes on the same hopeful note that Bradstreet did: "the mind has glimpses of Immortal Life," and despair is vanquished by beams of heavenly light.[11]

11. See Louis Legrand Noble, *The Life and Works of Thomas Cole* (1853), ed. Elliot S. Vesell (Cambridge, 1964), 203, 210–12, 214–17, 220–23, 239–40; *Thomas Cole*

Figure 10. The Voyage of Life: Old Age, by Thomas Cole (oil on canvas, 1840). Collection of Munson-Williams-Proctor Institute, Museum of Art, Utica, New York.

Cole's attention to detail in these four pictures is ceaselessly fascinating. He adjusted the boat's golden figurehead, for example, very explicitly. Its facial expression changes from an almost vapid placidity (in Childhood) to serene confidence (in Youth) to anxiety (in Manhood); then, in Old Age, the figurehead disappears entirely. In the first three pictures the figurehead holds an hourglass in which the sands of time steadily run down; in the fourth there is no hourglass at all: time has simply run out. Similarly, the boat and its passenger cast less of a reflection in each successive picture—a signal that the waters on which Everyman sails become ever more murky with the passage of time.

There is good reason to believe that Cole had read Bradstreet's poem and that both his similarities and his differences from her vision of the

(1801–1848) One Hundred Years Later: A Loan Exhibition (Hartford, Conn., 1949), 12, 28–30; Howard S. Merritt, *Thomas Cole* (Rochester, N.Y., 1969), 90–93.

life cycle are intentional. He uses, for example, certain archaic words to be found in her poem, such as "cark" and "carking" (meaning a burden of anxiety) to contrast childhood with manhood.[12] His religious motivations in designing the series—suffused though they may be with a romanticism unknown to the seventeenth-century mind—are not so far removed from Bradstreet's Puritan piety. They shared a belief in the need for saving faith (in a "Superior Power"), most especially during Manhood. They both perceived the life cycle as sequential passages of growth through moral experience. And Cole called his subject "a poetical one."[13]

It became commonplace for Cole's contemporaries to refer to the "voyage of life." That metaphor, often in quite an extended form, pervades American literature during the middle third of the nineteenth century. That it did so should come as no surprise to anyone who is aware that we had maritime frontiers as well as continental ones in those days and that so many young men went to sea, either to seek their fortune or to escape from trouble, or else to flee the tyranny of family life.[14] When Charles Dickens visited Boston in 1841, he noted that New England preachers in particular relied heavily upon maritime imagery. He quoted, for example, from the Rev. Edward Thompson Taylor (1793–1871), historical prototype for Father Mapple in *Moby Dick*:

'Who are these—who are they—who are these fellows? where do they come from? Where are they going to—Come from! What's the answer?'—leaning out of the pulpit, and pointing downward with his right hand: 'From below!'—starting back again, and looking at the sailors before him: 'From below, my brethren. From under the hatches of sin, battened down above you by the evil one. That's where you came from!'—a walk up and down the pulpit: 'and where are you going'—stopping abruptly: 'where are you going? Aloft!'—very softly, and

12. Compare Cole's program notes for "Manhood" in Noble, *Cole*, 216, with Bradstreet, "Four Ages of Man," line 92. I am equally certain that Cole was familiar with, and influenced by, pertinent Italian paintings of the seventeenth century. Compare Cole's "Old Age" with *Christ at the Sea of Galilee* by Alessandro Magnasco (1667–1749) of the Genoese School, no. 532 in the National Gallery of Art, Washington, D.C.

13. Noble, *Cole*, 293–97; Cole to the Rev. J. F. Phillips, March 21, 1840, ibid., 211.

14. See, e.g., James Fenimore Cooper, *The Pilot* (1823; New York, n.d.), 225, 382, 393; Henry David Thoreau, *A Week on the Concord and Merrimack Rivers* (1849; New York, 1961), 22, 70, 93, 95–96; Laura Wood Roper, *FLO: A Biography of Frederick Law Olmsted* (Baltimore, Md., 1973), chap. 2, "Seafaring, 1840–1844."

pointing upward: 'Aloft!'—louder: 'aloft!'—louder still: 'That's where you are going—with a fair wind,—all taut and trim, steering direct for Heaven in its glory, where there are no storms or foul weather, and where the wicked cease from troubling, and the weary are at rest.'— Another walk: 'That's where you're going to, my friends. That's it. That's the place. That's the port. That's the haven. It's a blessed har- bour—still water there, in all changes of the winds and tides; no driving ashore upon the rocks, or slipping your cables and running out to sea, there: Peace—Peace—Peace—all peace!'"[15]

The fourth and fifth decades of the nineteenth century were the heyday of fleecy steamboats on such teeming American rivers as the Hudson, the Ohio, and the Mississippi. Americans gave great parties and held dances on steamboats. As one French visitor remarked in 1850, "the Americans frequently make voyages on the steamboats to pass the honeymoon."[16] In retrospect, therefore, it seems all but inev- itable that the "Voyage of Life" allegory should have become so popu- lar during the middle of the nineteenth century.

Inevitability does not diminish, however, the wonderful paradox that a quintessential metaphor in our paramount period of national chauvinism had its origins in, and was taken without modification from, high Georgian literature. Who would have imagined that Dr. Johnson might provide a mantra, so to speak, for the age of Manifest Destiny? We know all too well that Fate plays curious tricks upon us; but rarely such a wry one as this.

III

Although Cole's paintings are unquestionably the most famous ren- dering of the life cycle in American art, they are by no means the only version. The period from about 1825 to 1870 was especially fecund in supplying variations upon Cole's theme. The nature and extent of those variations are important for several reasons: (1) they reveal just how obsessed Americans really were with the life cycle during the middle decades of the nineteenth century; (2) they suggest that our customarily sharp distinctions between high culture and popular

15. Dickens, *American Notes for General Circulation,* ed. John S. Whitley and Arnold Goldman (1842; Harmondsworth, Eng., 1972), 107–8, 136.

16. Quoted in Bernard De Voto, *Mark Twain's America* (Boston, 1932), 104, 320.

culture have perhaps been overdrawn; (3) they call attention to, and in fact highlight, a major transition in American conceptions of the life cycle following the decade 1840–50; and (4) they lead us to some utterly neglected yet extraordinarily symptomatic sources for the study of American culture. The iconographic evidence we will look at next is about as obscure as Cole's paintings are familiar.

Consider, for example, a large landscape composition by Asher B. Durand called *An Old Man's Reminiscences* (Figure 11). An oil on canvas that he painted in 1845, it hangs today in the Albany Institute of History and Art. The several Durand catalogs tell us very little about it; according to tradition it "may have been" inspired by Oliver Goldsmith's famous poem, "The Deserted Village."[17] Perhaps—but in 1840, immediately influenced by Cole's work, Durand had done two very large compositions called *The Morning of Life* and *The Evening of Life* (both in the National Academy of Design in New York). Five years later he obviously attempted, in an interesting way, to incorporate the entire life cycle allegory into a single scene. There is the old man contemplating various episodes, or phases, of his life: children at play, a courting couple, a man in a boat on a stream, and so forth. Chromolithographs of this painting enjoyed considerable popularity.[18]

Quite clearly, it depicts more than four stages of the life cycle, and that is an important phenomenon for us to note because the popular art ("midcult" in Dwight Macdonald's lexicon) of the 1830s and 1840s tended to favor a ten-stage presentation. These were didactic pictures but without being allegorical, and they suggest that a gradual transformation in American perceptions of the life cycle must have been in progress.

Figure 12, for example, shows a watercolor on paper called *Stages of Man,* and it dates from about 1825. (It might have been copied or adapted from one of the similar European prints that sold inexpensively and were available in the United States.) In this illustration the life-cycle phases are mechanically defined by decades—ten years old, twenty years old, thirty years old, and so on, right down to one hundred years old—and in that sense it seems, at first glance, rather uninteresting for our purposes. It certainly reveals no very clear con-

17. See John Durand, *The Life and Times of A. B. Durand* (New York, 1894), 173.
18. See Montclair Art Museum, *A. B. Durand, 1796–1886* (Montclair, N.J., 1971), 54–55, 57.

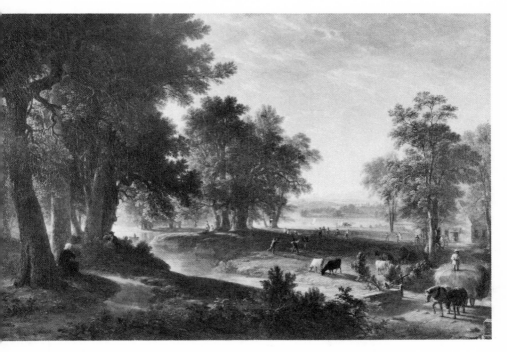

Figure 11. An Old Man's Reminiscences, by Asher B. Durand (oil on canvas, 1845). Collection Albany Institute of History & Art.

ceptualization of the life cycle, except for the possible inference that age fifty is the pinnacle of human existence.[19]

And yet four of the inset scenes provide—admittedly in a rather simplistic way—the same sense of ritualization that Erikson has attempted in a more sophisticated form in his book *Toys and Reasons*.[20]

19. An important study has, in fact, shown that a man did not usually become a community leader in New England until he had reached his late forties. The pinnacle of a local political career came at about the age of fifty. See Edward M. Cook, Jr., *The Fathers of the Towns: Leadership and Community Structure in Eighteenth-Century New England* (Baltimore, Md., 1976), 109–10.

20. Erikson, *Toys and Reasons: Stages in the Ritualization of Experience* (New York, 1977). Ralph Waldo Emerson may have been reacting against such mechanistic schematizations when he wrote in his journal (May 1838): "A great man escapes out of the kingdom of time; he puts time under his feet. He does not look at his performance and say, I am twenty, I am thirty, I am forty years old, and I must therefore accomplish somewhat [*sic*] conspicuous. See Napoleon at twenty-five, see what he had done at

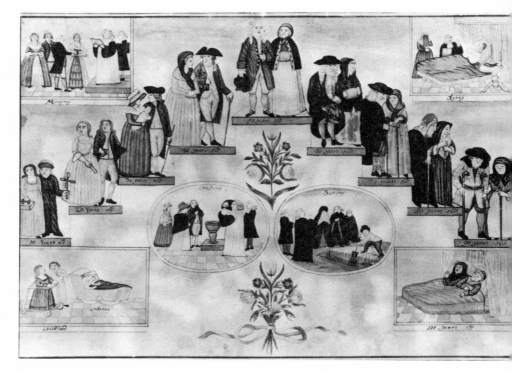

Figure 12. Stages of Man (watercolor on paper, ca. 1825). Abby Aldrich Rockefeller Folk Art Center, Williamsburg, Virginia.

By calling attention to the ceremonials attached to christening, marriage, deathbed rites, and burial, this artist acknowledged that special benchmarks in the process of maturation are at least as important as rhythmic ten-year anniversaries.

Other versions of the same theme, continued to appear during the nineteenth century. The picture in Figure 13, for instance, is titled *Stages of Man's Life from the Cradle to the Grave.* It is also a watercolor on paper, and it dates from about 1850. It seems to have been based upon

forty. He says rather, Is this that I do genuine and fit? Then it contributes no doubt to immortal and sublime results; no doubt it partakes of the same lustre itself" (*Journals of Ralph Waldo Emerson,* ed. Edward W. Emerson and Waldo E. Forbes [Boston, 1910], IV, 444–45). See also Emerson's entry for December 28, 1831, II, 441. I am indebted for these references to Richard Lebeaux of Michigan State University.

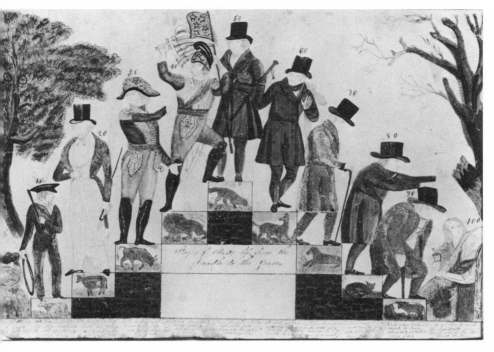

Figure 13. Stages of Man's Life from the Cradle to the Grave (watercolor on paper, ca. 1850). Abby Aldrich Rockefeller Folk Art Center, Williamsburg, Virginia.

a popular print of the same title made by Nathaniel Currier during the 1840s. It is a cruder composition than Figure 12, both in artistic execution and also in its striking domination. The importance of women is acknowledged only at the extreme ends of the life cycle: to provide domestic nurture for the small child and, ultimately, comfort for the dying centenarian. Between those terminal points, apparently, this artist's apprehension of reality is exclusively a man's world.[21]

Are we then looking at yet another example of the embarrassing phenomenon that David M. Potter called to our attention in 1962:

21. A much more elaborate rendering of the theme was advertised in the 1978 catalog of the Old Print Gallery in Georgetown, Washington, D.C. It is called *The Life and Age of Man: Stages of Man's Life from the Cradle to the Grave*. Below a large, wood-engraved illustration of the ten-stage life cycle, there is a twenty-six-stanza poem full of moralistic directives. Many of the verses compare man at different ages to various animals: e.g., "At ten he goat-like skips, and joys / in idle spurts and foolish toys."

namely, "that men will be regarded as the normative figures in the society, and that, in popular thought at least, the qualities of the masculine component in the society will pass for the qualities of the society as a whole"?22 Not quite. As we can see in Figure 14, *The Life and Age of Woman,* engraved in the mid- or later 1830s, at least some contemporaries perceived that women's life cycle was not the same as men's. To take only the most obvious example, age thirty (rather than age fifty) is designated as the "noon of life" for women, the "zenith of her intellectual and physical powers."

To say that Americans of the Jacksonian era recognized a different rhythm in women's lives, however, is *not* to say that they were ahead of their times. It merely means that they did not *altogether* subsume women under the generic category of Man. In most respects this engraving by Albert Alden (1812–83) of Barre, Massachusetts, is entirely consistent with the subordinate role and domestic sphere prescribed for females at that time. The epigram just below the clock and above the mother and daughter is taken from Proverbs 12: "THE VIRTUOUS WOMAN IS A CROWN TO HER HUSBAND." The print suggests that women have a distinctive life cycle of their own: partially for biological reasons, and partially because they have separate social functions. Alden may have regarded women as the "gentle sex," but at least he did not ignore them.23

Ample evidence indicates that American women themselves were deeply interested in conceptualizations of the life cycle, that they were responsive to the current didacticism and imagery, and that they were producers as well as consumers of such materials. We have the example of Catharine Beecher, age twenty-two, writing to her father: "I am like a helpless being placed in a frail bark, with only a slender reed to guide its way on the surface of a swift current that no mortal power could ever stem, which is ever bearing to a tremendous precipice, where is inevitable destruction and despair. If I attempt to turn the swift course of my skiff, it is only to feel how powerful is the stream

22. Potter, "American Women and the American Character," in *History and American Society: Essays of David M. Potter,* ed. Don E. Fehrenbacher (New York, 1973), 279.
23. *The Life and Age of Woman* must have been a very popular print; Currier and Ives struck eleven impressions of it. Albert Alden moved from his native Yarmouth, Mass., to Barre in 1834, where he lived until 1853. For a more conventional, ten-stage presentation of "The Life and Age of Woman," see the Currier and Ives print reproduced on the back cover of *American Heritage,* December 1976.

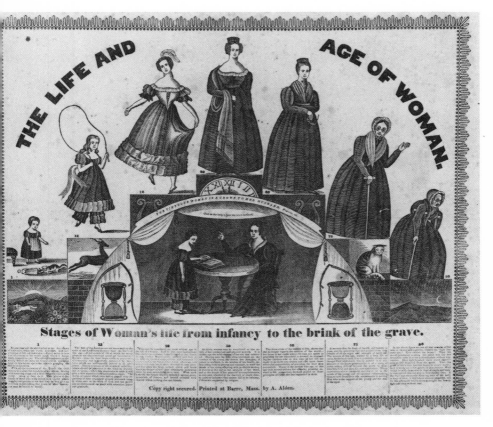

Figure 14. The Life and Age of Woman, by Albert Alden (engraving on paper, ca. 1834–44). Abby Aldrich Rockefeller Folk Art Center, Williamsburg, Virginia.

that bears it along. If I dip my frail oar in the wave, it is only to see it bend to its resistless force."[24]

Early in 1842 the *Boston Miscellany* published an English translation of a German essay on the phases of a woman's life. Subsequently Dr. Mary E. Walker, a Civil War medical worker and dress reformer from Oswego, New York, wrote a poem that demarked woman's life into six stages, an unusual number.

24. Quoted in Kathryn Kish Sklar, *Catharine Beecher: A Study in American Domesticity* (New Haven, Conn., 1973), 41. See also Peter R. Uhlenberg, "A Study of Cohort Life Cycles: Cohorts of Native-Born Massachusetts Women, 1830–1920," *Population Studies,* 23 (1969), 407–20.

When I Would Die and How
The Voices of Six Stages.
I would not die in infant years,
With no ideas of life—
Without a sense of hopes or fears,
Or even bitter strife.
I would not die in childhood days,
Ere I one earth joy knew—
In having many kinds of plays,
With other children true.
I would not die in life mature,
With all its castles built—
And golden hopes that seem secure,
With wreaths that never wilt.
I would not die in middle life,
Just when fruitions come—
When children bless husband and wife,
The midday of life's sun.
I would not die when age creeps on,
With mental gains in store—
When to be numbered with the "ton,"
Showered with blessing o'er.
I would not die until I felt,
A longing then to go—
And into future life would melt,
As gently as the snow.
At whatever time in life's date,
I go to fields Elysian—
I've never longed to see that state,
Through quiet transition.[25]

Alden's division of the woman's life cycle into seven stages and Walker's into six lead us to ask a critical question: Why should there have been a discrepancy between Thomas Cole's four stages and the popular prints that commonly extended the life cycle up to ten stages? They were almost contemporaneous. Isn't it curious, therefore, that quite different schematizations should have enjoyed a great vogue si-

25. Manuscript in private hands, quoted by Fred P. Wright in "Dr. Mary E. Walker," *Oswego County Yearbook* (1953), 46–53, and reprinted in *Bicentennial Issue, The Journal,* published by the Oswego County Historical Society (1977), 154–55.

multaneously? Not really. Not if we recognize that we are watching two related but discrete cultural traditions that became intertwined, enjoyed tremendous popularity together during the second quarter of the nineteenth century, and then went their separate ways: Cole's Christian allegory into decline, and the more secular and biological taxonomy toward its twentieth-century ascendancy.

We find some useful clues in two very brief articles that appeared in 1831 and 1840 in the *Boston Medical and Surgical Journal*. The first is titled "The Stages of Human Life." It is full of mathematical foolishness, but it does include the accompanying chart, which transposes the ten decennial "stages" of the popular iconography into the four "ages" of Anne Bradstreet and Thomas Cole.

Stages.	Weeks.	Years.	Weeks.	Days.	Natural Epochs.	Ages.
	40		40		Lactation,	} Childhood,
1	400	7	34	6	Milk teeth,	
2	800	15	27	3	Childhood,	} Youth,
3	1200	23			Youth,	
4	1600	30	34	5	Maturity.	}
5	2000	38	17	2		} Middle age,
6	2400	45	52			}
7	2800	53	34			}
8	3200	61	17	1		} Decline.
9	3600	68	51	6		}
10	4000	76	3	3		}

The chart, at first glance, may seem to be saying little more than the equivalent of "a gallon contains four quarts, but it also contains eight pints; divide your gallon to suit your convenience or your handiest unit of measurement." In fact, the chart conveys something more meaningful than that, because in the sentence immediately preceding it the anonymous author distinguishes between "the external and internal life." That is the critical clue. The external life corresponds to the mechanistic decennial divisions, and the internal life corresponds to the traditional Four Ages of Man: childhood, youth, manhood, and old age.

The 1840 article, titled "The Periods of Human Life," calls favorable attention to a formulation of the "ages of man" first published in 1825. It divides the life cycle into fifteen phases, stopping at the age of 105! Obviously, this schematization is entirely "external." The article does

not mention the Four Ages of Man or, for that matter, any scheme that might be considered an "internal" one.[26]

Thomas Cole's Christian allegory described and pertained to the "internal life." It reached back through Jonathan Edwards and other Awakeners to connect with Anne Bradstreet's Calvinist ethos. It peaked in popularity during the 1830s, '40s, and early '50s because evangelical Christianity was such a potent cultural force in those years. After the 1850s, however, as evangelical Protestantism became less pervasive and waned in fervor, interest in the spiritual life cycle waned, too. Not immediately and not entirely, but gradually. Although some vestiges lingered, even they had almost disappeared by the end of the nineteenth century. Just before Sidney Lanier's tragic and premature death in 1881, for instance, he indicated his desire to compose a poetic symphony called *Life* "in four movements, 1st Childhood, 2nd Youth, 3rd Manhood, 4th Old Age." That very same year Walt Whitman composed his brief poem titled "Youth, Day, Old Age and Night." And in Sarah Orne Jewett's *The Tory Lover* (1901), one character declares: "Lord bless us, when he's old's we are, he'll l'arn that spring al'ays gets round again long's a creatur' 's alive. . . . Ary thing that's livin' knows its four seasons, an' I've long maintained that after the wust o' winter, spring usu'lly doos come follerin' right on."[27]

By contrast, the "external life" that is delineated in *Stages of Man's Life* (Figure 13) or *The Life and Age of Woman* (Figure 14) would gain

26. "The Stages of Human Life," *Boston Medical and Surgical Journal*, 4 (June 14, 1831), 289–91; E. G. Wheeler, "The Periods of Human Life," ibid., 22 (June 29, 1840), 395–96.

27. Lanier to Sarah J. Farley, February 12, 1881, *The Centennial Edition of the Works of Sidney Lanier*, ed. Charles R. Anderson (Baltimore, Md., 1945), X, 290; *The Complete Poetry and Prose of Walt Whitman* (New York, 1948), 221; Jewett, *The Tory Lover* (Boston, 1901), 101. In 1868 Currier and Ives produced four prints called *The Four Seasons of Life*. The subtitles were "Childhood, the Season of Joy," "Youth, the Season of Love," "Middle Age, the Season of Strength," and "Old Age, the Season of Rest." Although the four-season format might seem to echo Thomas Cole, it is a very distant echo. As their subtitles suggest, the Currier and Ives pictures are much more sanguine—indeed, cheerfully optimistic—than Cole's. His Christian allegory, moreover, is almost entirely gone from the 1868 prints: e.g., "Old Age" in the Currier and Ives series bears no resemblance whatever to Cole's "Old Age." In the former an elderly couple is seated in their living room. The woman knits and smiles serenely. The man listens while his granddaughter reads to him. He, too, is serene. The scene is tranquil and domestic, and there is no religious element except for an oversize book, presumably the family Bible, which rests unobtrusively on a table. See Harry T. Peters, *Currier & Ives: Printmakers to the American People* (Garden City, N.Y., 1929), I, 242, and nos. 1076–79; II, no. 146.

Figure 15. Stages of Life (crate wood, ca. 1880), probably made on the estate of Mrs. Margaret Sargent McKean, north shore of Boston. Courtesy of the Schnabel Galleries, Hingham, Massachusetts.

momentum with the passage of time: not so much during the later nineteenth century—though Figure 15 provides a charming example of it in folk sculpture from about 1880—but after 1920 with the full impact of G. Stanley Hall and anthropological "life histories" in the United States. Thereafter, American social scientists groped toward a formula that would enable them to understand and explain both the external and the internal, or psychological, life. That search goes forward to this day and will undoubtedly continue. Before we examine what has happened to conceptions of the life cycle in the twentieth century, however, let us tidy up some loose ends pertaining to the nineteenth.

The "external" life cycle in popular iconography of the mid-nineteenth century was derived from European prints, which had become easily accessible and inexpensive. They, in turn, originated in a tradition that dated back a century and a half, at least, to the later seventeenth century. Figure 16, *Ye Steps of Old Age,* is an English engraving of that period. It is the ancestor of Figures 12–15, partly because it

Figure 16. Ye Steps of Old Age (English engraving on laid paper, ca. 1675–1700). Courtesy, The Henry Francis du Pont Winterthur Museum.

elucidates ten phases rather than four and partly because it is covered, quilt-like, with didactic messages.

The pictures by Thomas Cole and Asher B. Durand were no less moralistic, but they were addressed to a more educated clientele: people who knew scripture, and perhaps some of that literature called spiritual autobiography, and did not need to have every little homily made explicit. Cole and Durand appealed to an audience that might have ranged from "midcult" to "high" culture; the Currier and Ives prints appealed to an audience that ranged from "folk" culture to "midcult." Although such categories are both clumsy and crude, they have been with us for so long that they have a certain utility and resonance. Moreover, they make no pretense at being precise. They are exactly what they seem: rough measures of cultural stratification.[28]

28. See Van Wyck Brooks, *America's Coming of Age* (1915), reprinted in *Three*

IV

In the twentieth century, cultural custody of (as well as interest in) the life cycle concept has shifted almost entirely to the social (and, to a much lesser degree, the biological) sciences: psychology, anthropology, psychiatry, and most recently the "new" social history. More sophisticated perceptions of the life cycle have accompanied, and in some instances have occurred as responses to, actual changes involving particular phases of the life cycle itself. The stage we know as adolescence, for example, came slowly to be recognized during the later nineteenth century and then achieved a lengthy articulation in 1904 from G. Stanley Hall.[29]

Enough has been written about Hall that his important contributions can be handled summarily here. He was immensely interested in the life cycle. Like Erik Erikson, Hall worked extensively on aspects of adolescence during the first half of his professional career (the 1880s and 1890s); like Erikson also, Hall then turned his attention to middle and old age during the waning years of his career, culminating in the publication of *Senescence: The Last Half of Life* in 1922, when Hall had reached the age of seventy-eight. He perceived adolescence as lasting well into the twenties; maturity from the mid- or late twenties until about forty-five; and senescence from about forty-five until death.[30]

Whereas the age groupings to be found in Bradstreet's poetry and Cole's paintings were allegorical and symbolic, Hall and Erikson both sought to be descriptive, and fairly precise at that, not to mention prescriptive in some respects. (Yet Erikson's work barely mentions that of Hall, even though Erikson occasionally uses a vocabulary and combinations of words strongly reminiscent of Hall.[31]) As Winthrop

Essays on America (1934), ed. James R. Vitelli (New York, 1970), 17–19, 78–79; and Dwight Macdonald, "Masscult and Midcult," in *Against the American Grain* (New York, 1962), 3–75; but cf. Herbert J. Gans, *Popular Culture and High Culture: An Analysis and Evaluation of Taste* (New York, 1974).

29. See Hall, *Adolescence* (New York, 1904); Joseph F. Kett, *Rites of Passage: Adolescence in America, 1790 to the Present* (New York, 1977), esp. 216–29, 234–39; John and Virginia Demos, "Adolescence in Historical Perspective," *Journal of Marriage and the Family,* 31 (1969), 632–38.

30. See Dorothy Ross, *G. Stanley Hall: The Psychologist as Prophet* (Chicago, 1972), 252–54, 430–32. Hall's perception of five "chief stages" in the life cycle is somewhat tied to nineteenth-century notions of evolutionary theory. His work on stages of the life cycle lacks Erikson's explanatory power in relation to ego and personality development.

31. See, e.g., Erikson, "Reflections on Dr. Borg's Life Cycle," *Daedalus,* 105

Jordan has written, the "general tendency in various schools of psychology in the early twentieth century was to segment the life cycle into increasingly discrete and well defined units. An accompanying tendency was fully as important: the various segments of the life cycle were seen not merely as temporal stages but as *descriptions* of inner life and external behavior."[32]

Studies of the life cycle moved in several new directions during the 1930s. Psychologists like Arnold Gesell looked more closely at stages of childhood and adolescence, while William Healy, one of Erik Erikson's teachers, explored the formation of personality.[33] Of greater interest and perhaps more enduring importance was the concept of life history, developed by a cluster of thoughtful and imaginative social scientists. As John Dollard explained in 1935, the life history sought "to define the growth of a person in a cultural milieu and to make theoretical sense of it."[34] Dollard felt that he was ploughing a common ground that would be fertile for psychologists, sociologists, psychiatrists, and ethnologists. His interest lay in the relationship between culture and personality—"the life history is an account of how a new person is added to the group and becomes an adult capable of meeting the traditional expectations of his society for a person of his sex and age"—yet his primary emphasis was to enrich our understanding of culture by adding a new, individualized method and dimension to its study.

Simultaneously, American anthropologists pursued a separate but related approach: a summary view of the human life cycle—generalized rather than individualized—in cultures somewhat different from

(Spring 1976), 16: "between adolescence and senescence." Erikson's "epigenetic diagram" is important, among other reasons, because it indicates the extent of his desire to be both more comprehensive and more precise than his forebears. See Richard I. Evans, *Dialogue with Erik Erikson* (New York, 1967), 21–22.

32. Jordan, "Searching for Adulthood in America," *Daedalus,* 105 (Fall 1976), 8. The units were not always so "well defined," esp. prior to World War II; otherwise, Jordan's point is very well taken.

33. See Gesell, *Infancy and Human Growth* (New York, 1928), *The Guidance of Mental Growth in Infant and Child* (New York, 1930); *An Atlas of Infant Behavior: A Systematic Delineation of the Forms and Early Growth of Human Behavior Patterns* (New Haven, Conn., 1934), *The Psychology of Early Growth* (New York, 1938), and *Biographies of Child Development* (New York, 1939); Healy, *Personality in Formation and Action* (New York, 1938).

34. Dollard, *Criteria for the Life History: With Analyses of Six Notable Documents* (New Haven, Conn., 1935), 3, 4.

our own. One such work, now considered a classic in the field, is *An Apache Life-Way* by Morris E. Opler, in which the author's design was to introduce events and phenomena "in the order in which they are experienced in the course of the normal Chiricahua Apache life-cycle."[35] Opler's emphasis falls implicitly upon four phases: childhood; maturation; adulthood; death, mourning, and the underworld. His remarkable study might have sensitized Erikson, at a critical juncture in his development, against generalizing too readily about what can be considered normative or universal in the human life cycle.

Both of these approaches—Dollard's and Opler's—have been very fruitful and continue to be influential. The writing of life histories remains a vigorous pursuit today.[36] Yet Dollard's hope that he was providing a common ground for social scientists proved to be illusory. Why? In part because social scientists do not seem to browse much beyond the confines of their own well-defined disciplines; how else can we explain this incredible statement in an otherwise intelligent book on the life cycle in America, written by a prominent psychologist: "Although the study of the individual life cycle is generally considered an appropriate field of inquiry in the social sciences, nevertheless it remains virtually untouched."[37] In part, also, because there seems to be a basic incompatibility between the social psychologists' working assumptions and those of such psychiatrists as Erik Erikson and such psychologists as Kenneth Keniston and Daniel J. Levinson: whereas Dollard insisted that "the continuous related character of experience from childhood through adulthood must be stressed," Erikson, Levinson, and Keniston are much more interested in problems of *discontinuity* in the human life cycle, in moments of crisis and times of transition. They are most concerned with the sense of Self as a person apart, an individual in tension with society and culture.

During the 1960s and '70s, Erik Erikson's perception of the life cycle was like a spectacular flower: it attracted an extraordinary amount of attention; its seeds were very widely scattered; and they germinated with remarkable success. Such a best seller as Gail Sheehy's *Passages,* for example, is really a pop-sociological gloss (or adaptation) from

35. Opler, *An Apache Life-Way: The Economic, Social, and Religious Institution of the Chiricahua Indians* (Chicago, 1941), ix.

36. For an important example, see James M. Freeman, *Untouchable: An Indian Life History* (Stanford, Calif., 1979). Cornell University offers Anthropology 452, "Portraits, Profiles, and Life Histories," in which each student prepares a life history.

37. Daniel J. Levinson, *The Seasons of a Man's Life* (New York, 1978), 47.

Erikson's work.[38] Erikson and his writings have elicited a great deal of admiration as well as critical attention—especially his reflections (and continual refinements of those reflections) about the life cycle. It is not my purpose here to evaluate Erikson's schematization; others have done so at length, and they are far better qualified to do so than I am.[39] What *does* interest me, however, and what has been surprisingly neglected, is the matter of Erikson's relationship to his forebears: his predecessors in American thought and culture who also concerned themselves with the life cycle. Insofar as their schematizations differ from Erikson's, one might say that the flower we have been examining belongs to a plant that has undergone long-term mutations.

It is not my intention to fault Erikson for his neglect of American intellectual history. That would be, rather obviously, a fatuous exercise. Yet the fact remains that he seems to have been oddly oblivious to his conceptual forebears, or else simply uninterested in them. He certainly does not mention them or indicate awareness of them in any of his numerous essays on the life cycle. Except for Freud, Erikson acknowledges no predecessors with respect to this important aspect of his thought.[40] In one respect, that is perfectly understandable: Erikson did not have very much formal education, and he did not come to the United States until the age of thirty-one. There is no reason whatever for him to have read Anne Bradstreet's poetry, or to have examined Thomas Cole's paintings, or to have read undistinguished popular literature of the nineteenth century.

There is, on the other hand, considerable reason for him to have read G. Stanley Hall, the seminal psychologist, or such a pioneering anthropologist as Morris E. Opler.[41] It is passing strange, to say the

38. See Sheehy's excessively mechanistic *Passages: Predictable Crises of Adult Life* (New York, 1976), esp. 13–14, 356; and the essay "All of Life's a Stage," in *Newsweek,* June 6, 1977, p. 83.

39. See Robert Coles, *Erik H. Erikson: The Growth of His Work* (Boston, 1970); Paul Roazen, *Erik H. Erikson: The Power and Limits of a Vision* (New York, 1976), chap. 7; David Elkind, "Erikson's Eight Ages of Man," *New York Times Magazine,* April 5, 1970, pp. 25–27, 84–92, 110–19; and David Gutmann, "Erik Erikson's America," *Commentary,* 58 (September 1974), 60–64.

40. Citations to Freud's work abound in Erikson's writings, and one might literally say that Sigmund and Anna Freud were Erikson's principal faculty. Paul Roazen (*Erikson,* 12) has made the interesting point that Erikson frequently cites Freud's single mention of the concept of inner identity—as though Erikson needed to legitimize his own original idea by somehow locating its roots in Freud's work.

41. I am reasonably certain that during the later 1930s and early '40s, when Erikson

least, that Erikson should devote an entire essay to Dr. Isak Borg's fictive life cycle in Ingmar Bergman's motion picture *Wild Strawberries*,[42] but does not mention G. Stanley Hall in his work. We know that Erikson has been an analyst and an intuitive thinker rather than a stack-burrowing researcher, but there are (or at least ought to be) limits to his intellectual self-containment.

Erikson's concern for the human life cycle has been the most persistent theme and integrating focus of his work. It receives a crucial chapter in *Childhood and Society* (1950, 1963) and was the subject of his popular undergraduate course at Harvard throughout the 1960s. Erikson devoted a substantial section to it in *Identity: Youth and Crisis* (1968) and provided a long essay titled "Life Cycle" for the *International Encyclopedia of the Social Sciences* (1968). He elaborates upon the concept in *Life History and the Historical Moment* (1975) and does so even more in a later volume, *Toys and Reasons: Stages in the Ritualization of Experience* (1977).

Erikson has divided the life cycle into eight sequential stages. He perceives each one as a psychosocial phase of ego development in which the individual ought to establish new orientations toward him- or herself and the societal environment. Erikson defines each stage in terms of both a positive attribute and a negative component. He has diagrammed the stages and their attributes as shown in Figure 17.[43]

Erikson has explained that this diagonal arrangement "signifies a successive development and hierarchic differentiation of psychosocial strengths." He regards each transition in the sequence as a develop-

worked on childhood among two American Indian tribes, the Sioux and the Yurok, he would have read Edward Sapir's well-known essay "Cultural Anthropology and Psychiatry" (1932), reprinted in *Selected Writings of Edward Sapir*, ed. David G. Mandelbaum (Berkeley, Calif., 1949), 509–21. Erikson must also have been familiar with the work of Else Frenkel-Brunswik at Berkeley, who perceived five major phases in the life cycle. Her "Studies in Biographical Psychology" first appeared in 1936 and later (1963) in a revised form as "Adjustments and Reorientation in the Course of the Life Span," reprinted in Bernice L. Neugarten, ed., *Middle Age and Aging* (Chicago, 1968), 77–84. Erikson alludes to her work only in a brief footnote to *Childhood and Society*, 2d ed. (New York, 1963), 417. In the bibliography at the end of Erikson's article "Life Cycle" in the *International Encyclopedia of the Social Sciences* (New York, 1968), IX, 286–92, he includes *unpublished* manuscripts of his own but never mentions the published work of Frenkel-Brunswik!

42. Erikson, "Reflections on Dr. Borg's Life Cycle," 1–28.

43. From Erikson, "Life Cycle," 287, where the chart is adapted in turn from Erikson's *Childhood and Society*.

		1	2	3	4	5	6	7	8
VIII	MATURITY								EGO INTEGRITY VS. DESPAIR
VII	ADULTHOOD							GENERATIVITY VS. STAGNATION	
VI	YOUNG ADULTHOOD						INTIMACY VS. ISOLATION		
V	PUBERTY AND ADOLESCENCE					IDENTITY VS. ROLE CONFUSION			
IV	LATENCY				INDUSTRY VS. INFERIORITY				
III	LOCOMOTOR-GENITAL			INITIATIVE VS. GUILT					
II	MUSCULAR-ANAL		AUTONOMY VS. SHAME, DOUBT						
I	ORAL SENSORY	BASIC TRUST VS. MISTRUST							

Figure 17. Psychosocial Crises in the Life Cycle, from "Life Cycle," by Erik H. Erikson. Reprinted by permission of the publisher from the *International Encyclopedia of the Social Sciences,* David L. Sills, Editor. Volume 9, page 287. Copyright © 1968 by Crowell Collier and Macmillan, Inc.

mental crisis—"connoting not a threat of catastrophe but a turning point, a crucial period of increased vulnerability and heightened potential"—and believes that the diagonal indicates a "necessary sequence of such encounters but leaves room for variations in tempo and intensity." He has concluded that psychosocial strength "depends on a total process which regulates individual life cycles, the sequence of generations, and the structure of society simultaneously, for all three have evolved together."[44]

Erikson has attempted, then, to define a series of "ego values" or "ego qualities" characteristic of each successive phase in the life cycle. His perception of the life cycle is distinctive in that its phases are defined by the individual's interaction with a widening social network. It is also distinctive because of his special emphasis upon the attainment of ethical qualities: "As the individual proceeds developmentally from

44. Erikson, "Life Cycle," 286–87, 292.

the moralism of childhood through the ideology of adolescence to some adult ethics, the characteristic gains and conflicts of the early stages are not abandoned but, in the best of circumstances, renewed and reintegrated."[45]

Erikson's relentless refinements of his schematization have led him toward greater taxonomic elaboration. Having established distinct age categories, having related them to patterns of cultural conflict and historical change, and having illustrated them with biographical vignettes and more lengthy psychobiographical studies, he has gone on to attach an appropriate ritual to every stage of individual development. The chart in Figure 18 is designed to show how "each of the ritualizations that helped to integrate the stages of ontogeny provide a basic element for the major rituals which help to hold some basic institutions of society together: namely, faith in a cosmic order, a sense of law and justice, a hierarchy of ideal and evil roles, the fundamentals of technology, and ideological perspectives."[46]

Some of Erikson's critics have faulted him for asserting that his developmental stages are valid for all cultures at all times.[47] That charge is not entirely justified, however, because after Erikson's first visit to India in 1962 he began to show some awareness of the Hindu concept of four periods in the life of a man.[48] That exception to the contrary notwithstanding, Erikson's generic concept of eight stages is biologically based but also closely linked to his deep concern that mankind has become lamentably divided into what he calls "pseudo-species." His impulse, even after 1962, has therefore been to minimize differences within the family of man. As he explained in an interview published in 1967: "Insofar as every human being is born as an organism, there are certain aspects in his development which remain universal, no matter where he grows up. The culture can only aggravate or play down, and in that way make the stages more or less intense, or

45. Erikson, *Life History and the Historical Moment* (New York, 1975), 206.

46. Erikson, *Toys and Reasons*, 113–14.

47. See, e.g., Howard I. Kushner, "Pathology and Adjustment in Psychohistory: A Critique of the Erikson Model," *Psychocultural Review*, 1 (1977), 497.

48. See, e.g., Erikson, *Childhood and Society*, 108n; and esp. Erikson, *Gandhi's Truth: On the Origins of Militant Non-Violence* (New York, 1969), 34–39, 177, 399–400. For approaches to the life cycle in Indian culture, see Sudhir Kakar, "The Human Life Cycle: The Traditional Hindu View and the Psychology of Erik H. Erikson," *Philosophy East and West*, 18 (1968), 127–36; K. M. Sen, *Hinduism* (Baltimore, Md., 1961), 22–23; and William H. and Charlotte Viall Wiser, *Behind Mud Walls, 1930–1960* (Berkeley, Calif., 1963), 151–52.

ONTOGENY OF RITUALIZATION

	NUMINOUS	JUDICIOUS	DRAMATIC	FORMAL	IDEOLOGICAL	GENERATIONAL SANCTION
infancy	mutuality of recognition					
early childhood		discrimination of good and bad				
play age			dramatic elaboration			
school age				rules of performance		
adolescence					solidarity of conviction	
elements in adult rituals	NUMINOUS	JUDICIOUS	DRAMATIC	FORMAL	IDEOLOGICAL	GENERATIONAL SANCTION

(Toys and Reasons)

Figure 18. Ontogeny of Ritualization. Reprinted from *Toys and Reasons: Stages in the Ritualization of Experience,* by Erik H. Erikson, by permission of W. W. Norton & Company, Inc. and Marion Boyars Ltd, London. Copyright © 1977 by W. W. Norton & Company, Inc.

more or less prolonged. And it can aggravate or smooth out the transitions. But what emerges is pretty much tied to what is fundamental to the psychosexual stages as well."[49]

We know that Erikson read Ruth Benedict's famous article "Continuities and Discontinuities in Cultural Conditioning" because he cites it once in a footnote to *Childhood and Society* (p. 236 n.4). He does not seem to have been influenced by it, however, because he has obviously ignored (or else strongly disagrees with) Benedict's anthropological perspective. "All cultures must deal in one way or another with the cycle of growth from infancy to adulthood," she wrote. But then comes this vigorous contention: "Although it is a fact of nature that the child becomes a man, the way in which this transition is effected varies from one society to another, and no one of these particular cultural bridges should be regarded as the 'natural' path to maturity."[50] (For a depiction from the Far East, see the Japanese example in Figure 19.)

It is ironic, in one sense, that Erikson has achieved such fame as a practitioner of psychohistory and psychobiography. Although he has, indeed, been a profoundly influential pioneer in these areas of inquiry,

49. Evans, *Dialogue with Erikson,* 23.

50. Benedict, "Continuities and Discontinuities in Cultural Conditioning," *Psychiatry: Journal of the Biology and Pathology of Interpersonal Relations,* I (1938), 161. See also Robert J. Smith, "Cultural Differences in the Life Cycle and the Concept of Time," in Robert W. Kleemeier, ed., *Aging and Leisure* (New York, 1961), 83–112.

Figure 19. A Japanese representation of the stages of life (Daien-ji Temple in Mie Prefecture, ca. sixteenth century). Courtesy of Professor Hideo Kojima, Nagoya University, Japan.

and although he is remarkable for his cultural sensitivity and historical orientation, the fact remains that his seminal essay on the "eight ages of man" is intellectually ahistorical: it reveals no awareness whatever of Erikson's forebears in this particular line of inquiry.

V

It is fortunate for the cultural historian that Erikson's most interesting forebears have appeared at conveniently spaced intervals from the early colonial period, through the age of romanticism in the second quarter of the nineteenth century, on up to the professionalization of

the social sciences during the first four decades of the twentieth century, for this chronological pattern enables us to examine both continuities and discontinuities. The most striking continuity, perhaps, is that Erikson and his predecessors alike acknowledge some sort of tension between positive attributes and negative potentialities within each stage of the life cycle.

The discontinuities, however, are more striking and illuminating—primarily the divisional shift from predominantly four to Erikson's eight phases in the life cycle. *Why, we must ask, has this increase in subdivisions come about?* It is difficult to answer with assurance; but a cluster of considerations comes readily to mind.

We must begin with Erikson's mentor, Sigmund Freud. Freud devoted extensive attention to prepubertal stages of growth and thereby ensured that his successors would have to regard "childhood" with more particularity and finer internal gradations than, say, Anne Bradstreet and Thomas Cole had done. As late as 1945, apparently, Erikson still regarded adolescence as a stage in which the last of the epigenetic crises occurred. Subsequently, however, he enlarged his schematization of the life cycle, looked much more closely at adulthood, and conceptualized it into three phases—each with its own peculiar conflicts over intimacy, generativity, and integrity. Although he thereby "progressed" from being a Freudian to being a postFreudian, Erikson did not discard Freud's subcategories of childhood. Rather, he refined them and added his own to the continuum.[51]

Second, Erikson has suggested that rapid social change can cause shifts in the nature and perception of stages in the life cycle, and no one would deny the remarkable rapidity of social change during the past two generations. It has been bewilderingly swift. The family may or may not have become weakened, for example, but it has most assuredly been subjected to severe stress. One source of stress has been the egocentric, selfish individualism implicit in the so-called "human potential movement," which has encouraged increasing numbers of people to expand their personal options and reduce their constraints. As Erikson observed in an interview, "if the relation of father and son dominated the last century, then this one is concerned with the self-made man asking himself what he is making of himself."[52]

51. See Roazen, *Erikson*, 115; and Evans, *Dialogue with Erikson*, 52. See also Erikson, "The Roots of Virtue," in Julian Huxley, ed., *The Humanist Frame* (London, 1961), 152, in which Erikson's diagrammatic chart shows only six life stages.

52. See Erikson, *Life History and the Historical Moment*, 197–98; and Evans, *Dialogue*

Third, technology has transformed our lives in ways inconceivable to Bradstreet, Cole, or even G. Stanley Hall; and Erikson is properly sensitive to the psychological consequences and implications of technology. He refers to it frequently in his seminal chapter on the eight ages of man, and it serves as a crucial determinant in his explication of the life cycle. In discussing stage four, for example, he suggests that the young teenager acquires a "sense of the *technological ethos* of a culture," and in a subsequent context Erikson talks about "the dangers which emanate from human ideals harnessed to the management of super-machines."[53]

Technological innovation may have extended and transformed our perception of the life cycle in yet another way. The invention of the camera and its widespread use by the later nineteenth century made it possible to "record" various phases of life and thereby make us more sensitive to fine distinctions. Childhood and Youth would seem very crude categories once the family photograph album encouraged us to marvel how much a boy had grown between ages six and eight, or how much a young woman had matured between thirteen and sixteen.[54]

A fourth consideration involves the relatively compressed period of parenthood today as compared with its much longer duration two or three centuries ago. Colonial parents ordinarily continued to produce offspring until their mid-forties and sometimes even later. The youngest child often did not marry and leave home until his or her mother was well past sixty. That fact, combined with the higher mortality rate in those days, meant that for many persons the life cycle did not extend much beyond the fulfillment of parenthood. Today, by comparison, we speak of the "empty nest syndrome" and of parents prepared to begin a whole new (and prolonged) phase of life at about age forty-five.[55]

with Erikson, 41. See also Martin U. Martel, "Age-Sex Roles in American Magazine Fiction (1890–1955)," in Neugarten, ed., *Middle Age and Aging*, 47–57.

53. Erikson, *Childhood and Society*, 260, 263. The italics are his.

54. One should not minimize the influence of Dr. Benjamin Spock's *Baby and Child Care*, which has undergone an extraordinary number of printings since its initial publication in 1945. Its sections include "Problems of Infancy," "The One-Year-Old," "The Two-Year-Old," "Three to Six," "From Six to Eleven," and "Puberty Development."

55. See Robert V. Wells, "Demographic Change and the Life Cycle of American Families," in T. K. Rabb and R. I. Rotberg, eds., *The Family in History: Interdisciplinary Essays* (New York, 1973), 88; Tamara K. Hareven, "The Last Stage: Historical Adulthood and Old Age," *Daedalus*, 105 (Fall 1976), 18.

A fifth and closely related factor concerns the increase in human longevity—most especially during the past forty years. Obviously, the prolongation of life extends the life cycle and renders it capable of greater complexity. "Retirement" was not a normal event or phase of life in early America. Clergymen and schoolmasters, for instance, rarely retired. They continued until disability or death did them in. The concept of retirement started to emerge only in the later nineteenth century and then accelerated during the twentieth.[56] Now, we have a large category of people—"senior citizens" is our good-natured euphemism—for whom a new life (or at least a new phase of the life cycle) begins at sixty, sixty-five, or seventy. Moreover, given the higher rate of mortality in colonial times, a husband and his first wife then had little expectation of growing old together. In modern times that tendency has been turned around. Thus the long-range trend should be clear. As David Hackett Fischer has observed:

> In 1830, about one-third of all native born Americans survived to the age of sixty; in 1900 more than half did; in 1940, two-thirds; in 1960, three-quarters; and in 1975, four-fifths. That demographic trend caused a profound change in the rhythm of individual lives. . . . From 1650 to 1800 (approximately), the life cycle changed very little. Almost everyone married in early America, and once the responsibilities of a family were taken up, they were not laid down until the end of life. . . . From 1800 to the mid-twentieth century, as both fertility and mortality declined, the life cycle was transformed, and dramatically so. Early in the nineteenth century parents began to live beyond the period of their children's dependency. . . . [By 1950] a new period of life had come into being: that between adulthood and old age.[57]

If it is true that phases of the life cycle were less clearly delineated prior to the twentieth century, so too the symptomatic transitions from one stage to the next, both formal and informal, have now multiplied and acquired qualities that are at least pervasive if not uni-

56. See David Hackett Fischer, *Growing Old in America* (New York, 1977), 44, 46, 80; Carole Haber, "Mandatory Retirement in Nineteenth-Century America: The Conceptual Basis for a New Work Cycle," *Journal of Social History*, 12 (1978), 77–96.

57. Fischer, *Growing Old in America*, 106–7. On p. 56, n.61, Fischer has an excellent chart delineating shifts in the life cycle between 1650 and 1800. He provides figures for mean age at first marriage, last birth, last child comes of age, last child marries, and death. See also his Table 6 on p. 228, "The Demographic Life Cycle in America, 1650–1950."

versal. The standardization of educational, corporate, and military careers has resulted in the relative uniformity (if not regimentation) of graduations and promotions. The rising incidence of divorce and the growing acceptability of other life crises—such as entering and ending psychoanalysis—have added still more signposts to such established ones as getting a driver's license at sixteen to eighteen, or starting to receive one's pension at 65.[58]

During the 1960s, one might say, adult Americans discovered (or rediscovered) youth, became anxious about the protracted period of preparation required to enter the service sector and the professions, devised subcategories of youth and young adulthood, and—in envious imitation of the youth culture—too often behaved in unbecomingly childish ways.[59] During the 1970s, by contrast, we "discovered" adulthood and old age, but somberly rather than ebulliently. It may well be that the rapid growth of developmental psychology and the broad appeal of Erikson's eight ages of man should be viewed as emblematic responses to an "age of anxiety." We want to know that what we are doing and what is happening to us are O.K. We want predictability, and we desperately want definitions of "normality." What is more, we want these criteria in precise categories—not broad and vague ones—posted for all our peers to see. "I'm O.K., you're O.K." has a very special resonance in our time.[60]

That quest for predictability serves as yet another measure of change, however, because the most disturbing aspect of modern perceptions of the life cycle inheres in their mechanistic nature. We have been conditioned to expect the devotees of sociobiology to emphasize the inevitable aspects of our life course, but one might still hope that

58. "Judaism's New Book of Daily Prayer," *New York Times,* March 13, 1977, p. E9; John A. B. McLeish, *The Ulyssean Adult: Creativity in the Middle and Later Years* (New York, 1976).

59. See Kenneth Keniston, "Youth: A 'New' Stage of Life," *American Scholar,* 39 (1970), 632–36.

60. This essay has concentrated upon Erikson and his predecessors. Quite obviously one might write a much longer study of his successors, for developmental psychology has become notably trendy. In the years since 1963 (when the second edition of *Childhood and Society* appeared), Erikson has written so extensively to gloss and refine his own schematization of the life cycle that one might almost consider him one of his own *epigoni!* See also Paul B. Baltes and K. Warner Schaie, eds., *Life-Span Developmental Psychology: Personality and Socialization* (New York, 1973); Marjorie Fiske Lowenthal et al., *Four Stages of Life: A Comparative Study of Women and Men Facing Transitions* (San Francisco, 1975); and William C. Sze, ed., *Human Life Cycle* (New York, 1975), a 737-page collection of essays.

psychologists and psychiatrists would remain sensitive to nonrational elements in human behavior as well as mankind's diversity and freedom of action. Instead, alas, Erikson insists upon both the inevitability and the universality of his schematization. And Daniel Levinson declares that "there is some underlying order in the life cycle."[61] He spent a decade discovering that "order" for forty middle-aged males. Based upon his sampling and viewed through four vocational categories, Levinson offers us a paradigm of man's unavoidable mid-life crises.

The achievement of twentieth-century social science with respect to the human life cycle, at least, is that its practitioners, at their best, have attempted to integrate that nineteenth-century dualism of the external and internal lives. Modern practitioners pay attention to psychology as well as biology—to the condition of man's mind as well as his chassis.

The less fortunate aspect of modern social science, on the other hand, is that its penchant for theory tends to race ahead of empirical and historical realities. Social scientists do their research or their clinical work, to be sure. But then they present us with schematized formulae that we are expected to accept, virtually, as higher law. Erikson, Keniston, and Levinson may be entirely correct; or they may be only partially so; or they may, within a generation, be markedly modified by their successors.[62] Whichever happens, we have come quite a distance from the days of Bradstreet and Cole, who codified in an attractive way what their culture already knew by tradition. The Puritan poet and the Anglo-American painter did not *create* conceptions of the life cycle so much as they helped their contemporaries to perceive and reflect upon criteria of the human condition that were already established and accepted.

61. Levinson, *The Seasons of a Man's Life*, 47.

62. E.g., a brand-new area of investigation that has been opened just during the past few years involves the incredibly complex relationship (which changes over time) among individual life cycles, various age cohorts, intergenerational relationships, and the nature of family structure. See Tamara K. Hareven, ed., *Transitions: The Family and the Life Course in Historical Perspective* (New York, 1978); Hareven, "Cycles, Courses and Cohorts: Reflections on Theoretical and Methodological Approaches to the Historical Study of Family Development," *Journal of Social History*, 12 (1978), 97–109; and John Modell et al., "Social Change and Transitions to Adulthood in Historical Perspective," *Journal of Family History*, 1 (1976), 7–32. A particular virtue of this approach is that it de-emphasizes the categorical taxonomy of stages found in Hall, Erikson, and Levinson and instead seeks to understand individual transitions more fully in the context of other, concurrent social changes and institutions.

Social scientists today are not satisfied with merely telling us—albeit more elegantly—what we already know. They are understandably determined to forge ahead in an effort to discover and explain what we have known only partially and understand in very limited ways. They have, in a sense, taken up the great challenge of American exploration, which for so long centered upon the conquest of Nature. Now, it is the mastery of human nature that is sought: mastery in a cerebral sense— not to control it but, at the very least, to comprehend it.

In the last analysis, one can only conclude that the life cycle itself has been extended and modified through centuries of human experience in America.[63] Our perceptions of the life cycle have changed accordingly; and while Erik Erikson's eight ages of man provide an excellent key to those perceptions during the third quarter of the twentieth century, they are insufficient to understand the reality as well as the shifting conceptions of the life cycle at earlier times in the history of American thought and culture. To achieve that understanding, we must examine the poetry and iconography, the essays and allusions of Erikson's forebears.

I am grateful to my designated critic at the American Studies Association meeting in 1977, David F. Musto of Yale University, and also to numerous friends who provided valuable responses to various revisions: Howard M. Feinstein, James M. Freeman, John Higham, Joseph F. Kett, Walter LaFeber, R. Laurence Moore, William Provine, S. Cushing Strout, Laurence R. Veysey, and John Wilmerding.

63. In addition to works cited above, see also John Demos, *A Little Commonwealth: Family Life in Plymouth Colony* (New York, 1970), pt. 3, "Themes of Individual Development"; Catherine M. Scholten, " 'On the Importance of the Obstetric Art': Changing Customs of Childbirth in America," *William and Mary Quarterly,* 34 (1977), 426–45; and Carroll Smith-Rosenberg, "Puberty to Menopause: The Cycle of Femininity in 19th-Century America," in Lois Banner and Mary S. Hartman, eds., *Clio's Consciousness Raised: New Perspectives on the History of Women* (New York, 1974), 23–37.

Chapter 9

Moses Coit Tyler: The First Professor of American History in the United States

This labor of love began as a centennial lecture presented at Cornell on November 4, 1981, to mark the one hundredth anniversary of Tyler's appointment at Cornell as the first professor of American history at any American college or university.

An abridged edition appeared in the *Cornell Alumni News* (June 1982, pp. 29–32), and the full text in the *History Teacher,* 17 (November 1983), 61–87. It is reprinted, slightly modified, by permission of the Society for History Education; and I am grateful to David D. Hall for his helpful reading of the manuscript.

As a prelude to Tyler's tale, it is interesting to note the migration of two fine personal libraries to young institutions of higher learning. When Jared Sparks died in 1866, Harvard—where he had served as president, 1849–53—kept his collection of historical manuscripts but offered his library for sale. Henry W. Sage (a local benefactor and trustee) bought it for Cornell, which meant that the university's holdings in American history would be strong from the outset.

Because Sparks had been a specialist on the age of the American Revolution, his library was especially well suited to Tyler's needs. As an additional link between the two men, Sparks first introduced in 1839 a course of lectures at Harvard on the American Revolution. See Michael Kammen, *A Season of Youth: The American Revolution and the Historical Imagination* (New York, 1978).

Tyler's will specified that if his daughter decided to dispose of his

library, she should sell it to a public institution. Tyler had often visited Michigan's Upper Peninsula, where one of his nephews lived. In 1904 three public-spirited residents of that region bought Tyler's books for the college in Marquette that today is called Northern Michigan University, which proudly keeps the Tyler Collection intact. The volumes contain some marginalia, but they are not extensive.

I

More than a century ago, in 1881, Moses Coit Tyler (Figure 20) was invited to Cornell to fill the first professorship of United States history created at any American university. It is fascinating to re-examine the circumstances of that episode because doing so provides us with an opportunity to look at the teaching of history in late nineteenth-century America, at the origins of the historical profession, at the Anglo-American cultural context that shaped Tyler's outlook, and finally, at the achievements as well as the limitations of his work. Perhaps we should begin, though, with a seemingly simple question: who was Moses Coit Tyler?

His forebears had migrated from England to the Plymouth Colony around 1640. Moses was born in Griswold, Connecticut in 1835, but his restless family moved westward that very year—first to Constantia, New York, in Oswego County, and then in 1837 to various towns in Michigan: Marshall, Burlington, Union City, and in 1842, Detroit. There he attended public schools as well as the First Congregational Church. His next step may surprise you, but it resulted from a combination of frontier conditions and his father's continuous failure in business. At the age of fifteen Moses Coit Tyler became a schoolteacher in a hamlet thirty-five miles north of Detroit. It had the rather implausible but romantic name of Romeo. A year later, in 1851, Moses moved on to Battle Creek, then to Paw Paw, and finally to Chicago as a book salesman. His formative circumstances seem to have been ceaseless travel, financial pinch, and intellectual hunger.

In 1852 he entered the University of Michigan as a freshman and spent a fruitful year; but when a relative in Hartford made it financially possible for Moses to transfer to Yale, he seized the chance, starting once again as a freshman and graduating in 1857. During his senior year there, at a meeting of Skull and Bones, he met Andrew Dickson

Figure 20. Moses Coit Tyler, undated photograph. Courtesy, Department of Manuscripts and University Archives, John M. Olin Library, Cornell University.

White of Homer and Syracuse, New York. Their friendship deepened when the two young men spent twenty-nine hours together on a train from New York City to Albany that happened to get stuck in one of the worst blizzards to hit the Hudson Valley in several decades. Their relationship would be a close one for the remaining forty-three years of Tyler's life. White's position as the first president of Cornell profoundly affected not only Tyler's career but the development of American historical scholarship as well.

Tyler considered the ministry his most likely career; studied theology for two years at Andover; accepted a call from the small Congregationalist church in Owego, New York (an abolitionist splinter group); moved on to a larger congregation at Poughkeepsie early in 1861; resigned that pulpit in October 1862 when he suffered some sort of nervous and physical breakdown; and went to Boston where he became a disciple of Dio Lewis, proprietor of the Normal Institute for Physical Education. Doctor Lewis had literary interests, but his calisthenic regimen—called "musical gymnastics"—was apparently just what Tyler needed. Within six months, his health restored, Tyler sailed for England on a ship suitably named the *Victoria*. He left behind a wife, Jeannette Gilbert of New Haven, a daughter, Jessica (born in 1860), and a newborn son, Edward. There is no evidence that this family had been the cause of his collapse in 1862; he rejoined them when he returned from England three and a half years later in 1866, but a pattern of lengthy absences was thereby established. Tyler took many vacations alone during the remainder of his life, and no more children were added to the family after Ned's birth in 1863.

Tyler established himself in England as a lecturer and essayist. At first he seems to have been primarily an evangelist for Dr. Lewis's health-restoring musical gymnastics, but gradually he began to interpret American civilization to the British and vice versa. In 1867 Tyler joined the faculty at the University of Michigan, where he taught English and rhetoric. In 1873 he accepted an invitation to edit the *Christian Union;* but a year of New York City, and especially of close contact with the Henry Ward Beecher adultery scandal, aggravated Tyler's delicate nervous system. Musical gymnastics might have restored his physical health a decade earlier, but musical gymnastics could not obliterate the stench of sin. So in 1874 Tyler returned to Ann Arbor. At the same time, however, he let Andrew D. White know that he would be interested in teaching American history at Cornell.[1]

Seven years later, on March 7, 1881, White sent the letter for which Tyler had long been hoping. To make matters a bit more unusual, White sent it from Berlin, where he was concluding a term of service as U.S. ambassador.

1. Tyler to White, March 1874, Andrew D. White Papers, box 17, Department of Manuscripts and University Archives, Cornell University Library (hereafter CUL), Ithaca, N.Y.

Suppose that our trustees establish a professorship of American history and literature at the coming commencement—would you be inclined to accept it? . . . The situation would be in many respects attractive. The collection of American books in the university library, including as it does [Jared] Sparks's private library as well as those which I have myself brought together, give you much material. Then you could be near the Historical societies of New York and Brooklyn, to say nothing of New England. With our present railway communication a new and broader lecture field would be easily open to you. But, best of all, your college work would thus be brought entirely into line with your literary work. Please answer me at your earliest convenience.[2]

On May 21 Tyler telegraphed his acceptance to Henry W. Sage "in the faith that it is the will of God," he wrote in his journal, "& with earnest prayer for God's blessing on the act." In July he came to Ithaca, and on July 19 he spent a day inspecting Americana in the university library. On July 28 he recorded that "every day increases my satisfaction that I have come here." He remained at Cornell for the rest of his life, though every day did not always increase his satisfaction. On November 4 he "took a walk & was driven back by a flurry of snow. I am depressed by this climate." On November 16 he wrote: "Feel brain-weary & dull. Dawdled thro' the forenoon without accomplishing much. Is it Ithaca air?" Two days later, after teaching his seminar, Tyler encountered Andrew D. White. While the two walked, they met Willard Fiske, the professor of north European languages. Fiske declared "that he was so disgusted with this climate that he had proposed to White that one of them should buy a house in Paris & the other in Rome; between the two places they should divide the year; & every 3 months send over a message that Cornell University had their best wishes." On December 12, after six months, Tyler noted in his journal that "the long Faculty meeting spoiled my brain for any reading tonight." On February 28, 1882, he expressed disappointment in the Cornell undergraduates: "Dull boys and girls, some of them." On May 19, 1882, Tyler observed that it had been exactly a year since he and his wife "were received here by the Sages, & inspected the university—& I was conquered. The transition has been toilsome & saddening; a great interruption to my book-work; but in the long run," he concluded, "it promises to be a benefit."[3]

2. *Moses Coit Tyler, 1835–1900: Selections from His Letters and Diaries,* ed. Jessica Tyler Austen (Garden City, N.Y., 1911), 118.
3. All of these statements are from Tyler's manuscript diaries, CUL.

II

Tyler seems to have had a particular penchant for vacillation, agonizing, and melancholy. As F. O. Matthiessen remarked in 1934, Tyler "shared to the end of his days in the spiritual restlessness of his era, harassed by doubt and yet driven on by the necessity of faith."[4] Tyler became an Episcopal deacon in 1881 and was ordained a priest in 1883. Although he ceased to be active in the ministry from time to time—preaching left him utterly exhausted—he always yearned for it. On June 7, 1883, he remarked in Ithaca that "the two years that have passed since I decided to come here have been given to the organization of my class work, and at last I have got that so well arranged that I can begin the next year without anxiety, and can make much time for real literary production. And yet, my soul constantly says, 'Thou ought to be preaching the Gospel, rather than teaching American history, or writing books upon it.'" A decade later, having chastised himself more than a dozen times over his indecisiveness, Tyler preached on Palm Sunday in Slaterville, near Ithaca: "It fatigues me more than I can bear . . . my bodily strength is not enough for two professions, and my profession in this university is the one to which Providence seems to appoint me."[5] Tyler always leaned heavily upon "Providence" when he needed assistance in coming to terms with tough decisions.

Tyler's obsession with his health often served to justify an alteration in the trajectory of his life: the decision to leave his church in Poughkeepsie in 1862, to go to England in 1863, to abandon his desk on any given day, or to cease his pastoral responsibilities during the two decades in Ithaca. Actually, his health seems to have been just fine most of the time. He loved vigorous walking, went horseback riding all over Tompkins County, took pleasure in shoveling snow, and often rode his bicycle around Ithaca during the 1890s.[6] Somehow, Dio Lewis's system of muscial gymnastics had such a powerful impact upon Tyler that it became a metaphorical way of explaining the layman's acquisition of historical knowledge. In 1898 Tyler prepared an essay called "The Educational Value of History." He started with "the common conception of history as an enormous body of facts about the human family in the past,—the effort to know and retain a

4. Matthiessen, book review in *New England Quarterly*, 7 (1934), 745.
5. *Letters and Diaries,* 121, 177, 179–80, 271.
6. See ibid., 70, 264; and Tyler's commonplace book, February 22 and March 3, 1881, CUL.

considerable number of these facts being regarded as a fine gymnastic exercise for the faculty of memory."[7]

Underlying Tyler's tripartite concern for history, health, and religion was a persistent perplexity about his vocation and identity. *Vocation* would determine *identity,* and those two words recur constantly in the diaries and commonplace books that he kept for forty-one years. Time and again he pondered his "inward call to a life of study" and reviewed his options as historian, biographer, or writer of imaginative literature. In 1869, at the age of thirty-four, he complained that "this problem of my life work, though my life is probably half gone, is yet unsolved. The question which for many years I have continually put to myself is this: Am I to be a literary artist, or am I to be a literary man applying his art to affairs? My own uncertainty on this subject sometimes amounts to anguish."[8]

Although Tyler found his true calling by the mid 1870s, anguish and melancholy harried him to the end of his days. Even though he was an accomplished lecturer—he had enjoyed great success in England as a young man—he usually began the academic year with "anxiety." In March 1881, waiting to give the first of his Lowell lectures in Boston, Tyler tells us that he "was scared at first. My voice disobedient and unnatural." A pattern of phrases runs through his diaries like a litany: "burdened and anxious," "depressed horribly," "weakness and depression," "feel unaccountably depressed; the mistakes of my life, the defects of my character, oppressed me; the littleness of what I have done in any direction compared with my real opportunities of doing much gave me a sense of failure," "am in the dumps," *ad infinitum*.[9] In May 1882, at the end of his first year of teaching at Cornell, Tyler suffered another nervous breakdown and was advised by his physician to go to Europe for three months. Tyler did, and enjoyed himself immensely. Jeannette and the children remained in Ithaca.[10]

Like many of his Victorian contempories, Tyler did take quite a while to find his vocation, though not so long as all this anguish might suggest. In 1865 he first thought about planning six or eight lectures,

7. "The Educational Value of History," typescript in Tyler Papers, CUL, published in vol. 1 of the *Library of Universal History* (New York, 1898–99).

8. *Letters and Diaries,* 42.

9. Ibid., 114–15, 117, 180, 211–12, 234, 250, 252, 262, 264, 269. See also Howard Mumford Jones and Thomas Edgar Casady, *The Life of Moses Coit Tyler* (Ann Arbor, 1933), 174, 187, 203, 222, 235, 250, 253, 264.

10. Jones and Casady, *Tyler,* 211; *Letters and Diaries,* 131.

devoted to the history of American literature, "for a purely literary audience and with a view to publication." Early in the 1870s, once he had begun teaching at Michigan, Tyler prepared a report to the regents in which he boldly proposed that American literature be included in the curriculum along with English literature.[11] In 1872 he wrote a series of letters to Benson J. Lossing, a successful popularizer of American history, and to Andrew D. White—letters that reveal Tyler's fascination with the new field as well as his recognition that Cornell was likely to become preeminent in it.

Late in 1871, White arranged with George Washington Greene, of Brown University, to visit Cornell as a nonresident professor. Greene did so in 1872, '73, and '74, offering general instruction in United States history but mostly reading, in a very dry manner apparently, from works that he had already published or from page proofs about to be published concerning the American Revolution.[12]

Tyler kept track of these developments with intense interest: "The unique thing which they have done is in making Mr. Greene Prof. of *American* History. Already they had three Professors of History in general—i.e. Pres. White, Prof. Russel & Goldwin Smith. . . . But Cornell is the pioneer in recognizing Amn History as worthy of a separate chair." During the spring months of 1872 Tyler kept White informed: "I am working away with huge joy at my adopted field in Amn history, & am making good progress." Tyler indicated to his friend that Michigan might very well act upon a plan that he had projected, "viz., the establishment of a Professorship of American Literature & History." But he quickly added that he would prefer to have such an appointment at Cornell, especially now that White and Sage had acquired the library of Jared Sparks (Figure 21) to be the nucleus of Cornell's collection in the history of the United States. Just in case White had any doubts about Tyler as a performer on the podium, Tyler added that he had "learned how to lecture to students" and felt "cheered & strengthened by the perfect success I have had in taming them into quiet manners, in holding their attention, & in evoking their enthusiastic interest."[13]

11. Jones and Casady, *Tyler*, 111, 127.
12. *Autobiography of Andrew Dickson White* (New York, 1905), I, 383; John H. Selkreg, ed., *Landmarks of Tompkins County, New York* (Syracuse, N.Y., 1894), 449, 571.
13. Tyler to Lossing, January 18, 1872, special folder, Tyler Papers; Tyler to White, April 18, June 5 and 20, 1872, White Papers, boxes 12 and 13.

Figure 21. Jared Sparks, by Thomas Sully (oil on canvas, 1831). Courtesy of the Reynolda House Museum of American Art, Winston-Salem, North Carolina.

White told Tyler to be patient because Cornell did not yet have adequate funds for a permanent professorship in his new field. The irony is that back in 1867 White had offered Tyler a position teaching literature at Cornell, but Tyler had declined because the new campus at Ithaca seemed too primitive, especially with all those cows wandering around. So he consented to teach English, composition, and elocution at Michigan and then spent much of the next fourteen years trying to get re-invited to Cornell on his own terms. When the call finally came in 1881, Tyler had established himself as one of the foremost scholars

in the country in early American history. In 1873, during his editorial stint at the *Christian Union,* he had asked rhetorically a question that was altogether pertinent: "Who shall explain the odd contradiction in our national habits of furiously boasting of American history, and steadily refusing to know anything about it?" In 1875 he described himself to George H. Putnam, the publisher, as "a special student of American history, and have paid particular attention to what we dignify as literature in America in the 17 and 18 centuries." Three years later Tyler completed a massive manuscript which Putnam published in November 1878 as *A History of American Literature, 1607–1765* in two octavo volumes. It was truly a pioneering work: thorough, stately, and judicious. It received a most favorable response, which reinforced Tyler's enthusiastic belief that nothing could be more interesting than "the intellectual history of a nation."[14]

Consequently, in 1881 when Cornell appointed Tyler to the first chair at any American university in the history of the United States, it acquired a nationally recognized man of letters who had been waiting some years for the call. In the period after 1874, when George Washington Greene read his last set of page proofs aloud to drowsy undergraduates, instruction in American history had occasionally been offered by Professor William C. Russel, whose principal field was actually modern languages.[15] In May 1879 Hermann E. von Holst visited Cornell and gave a series of ten lectures on his specialty, American constitutional history. In April 1881 John Fiske, the most prolific popularizer of his day, delivered another mini-course in U.S. history.[16] The Cornell community was thereby prepared for Tyler's appointment.

III

Tyler and his family reached Ithaca with somewhat mixed emotions—in Tyler's case because just after he accepted White's offer,

14. Jones and Casady, *Tyler,* 111, 114–15, 137, 156, 176, 190; *Letters and Diaries,* 43, 64, 71, 75, 113.

15. In 1878–79 Russel taught history to Hiram Martin Chittenden, who subsequently transferred to the U.S. Military Academy; in 1902 he published an exhaustive three-volume history of the fur trade in the far West. See Gordon B. Dodds, *Hiram Martin Chittenden: His Public Career* (Lexington, Ky., 1973), 3–4, 72, 74, 87. See also Glenn C. Altschuler, *Andrew D. White—Educator, Historian, Diplomat* (Ithaca, 1979), 138–39.

16. Milton Berman, *John Fiske: The Evolution of a Popularizer* (Cambridge, Mass., 1961), 70, 141.

Columbia University inquired whether he would be interested in a professorship at $7,000 per year, more than twice what he would receive from Cornell. He was immensely attracted, and his wife would have preferred New York City; but Tyler, always anxious about rectitude, felt that he had given White his word and would simply have to live with the consequences. As for eighteen-year-old Ned, I don't know his precise feelings about leaving Ann Arbor, but he clearly was in no rush to reach Ithaca. On August 10, 1881, moving day at the Tyler homestead, Ned arose at 4:00 A.M., announced that he was *walking* to Detroit, and according to Tyler's entry in his diary, said he intended to walk to Ithaca. Ned did, too (all but twenty miles of the way, arriving at the Tyler's temporary home in Cascadilla Hall on August 27. Tyler's only comment? "I am most happy over the strong character this has developed." Tyler was a devotee of Charles Kingsley's "muscular Christianity." Tyler's 1885 essay "Christianity and Manliness" contended that manliness is determined by purity and that unchaste conduct is therefore unmanly. Perhaps he felt that Ned's eighteen-day hike would serve to inhibit the boy's sex drive.[17]

Tyler spent the summer of 1881 preparing for his new duties at Cornell. In June and July, when he wasn't gnashing his teeth over the missed opportunity at Columbia, he read all the published volumes of Francis Parkman's history. In August he read von Holst. In September he spent the mornings planning his lectures and observing to his journal that "the Colonial field opens many rich subjects for literary exposition." On November 1, President White decided to attend one of Tyler's lectures. I assume that White intended this as a gesture of collegiality rather than inspection, but Tyler seems to have reacted with alarm. "I asked him for his ticket of admission," Tyler notes, "& told him that no one was admitted without it." White insisted on staying, ticket or no ticket. Tyler then tried to get White to give an impromptu guest lecture. That ploy failed also, so Tyler took the platform.[18]

Sketchy evidence indicates that Tyler's lectures were not altogether smooth that first year, even though he reassured himself: "My au-

17. Tyler diaries, June 16, July 28, August 10 and 27, 1881; Tyler, "Christianity and Manliness," *Christian Union* 32 (November 5, 1885), no. 19. Leslie Stephen once defined muscular Christianity as the duty to "fear God and walk a thousand miles in a thousand hours" (*Sketches from Cambridge,* quoted in Gertrude Himmelfarb, *Victorian Minds* [New York, 1968], 206).

18. Tyler diaries, June 16, July 28, September 2, 3, and 22, November 1, 1881.

diences keep up surprisingly." After his last lecture of the fall term he confessed, "I began in anxiety & doubt; & end in assurance of having gained a strong foot-hold." On May 3, 1882, he forgot to show up to give his class an examination. In 1883, he recorded, "I am getting the hang of history lectures now." By then he had developed a two-year sequence. The course for juniors ran from prehistoric civilizations in North America until 1765; the one for seniors covered the century 1765–1865. A senior who took the course in 1898–99 remarked that "Professor Tyler was extremely careful, almost dictating to his students and numbering his points as he dictated."[19]

I wish that I could tell you more about Tyler's life on the campus. We know that he moved his family from Cascadilla Hall to a house on Seneca Street. The bookshelves of his large library were visible from the street, and one day in 1883 a freshman came to the door to ask whether Tyler's home was a used bookstore. He lectured in a large room at the eastern end of Sage College. Students liked to call him Coses Moit instead of Moses Coit, and one of them recalled, sixty years later, that Tyler had "sartorial flare."[20]

You will hardly be surprised to learn that his students varied greatly in the quality of their preparation and ability. His best included Charles H. Hull, class of 1886, who later taught at Cornell—from 1893 until 1931—and in 1901 succeeded Tyler as the professor of American history. Charles A. Beard came to Cornell in 1899 and studied briefly with Tyler. On the other hand, a letter that Tyler received in 1893 from Edward Eggleston was not at all unusual: "There is a lad in Dakota who has some claim on me by distant relationship who wishes to find a school 'where they learn boys trades, give them an education by letting them work part of the time to pay for their tuition.' I am told he is a studious fellow who even reads while he sits on his pony minding sheep. It occurred to me that at Cornell you would know if there was any such place."[21] Eggleston's tongue may have been somewhere between his cheek (in Lake George) and the Dakota lad's pony.

19. Tyler diaries, October 6, December 8, 1881; and May 3, 1882; Jones and Casady, *Tyler,* 210, 213; *Letters and Diaries,* 185, 194. The Department of Manuscripts and University Archives, CUL, has the papers of Daniel Chauncey Knowlton (1876–1966), a Cornell undergraduate in 1895–99. Knowlton took Tyler's course in 1898–99, and his papers include the lecture notes that he kept.

20. *Letters and Diaries,* 186; unpublished memoir of Bertha Wilder Reed (February 1957), Department of Manuscripts and University Archives, CUL.

21. Beard to Tyler, January 26, 1900, Tyler letters, IX, 142a; Eggleston to Tyler, November 13, 1883, Tyler letters, VI, 135, CUL.

Tyler required seclusion in order to write and therefore regarded his study as a *sanctum sanctorum*. He always had. In 1873, while editing the *Christian Union* in New York, he informed Andrew D. White that he did not get to the office until 2:00 P.M. Mornings he spent in a top floor room at Bible House: "There I have a den that no mortal has ever entered except myself & the Janitor. It is a perfect refuge; & almost no one of my friends knows where it is." In Ithaca, Tyler worked every morning in a housetop study at home. In the afternoon he would go to his office, which he liked to call his "laboratory," at the southern end of Morrill Hall. By 1885, however, he complained that he was too easily interrupted there. Consequently, "I shall have to sport the oak more and more": that is, keep his door shut![22]

Faculty meetings invariably seemed a deadly waste of time to Tyler. Although he felt strong institutional loyalties, an administrative type he decidedly was not. During his first decade at Cornell, Tyler was preoccupied with developing his courses and writing his admirable biography of Patrick Henry, which appeared in 1887. Between 1889 and 1891, when President Charles Kendall Adams wanted to revamp the history curriculum and attract Herbert Baxter Adams from Johns Hopkins, Tyler dragged his feet. He did participate in a movement by the Cornell faculty to form a senate and curb the president's appointive powers. During the 1890s, however, Tyler became more entrepreneurial. He pressed Jacob Gould Schurman to establish an instructorship in American history as well as additional scholarships for graduate students. Tyler believed that his department (that is, the Department of American History) "had a very special mission to perform here, in the history of New York State, which has been shamefully neglected." In 1896 he began to encourage advanced students to undertake studies in local history and envisioned a Cornell series of monographs in New York history. The first of these, completed in 1897, was a thesis on early Elmira.[23]

In 1893 Tyler received an especially interesting letter from Senator Henry Cabot Lodge. "I am glad to know of the growth & success of

22. Tyler to White, July 9, 1873, White Papers, box 15; George Lincoln Burr, "Moses Coit Tyler, A Memorial Address," *Annual Report of the American Historical Association for the Year 1901* (Washington, D.C., 1902), I, 189–91; "Record of Daily Work," July 1, September 14 and 23, 1885, Tyler Papers. For Tyler's lonely trips and vacations, see *Letters and Diaries*, 202, 282, 298, 318, 322.

23. *Letters and Diaries*, 201; Jones and Casady, *Tyler*, 241–42; Schurman to Tyler, April 29, 1897, Tyler letters, VIII, 189; lengthy interview with Tyler published in the *Buffalo* (N.Y.) *Express*, June 13, 1897, folder of miscellaneous newspaper clippings, Tyler Papers.

your courses at Cornell," Lodge wrote. "It makes me blush with shame to think that 20 years ago there was practically no teaching of American history in our great colleges & with pleasure to realize that now thanks to you & others our own history is a great & flourishing department in our large colleges. This is part of the spirit of true Americanism which has grown mightily of late."[24]

Lodge's historical assessment was fairly accurate, and few persons were better situated than he to make it. He had received his B.A. from Harvard College in 1871, his Ll.B. there in 1874, and a Ph.D. in 1876. A protégé of Henry Adams, Lodge taught American history at Harvard between 1876 and 1879. Thereafter, politics became his principal pursuit.

After Henry Adams went to Washington in 1877 and Lodge to the Boston State House two years later, American history almost disappeared at Harvard. By the time of Albert Bushnell Hart's graduation in 1880, only a one-semester survey was offered—but then, in 1880 there were only eleven professors of history in the entire United States. When Edward Channing asked for the opportunity to teach American history at Harvard that year, President Eliot told him to teach European instead. "There are only two colleges in this country within my knowledge where much is made of American history," Eliot wrote, "and you know how elementary the teaching on that subject is in American schools." Eliot's response to the problem of a trivialized subject was to degrade rather than uplift. So Channing taught European history as commanded; Hart went off to Freiburg to study with Hermann von Holst and returned to Harvard in 1883 as a young instructor to give the only course offered in American History.

It was also in 1883 that a faculty member at Nebraska State University complained to Herbert Baxter Adams: "It is painful to realize the condition of historic study in the multitude of so-called colleges and universities in the United States. . . . When a chair of History was established here, grave professors, educated under the old order of things, regarded it as an unwarranted expenditure of time and money. History should, they thought, be made auxiliary to some other department."[25]

24. Lodge to Tyler, February 24, [1893], Tyler letters, VIII, 98. Tyler's letter to Lodge, February 22, 1893, is in the Lodge Papers, Massachusetts Historical Society, Boston.
25. Carol F. Baird, "Albert Bushnell Hart: The Rise of the Professional Historian," in Paul Buck, ed., *Social Sciences at Harvard, 1860–1920, from Inculcation to the Open Mind* (Cambridge, Mass., 1965), 129–74, esp. 135.

Yet a gradual amelioration seems to have begun just in 1883, when John Bach McMaster accepted a new chair of American history at the University of Pennsylvania's Wharton School. James K. Hosmer offered courses at the University of Missouri and at Washington University in St. Louis until 1892, when he left to become librarian of the Minneapolis Public Library; in the meantime he had published *Samuel Adams* (1885) and *The Life of Young Sir Henry Vane* (1888). In 1887 Harvard promoted "Bushy" Hart to assistant professor of American history, and ten years later to full professor. In 1891 McMaster moved over from Wharton to Penn's new School of American History. Three years later a Historical Committee of the United Confederate Veterans recommended that every southern university ought to establish a chair of American history. The response to that suggestion, born of regional chauvinism, was hardly overwhelming: only Peabody Normal College in Tennessee created such a chair.[26] But Moses Coit Tyler was understandably optimistic by 1897 when he told an interviewer, "I believe the day will soon come when the chair of American history will be the central feature in the historical departments of all our universities."[27]

Glancing at Tyler and his contemporaries as a group, one notices their lack of what we would consider professional training. Almost all of them were self-taught as historians, having originally prepared for some other vocation: Tyler, Hosmer, and Edward Eggleston for the ministry; George Washington Williams, the founder of black historical scholarship, for the ministry, journalism, and law;[28] John Bach McMaster for engineering, which he taught at Princeton; and Charles Janeway Stillé for law. Stillé became a popular pamphleteer on political issues before turning in 1880 to studies of colonial and revolutionary Pennsylvania; in 1886 he became a professor of history at Penn.[29]

26. Eric F. Goldman, *John Bach McMaster: American Historian* (Philadelphia, 1943), 51–52, 61; Hosmer's unpublished autobiography is in the Minnesota Historical Society, St. Paul; Herman Hattaway, "Clio's Southern Soldiers: The United Confederate Veterans and History," *Louisiana History,* 16 (1971), 225, 227.

27. Tyler interview, *Buffalo Express.*

28. See John Hope Franklin, "George Washington Williams and the Beginnings of Afro-American Historiography," *Critical Inquiry,* 4 (1978), 661–63.

29. Stillé (1819–99) was particularly interested in the Swedish colonies on the Delaware. He also edited the works of John Dickinson (1892) and wrote a biography of Anthony Wayne (1893).

IV

Scientific history, so-called, emerged as the strong new trend of the 1880s and '90s, and has been thoroughly studied.[30] The group that I have just described was transitional, however, neither approving of their romantic predecessors (like Sparks and George Bancroft) nor altogether comfortable with the notion of history as an applied science. Tyler felt that his magnum opus, *The Literary History of the American Revolution, 1763–1783,* published in two volumes in 1897, was "the product of a new method." He perceived the external history of public events as being reasonably familiar, so his aim was to "set forth the inward history of our Revolution—the history of its ideas, its spiritual moods, its motives, its passions, even of its sportive caprices and its whims."[31]

Tyler justified his careful scrutiny of revolutionary writers by his belief that they had created, shaped, and directed public opinion. Although we may not entirely accept his premise, I think we are obliged, at the very least, to acknowledge Tyler's intellectual growth in conceptualizing his masterpiece. Back in 1880, when the project was still immature, he regarded the decades after 1765 as "a period in which political and military struggles are the great trait . . . these struggles converge on the effort for complete detachment of America from Europe; and . . . the literature of the time is chiefly an expression of these energies."[32] Essentially, he saw literature as epiphenomenal to political and military events. By 1897, however, Tyler's scheme had been entirely transformed. Here is the way he put it in the preface:

> This study of the American Revolution brings about a somewhat different adjustment of its causal forces, of its instruments, its sequences, its acts, and its actors. The proceedings of legislative bodies, the doings of cabinet ministers and of colonial politicians, the movements of armies, are not here altogether disregarded, but they are here subordinated: they are mentioned, when mentioned at all, as mere external incidents in connection with the ideas and the emotions which lay back of them or in front of them, which caused them or were caused by them.

30. See Deborah L. Haines, "Scientific History as a Teaching Method: The Formative Years," *Journal of American History,* 63 (1977), esp. 900 and 911 for interesting quotations from Tyler, who belonged only marginally to the "scientific" group.

31. This quotation and the others that follow are from Tyler's preface to *The Literary History of the American Revolution* (1897; New York, 1957), v–vii.

32. *Letters and Diaries,* 107.

During a seventeen-year span, between the ages of forty-five and sixty-two, Tyler developed both a rationale and a method for studying the role of ideas in American history. Although his method has necessarily been refined by subsequent practitioners of American Studies, his rationale was adopted with only slight modification more than a generation later by the likes of Perry Miller and Howard Mumford Jones—each of whom, incidentally, wrote a laudatory preface to modern reprint editions of Tyler's two major works.[33]

Tyler also declared in 1897 that his fresh approach, his "inward history," resulted in

> an entirely new distribution of the tokens of historical prominence—of what is called fame—among the various participants [in the Revolution]. Instead of fixing our eyes almost exclusively, as is commonly done, upon statesmen and generals, upon party leaders, upon armies and navies, upon Congress, upon parliament, upon the ministerial agents of a brain-sick king . . . and instead of viewing all these people as the sole or the principal movers and doers of the things that made the American Revolution, we here for the most part turn our eyes away toward certain persons hitherto much neglected, in many cases wholly forgotten—toward persons who, as mere writers . . . nourished the springs of great historic events by creating and shaping and directing public opinion during all that robust time; who . . . wielded only spiritual weapons; who still illustrate . . . the majestic operation of ideas, the creative and decisive play of spiritual forces in the development of history, in the rise and fall of nations.

This declaration and the one that preceded it enable us to set Tyler very precisely among his Anglo-American contemporaries. For a cluster of reasons, I find it helpful to consider Tyler as a mid-Victorian in the fullest sense of the phrase. Like Matthew Arnold, Tyler cherished "order," meaning orderliness as well as intellectual or rational order. And Tyler associated order with psychological serenity; like Arnold, he believed that human nature required a sense of order.[34] What is

33. Miller wrote an eight-page foreword to the Collier soft-cover edition of *A History of American Literature, 1607–1765* (New York, 1962). Jones prepared a four-page foreword to both the Cornell University Press edition (Ithaca, 1949) and the Frederick Ungar reprint of *The Literary History of the American Revolution, 1763–1783* (New York, 1957).

34. *Letters and Diaries*, 268; Peter Allan Dale, *The Victorian Critic and the Idea of History: Carlyle, Arnold, Pater* (Cambridge, Mass., 1977), 131.

absolutely crucial to our understanding of Tyler as a mid-Victorian, however, is that a metaphysical concern with the meaning of the historical process itself interested him very much, whereas he was indifferent to epistemological problems involving the nature of historical knowledge. For Matthew Arnold, Thomas Carlyle, and Walter Pater the historical process could be reduced, essentially, to the development of what they called mind or Spirit or Zeitgeist. Hegel, in his introduction to his lectures on the philosophy of history (1822–23), had accented a distinction between the nonhistorical processes of nature, which are regulated by natural law, and the processes of history, which are governed by thought.[35] From the mid-Victorians, like Carlyle, Arnold, Gladstone, Kingsley, and a quartet of historians to whom I shall refer in a moment, Moses Coit Tyler acquired his rationale for writing the history of ideas and their impact upon public affairs.[36]

Tyler's emphasis upon the paramount role of mind, human expression, and public opinion was intimately connected to a concern that was equally characteristic of historians in Great Britain and on the continent at that time: namely, the value of history as a measure of moral standards. History had had a customary link with moral philosophy, but the moral dimension of historical inquiry to which I refer was as much theological *and* practical (or applied) as it was philosophical. In writing of Christoph Schlosser, Jacob Burckhardt, Johann Gustav Droysen, Lord Acton, and William Stubbs, Professor Felix Gilbert has observed that "it is remarkable to what extent the writings and utterances of nineteenth-century historians abound in reflections and judgments of a moral character; for many of these historians world history was a world court."[37] In his inaugural lecture as Regius Professor at Oxford and in many of his routine lectures thereafter, Stubbs stressed the importance of history in forming ethical convictions and determining a moral order of values. In 1869 W. E. H. Lecky published his two-volume *History of European Morals*. Lecky (1838–1903)

35. Dale, *Victorian Critic*, 6, 126, 195; Himmelfarb, *Victorian Minds*, 194.

36. Although Tyler believed strongly that his eighteenth-century writers had shaped public opinion, it is not clear whether he shared the view of his colleague Charles Kendall Adams that the historian's task was to mold public opinion and "set it right." See Adams, "Recent Work in the Colleges and Universities of Europe and America," *Annual Report of the American Historical Association for the Year 1889* (Washington, D.C., 1890), 36.

37. Gilbert, "Reflections on the History of the Professor of History," in *History: Choice and Commitment* (Cambridge, Mass., 1977), 451–52.

was almost exactly Tyler's contemporary and, like him, a historian and essayist, a strong liberal deeply interested in the phenomenon of public opinion. Tyler greatly admired Lecky's work and assigned chapters of his volumes on the eighteenth century to students at Cornell.[38]

In 1854, at the age of nineteen, Tyler wrote to an aunt that "nothing is ever lost by taking a firm stand on all moral questions and by displaying moral courage and independence of character." That belief became a kind of credo throughout the course of his professional and personal life. In 1866 he was horrified by the sight of flagrant prostitution in Cardiff, Wales: "I have not seen whoring so coarsely displayed before." Four years later the notorious Beecher-Tilton adultery scandal so sickened him that he could not write about it in his journal, even though he knew both men quite well. Tyler brooded about his own "moral nature," believed that "intellectual regeneration" was inseparable from moral regeneration, and felt that he could not do his best work unless "energized by my moral activities." At times his priggishness does get to be a bit much. In July of 1882, recuperating in Paris from his first year of teaching at Cornell, Tyler sat on a bench staring at Victor Hugo and ingesting Hugo's milieu. "There I sat down for a full hour—and drank it all in; and that is all that I did drink, although the café was there." In 1897, after Tyler finished reading the proofs of his *Literary History,* he took a twelve-day cruise to Great Britain in order to recover his strength and settle his nerves. In Glasgow he stayed at a temperance hotel, a fact that he called to the attention of Andrew D. White in a letter that opens, "Dearly Beloved Excellency" (referring, I assume, to White's ambassadorial position in Germany).[39]

Tyler's high-mindedness, his determination that moral and intellectual attributes must master the sensuous, passionate, and emotional tendencies, and his penchant for manly Christianity all remind one of Carlyle, J. A. Froude, James Bryce, Leslie Stephen, and Dr. Thomas Arnold, the illustrious Master of Rugby.[40] More particularly, though,

38. Andrew D. White to Lecky, July 30, 1890, in [Elizabeth Lecky], *A Memoir of . . . Lecky* (New York, 1909), 186.

38. *Letters and Diaries,* 7, 29, 42–43, 49, 84–85, 168; Tyler to White, September 17, 1897, White Papers, box 81. In Tyler's journals, "Great Diana" seems to be his euphemism for "God damn."

40. See Himmelfarb, *Victorian Minds,* 243, 290–92, 303; Edmund Ions, *James Bryce and American Democracy, 1870–1922* (London, 1968), 30, 68; Dale, *Victorian Critic,* 104,

I am inclined to look at Tyler alongside four English historians who were, chronologically and spiritually, his close contemporaries. I have in mind Sir John Seeley (1834–95), Regius Professor of Modern History at Cambridge, 1869–95; Lord Acton (1834–1902), Seeley's successor as Regius Professor, 1895–1902; J. R. Green (1837–83), a clergyman who became librarian at Lambeth Palace and then an active historian without academic affiliation; and finally, George Otto Trevelyan (1838–1928), member of Parliament, 1865–97, Liberal politician, and author of a six-volume history of the American Revolution published between 1898 and 1914. These men were not alike. Each one had very distinctive attributes, achievements, and eccentricities; nonetheless, Tyler had much in common with them all.

J. R. Seeley was firmly commited to the notion of the organic nation-state and believed that historical study should be used to foster national unity. Like Tyler he came of age imbued with a strong sense of duty, suffered periodic physical and nervous breakdowns from self-generated pressure and overwork, began his career as a writer on religious subjects, remained preoccupied with morality after his evangelical enthusiasm ceased, and expected the state to serve as the foremost agency of religion and morality in the modern world. Seeley believed that in order to establish history as a serious discipline he must discredit the excessively romantic approach of his predecessors. (Tyler had comparable feelings about Bancroft and John Gorham Palfrey.) Seeley also fought very hard to achieve recognition for his chosen field. In 1873 there were only two teaching positions in all fields of history at Cambridge. A major turning point occurred in 1883, when the university created five lectureships in history. Then, when the Triposes were reformed in 1885, English history made an immense breakthrough: English constitutional history, English economic history, a Special Subject in English history, and yet another option for essays on English history. Seeley's claim that "the true Bible of every nation is its national history" might have seemed a trifle overstated to Moses Coit Tyler, but not by much.[41]

112, 118. In 1879 Tyler noted in his journal that "even all my mistakes are taken into account and have been permitted as a part of the manifold process of discipline and victory in my life" (*Letters and Diaries,* 106).

41. Deborah Wormell, *Sir John Seeley and the Uses of History* (Cambridge, 1980), 13, 22, 29, 47, 75, 77, 79, 110–12, 131, 133; G. Kitson Clark, "A Hundred Years of the Teaching of History at Cambridge, 1873–1973," *Historical Journal,* 16 (1973), 545.

The Quest for Meaning

Lord Acton's Germanic and aristocratic origins differentiate him from Tyler in many ways. Yet their personal and intellectual similarities are extraordinary. Like Tyler, Acton was a conservative liberal who had been deeply influenced by Edmund Burke. Acton wrote for Roman Catholic reviews just as Tyler had for the *Christian Union*. Acton brought a singularly ethical approach to every topic. In 1887 he declared in the *English Historical Review* that "it is the office of historical science to maintain morality as the sole impartial criterion of men and things." His contemporaries found Acton to be a lone wolf, unaccustomed to consultation. As his biographer puts it, "Acton was never a young man but passed directly from his retarded boyhood to that form of maturity verging on middle age." (One recalls Tyler beginning to teach school at the age of fifteen.) He was austere, judgmental, incredibly learned, and passionately interested in the history of liberty. Just as Tyler played a major role in launching the American Historical Association in 1884–85 and contributed to the first issue of its *Review*, Lord Acton, along with J. R. Green, helped to inaugurate the *English Historical Review* in 1886.[42]

Green's *Short History of the English People* enjoyed a vast popular success after its publication in 1874. One ingredient of that success was his emphasis upon the social development and progress of popular life. Hence I am reminded of Tyler's preface to the *Literary History*, where he sought to bring the reader "into a rather direct and familiar acquaintance with the American people themselves, on both sides of the dispute, as, sitting at their firesides or walking in their streets, they were actually stirred to thought and passion by the arrival of the daily budget of news touching an affair of incomparable moment to themselves" (p. viii). We know that Tyler read Green's *Short History* in July 1885, that he admired its moral tone and political perspective, and that Green augmented Tyler's appreciation of the power of the press and the role of the political essay in Anglo-American culture prior to the Revolution.[43]

The personal parallels between Green and Tyler are most striking. Especially devout as a young man (even High Church), Green was ordained as a deacon in 1860, one year after he finished at Oxford.

42. David Mathew, *Lord Acton and His Times* (University, Ala., 1968), esp. 24, 191, 330, 333. (After 1870 Lord Acton repudiated Burke.) For Tyler's adulation of both Burke and Charles Sumner, hence his conservative liberalism, see *Letters and Diaries*, 45, 54.
43. See Tyler, *Literary History*, I, 21, and chap. 9.

Between 1860 and 1869, while serving as a curate (and giving excellent sermons), he read chronicles and historical literature of all kinds and began to write historical essays. He became increasingly liberal on theological matters and in 1869 underwent a double crisis. The sense that he no longer had a calling for the clerical life was aggravated by declining health—specifically, weak lungs. He then served as librarian at Lambeth, acquiring immense historical knowledge by means of patient research and a rather solitary life. The extraordinary success of his *Short History* brought pressure for enlargement, so he expanded it into a four-volume *History of the English People* (1877–80) and followed that in 1883 with the *Conquest of England*. Like Tyler he cared about local history and urged the formation of the Oxford Historical Society.[44]

V

In June of 1882, fresh from that debilitating first year at Cornell, Tyler listened to George Otto Trevelyan speak in the House of Commons. "He is very able," Tyler noted, and indeed he was. In 1884 Trevelyan entered Gladstone's cabinet. But that suggests an important difference between Tyler and most of the men we have been looking at for comparative purposes. Unlike Seeley, Acton, and Trevelyan, Tyler was instinctively a political spectator rather than a participant. Addicted to parliamentary debates, Tyler could be a very keen observer.

But if preaching exhausted him, and it did, then political activism would have prostrated him. In 1880 Tyler sent his brother a letter that strikes me as an interesting piece of self-deception: "If I had a snug private income to live on I would devote the rest of my life to literature and politics—i.e., to writing American history and to making it. The way into the public eye from this locality is quite open to a fellow but the money bother is in my way and I shall continue pedagogue. Only it is fun to dip into real life once in four years."[45]

If truth be told, Tyler couldn't stand any more than a "dip." Less than a month after writing that letter he attended the Republican state

44. "Green," in *Dictionary of National Biography*.

45. Tyler to John Tyler, April 19, 1880, *Letters and Diaries*, 109. His reaction to Trevelyan's speech appears on p. 137.

convention in Michigan: "I have learned a good deal concerning men and things in practical politics," he confessed to his journal, "and my present feeling is one of disgust." The dip had given way very quickly to disgust. Therein lies a crucial distinction between Tyler, Trevelyan, and Acton.[46] All three were genteel men; but the English historians at least understood that a vast gulf lay between politics and literary studies—perhaps because both Trevelyan and Acton were men of affairs first and historians second, whereas Tyler vacillated for most of his life between the pulpit and the lectern.

Although Trevelyan worked on his brilliant biography of Charles James Fox shortly before the period when Tyler wrote his *Patrick Henry* (1887), Trevelyan waited until 1897, when he resigned from the House of Commons, to begin his six-volume work on the American Revolution. What that work so obviously has in common with Tyler's study of the Revolution is the effort of both authors to achieve ideological detachment. Although Trevelyan had never visited America and relied heavily on secondary works (some of them no longer up-to-date or entirely reliable), he managed to dispose of all sorts of anti-British myths; did much to improve the perceptions that Americans had of Britain; won the admiration of readers as diverse as Claude Van Tyne and Henry James; and, in fact, was more widely read in the U.S. than in the U.K.[47]

This fascination for the American Revolution that Tyler shared with Trevelyan is noteworthy because it is symptomatic of the Anglo-American rapprochement that developed during the generation prior to World War I. In 1893 Goldwin Smith introduced his history of the United States by explaining that he was "an Englishman who regards the American Commonwealth as the great achievement of his race . . . yet desires to do justice to the mother country, and to render to her the meed of gratitude which will always be her due."[48] Similarly,

46. Ibid., 110. See Gertrude Himmelfarb, *Lord Acton: A Study in Conscience and Politics* (Chicago, 1952). Tyler did put aside his two projects on Patrick Henry and the Revolution long enough to write a eulogistic portrait of a local politician: see *In Memoriam: Edgar Kelsey* (Ithaca, 1886). But see Tyler to Henry Cabot Lodge, February 22, 1893, Lodge Papers.

47. G. M. Trevelyan, *Sir George Otto Trevelyan: A Memoir* (London, 1932), 105, 136–42; Trevelyan. *The American Revolution*, ed., abr. Richard B. Morris (New York, 1964). Trevelyan heaped lavish praise on Tyler's work (I, chap. 2, n.1).

48. Smith, *The United States: An Outline of Political History, 1492–1871* (New York, 1893), v. Cf. Woodrow Wilson, "Mr. Goldwin Smith's 'Views' on our Political Histo-

Moses Coit Tyler kept a "Record of Daily Work" during 1885 in which he frequently recorded his efforts to acquire "a more minute knowledge of the English side of our history during the Rev." Tyler chose to offer an essay on the Loyalists for the inaugural issue of the *American Historical Review* (1895); and in an interview in 1897, when the first volume of the *Literary History* appeared, Tyler complained that the Loyalists had been unduly vilified by descendants of the patriots. He believed that legally and constitutionally the Tories had been correct in many key respects. They deserved, therefore, "a candid, clear statement of their side of the case."[49]

Tyler shared with Goldwin Smith a fervent belief in the spiritual unity of the English-speaking peoples. In 1866, two years after Smith brought out his *England and America,* Tyler published an essay in which he referred to "that unlucky quarrel which broke out between the English and the Americans about a hundred years ago." Thirty years later he sent copies of the *Literary History* to various British acquaintances and must have felt gratified by their responses. W. E. H. Lecky found it "full of instruction to both our countries," and William E. Gladstone explained that "for nearly half a century I have been an admiring student of the American Revolution, and I believe myself to owe to it an appreciable part of my own political education."[50] Though many friends and some reviewers regarded it as "marvelous that you have held the balance so evenly and have succeeded in deciding all questions with such marvelous impartiality," most English reviewers rather obtusely viewed him as anti-English, while Americans tended to be baffled by his lack of animosity toward the Tories.[51]

A recent book by Vivien Hart, *Distrust and Democracy,* introduces a very pertinent attitude or category that she calls "democratic elitism." That seems to me an apt phrase to describe the drift of Tyler, Arnold,

ry," *Forum*, 16 (December 1893), 489–99; Elisabeth Wallace, "Goldwin Smith on History," *Journal of Modern History*, 26 (1954), 220–32.

49. "Record of Daily Work," 11, 14, 15, Tyler Papers; Tyler, "The Party of the Loyalists in the American Revolution," *American Historical Review*, 1 (1895), 24–46; Tyler interview, *Buffalo Express*.

50. Tyler, *Glimpses of England* (New York, 1898), 279; *Letters and Diaries*, 301; Gladstone to Tyler, August 18, 1897, a penny postcard in a bound volume labeled "Personal Letters to Tyler about *The Literary History of the American Revolution*," Tyler Papers.

51. Charles Kendall Adams to Tyler, July 30, 1897, *Letters and Diaries*, 295; Jones and Casady, *Tyler*, 259.

Seeley, and Acton during this period. In 1882, when Tyler met James Russell Lowell in London, it disturbed him that Lowell expressed doubts about the viability of democracy in America. In the later 1890s, however, Tyler conceded "that the full development even of American capacity for self government is still far off, and only to be reached by us after much more blundering and loss, and shame, and sorrow." In 1900, after giving a lecture at Chautauqua, Tyler told his wife that the audience comprised "a dull and commonplace looking lot of people, and many of the faces had a depressing look as of hopeless stupidity."[52] Two years earlier Tyler characterized himself as a "theoretical democrat"[53]—an appropriate description, I believe, for a man who greatly admired both Charles Sumner and Edmund Burke.

VI

In seeking a judicious assessment of Tyler as a man and as a scholar, we might begin with the brief biographical pieces written by George Lincoln Burr in 1901. Burr had known Tyler for twenty years, and with characteristic generosity published no fewer than three eulogistic essays. In one of them, Burr observed that his colleague "joined a great simplicity of heart and an exceedingly sunny temper. Rare, indeed, was the mixture in him of austerity and boyishness, of humor and fastidious taste."[54] To which I can only reply: nonsense! The austerity and fastidious taste may stand uncorrected, but examples of Tyler's humor are rare, indeed, although one does occasionally find them.[55] Boyishness and sunny temper Tyler must have saved for some private vis à vis with Burr. I don't see it.

Instead, I find a man more often melancholy than sunny, and some-

52. See Hart, *Distrust and Democracy: Political Distrust in Britain and America* (Cambridge, 1978); *Letters and Diaries,* 142, 320; Tyler's manuscript draft of the preface to *Glimpses of England,* 4, included with his personal copy, Tyler Papers.

53. Manuscript draft of preface to *Glimpses of England,* 4.

54. Burr, "The Late Professor Moses Coit Tyler," *Critic,* 38 (1901), 136–37. See also "Moses Coit Tyler," *New England Historical and Genealogical Register,* 55 (1901), xciii–xcv; and "Moses Coit Tyler, A Memorial Address," 187–95, where Burr added "that whimsical playfulness of fancy, that love of companionship, the fertility in anecdote" to the litany of Tyler's charms (p. 195).

55. See, e.g., the lovely tale that Tyler tells in *Glimpses of England,* 283–85. Tyler's good stories were invariably historical and usually had something to do with Anglo-American history in particular.

times just plain morbid. In 1884, three years after he arrived at Cornell, now forty-nine years old, Tyler went secretly to buy a burial plot for himself. Returning home, he recorded in his journal that the possible purchase denoted "my feeling that I have come here to stay. A gradual conviction has filtered through my consciousness that here I have found my work, my home, my grave." Then he added, "Lest the fact should give pain, I have not mentioned it to any one of the family." On Ash Wednesday in 1890, feeling depressed about his work, he "wandered off in the fresh air and visited a peaceful and inviting spot—the East Lawn cemetery—looking about for a good, comfortable place in which this poor body may be laid to rest." Two weeks later he strolled on frozen ground to Pleasant Grove cemetery, two miles north of the campus, and decided that he preferred it to East Lawn. He repeated these visits periodically, and reassured himself with the reminder that "all will be well—especially after this body takes possession of its quiet and cosey little home up on the Lansing road."[56]

By the time Tyler reached his early fifties, he had become obsessed with the mortality of major writers, churchmen, and politicians. "How I envy those to whom the sunset has peacefully come," he wrote in 1893; a few years later, in a letter to J. Franklin Jameson about *The Literary History of the American Revolution,* he whimpered: "If I don't hurry up & finish it soon, it will finish me."[57] None of which, needless to say, was unique in Tyler's personality. At the age of forty Erasmus of Rotterdam decided that he had crossed the threshold of old age and began to prepare for his demise. "The last act of the play has begun," he often said, even though he lived to be seventy. One also thinks of Matthew Arnold, who spent two years writing his most important poem, "Empedocles," but then suppressed it on grounds of "excessive morbidity."[58]

Despite all this gloom, Tyler's self-confidence must have grown during the mature years of his professional career. Note that his first two volumes, published in 1878, were titled *A History of American Literature, 1607–1765,* whereas the successor set he boldly called *The*

56. *Letters and Diaries,* 194, 254–55, 269, 276.

57. Ibid., 263, 270, 272, 297; Tyler to Jameson, October 17, 1886, Jameson Papers, box 132, Library of Congress, Washington, D.C. Actually, Tyler finished the *Literary History* eighteen days later on November 3, 1896, and celebrated by going horseback riding in the Danby hills (*Letters and Diaries,* 287).

58. See Johan Huizinga, *Erasmus* (New York, 1924), 76–77, 192; Dale, *Victorian Critic,* 104–5.

Literary History of the American Revolution, 1763–1783. Tyler's expansiveness was characteristic of the age. In 1895, when J. Franklin Jameson invited him to contribute to the inaugural issue of the *American Historial Review,* Tyler replied "I should wish to be very elaborate and to have plenty of room. What is the maximum limit that you could give me?"[59] In addition to the four big books on which Tyler's fame primarily rests, his biography of Patrick Henry (1887) turned out to be the longest by far in the "American Statesmen" series.

Although Tyler had a penchant for old-fashioned rhetoric—he loved the word "wrought" as a description of what he did at his desk—the length of his books resulted far less from wordiness than from thoroughness. That had always been his compulsion. In 1871 he noted in his journal: "To prepare myself fully for the field of American history that it may be my privilege to cultivate, I purpose first to go over critically all the writers upon the subject of any note—Bancroft, Hildreth, Grahams, Holmes, Palfrey, Robertson, and so on." He constantly searched for new or neglected sources, spared no expense to acquire rare copies of early American imprints, carefully checked the holdings of all major repositories, and—as in the case of John Trumbull—gained private access to the papers of revolutionary writers that had remained in the possession of their descendants.[60] Tyler's thoroughness is one of the reasons why his work remains so useful to us today. In the *Literary History,* for example, you will find chapters devoted to Joseph Stansbury, a Loyalist songwriter and satirist; to Jonathan Odell, perhaps the chief Tory satirist; and even to the *now* fashionable subject of prison literature, a topic hardly in vogue among historians in the late nineteenth century.

It should not be surprising that we no longer share all of Tyler's literary assessments. He could be condescending to Phillis Wheatley, the first black poet to be published in America, and his fondness for calling the Declaration of Independence a "war song" strikes an odd note. Tyler was more likely to be excessively generous than condescending, however, especially when he wrote about relatively obscure people whom he regarded as personal discoveries. Nor is Bernard Bailyn unfair in remarking that Tyler failed to grasp "the peculiar

59. Tyler to Jameson, June 10, 1895, Jameson Papers, box 132.
60. *Letters and Diaries,* 66, 208; Tyler to Samuel L. M. Barlow, March 19 and April 3, 1888, Huntington Library, San Marino, Calif.; Tyler to Jameson, June 10, 1895; Jameson Papers, box 132.

mental and psychological dispositions of the late eighteenth-century world."[61]

Tyler's customary approach was biographical—simultaneously a source of strength and a source of weakness.[62] During the last three years of his life he planned a five-volume series, tentatively called "A Century of American Statesmen," that would have been more political and less literary than his earlier works. In 1898 Tyler told White that he had begun his "American Plutarch" and added that Francis Miles Finch, the first dean of Cornell's law school, "the other day . . . defined history as 'massed biography.' That gives my conception of this scheme."[63]

Contemporaries as well as subsequent critics have felt that his major works manage to transcend the limitations inherent in a biographical mode of research and exposition. In 1897 Harvard's Albert Bushnell Hart praised Tyler lavishly for his "discussion of the recently serious questions of the Revolution—principles, political arguments and responsibility." Thirty-seven years later F. O. Matthiessen observed that Tyler had tried to write not literary criticism "but intellectual history as presented by a series of biographies of minds in action." Tyler would have been pleased with that assessment, for as he explained to Jameson in 1895, his goal was to "cast fresh light . . . on the intellectual and moral conditions of the entire period of the Revolution."[64]

Tyler's niche in the history of American literary criticism seems secure. In 1896 a young teacher at Penn State, Fred Lewis Pattee, who

61. See Bernard W. Bell, "African-American Writers," in *American Literature, 1764–1789: The Revolutionary Years* (Madison, Wis., 1977), 181; essay on Tyler by William P. Trent, *Ithaca Daily Journal*, August 5, 1901; Bailyn, *The Ordeal of Thomas Hutchinson* (Cambridge, Mass., 1974), 403.

62. In addition to the works that have been discussed, see Tyler, *Three Men of Letters* (New York, 1895), consisting of very long essays on George Berkeley, Timothy Dwight, and Joel Barlow.

63. Tyler to White, March 6, 1898, White Papers, box 82. He also intended to write a "Literary History of the American Republic during the First Half Century of Independence, 1783–1833," as well as a historical novel on Bacon's Rebellion (1676–77). Just before his death, however, Tyler destroyed all of his "work in progress."

64. Hart to Tyler, May 6, 1897, *Letters and Diaries*, 289; Matthiessen in *New England Quarterly*, VII, 749; Tyler to Jameson, June 10, 1895, Jameson Papers, box 132. George Lincoln Burr, who seems to have been oblivious to Tyler's personal eccentricities, was much closer to the mark in his professional evaluation. Burr pointed out that Tyler did not teach "literature under the guise of history. The history of ideas, indeed, had with him ever the foremost place. . . . His interest in the story of America antedated, in fact, his study of her literature, and his earlier dream was of writing a history of the American people" ("The Late Professor Tyler," 137.)

eventually held the first chair in the United States devoted entirely to American literature,[65] published a controversial essay titled "Is There an American Literature?" It evoked a long and angry refutation from the *New York Times,* and Pattee received a barrage of sarcastic letters.[66] The publication of Tyler's *Literary History* in 1897 could hardly resolve the issue to everyone's satisfaction; that would not happen for another quarter century. But the attention and lavish praise that Tyler did receive made his work an immediate landmark in the historiography of American literature. It remains so to this day.[67]

I would be overstating the case, and perhaps anachronistic, if I claimed that the American Studies movement began exclusively and exactly with Moses Coit Tyler. Yet I cannot think of anyone whose credentials are stronger. Although he was a fervent nationalist, he numbered "the cultivation of fairmindedness as a habit, and the suppression of intellectual partisanship" among the chief benefits of historical study. Appreciating one's own culture helped in understanding others—a generalization that certainly applies to Tyler himself. "History is for time," he observed in the late 1890s, "what travel is for space; it is an intellectual journey across oceans and continents of duration."[68]

As early as 1866, in an essay "On Certain English Hallucinations Touching America," Tyler had talked about the desirability of endowing professorships in American history at Oxford and Cambridge. His reason was unexceptionable: British ignorance of the United States.[69]

65. Pattee began teaching at Penn State in 1894 as professor of English and rhetoric. In 1918, largely as a result of a departmental feud over territorial matters, he became professor of English and American literature and, two years later, simply professor of American literature. Interesting similarities exist between the careers of Pattee and Tyler. Neither one ever earned a doctorate. In 1892 Pattee was licensed as a Methodist preacher. He served as chaplain at Penn State from 1912 until 1927 and conducted compulsory chapel services every morning at eight. See James J. Martine, *Fred Lewis Pattee & American Literature* (University Park, Pa., 1973), 17, 24, 59, 79–80, 83.

66. Pattee's essay appeared in *Dial,* 21 (November 1, 1896), 243–45. See also *Penn State Yankee: The Autobiography of Fred Lewis Pattee* (State College, Pa., 1953), esp. 118, 163, 173–74, 325.

67. Fame is very ephemeral, however, as Tyler often noted (see *Letters and Diaries,* 177, 186). Frederick Clarke Prescott, who taught English and American literature at Cornell from 1897 until 1940, edited an anthology called *Prose and Poetry of the Revolution: The Establishment of the Nation, 1765–1789* (New York, 1925), and never mentioned Tyler's work in the introduction!

68. See "Our Right to 'America,'" a very long report of Tyler's Chautauqua lecture titled "The Problem of a National Name," *New York Times,* July 23, 1900, p. 8; and Tyler, "The Educational Value of History," 12, 16.

69. Tyler, *Glimpses of England,* 289.

Tyler's recommendation would not be fulfilled until 1922 at Oxford and 1944 at Cambridge. His own ambition, at least, was consummated at Cornell in 1881, a turning point as advantageous to the fifteen-year-old institution as it was to the forty-six-year-old appointee.

In 1897 Tyler reminisced about the events of 1881:

> As soon as I had accepted the professorship of history at Cornell I began to talk about cutting it up into slices, reserving to myself the American slice. Well, I remember how some of the trustees doubted and wondered at this, and one of them asked me if there was enough in American history to occupy the whole time of one man—whether this was not carrying specialization in work too far? Of course they looked for a precedent—and there was none. However [Andrew D. White] had for years known that I was working on the subject, and that I wanted to prove that the record of our country was extensive enough and ripe enough to form a separate department of University instruction. [So White supported me and the trustees] finally told me to go ahead and do the things I felt called to do, and could do best.[70]

For almost a quarter of a century Tyler had been in quest of his proper calling and the ideal place to pursue it. More than one hundred years ago Andrew Dickson White and Henry W. Sage had faith in the importance of Tyler's chosen field and in him as the ideal scholar to inaugurate the field. In the subsequent nineteen years Tyler did not always keep faith with himself. He was too anguished a mid-Victorian to know the comforts of true self-assurance. But he did keep faith with Cornell and found there, just as he predicted he would, his work, his home, and—on December 28, 1900—his long-awaited grave.

70. Tyler interview, *Buffalo Express*.

"This, Here, and Soon": Johan Huizinga's *Esquisse* of American Culture

In 1782 the Netherlands recognized the independence of the young United States by signing a treaty of amity and commerce. Two hundred years later the Dutch Historical Association and the Netherlands American Studies Association celebrated the bicentennial of that enduring friendship by sponsoring a remarkable symposium in Amsterdam. The paper that follows was my contribution;[1] it was published in *A Bilateral Bicentennial: A History of Dutch-American Relations, 1782–1982*, edited by J. W. Schulte Nordholt and Robert P. Swierenga (New York and Amsterdam, 1982), and appears here by permission of the publisher, Meulenhoff International.

In the years since 1982 the Netherlands has become a kind of second home for me. A cluster of good friends deserve much of the credit for that: Professor Rob Kroes of the University of Amsterdam; Anne Gurvin, cultural attaché at the U.S. Embassy in The Hague; and two Dutch friends who earned their Ph.D.s in American

1. I had intended to use "Huizinga's Vision of American Culture" as my subtitle, but then I noticed that in writing about the nature of "historical understanding" Huizinga explicitly rejected the phrase "historical vision." In view of his particular sensitivity to matters of iconography and vision, it would have been cavalier to employ a word-concept that seemed to him so inappropriate. Cf. "The Task of Cultural History," in Johan Huizinga, *Men and Ideas: History, the Middle Ages, the Renaissance* (New York, 1959), 53.

Studies and American History at Cornell, Joke Kardux and Eduard van de Bilt.

In the wake of this bicentennial friendship I prepared a series of essays on Dutch history and culture for the travel section of the *New York Times*: on the Kröller-Muller Museum in Otterlo (November 21, 1982); the Zuider Zee historical village at Enkhuizen and the open-air museum near Arnhem (September 18, 1983); the art and architecture of Haarlem (September 30, 1984); and the historic forts of Naarden and Muidersloot (March 24, 1985). My presentation at the 1984 conference of the Netherlands American Studies Association, "Historical Reflections upon the Role of Utopianism in American Culture," appears in *Nineteen Eighty-Four and the Apocalyptic Imagination,* edited by Rob Kroes (Amsterdam, 1985), 110–26.

I

To offer yet another essay on Johan Huizinga may understandably seem superfluous. Several fine articles about him have appeared in the United States, even more in Europe, and a great many in his native land. Huizinga has hardly been neglected since his death in 1945. His books remain in print; indeed, most of them have been translated into various languages, which befits one of the masters of modern historical thought. In the familiar portrait, made in 1936 by H. H. Kamerlingh-Onnes (Figure 22), we see the scholar in his study, notice the inquisitive but calmly reflective face, long and upward-curving lines at the outer edges of his eyes, a short neck, rounded shoulders, and the humped upper back of a desk-bound man, age sixty-five, who had spent so much of his life reading and writing.[2]

Our sense of Huizinga's temperament is equally familiar, for it has been sketched often: anti-Freudian and anti-Marxian because both of those value systems were anti-Christian in their implications, and because Huizinga's mind was too subtle to be trapped by any mode of determinism. Then there is the conservative Huizinga: the man of delicate aesthetic sensibility, the harsh critic of technology (so mecha-

2. The portrait appears in C. T. van Valkenburg, *J. Huizinga: Zijn Leven en Zijn Persoonlijkheid* (Amsterdam, 1946), plate facing p. 7; and as the frontispiece in Johan Huizinga, *Geschichte und Kultur: Gesammelte Aufsätze,* trans. and ed. Kurt Köster (Stuttgart, 1954).

Figure 22. Johan Huizinga by H. H. Kamerlingh-Onnes (1936).

nistic in its social implications) and of mass culture. At a conference held in 1972 at Groningen, to celebrate the one hundredth anniversary of Huizinga's birth, E. H. Gombrich remarked upon his plea for renunciation. The stoic historian "wanted to persuade his contemporaries to exercise restraint, to practise austerity and to seek the simple life."[3]

Huizinga has been criticized for romanticizing the past, for anthropomorphizing culture, for elitism, for a lack of conceptual rigor, and for undue pessimism about the human condition and its prospects. The only aspect of the customary characterization of him that has been softened in recent years is the view (initially emphasized by Pieter Geyl and Jan Romein) that Huizinga was indifferent to political realities. As Robert Anchor wrote in 1978, however, Huizinga "plausibly viewed politics as *symptomatic rather than causative*" and "sought to diagnose the disease of which the myths of national and racial superiority, and the new justifications for violence, cruelty, and war were the most conspicuous signs. Such statements, indeed, were not neutral. The Nazis deemed them dangerous enough to detail Huizinga during the occupation in the out-of-the-way town of De Steeg."[4]

Despite familiar criticisms, Huizinga retains our respect. *The Waning of the Middle Ages* (1919) continues to be widely read; it is still regularly assigned as a required text at American universities.[5] When Huizinga's two books on the United States were published together in English translation (1972), that volume, titled *America: A Dutch Historian's Vision, from Afar and Near,* enjoyed considerable success in various sorts of college courses in the United States.[6] Above all, *Homo Ludens* (1938), which was not translated into English until 1950, is frequently cited by scholars and popular writers alike. In *The Complete Book of Running,* for example, a best-selling manual for joggers published in

3. Gombrich, "Huizinga's *Homo ludens,*" in W. R. H. Koops et al., eds., *Johan Huizinga, 1872–1972* . . . (The Hague, 1973), 144, 153.

4. Anchor, "History and Play: Johan Huizinga and His Critics," *History and Theory,* 17 (1978), 85–86 (the italics are Anchor's); R. L. Colie, "Johan Huizinga and the Task of Cultural History," *American Historical Review,* 69 (1964), 618–19, 629; Pieter Geyl, "Huizinga as Accuser of His Age," *History and Theory,* 2 (1963), 231–62.

5. F. W. N. Hugenholtz, "The Fame of a Masterwork," in Koops, ed., *Johan Huizinga,* 91–103; Reuel Denney, "Feast of Strangers: Varieties of Sociable Experience in America," in Herbert J. Gans et al., eds., *On the Making of Americans: Essays in Honor of David Riesman* (Philadelphia, 1979), 254, 268, where he appears as John Huizinga.

6. Letters to the author from John M. Gates, November 2, 1981; Charles F. Howlett, November 12, 1981; Jeff LaLande, November 24, 1981.

1977, Jim Fixx announced that "any decently thorough inquiry into the meaning of sport will eventually bring us to the source of much present-day thinking on the matter: Johan Huizinga's profound *Homo Ludens: A Study of the Play Element in Culture*" (p. 20). If, in fact, *Homo Ludens* has become Huizinga's best-known book, that may well be symptomatic of a remarkable increase in leisure during the past generation, and of our attention to leisure as a many-faceted cultural phenomenon. Surely, much has changed since 1931, when Supreme Court Justice Oliver Wendell Holmes wrote that "one dreams of leisure but as the old farmer said, when he saw the hippopotamus, I don't believe there's no such critter."[7]

Although much has now been said about Huizinga and his views, no one (to the best of my knowledge) has yet undertaken a discrete examination of his changing perceptions of American culture—a story, or relationship, that essentially took place during the quarter-century between 1916 and 1941. There are several reasons why I am glad to attempt such an assessment. First, I must admit not merely my professional admiration for Huizinga, especially the wonderful range of his interests and reading,[8] but even a certain empathy for many of his cultural criticisms and predilections, however unfashionable they may be. Second, Huizinga had the courage to generalize: about Dutch civilization, about the factors that had shaped the American national character, and, ultimately, about the density of humankind and its evolving culture. Wallace Notestein, a distinguished historian from the United States who was nearly Huizinga's contemporary, wrote to a

7. Holmes to Mrs. Charles Warren, March 22, 1931, Warren Papers, box 2, Library of Congress, Washington, D.C. For an important example of the impact of *Homo Ludens,* see Allen Guttmann, *From Ritual to Record: The Nature of Modern Sports* (New York, 1978), 4, 6–7, 13–14, 80.

8. In 1936 Lewis Stiles Gannett, who wrote a regular column called "Books and Things" for the *New York Herald Tribune,* asked Huizinga what he was currently reading for pleasure. Huizinga replied with four titles: Gilbert Murray, *Then and Now: The Changes of the Last Fifty Years* (1935); Sir R. W. Livingstone, *Greek Ideals and Modern Life* (1935); Fernando del Pino, *La Gran Decisión* (1936); and Paul Hazard, *La Crise de la conscience européenne, 1680–1715* (1935), 3 vols. Six months earlier he had been reading George Sarton's massive *Introduction to the History of Science* (1927–31), 3 vols. at that time. See Huizinga to Sarton, April 9, 1936, and Huizinga to Gannett, October 1 and 20, 1936, Houghton Library, Harvard University, Cambridge, Mass. Huizinga had already written *In the Shadow of Tomorrow* (New York, 1936) before he read Murray and Livingstone. I am inclined to believe that he independently arrived at his pessimism about the present and the future and therefore was more disposed to select books that eulogized earlier times and nobler cultures.

friend in 1933 that "we should all write more about History in its general aspects. Are we all thinking enough about that?"[9] Huizinga most certainly was, especially during that dark decade of the 1930s.

A third reason for looking at Huizinga's changing perceptions of American culture is that they are indicative, in microcosm, of the contrapuntal quality of Dutch-American cultural relations: on again, off again; alternately apathetic and enthusiastic. Between the 1860s and 1953 a frieze of frescoes was painted in the rotunda of the Capitol in Washington, D.C. The frieze depicts many important aspects of American history, including the contributions of Columbus, Cortez, Pizarro, De Soto, Pocahontas, William Penn, and many others. Yet the role of the Dutch in the New World is strangely neglected, even though American art and iconography obviously owe a substantial debt to the Netherlands. We can see it in the Hudson River School, and particularly in a major historical painting that was offered for sale in 1980: Robert Weir's large canvas called *The Landing of Henry Hudson*, done in 1838. One finds evidence of confusion during the early 1930s about Dutch colonial settlements and traditions in America. But by 1937 a Netherlands Pioneer and Historical Foundation had been established, and a few years later the Library of Congress housed a Netherlands Studies Unit. In 1974 Paul O'Dwyer, president of New York's city council, insisted that the official date for the founding of New York be changed from 1664, the time of England's conquest, to 1625, when Dutch colonists began to arrive. O'Dwyer introduced a bill in the council to alter the date on both the city's flag and its official seal. When interviewed, he explained that his initiative "was an effort to set history straight and to recognize the city's Dutch heritage on the 700th anniversary of the founding of the city of Amsterdam."[10]

Fourth, and perhaps most important, I believe that an examination of Huizinga's sketches of the United States will enhance our understanding of him as a writer in at least two, paradoxically contradictory, ways. On the one hand, I find that his comparatively unfamiliar books on the United States (first published in 1918 and 1927) explicitly anticipate the major themes of his better-known books, especially *In the*

9. Notestein to August C. Krey, April 14, 1933, Krey Papers, folder 173, University of Minnesota Archives, Minneapolis.

10. Victor H. Paltsits to A. J. F. van Laer, October 20, 1927, Paltsits Papers, New-York Historical Society, New York City; Alfred Bagby, Jr., to Lyon G. Tyler, March 2, 1932, Tyler Papers, group 5, box 7, Swem Library, College of William and Mary, Williamsburg, Va.; *New York Times*, June 27, 1974, p. 49.

Shadow of Tomorrow (1936) and *Homo Ludens* (1938). On the other hand, I also find that Huizinga seems to have compartmentalized his studies of America and of Europe, with the result that emphases and insights that inform his work on the New World are often strangely missing from his writings on the Old, and vice versa. Curious? To be sure, but historians in general—even the very best—are neither consistent nor lacking in elements of the nonrational. A close look at Huizinga on America can teach us something fresh about the complexities and curiosities of the historian's craft.

II

In about 1915 or 1916, Huizinga became interested in American history. He began to read those materials available to him in Holland and in 1917–18 offered a general course at the University of Leiden on the history of the United States. Explaining that "we know too little about America," he published four long essays in 1918 and two years later revised them as a book. Pieter Geyl rendered the title of this study as *Man and the Crowd in America*. Professor Herbert H. Rowen of Rutgers, whose fine translation has made the work accessible to those of us unable to read Dutch, calls it *Man and the Masses in America*.[11]

Call it what you will, the volume is interesting and important for many reasons. For example, it reversed the popular and *politique* image that Dutch and American history were remarkably similar. On January 18, 1912, Horace White, a prominent newspaperman and Republican politician, spoke at the annual dinner of the Holland Society of New York (held at the Waldorf-Astoria). In response to the toast "The Netherlands and the United States," White remarked that "the Netherlands and the United States have much in common, both in history and purpose. Each wrested independence from a powerful empire after a protracted struggle; each forged in the fires of that struggle a chain of inseparable parts; each in her time became a refuge for the oppressed, and the home of freedom, tolerance and good will.

11. All citations are to *America: A Dutch Historian's Vision, from Afar and Near*, trans. and ed. Herbert H. Rowen (New York, 1972). The first volume was noticed sympathetically in *American Historical Review*, 25 (April and July 1920), 558–59, 742. For Geyl's warm praise of Huizinga's early essays on America, see "Accuser of His Age," 245–46. For Colie's translations of the titles of Huizinga's two books on the United States, see "Huizinga and the Task of Cultural History," 612–13.

From her trials, and as the outcome of her heroism, each country reared a great man—soldier, statesman, ruler—William the Silent, and George Washington."[12]

Huizinga was much too shrewd, as well as too knowledgeable, to follow that route of reductivism. In comparing the American Revolution with the French and "the controversy over the Dutch Patriots" (of the 1770s and '80s), he found it "at once apparent that the American Revolution was more conservative than either of these others. There was no towering political and social structure to be overthrown, as in France." Not only did Huizinga repeatedly anticipate the provocative thesis of Louis Hartz's *The Liberal Tradition in America* (1955) but by comparing English, Dutch, and French colonies in the New World, he also anticipated Hartz's pioneering volume, *The Founding of New Societies: Studies in the History of the United States, Latin America, South Africa, Canada and Australia* (1964).[13]

Huizinga is equally fascinating in his treatment of democracy in America. Repeated references to Alexis de Tocqueville and James Bryce indicate his thorough familiarity with their classic inquiries. But much had changed in the United States since Bryce published *The American Commonwealth* in 1889; consequently, Huizinga's observations are suitably fresh and acute. He emphasized the decline of democracy in American life and was attracted to the Turner thesis because it helped him to explain the demise of "the old individualist pioneer democracy." Huizinga believed that Americans achieved efficiency at the expense of democracy; that powerful economic forces worked against egalitarianism; that governmental institutions were becoming less democratic in their actual operations; and that workers were not adequately represented on juries.[14]

He was ahead of his time, moreover, in commenting that "conservatism and democracy are not contradictory" in the United States. "Bourgeois democracy has an old and strong tradition in America . . . and when we see institutional processes such as initiative and

12. White, "Gifts of Two Nations to Civilization," in *Speeches and Writings* (Syracuse, 1932), 237.

13. Huizinga, *America*, 8, 17, 18, 31.

14. Ibid., 142–43, 147, 149, 151. See Bryce to Max Farrand, October 6 and December 3, 1919, and February 20, 1920, Farrand Papers, Huntington Library, San Marino, Calif. On October 6, Bryce told Farrand that there were "currents of American opinion & phases of constitutional development which have been changing so much during recent years that I may not fully understand them."

referendum work in a conservative way, we have, from the American point of view, absolutely no right to call the result undemocratic for that reason." Huizinga believed that America's self-proclaimed mission had long been "to give the world the model of a wise, mighty, and prosperous democracy." He argued that American society had been "too thoroughly commercialized" and that "too many individuals are involved in keeping the machinery of production in operation, for a revolutionary doctrine to be able to get much of a grip there." He accurately regarded Woodrow Wilson as a conservative democrat.[15]

The compatibility of contradictory tendencies in American culture fascinated Huizinga. He repeatedly mentions the dominance of "practical idealism" (see pp. 166, 176) and "collective individualism" (pp. 50, 165, 173). As he concluded his lengthy first essay, "the twin concepts of Individualism and Association are felt as a contradiction in American history much less than one would expect on the basis of European history."[16] Although he echoed Tocqueville on the inevitability of conformism in the United States, he nonetheless found that individualism had been able to coexist, and even flourish, alongside the powerful pressures to conform: "While conservative piety and obedient imitation nourished traits of tame conventionality, the living and individual element of the national character grew in the struggle with nature."[17]

Again and again I am impressed by Huizinga's ability, despite limited library resources for Americana, and without his having been to the United States (yet), to anticipate the shrewdest insights and inquiries of subsequent observers and scholars. His analysis of public opinion, and especially its changing role in politics, predated Walter Lipp-

15. Huizinga, *America,* 150, 157–59, 161. In fairness to Huizinga, who is frequently accused of elitism, it should be noted that in 1926 he remarked, "Modern culture must be democratic if it is to be at all" ("The Task of Cultural History," 50).

16. Huizinga, *America,* 32–33, 57, 60, 173, 229. Huizinga did note similarities between the impulse to "join" in Europe and in the United States, but he then relied upon a simplistic explanation that ever since the 1890s Europe had been "much more strongly Americanized than we ordinarily realize" (p. 33). E. J. Hobsbawm's current work on the extraordinary expansion of the middle class at that time is more persuasive. Hobsbawm views "joining" as a pan-Atlantic symptom and a means of validating one's membership in the middle class. Huizinga's close attention to "joining" anticipates the seminal essay by Arthur M. Schlesinger, Sr., "Biography of a Nation of Joiners," *American Historical Review,* 50 (1944), 1–25.

17. Huizinga, *America,* 177, also 165, 172, 208.

mann's now classic book *Public Opinion* (1922).[18] Huizinga startles me by wondering, "How did the Yankee grow out of the seventeenth-century Puritan of New England?"—a question that Richard Bushman first began to answer, for one colony, in 1967.[19] Huizinga follows with a fascinating speculation that "notwithstanding what happened in Europe, the Enlightenment in America did not combat faith or at least make it impotent but only pushed it a little to one side." He then adds that, in consequence, the United States avoided "the great struggle of revenge against the Enlightenment."[20] Scholars have yet to develop the implications of that insight, or even test it as a hypothesis. Huizinga was equally shrewd in pointing out that "naïve ancestor worship" was "characteristic of America."[21] His acuity here is all the more impressive because the phenomenon in its most blatant form was of recent vintage (c. 1885–1915) and had not been discussed in works available to Huizinga. Finally, I am struck by his recognition that great constitutional issues in the United States had a way of developing from relatively trivial quarrels, or what Huizinga would call "only a paltry affair."[22]

Did his American muse ever nod? Of course it did, though one often cannot tell whether the cause was insufficient information, misleading material, or sheer miscalculation. A few examples may suffice. When he wrote of the early colonists that "little or nothing is brought over of whatever is bound up with the history and legends of the mother country," had he not read Edward Eggleston's *The Transit of Civilization from England to America in the Seventeenth Century* (1900)?[23]

18. Ibid., 137, 156, 159–60. Huizinga was acutely sensitive to nuances of language, anticipating Raymond Williams's *Keywords: A Vocabulary of Culture and Society* (New York, 1976). He observed, e.g., that "individualism" did not have the same connotations in the American context that it had in Europe (p. 31), and that the word "service" had undergone a process of degradation, with the result that it meant different things to different people (pp. 310–11). See also *America*, 266–68, 275, and Huizinga, "The Spirit of the Netherlands" (1935), in *Dutch Civilisation in the Seventeenth Century and Other Essays* (New York, 1968), 110–12, 127.

19. Huizinga, *America*, 178. See Bushman, *From Puritan to Yankee: Character and the Social Order in Connecticut, 1690–1765* (Cambridge, Mass., 1967).

20. Huizinga, *America*, 179–80, 200.

21. Ibid., 193.

22. Ibid., 19.

23. Ibid., 174. Cf. David Grayson Allen, *In English Ways: The Movement of Societies and the Transferal of English Local Law and Custom to Massachusetts Bay in the Seventeenth Century* (Chapel Hill, N.C., 1980); and T. H. Breen, *Puritans and Adventurers: Change and Persistence in Early America* (New York, 1980).

Huizinga mistakenly regarded Jefferson as a shrewd and aggressive political organizer.[24] He seems to have misunderstood the nature and significance of Andrew Jackson's political career, failing to realize that Jackson himself was a frontier nabob and nascent capitalist.[25] I also believe that Huizinga seriously underestimated slavery as a social issue and excessively emphasized tariff protectionism as a major precipitant of secession and Civil War.[26]

I am rather inclined to doubt whether "secrecy, violence, and corruption" were any more characteristic of political action groups in the United States than of their European counterparts. Similarly, Huizinga seems needlessly cynical in generalizing about the self-seeking proclivities of American politicians. Consequently, he missed the intense degree of ideological commitment in Thaddeus Stevens and reduced that passionate man's motives in the Reconstruction era to little more than "unscrupulous party policy." Nor did Huizinga understand that the Ku Klux Klan enjoyed episodic bursts of intimidating power long past 1870.[27] And finally, to terminate this recital of shortcomings in the historical essays of 1918–20, Huizinga's assertions about American literary culture are often capricious. He could be quite canny about individual authors, especially Emerson, Thoreau, and Hawthorne, and he shrewdly redressed the historians' neglect of Walt Whitman (indeed, Huizinga's strong empathy for Whitman is one of the most engaging and surprising aspects of his book). Nevertheless, he overlooked the imaginative. implications of what Perry Miller labeled Nature's Nation (according to Huizinga, "The great and true spirit of America does not reveal itself in romanticism of any kind"), and he was fairly wide of the mark in declaring that "the imaginative element in American literature is primarily defined by dependence on Europe and the European past."[28]

24. Huizinga, *America*, 50. Cf. Joseph Charles, *The Origins of the American Party System* (New York, 1961), 80–90; and Noble E. Cunningham, Jr., *The Jeffersonian Republicans: The Formation of Party Organization, 1789–1801* (Chapel Hill, N.C., 1957).

25. Huizinga, *America*, 28, 30–31. Our understanding of Jackson has been reshaped by the work of Robert V. Remini, Charles G. Sellers, Richard Hofstadter, Michael P. Rogin, and Thomas P. Abernethy.

26. Huizinga, *America*, 9, 11.

27. Ibid., 49, 137, 47.

28. Ibid., 193, 195, 218–19, 223. I find it odd that Huizinga seems not to have read the four classic volumes by Moses Coit Tyler, *A History of American Literature, 1607–1765*, 2 vols. (New York, 1878), and *The Literary History of the American Revolution, 1763–1783*, 2 vols. (New York, 1897).

Far more interesting, though, is this twofold question: from whom did Huizinga learn his American history, and how did the addition of that "string to his bow" affect his overall performance as a virtuoso? The answer to the latter question is as curious as the response to the former is obvious. Charles A. Beard and Frederick Jackson Turner were his major mentors. Turner's essays on the frontier and his "Social Forces in American History" are cited quite frequently. As Huizinga wrote to Turner in 1919, "the notions I borrowed from your 'Significance of the Frontier' of 1893 have helped me more than most of my other reading to form a clear understanding of the main substance of American history."[29] Beard's *Economic Interpretation of the Constitution* (1913), his *Economic Origins of Jeffersonian Democracy* (1915), and a textbook called *Contemporary American History, 1877–1913* (1914) were equally important. Huizinga cited Beard more than any other historian, adopted his view of the Constitution as (in Huizinga's words) an "agreement of covetous speculators," and followed Beard's emphasis on the determinative role of economic forces in shaping American imperialism at the close of the nineteenth century. To paraphrase Samuel Eliot Morison, whose early work Huizinga also read, he literally viewed American history "through a Beard."[30]

Yet his reading in American history does not seem to have affected Huizinga's work in European history—there's the great mystery. He wrote at the very beginning of *Man and the Masses in America* that he wished to use "the facts of American history" as a means of testing the "schematic forms through which we are accustomed to understand history" (p. 7). In his interesting letter to Turner, Huizinga declared that "it has been a great surprise to me to see how much we Europeans could learn from American history, not only as to the subject itself, but also with regard to historical interpretation in general."[31] Neverthe-

29. Huizinga to Turner, March 10, 1919, Turner Papers, Huntington Library, San Marino, Calif.

30. See Huizinga, *America*, 5, 9, 21, 57n, 124, 134. In addition to printed sources and yearbooks, Huizinga also relied upon John Bach McMaster, Albert Bushnell Hart, Woodrow Wilson, James Ford Rhodes, Andrew C. McLaughlin, Frederick L. Paxson, Arthur M. Schlesinger, Sr., and Walter Hines Page. Among the major American writers, he seems to have read extensively in Emerson, Thoreau, Hawthorne, Whitman, and Henry and William James. Huizinga's *America* often seems strongest when he does not have "authorities" like Turner and Beard to guide him. For those topics where there were "experts," Huizinga was likely to become derivative; in their absence he was much more inclined to be shrewdly speculative and comparative. Understandable, perhaps, but unfortunate nonetheless.

31. Huizinga to Turner, March 10, 1919, Turner Papers.

less, the same Johan Huizinga who ascribed such importance to economic factors in his book about America—at times he almost sounds like an economic determinist—has an altogether different tone in *The Waning of the Middle Ages,* a book on which he worked at the very same time, and published in 1919. As Pieter Geyl and S. Muller Fzn. have noted, Huizinga's treatment of French-Burgundian culture in the fifteenth century is characterized by "systematic neglect of economic and political factors."[32]

What is one to conclude? Did Huizinga fail to do what he told Frederick Jackson Turner he would do: namely, expand his mode of historical interpretation? Did Huizinga take off one set of eyeglasses and put on another when he shifted back and forth from the Old World to the New? Yes, I suspect that he did, and for two reasons. First, writing about the United States was not exactly writing *history* for Huizinga. Despite his insistence that his analysis would be that of a cultural historian (pp. 3–5), his approach more nearly approximated that of the serious journalist: the analyst of contemporary affairs, the author of *In the Shadow of Tomorrow* (1936) and related essays.

I find it very significant that Huizinga did not care for early American history, despite the fact that the Dutch had been important participants in that story and that the colonial period corresponded chronologically with a phase that he cared about very much in his own country's history. One of Huizinga's finest and longest essays is called "Dutch Civilisation in the Seventeenth Century." He dismissed the comparable period in American history, however, because he found it uninteresting and aesthetically unattractive: "The history of North America before the War of Independence shows all the features proper to colonial history in general; viz., a certain lack of unity, a certain disparity, a certain rusticity. . . . The general reader . . . will not be struck by particular beauty of line or color in the story of the thirteen separate colonies."[33]

The second reason, in my opinion, is that Huizinga seems to have believed in what we now call "American exceptionalism." If civilization in the United States was profoundly different, then an interpretive schema appropriate to the Western Hemisphere might easily be unsuitable elsewhere. Here is a pertinent passage from *Man and the Masses in America:*

32. Geyl, "Accuser of His Age," 244–45.
33. Huizinga, "History Changing Form," *Journal of the History of Ideas,* 4 (1943), 219.

At bottom, every political and cultural question in America is an economic one. On America's virgin soil, which is free of old, strongly rooted social growths, economic factors work with a freedom and directness unknown in European history. Political passions in America are deliberately directed to economic questions, and these are not subordinated to a system of intellectual convictions which become for the man who believes them the content of his culture. (*America*, 9)

E. H. Gombrich got to the heart of the matter in 1972, when he observed that Huizinga was attracted by the challenge of describing a culture that "could not be encompassed" by the traditional forms applied to European history.[34]

Huizinga may well have been misguided in believing that an economic interpretation was suitable for the United States but not for Europe. Many historians have assumed, after all, that the New World was colonized *when it was* precisely because new economic forces had been unleashed in Europe. Be that as it may, Huizinga seems to have believed otherwise. Hence his apparent proclivity for compartmentalization. Hence the extraordinary differences in texture and tone between *Man and the Masses in America* (1918–20) and *The Waning of the Middle Ages* (1919). Huizinga would have said to his critics that different eras and contexts present divergent historical problems. Every *problématique* deserves its very own mode, or system, of explanation.

III

During the years from 1920 until 1926, when Huizinga came from Holland for his only visit to the United States, cultural relations between the two nations intensified in very positive ways. A primary reason seems to have been the abundance of historical anniversaries to commemorate. In 1920 committees were formed in Holland and the United States to plan the tercentenary, beginning August 29, 1921, of the Pilgrims' departure from Holland and their subsequent arrival at Plymouth. In 1923, a Huguenot-Walloon New Netherland Commission came into existence; and the following May a Huguenot-Walloon Tercentenary was celebrated on Staten Island. Meanwhile, a pro-

34. Gombrich, "Huizinga's *Homo ludens*," 141. It should be noted, however, that one finds clear-cut previews of *Homo Ludens* in *Man and the Masses in America*. See, e.g., *America*, 53–54.

fessorial chair of Dutch history, ideals, and literature was established at Columbia University; organizations called the Netherland–America Affiliation were created in New York City and The Hague; in 1923 Edward Bok began to publish a series of volumes called "Great Hollanders" (Huizinga's *Erasmus* appeared in that series in 1924); and a Summer School for American Students opened at the University of Leiden in 1924. That same year Victor Hugo Paltsits, chief of the Manuscript Division at the New York Public Library, prepared a paper for the American Antiquarian Society, "The Founding of New Amsterdam in 1626." In 1925 he presented a revised version to the New York Genealogical Biographical Society; one year later various exhibitions and publications, popular as well as scholarly, marked the 300th birthday of New Amsterdam (which to many people really meant the genesis of New York as a whole).[35]

A number of the key individuals involved in these activities were either friends of Johan Huizinga or, at the very least, professional colleagues: Daniel Plooij, archivist and officer of the Leiden Pilgrim Society; Cornelis van Vollenhoven, professor of international and colonial law at the University of Leiden; Albert Eekhof, professor of church history at Leiden; and Adriaan J. Barnouw, Queen Wilhelmina Exchange Professor at Columbia. Nevertheless, Huizinga seems to have had little interest in the historical hoopla that culminated in 1926,[36] and his visit should be described as sociological and cultural rather than historical in orientation. It resulted in a slender book, *Life and Thought in America*, published in 1927.[37]

35. See Arthur Lord to D. Plooij, November 29, 1920, Lord Papers, Pilgrim Society, Plymouth, Mass.; J. Franklin Jameson to Worthington C. Ford, March 8, 1920, Jameson Papers, box 84, Library of Congress, Washington, D.C.; Victor H. Paltsits to Jameson, September 16, 1925, Jameson Papers, box 117; Jameson to Victor H. Paltsits, February 2, 1920, Paltsits Papers. On December 21, 1922, Albert Eekhof sent Paltsits a postcard message from Leiden: "I can not forget you. This afternoon I have sent to you 'registered' a real Dutch Calendar. Every week a picture of Holland. It is a token of friendship and high appreciation for all what [sic] you have done for me in so many ways" (Paltsits Papers).
36. See Huizinga, *America*, 20, for the only reference in his two books to Holland as an inspiration for American independence.
37. For extracts from the journal that Huizinga kept during his four-month trip, see Leonhard Huizinga, *Herinneringen aan Mijn Vader* (Remembering my father) (The Hague, 1963), 120–51. I am deeply grateful to Professor J. W. Schulte Nordholt of Leiden for calling this book to my attention, and to Eduard van de Bilt for supplying me with a content analysis. Huizinga's visit to the United States (with a diverse group of Europeans) was facilitated by the Laura Spelman Rockefeller Memorial Fund. Although he enjoyed seeing a few historical sites, such as Mount Vernon, Independence

One immediately notices a radical shift in Huizinga's tone. In 1918, writing the preface to *Man and the Masses in America,* he explained that he found himself "stimulated and fascinated as seldom ever before. . . . Something of America's spiritual élan is transmitted to anyone who takes the trouble to understand the spirit of the country." Eight years later Huizinga found the United States to be a spiritual wasteland. The strongest leitmotif of his critique is summed up in an epithet that he repeated throughout the 1927 book: "This, Here, and Soon." It meant that the United States had become a "transitive" rather than a "transcendental" society, a culture that prized communication as a powerful means of influence, and one in which the American "builds himself a better abode in imagination, he creates a world that recognizes him."[38] In 1918 he had casually noticed the "perpetual tension in America between a passionate idealism and an unrestrainable energy directed to material things." By 1926, however, this gap between altruistic ethos and sordid reality had become a dark obsession in Huizinga's mind. He found a stark contrast between "the attitude of the nation in general and the tone of its literature."[39]

In 1918 he had called attention to efficiency: "what the American wants more than anything else." He returned to this point frequently and concluded that "in the American mind efficiency and democracy are closely related concepts. The endeavor to democratize the idea of God goes hand in hand with pragmatism, and both arise out of the spirit of 'This, Here, and Soon.'" By 1927 Huizinga's tone had become considerably more shrill. He linked the ugly trends of conformity and standardization to the American penchant for efficiency. He condemned the American passion for "saving time," conserving human energy, and not wasting opportunities.[40] "The notion that there could exist anything like over-organization does not torment

Hall, and the Lincoln Memorial, most of his time was given over to prearranged contacts with professors of law, economics, and business (which did not please him) and to observing political institutions in action, such as the Supreme Court and Congress (which impressed him even less). Nevertheless, Leonhard Huizinga felt that the trip to the United States was one of the pivotal events of his father's life, and that he gained considerably in self confidence as a consequence of it.

38. Huizinga, *America,* 283, 314–15.

39. Ibid., 166, 255–56. Cf. James Bryce to Max Farrand, February 20, 1920, Farrand Papers: "On the whole the changes in America seem to me more beneficial than those I have seen here. I certainly feel a hopefulness about the U.S. which I cannot feel about any people in Europe."

40. Compare Huizinga, *America,* 94–96, 139, 142–43, 199, with 237, 251, 297.

them." The American expectation that technology and "technological organization" could solve any problem disturbed him deeply.[41]

Progress had become a pejorative concept for Huizinga. He selected as an epigram for the first page of chapter 1 the observation by William James that "progress is a terrible thing" (even more ironic than Huizinga recognized?) and played variations on that theme throughout the book: that Americans had discarded faith because science had replaced religion, and that "the new materialism" had caused a "spiritual emptiness" in the United States.[42] There is a sense in which our intellectuals have only recently begun to catch up with Huizinga: during the later 1970s, for example, the American Academy of Arts and Sciences, supported by the Rockefeller Foundation, undertook a major, multidisciplinary project "on the transformation of the idea of progress."[43]

In Huizinga's own time, however, a kindred spirit in the United States, Carl L. Becker, took a somewhat different view. In a slim volume called *Progress and Power,* comprising three lectures presented at Stanford in 1935, Becker opened with a point similar to Huizinga's. "Standing within the deep shadow of the Great War, it is difficult to recover the nineteenth-century faith either in the fact or the doctrine of progress." But Becker unfurled, as an open question, the great issue on which Huizinga had already passed judgment: "May we still in whatever different fashion, believe in the progress of mankind?" Although his answer cannot be labeled as entirely positive, Becker remained more hopeful than Huizinga. Becker began with the assumption "that the multiplication of implements of power has at every stage in human history been as essential to the development of intelligence as the development of intelligence has been essential to the multiplication of implements of power." He concluded that machines are not inevitably beyond man's moral and social control. "The machines, not being on the side of the angels, remain impassive in the presence of indignation, wishful thinking, and the moral imperative, but respond without prejudice or comment or ethical reservation to relevant and accurate knowledge impersonally applied."[44] This was the major difference between Becker and Huizinga on the problem of progress.

41. Ibid., 296, 301, 307. For anticipations of these criticisms in 1918, however, see pp. 111, 117, 181.

42. Ibid., 231, 234, 305, 310, 317, 321, 325.

43. See Gabriel A. Almond, Marvin Chodorow, and Roy Harvey Pearce, "Progress and Its Discontents," *Bulletin of the American Academy of Arts and Sciences,* 35 (December 1981), 4–23.

44. Becker, *Progress and Power* (1936; New York, 1949), xlii, 7, 9, 107, 111.

Huizinga felt concerned about contemporary American scholarship because in the books that he read "one repeatedly meets a tone of mocking disdain for all faith." He does not mention Carl Becker, who would have been a prime example, but Huizinga does deride the "utterly naïve evolutionism" of James Harvey Robinson's *The Mind in the Making: The Relation of Intelligence to Social Reform* (1921), disliked Harry Elmer Barnes's *The New History and the Social Studies* (1925), and expressed particular distaste for current work in social psychology. What Huizinga had admired in Ralph Waldo Emerson, "the sense of the direct and constant presence of mystery in and behind everything," seemed to have disappeared in modern America.[45]

The litany of Huizinga's laments would scarcely provide a lift for sagging spirits. It worried him that "the idea of education is in fact a religion."[46] The democratization of culture could only augment the "mediocrity which permeates American life." He sneered at the "overwhelming success" of his countryman Hendrik Willem van Loon, educated at Cornell and Harvard, who had chosen to remain in the United States as a popularizer of Dutch, American, and world history: "His unpretentious scribblings, which the least-educated man can understand, meet the minimum commitment which a public of millions has left over for knowledge."[47] It troubled Huizinga that "America's mind is fundamentally antihistorical"; that "America, with its all-pervasive sense of the future, worships the young"; and that "movie romanticism" was merely the most banal manifestation of "hero-worship" in the United States.[48]

45. Huizinga, *America*, 246, 282, 310, 317, 320, 325; Huizinga, "The Task of Cultural History," 33. Huizinga repeatedly used as his illustration from social psychology a book by H. A. Overstreet, *Influencing Human Behavior* (1925).

46. This phrase, that "education had become the religion of the United States," was very much in the air by the mid-1920s. When President James R. Angell of Yale University used it in a public lecture given at Chicago in 1924, Max Farrand (who previously had taught at Yale but in 1924 was an administrator with the Commonwealth Fund) claimed that Angell had picked it up from him (Farrand to Henry L. Greer, October 6, 1924, Farrand Papers).

47. Huizinga, *America*, 181, 239, 245, 251, 281, 308. In 1924 van Loon was deeply hurt by Huizinga's tart review in *De Gids* of *The Story of Mankind*. As van Loon wrote, with customary self-pity, to a former teacher: "Now that some of my books have been translated into most modern languages, I usually find some sort of welcome in the countries through which I pass. But Holland takes it as almost a personal offense that I should, in some measure, have succeeded after I bade it farewell. I act upon the excellent burghers as a red rag before a steer" (quoted in Gerard Willem van Loon, *The Story of Hendrik Willem van Loon* [Philadelphia, 1972], 151–52).

48. Huizinga, *America*, 205–6, 251, 260–62, 319. See also Huizinga to Turner, March 10, 1919, Turner Papers. Many in the United States, especially social and

Huizinga seems to have encountered too many arrogant and nationalistic individuals during his 1926 tour, even among academics and intellectuals, who should have been, by definition, candid social critics. He considered American society "an extroverted culture" and regarded the press as an especially egregious example of all that was wrong in the United States. He disliked the "selective emphasis" of our newspapers, their unwillingness to moralize about the news, the banality of their political views, the vulgarity of their advertising, and their "trashiness" in general.[49]

One is obliged to respect Huizinga's honesty and intensity of feeling in *Life and Thought in America,* even if one does not concur in all of his judgments.[50] But the book is interesting and important as more than just another critique. It helps to illuminate the genesis of his well-known cultural pessimism of the 1930s and 1940s. *America* adds chronological precision and a certain causal impetus to our understanding of Huizinga's subsequent trajectory as a cultural critic. *In the Shadow of Tomorrow* (1936) does not mention the United States very often, but when it does, Huizinga simply compresses and reiterates what he had written so stridently a decade earlier; once again he quotes William James's remark that "progress is a terrible thing" (p. 56). More to the point, just as Tocqueville had viewed democracy in America as a harbinger of Europe's destiny, so Huizinga confronted in the United States his anxieties about the potential degradation of a fading European culture that in many respects he idealized.[51]

> Behind the democratic ideal rises up at once the reality of mechanization. . . . The mechanistic conception of social life, with its exclusion of morality and exhortation, seems to leave almost no means for intervention. If we are all just the nearly helpless followers of fashions, manners,

political conservatives, shared Huizinga's apprehension about the tendencies of American culture. See, e.g., Morton Keller, *In Defense of Yesterday: James M. Beck and the Politics of Conservatism, 1861–1936* (New York, 1958), 153–56, 158, 160, 197–98; Ralph Adams Cram, *Convictions and Controversies* (Boston, 1937).

49. Huizinga, *America,* 232, 238, 242, 244, 246, 247, 252–53, 265. On p. 265 Huizinga simultaneously seems to echo Walter Lippmann's *Public Opinion* (1922) and *The Phantom Public* (1925) and to anticipate some of the well-known views of Marshall McLuhan.

50. He is responsible for occasional factual errors, see esp. *America,* 295, where he presents incorrect dates for the founding of Harvard (it should be 1636) and the College of William and Mary (it should be 1693).

51. Ibid., 316.

and habits defined by our group, the poor slaves of our personal habits, which together determine our character . . . is there any way to bring about *change*, to change and to improve all that which *must* be changed? (*America*, 281–82)

The European traveler finds it almost impossible to concentrate when he is in a big American city. The telephone becomes a curse. The variety of personal assistance and technical devices causes as much diversion of attention and loss of time as it saves work. (*America*, 252)

The general leveling of culture also affects love life. Just as intellectual enjoyment becomes available for everyone in a thousand ways, and hence loses the quality of something conquered, something which represents success and to which one pays worship, so there also arises a form of sexual satisfaction which signifies the dissolution of old forms of civilization. (*America*, 262–63)

Note well, however, that Huizinga made very few criticisms of the United States in 1927 that he did not subsequently make of the Netherlands in 1934–35 or of Europe generally in 1935–36. As he wrote in the foreword to *Life and Thought in America*: "Modern civilization is on trial in America in a simpler way than among us. Will Europe be next?"[52] In "The Spirit of the Netherlands," Huizinga's testy descripton of bourgeois life in Holland sounds remarkably like that in the United States. His "feeling of living in a world that hovers on the brink of annihilation," his laments about "mankind's astonishing cultural decline" and "the grim idols of technocracy and overorganisation" provide a coda to the 1927 book on America as well as an overture to *In the Shadow of Tomorrow*.[53]

In that profoundly pessimistic and controversial book, the word "puerilism" is so pejorative yet important that Huizinga devotes an entire chapter to it. Early in the chapter he hammers this devastating judgment: "The country where a national puerilism could be studied most thoroughly in all its aspects, from the innocent and even attractive to the criminal, is the United States." But then he blinks and softens the blow by adding that "one should be careful to approach it

52. Ibid., 178, 230, 242–43, 314. On p. 305 he quips, "Not all Americans think, any more than Europeans."
53. "The Spirit of the Netherlands," 113, 118–19, 122, 136. On p. 128 he defines "conservative" quite positively, "in the worthy sense of wishing to preserve what is good and refusing to kow-tow to the fashion of the day."

with an open mind. For America *is* younger and more youthful than Europe. Much that here would deserve to be qualified as childish is there merely naïve, and the truly naïve guards against any reproach of puerilism. Besides, the American himself is no longer blind to the excess of his youthfulness. Did he not give himself Babbitt?"[54]

Despite his harsh strictures upon American civilization in 1927, and perhaps precisely because—as Huizinga had predicted—Western Europe all too swiftly caught up with the United States, he could not terminate his interest in 1927 or 1936, any more than he could have in 1920. He explained to Frederick Jackson Turner in 1919, "I hope to revert to American history sometime more for when you have once been captivated by its enormous problems and its stirring tone, it will not let you go the rest of your scholarly life."[55] In the academic year 1940–41, Huizinga selected as one of the principal subjects for his lectures at Leiden the history of the United States, "a topic which appeals to me again and again."[56] His perception of America at that time appears in a communication presented on January 15, 1941, at the Netherlands Academy of Sciences (Section of Letters). This *esquisse* (see n. 33 above) is as bizarre as it is fascinating. It adds a curious "postscript" to the impressions he formulated in 1917–18 and 1926–27.

More than ever, Huizinga in 1941 reminds one of Henry Adams: a similar disdain for the vulgarity of modern culture; a similar affection for the medieval age of faith (Huizinga and Adams both idealized twelfth-century France); and a similar bewilderment at technological complexity. How could one possibly hope to make any sense of it? Huizinga found American history from 1776 until 1865 attractive because its wholeness seemed comprehensible, "its general idea is available to all." The period had "a distinct form" because "its public life [was] conducted by an *élite*. The masses still remain in the background." Despite the conservative pitch of that last statement, Huizinga's criteria

54. *In the Shadow of Tomorrow*, 172–73.

55. Huizinga to Turner, March 10, 1919, Turner Papers.

56. Huizinga to Hendrik Willem van Loon, October 11, 1940, van Loon Papers, box 13, Department of Manuscripts and University Archives, Cornell University, Ithaca, N.Y. I do not know how or when Huizinga and van Loon commenced a cordial relationship. It is clear that van Loon offered during the summer of 1940 to arrange for Huizinga to come to the United States. Huizinga replied from Leiden on August 15, 1940, that "my place remains here: in my country and in my office, whatever the following times may bring" (van Loon Papers). I am indebted to Joke Kardux and Eduard van de Bilt for translations of these two letters from Dutch to English.

seem to have been more aesthetic than ideological. He preferred the period after 1789 because "the historical lines are relatively simple. The persons acting are of a marked type, and the conditions and the conflicts are easy to grasp. In short, the history of those years shows shape and color."[57]

Huizinga's notion of the historian as artist—hence the need for materials of high drama—almost seems to overbalance his sensitivity to human suffering. The American Civil War attracted him as a writer because "only a crisis which breaks the political unity itself can bring again to the fore the *story* quality of history." By contrast, in the period after the Civil War "the history of the United States not only loses dramatic pathos, but is also robbed of comprehensible and striking form. The general reader at least will find it more or less confused, perplexing, and without unity." I cannot tell whether this echo of Henry Adams is intentional or accidental, but Huizinga is explicit about his assessment of the central problem for historiography in 1941. Once again, as in 1926, he looked to the United States as much for its illustrative value as for its intrinsic substance: "As I speak of the gradual loss of form inherent in the material of modern history, particularly in the history of the United States since the Civil War, I should like to make it clear that I find this increasing shapelessness due not to an optical illusion nor to a deficiency in the forces or fashions of historical imagination, but to a change in the components of history itself."[58]

It irked Huizinga that "history has had to change its record of personal happenings to one of collective phenomena." Had he never read Gibbon's *Decline and Fall of the Roman Empire,* or Burckhardt's *The Civilization of the Renaissance in Italy?* Of course he had; but he went on to add that "in a history dominated by the economic factor—as American history undoubtedly is, far more so than European—the human element recedes into the background."[59] Huizinga's incomprehension

57. Gombrich, "Huizinga's *Homo ludens,*" 148; Huizinga, "History Changing Form," 219, 220.

58. Huizinga, "History Changing Form," 219, 221. Cf. Max Farrand's slim interpretive volume written primarily for Europeans, *The Development of the United States from Colonies to a World Power* (1918), and Farrand's observation to Theodore Roosevelt that "the merit of the book probably lies in having the very definite purpose to explain the great change which came over the United States about 1890" (August 15, 1918, Farrand Papers). Farrand had sought to impose form where Huizinga would find only formlessness.

59. Huizinga, "History Changing Form," 222. Huizinga also sounds oddly like a scholar unfamiliar with Henri Pirenne's *Medieval Cities: Their Origins and the Revival of*

of the prime reality in American social history since 1870, the massive and heterogeneous migration from Europe, reinforced his idealization of the individual free to shape his own destiny as well as that of his society.

> Several decades of increasing shapelessness in American history can be explained by the fact that a political unit covering the main part of a whole continent loses, by its very homogeneity, the most fertile of all themes for history: the conflict between independent powers, be they peaceful rivals or hostile opponents. Furthermore, the ever-increasing preponderance in such a continent-commonwealth of economic forces is likely to obscure the human being as an actor in history.[60]

Huizinga concluded this *esquisse* with an observation that distresses me because I believe it to be doubly perverse. It pained him that "the modern world is becoming more and more accustomed to thinking in numbers. America has hitherto been more addicted to this, perhaps, than Europe. . . . Only the number counts, only the number expresses thought." Huizinga here seems truly the intellectual prisoner of a certain type of anti-Americanism. We need look no further than Matthew Arnold's *Civilization in the United States,* in which he observed that "the great scale of things in America powerfully impresses Mr. [John] Bright's imagination always; he loves to count the prodigious number of acres of land there, the prodigious number of bushels of wheat raised," and so on.[61] Americans did not invent the quantitative imagination, nor do we enjoy any monopoly over it.

Huizinga ended with a dismal prognosis for history as a discipline: "This shift in the mode of thinking is full of great dangers for civilization, and for that civilizing product of the mind called history. Once *numbers* reign supreme in our society, there will be no story left to tell, no images for history to evoke."[62] The application of quantitative methods to historical investigation has resulted in some dreary and

Trade (1925) and Pirenne's *Economic and Social History of Medieval Europe* (1933). In fact, he had known Pirenne well since 1908—when Huizinga taught at Groningen and Pirenne at Ghent—and greatly admired his work. See Bryce Lyon, *Henri Pirenne: A Biographical and Intellectual Study* (Ghent, 1974), 185–86, 203, 337, 364, 384.

60. Huizinga, "History Changing Form," 223.

61. Ibid.; Arnold, *Civilization in the United States: First and Last Impressions of America* (Boston, 1888), 82–83.

62. Huizinga, "History Changing Form," 223.

even wrongheaded scholarship, to be sure. But Huizinga was unduly pessimistic about the inevitability of such consequences; some of the finest works of American scholarship since 1969 have depended heavily upon "numbers" without any loss of "story" or of "images to evoke." They do not always tell a story or evoke images that Huizinga would have found attractive, yet they surely qualify as innovative, influential, and highly significant works of history.[63]

IV

Like Johan Huizinga, Matthew Arnold wrote essays about American civilization both before *and* after he had visited the United States. Unlike Huizinga's, however, Arnold's treatment became more favorable after his initial lecture tour during the winter of 1883–84. He envied the United States its innocence of those impossible problems that seemed to plague England: aristocratic domination of a rigid class structure, an excess of religious dissent, and the Irish question. More positively, he felt that American institutions, being new, were well suited to American needs. After returning to England, Arnold observed that "to write a book about America, on the strength of having made merely such a tour there as mine was, and with no fuller equipment of preparatory studies and of local observations than I possess, would seem to me an impertinence."[64]

One could be tempted to confront Huizinga's ghost with that modest concession, were it not for the fact that he *had* done his "homework," so to speak. Few foreign visitors have made more thorough

63. See, e.g., Sheldon Hackney, *Populism to Progressivism in Alabama* (Princeton, N.J., 1969); Leonard L. Richards, *"Gentlemen of Property and Standing": Anti-Abolition Mobs in Jacksonian America* (New York, 1970); Joan W. Scott, *The Glassworkers of Carmaux: French Craftsmen and Political Action in a Nineteenth-Century City* (Cambridge, Mass., 1974); Herbert G. Gutman, *The Black Family in Slavery and Freedom, 1750–1925* (New York, 1976); Douglas S. Greenberg, *Crime and Law Enforcement in the Colony of New York, 1691–1776* (Ithaca, 1976); Stuart M. Blumin, *The Urban Threshold: Growth and Change in a Nineteenth-Century American Community* (Chicago, 1976); and Alan Dawley, *Class and Community: The Industrial Revolution in Lynn* (Cambridge, Mass., 1976), to mention just a few.

64. Arnold, *Civilization in the United States,* 111, 118–19, 122, 125–27, 136, 152. It should be added that Arnold's *third* essay about the United States (written in 1887–88, shortly before his death) was much less favorable than his second. Arnold's eldest daughter, by the way, had married an American and settled in the United States. See ibid., 173–79, 181, 188–90.

"preparatory studies" than teaching a university course and doing extensive historical reading about American culture. Huizinga's negativism from 1926 until his death resulted from a special situation: the United States was not merely another country, an exotic culture to be examined; it represented the accelerating thrust of the present as well as an ominous portent for the future. Because Huizinga cared so strongly about the preservation of culture as he had known it, what seemed to be taking place across the Atlantic served as a distressing signal of impending catastrophe.

It is worth noting at least a brief comparison between Huizinga and James Bryce, for their temperaments were as similar as their motives for writing about the United States. In 1882 Bryce decided to follow in Tocqueville's footsteps "to try to give my countrymen some juster views than they have about the United States." He added that he often felt "vexed here at the want of comprehension of the true state of things in America."[65] As a Scottish Calvinist, Bryce had a moralistic temperament that prevented him from investigating the seamier aspects of American life. He could not, for example, comprehend the coarse pleasures of the working class in the United States. Unlike Huizinga, however, Bryce was intensely interested in governmental institutions and the political process. Like so many Britons of his generation, he admired the American Constitution as a remarkably stabilizing keel for our ship of state.

Huizinga has frequently been compared with Marc Bloch, because both were seminal historians who responded very differently to the challenge of Fascism: one with militant activism, the other with quiet resignation. Because they differed so radically—in temperament as well as religious background—and because Bloch was fourteen years younger, I find it somewhat more instructive to compare Huizinga (1872–1945) with four historians who were his exact contemporaries.

Elie Halévy (1871–1937), whose ancestry was Calvinist *and* Jewish, shared Huizinga's austerity and disciplined commitment to scholarship. Like Huizinga, he drifted into History as a calling (Halévy from Philosophy and Sociology). Like Huizinga, who had ulterior motives,

65. Bryce to Mrs. Sarah Whitman, December 14, 1882, quoted in Edmund Ions, *James Bryce and American Democracy, 1870–1922* (London, 1968), 120–21, 127–28. In 1883 Bryce taught a graduate seminar on Tocqueville and American history at Johns Hopkins University (ibid., 101, 118–20). See Bryce, "The Predictions of Hamilton and de Tocqueville," *Johns Hopkins University Studies in Historical and Political Science,* 5th ser., vol. 9 (Baltimore, 1887); and the Bryce letters cited in n. 14 above.

intellectually speaking, for studying the United States, Halévy explored modern British history as a laboratory for understanding liberalism and democracy. He believed that elites had an obligation to elevate republican public opinion, and saw a tension within democratic socialism between a desire to liberate individuals and the overwhelming impulse to organize and regulate them. After passionate involvement in the Dreyfus affair, Halévy withdrew from active participation in public life. In 1900 he wrote two sentences that Huizinga himself might well have written: "A man disposed to fulfil his civic duties, but resolved to keep intact the greatest part of his time for the accomplishment of tasks properly intellectual, must rigorously limit the practical part of his existence. I ignore the Dreyfus affair, I ignore politics." Also like Huizinga, he was more of a Europeanist than a nationalist and wished to preserve all that was best in European culture. Following World War I, Halévy fell into a mood of "moral digust" and devoted the last decade of his life to investigations of contemporary history, particularly the meaning of progress in a democratic society. As a historian Halévy always rejected economic determinism. He regarded Communism and Fascism as equally tyrannical—a view that shocked many of his friends—because he dreaded any form of statism or organized, hierarchical oppression. Huizinga shared that perspective.[66]

Halvdan Koht (1873–1965), the Norwegian historian, decided to visit the United States in 1908–9 because "in America one could study the history of the future." He had very mixed reactions to what he saw. Although delighted by "the unconquerable spirit of progress" that he encountered throughout the country, he also perceived many "imperfections," especially the degree to which Americans seemed bound by social conventions, "outward forms," such as the stigma on women who smoked.

At Columbia University, however, he came under the influence of James T. Shotwell, William A. Dunning, and especially Edwin R. A. Seligman, whose *Economic Interpretation of History* (1907) impressed him greatly. In 1909 he met Frederick Jackson Turner and John R. Commons, and then felt eager to introduce the study of American

66. See Myrna Chase, *Elie Halévy: An Intellectual Biography* (New York, 1980), esp. 32, 38–39, 46, 172–73, 175–76, 181, 183–85, 189, 209, 211, 214, 220. Cf. *Geschichte und Kultur* (a collection of miscellaneous writings by Huizinga), ix–xl, "Huizinga the Historian," for an essay that stresses his fear of nationalism and his sympathy for the idea of a unified Europe.

history in Norway. He did so immediately, in 1909–10, at Kristiania (Oslo); very soon the subject even became a requirement for the degree in history. Koht prepared a section on American culture for an eight-volume history of world culture (1912). In 1920, the same year that Huizinga's *Man and the Masses in America* was published in revised form, Koht brought out (in Norwegian) *The American Nation: Its Origins and Its Rise.* Unlike Huizinga, however, Koht emphasized class conflict, carried the economic emphasis from his American contacts to his work on Norwegian history, and became very active in public affairs.[67]

Arthur O. Lovejoy (1873–1962) shared Huizinga's personal austerity and passion for the history of ideas. Lovejoy differed significantly, however, in preferring to trace ideas through time in a linear fashion, whereas Huizinga loved to sketch as a still life the picture of a civilization at a pivotal moment in time. Lovejoy differed also in his political activism. He worked vigorously as a pamphleteer during both world wars, was a passionate defender of civil liberties, and perceived early in the 1930s that Nazi Germany posed a grave threat to the security of Europe and the United States. He spoke out repeatedly in opposition to Hitler and after 1939 pushed vigorously for increased American aid to the Allies.[68]

Among this quartet of distinguished contemporaries, however, the most interesting comparison can be made with Carl L. Becker (1873–1945). Like Huizinga, Becker was more of an essayist than a narrative historian rooted in archival research. They shared an interest in significant eras of transition, and both liked to challenge the conventional wisdom of historical periodization. In 1920, just when Huizinga published his revised and expanded work on American history, Becker brought out *Our Great Experiment in Democracy: A History of the United States,* which was also influenced by Turner and Beard. In 1924 Becker made his only trip to Europe, a visit as superficial as Huizinga's to the United States seems to have been in 1926. Becker did the obligatory

67. Koht, *Education of an Historian* (Oslo, 1951; New York, 1957), 164, 169, 176, 182, 196–97, 202, 205. In February 1910 he gave a lecture before the Academy of Sciences at Oslo on the American Revolution. Printed in English as "Genesis of American Independence," it was his first publication concerning the history of the United States. In 1910 he also published *Money Power and Labor in America;* in 1949, *The American Spirit in Europe: A Survey of Transatlantic Influences.*

68. Daniel J. Wilson, *Arthur O. Lovejoy and the Quest for Intelligibility* (Chapel Hill, N.C., 1980), 186, 195–200.

things, felt quite homesick, and wrote to his wife from Paris that "my foreign travel has come too late to be of any great benefit."[69]

During their final decade (1936–45), however, these two men, who were temperamentally so similar, followed divergent intellectual paths. Although Becker was in many respects socially conservative, he was less apprehensive about the development of technology and social organization (or regimentation) as inevitably oppressive evils. During the later 1930s his faith in democracy was rejuvenated, and he explicitly rejected the counsel of despair that was so much in the air among intellectuals of the day: "We still hold, therefore, to the belief that man can, by deliberate intention and rational direction, shape the world of social relations to humane ends. We hold to it, if not from assured conviction, then from necessity, seeing no alternative except cynicism or despair."[70]

While Becker was secure in Ithaca, New York, writing *How New Will the Better World Be? A Discussion of Post-War Reconstruction* (1944), Huizinga was under Nazi surveillance at De Steeg, near Arnhem on the Rhine, writing *The World in Ruins: A Consideration of the Chances for Restoring Our Civilization* (1945). It seems fair to say that their divergent circumstances help to explain their relative positions of pessimism and optimism. It may be equally fair to suggest, however, that their divergence can be dated back to the years 1936–39, when Becker recovered from the profound disillusionment with Wilsonian idealism that he underwent after World War I, whereas Huizinga's despair only deepened.

Ultimately, of course, Huizinga's apprehension was not so much political as it was cultural. Therefore, defeating Fascism could not provide a sufficient solution to the malaise, indeed crisis, that he perceived in contemporary civilization. Although Huizinga felt disaffected from American culture, his visual sensitivity would have caused him to appreciate a painting done by Thomas Hart Benton in 1943. Titled *Wreck of the Ole '97* (Figure 23), it depicts the crash in 1903 of a fast mail train, No. 97 of the Southern Railway. The train leaped

69. See *"What Is the Good of History?" Selected Letters of Carl L. Becker, 1900–1945,* ed. Michael Kammen (Ithaca, 1973), 94, 97. Just when Huizinga first presented "In the Shadow of Tomorrow" as an address at Brussels in 1935, Becker lectured at Stanford on the difficulty, standing "in the shadow of the Great War," of achieving a judicious perspective on mankind's history and destiny (Becker, *Progress and Power,* 19).

70. Becker, *New Liberties for Old* (New Haven, Conn., 1941), 94; Becker, *Modern Democracy* (New Haven, Conn., 1941).

Figure 23. Wreck of the Ole '97, by Thomas Hart Benton (lithograph, 1944). Courtesy of the New Britain Museum of American Art, New Britain, Connecticut.

from its tracks while speeding down a steep grade and plunged into a ravine. Benton's picture suggests that a broken track rather than a reckless engineer was the cause of that catastrophe. His interpretation of the story indicates Benton's belief that man's fate was being determined by a mechanized (and flawed) world rather than by his own will and actions. The tale of No. 97's fatal crash became the theme of a well-known ballad, which sold more than a million records in 1939. To Johan Huizinga, who appreciated allegory as much as iconography, the ballad, the mass culture that paid for it, the painting, and its lithographic copies for consumers would all have seemed suitably symptomatic of a culture *and a world* too much in the clutches of "This, Here, and Soon."

I am deeply grateful to the chairman of the organizing committee for

the 1982 symposium, J. W. Schulte Nordholt, professor of American History and Culture at Leiden University. He ran the conference in Amsterdam about as well as an international conference can possibly be run: from a palace reception with Queen Beatrix to an excursion on the canals, all accompanied by stimulating conversation along with old and new gin—in abundance. I must also thank Professors Hans R. Guggisberg (University of Basel) and Herbert R. Rowen (Rutgers University) for their thoughtful readings of my paper.

Chapter 11

Uses and Abuses of the Past:
A Bifocal Perspective

with CAROL KAMMEN

This joint presentation was made in Minneapolis on October 24, 1981, following luncheon at the 132d annual meeting and history conference of the Minnesota Historical Society. A transcript of our "double talk" was originally published in *Minnesota History*, 48 (Spring 1982), 2–12, copyright 1982 by the Minnesota Historical Society; used with permission.

Many of the points made by Carol Kammen are developed fully in her book *On Doing Local History: Reflections on What Local Historians Do, Why, and What it Means* (Nashville, Tenn.: American Association for State and Local History, 1986).

Those interested in a more detailed account of the Great Northern Railway expeditions of 1925 and 1926 can consult Michael Kammen, "Business Leadership and the American Heritage: Exploitation or Education?" in *Cornell Enterprise* (Fall 1986), a journal published by the Johnson Graduate School of Management, Malott Hall, Cornell University.

CAROL KAMMEN: I begin with a definition, because I feel that "amateur" is a loaded word, and I would like to deal with that. An academic or professional historian is customarily someone who has studied history, who has been accepted by his or her peers, who receives their praise and suffers their criticism, and who earns a living by teaching, writing, or interpreting history, or some combination of these activities. Such a person is relatively easy to spot and to define.

When we deal with the term "amateur," however, we are on much shakier ground—not because of the activities of amateur historians but because of the word itself. It has come to mean not really good enough, or as good as could be expected under the circumstances. A play by a little theater group, for example, is often called an amateur effort; that is a way of saying it was all right. Yet the word "amateur" has nothing to do with shoddy or second rate. Rather, it comes from the Latin *amator,* which means "lover." Therefore an amateur historian is one who loves history: reading it, knowing it, researching it, perhaps writing and interpreting it. Why, then, has the word been debased? Jacob Burckhardt suggested that "the word 'amateur' owes its evil reputation to the arts. An artist must be a master or nothing, and must dedicate his life to his art, for the arts, of their very nature, demand perfection."[1]

History does not demand any less of us than our very best, but amateur historians tend to be people who earn their livings in other fields. Amateur status, it seems to me, is respectable today solely as a classification for athletes, and then just because only amateurs get to go for the Olympic gold. It is time that amateur historians also go for the gold.

There are some further problems, of course, with being an amateur or local historian. An amateur historian is considered by many people to be a history buff. A local historian, I think, is something more than a buff. He or she must be the master of many disciplines, for local history, with its limited geographic focus, is possibly the broadest field of inquiry within the discipline. At its best, local history is social, political, and economic history; it is religious and intellectual history; and it is the place to find the individual and his reactions to events. (An example appeared in the Fall 1981 issue of *Minnesota History,* an article that considered the place of personality in history.[2]) Local history is where we find women's voices. It is the place to find information about child rearing, about education, about the influence of state and national government upon localities, and about leisure or privacy or sex.

Local history is often coupled with folklore. Properly done, I think each can illuminate the other. Local history is a field ripe for the cultural historian, the historian of both material culture—clothing, architecture, artifacts—and the historian trying to determine who it is

1. Burckhardt, *Force and Freedom: Reflections on History* (New York, 1943), 99.

2. Emma S. Thornton and Pauline G. Adams, "The Person in History: An Affirmation," *Minnesota History,* 47 (1981), 275–83.

we are as a people, what makes us different, and what we have in common. I think that methods for local history range from the traditional, archival resource methods to oral, statistical, and literary ones.

So here are we two, a professional and an amateur historian, to look at the question of manipulating the past in order to create or to shape the present. This question implies that history is not studied just to be known but to be used. But "used" is yet another word with ambiguous overtones. Is history tarnished because it is used? I do not think that the implication is quite as bad as it sounds: we all use history in a variety of ways and for many purposes. We use our national and our own personal histories, altering and shaping them to see what pleases us; we block out the unpleasantness and forget those things that are unflattering. The word "manipulate," however, has overtones too. Let us first turn to how and why people manipulate the past.

MICHAEL KAMMEN: Among the many reasons why people manipulate the past, I think the greatest number results from various forms of chauvinism. Each of us could surely develop his or her own list, but I will suggest some and try to illustrate them with examples from American history.

The most obvious has to do with state pride and interstate rivalry. One example that comes to mind is the Mecklenburg Declaration of Independence, involving the claim that in a backwoods county of North Carolina in May of 1775—more than a year before the rest of the colonies proclaimed independence—the leaders of one community declared theirs from England. It seems virtually certain, although in some quarters dispute goes on to this day, that the so-called Mecklenburg Declaration of Independence is spurious. Ultimately, I think the whole enduring episode arises from the fact that for a very long time North Carolinians felt—at least in historical terms—that they lived between two states, Virginia and South Carolina, that enjoyed much greater prominence. More important events occurred in those two states; more prominent individuals in terms of their contributions to our history had come from those states; and therefore pride in the Mecklenburg Declaration of Independence was a way of claiming that North Carolina, too, had played an important role in the American Revolution.[3]

3. See William Henry Hoyt, *The Mecklenberg Declaration of Independence* (New York, 1907). There were two "declarations," on May 20 and May 31, 1775; the second is not quite a declaration, and the first is almost certainly a forgery.

A second form of chauvinism, sectionalism or regionalism, involves patterns of condescension or neglect on the part of one region toward another. An interesting example that I recently found appeared in the *New York Times* on December 30, 1888. It was a brief notice with a dateline of St. Paul saying that during the balmy winter Minnesotans were then experiencing, one R. J. Baldwin had found in the historical society a volume indicating that the winter of 1688–89 was also very warm—warm enough so that Baron Lahontan decided to lead an expedition through the Upper Mississippi Valley. He canoed through various rivers without encountering ice. Then the *New York Times* editorialized, pointing out that 1688–89 was "a date so remote that it sounds very oddly in the ears of the Westerner, who regards any event of 50 years ago as belonging to ancient history."[4]

This form of condescension on the part of easterners, coupled with their prejudice that westerners lack a sense of history, has caused in some cases an excessive reaction on the part of those poor souls patronized by people from the Northeast. During the last decade of the nineteenth century the United Confederate Veterans were very exercised about the problem of textbooks in American history because all those then in use had been written by northerners and published in the North. Southerners, especially the veterans, believed them to be unfair. They urged that more historians be trained in the South and that historical research and writing be stimulated. The goals of this veterans' group were promoted by a son of President John Tyler, Lyon G. Tyler (Figure 24), who was president of the College of William and Mary and perhaps the foremost chauvinist of southern history during the first third of the twentieth century. Lyon Tyler loathed Abraham Lincoln, and long after many other southerners were willing to acknowledge Lincoln's greatness and importance in holding the Union together, Tyler kept alive in the South a kind of vendetta.

In 1932 he wrote a letter to Albert B. Hart, a prominent professor of history at Harvard, taking Hart to task for his pro-Lincoln writings and explaining exactly why he, Tyler, felt that Lincoln had received a better press than he deserved. Tyler claimed that Lincoln was "a vulgar, dirty talker" and "a tricky politician"; that "he could have avoided the great war in 1861, whereby he reddened his garments with the blood of thousands of fine young men in the North as well as in the

4. Baldwin was probably Rufus J. Baldwin, a pioneer Minneapolis banker, lumberman, and state senator (1861–63). On Lahontan and Minnesota weather, see Stephen Leacock, "Lahontan in Minnesota," *Minnesota History*, 14 (1933), 376.

Figure 24. Lyon G. Tyler, by Mary Travis Burwell (oil on canvas, 1920s).
Joseph and Margaret Muscarelle Museum of Art, College of William and Mary.

South"; that "he used words to produce effect and not to tell the truth"; and that "he was a slacker, and sent thousands of young men to their deaths while he kept his own son out of all danger." Tyler maintained that Lincoln "might have concluded the war in 18 months instead of taking four years"; that "he destroyed the Principle on which the Union was founded—the right of self-government," and on and on and on.[5]

Tyler became very angry about a lot of things. Many of you may have grown up with a history textbook by David Muzzey, which most educators long believed was a rather good one. Tyler wrote a number of pamphlets, widely distributed in the South, demonstrating all the ways in which Muzzey had manipulated the past in order to boost the pride of northerners—particularly New Englanders and their contributions to American history—and to minimize the role of southerners.

I suggest that in some respects sectional pride and chauvinism can be useful in setting the record straight, or perhaps in balancing the historical ledger. For example, when most of us think about the history of Thanksgiving, we assume that the holiday had its origins in New England in 1621 with the Pilgrims' decision to sit down with the Indians to a meal and thank God for the first harvest. During the later 1950s, however, when the 350th anniversary of Jamestown's initial settlement was celebrated, a group of Virginians decided that New England had received too much credit for the first Thanksgiving. They organized a not-for-profit organization called the Virginia Thanksgiving Festival, Inc., and they did a great deal of historical research. Their pamphlet argues that the initial occasion occurred in 1619. Almost two years before any colonists set foot in Massachusetts, a band of stolid Englishmen was commanded to establish a settlement in Virginia. Immediately upon landing at their final destination, today called Berkeley Plantation, they thanked God for their good fortune. Every year since, apparently, the event has been commemorated as spelled out in those original instructions. My point is simply that there is some validity to the claims of the Virginians, and they ought to be better known than they are. This new organization is clearly the result of sectional feeling, but it has also helped to serve as a legitimate corrective.

5. Tyler to Hart, January 4, 1932; see also William E. Dodd to Tyler, March 12, 1931, both in Tyler Papers, Group 5, Swem Library, College of William and Mary, Williamsburg, Va.

The element of ethnic pride, a third form of chauvinism, is a theme of the Minnesota Historical Society's 1981 annual meeting. Of the many different examples one might choose, I have selected one that concerns the rivalry between Nordics and Italians over who had primacy in discovering America. In New England during the 1880s all sorts of special Scandinavian-oriented or Norse-oriented associations and groups sprang into being. In part, this had to do with the fact that the Italians were getting very uppity in New England politics generally and in Boston politics particularly, and the old WASP New Englanders wanted to keep the Italians as well as the Irish in their places. Yankees did not like the idea that in 1892 they would have to celebrate the 400th anniversary of the discovery of America by Columbus. He was, after all, Italian, and they did not want to give him *that* much attention. So there was a great deal of lobbying (beginning in 1876) and fund-raising to erect a statute of Leif Ericson in Boston. Finally the sculpture was unveiled on October 29, 1887, with many orations given in praise of Scandinavian explorers. A Scandinavian memorial association was established on the spot, and activity of this sort continued right down into the 1920s, when someone discovered on an island just three miles south of Martha's Vineyard a rock bearing the name of Leif Ericson in runic letters with the date MI after his name. Well, it seems pretty clearly to have been a false inscription. That is to say, it was *not* inscribed by Leif Ericson a millennium ago. What is not clear is whether the inscription was simply made by someone who admired Leif Ericson and his contribution, or whether it was actually planted in order to imply or assert the primacy of Scandinavians in discovering North America.[6]

A more recent example of this sort of thing involves what is called the Vinland Map and the Tartar Relation. This famous map, purchased by Yale University in 1965, was dated by scholars to approximately the middle of the fifteenth century. It clearly indicated a knowledge of the western Atlantic and the likelihood of a landfall by Scandinavians, which therefore would undercut Columbus's claim. Yale purchased this map in good faith, and it cost a great deal of money. The university authorities did the right thing in buying it if they believed it was authentic at the time; but Yale showed a certain lack of class by making the press release public just three days before Columbus Day, 1965. Be

6. See Edmund B. Delabarre, "The Runic Rock on No Man's Land, Massachusetts," *New England Quarterly*, 8 (1935), 365–77; and Oscar J. Falnes, "New England Interest in Scandinavian Culture and the Norsemen," ibid., 10 (1937), 211–42.

that as it may, in 1974 Yale University had to eat crow, because after a great deal of research it was discovered that this map had been forged by a Yugoslavian professor of ecclesiastical law who wished to undermine Italy's claim to historical importance. The map turns out to be one of the truly great forgeries in all of American history and is clearly another example of ethnic chauvinism as a stimulus to manipulate the past.[7]

The fourth type of chauvinism is local pride. I will give just one example. On December 17, 1980, there was an article in the *New York Times* titled "Two-Level Outhouse Puts Minnesota Town on the Historical Map." The town is Belle Plaine. This 109-year-old outhouse is now on the National Register of Historic Places. The reason it was built? Because the Bowler family in Belle Plaine had twelve children, and sometimes more than one had an urgent call of nature at the same time. So they built a rather cleverly designed three-seater on top and a three-seater on the bottom (Figure 25). But the claim that Belle Plaine has the only two-story outhouse in the United States is not true. When Carol and I drove across the United States in 1976, we stopped in Nevada City, Montana, and I have a picture of a two-story outhouse (Figure 26) that remains functional at that site. And there may be others. As I say, local chauvinism is yet another reason why people manipulate the past to serve the present.

The fifth form of chauvinism is perhaps the most common. It involves nationalism and, more particularly, the relationship between ideology and foreign relations. One thinks, for example, of the great textbook controversies during the first half of this century. In the 1920s if a textbook was too sympathetic to Great Britain—if, for example, it indicated that part of the responsibility for the American Revolution may have been on *our* side, and not all the blame could be placed on Lord North and King George III—the author was likely to find himself in trouble. Investigative commissions in Chicago, in Wisconsin, in New York state, and elsewhere held stormy sessions on the subject.[8]

7. See *New York Times,* February 3, 1974, p. A42.
8. Bethany Andreasen, "Treason or Truth: The New York City Textbook Controversy, 1920–1923," *New York History,* 66 (1985), 397–419; Bessie Louise Pierce, *Public Opinion and the Teaching of History in the United States* (New York, 1926), 210, 236–38; James Truslow Adams, "History and the Lower Criticism," *Atlantic Monthly,* 132 (September 1923), 308–17; and Adams, "Why Historians Get Headaches," *Rotarian,* January 1940, pp. 12–14.

Figure 25. The two-story outhouse in Belle Plaine, Minnesota. Courtesy, Minnesota Historical Society.

There are at least four other reasons why people manipulate the past that really do not have anything to do with chauvinism. Each, I think, is a separate category. One has to do with the fostering of group cohesion, group solidarity, or simply group survival. One thinks of the labor movement in this country, which has often found itself in a position of insufficient strength. In 1980 in Lawrence, Massachusetts, for example, there was an elaborate celebration aimed at reliving the famous strike of 1912 in that milling town. As the press reported, the purpose of the celebration was in large part to fulfill the labor movement's need to keep its past alive and meet that industrial community's need to breathe new life into its future.[9]

A different reason why people manipulate or use the past has to do with public relations in a capitalist society where entrepreneurship is important. I have been fascinated ever since I began using the manuscript collections of the Minnesota Historical Society in 1980 by the two great railroad expeditions that took place in 1925 and 1926: the

9. *New York Times,* April 27, 1980, p. 26.

Figure 26. The two-story outhouse in Nevada City, Montana.

first one went to the upper Missouri River region; the other traveled to the mouth of the Columbia River, retracing the steps of Lewis and Clark. They were Great Northern Railway expeditions. W. R. Mills, general advertising agent and assistant to Ralph Budd, president of the Great Northern, had to handle a great deal of correspondence in connection with these expeditions, which set out from the Twin Cities. Mills always discreetly explained in his letters that his organization was trying to direct the attention of the people invited to participate in these touristic ventures to "the historic background of the Northwest, and this is in reality the intent of the entire expedition." Budd could be

more frank—perhaps because he was the president. In a letter to the magazine editor Lawrence F. Abbott, he expressed pleasure that Abbott believed in "the soundness of the work the Great Northern Railway has undertaken and is carrying on in bettering its public relations." He was being quite honest. The historical content of these expeditions was important, to be sure, and they were conducted in a remarkably sensible and educational way (see Figure 27). But the plain fact is that those who ran the Great Northern would not have spent all that money and made such great efforts if they had not believed that doing so would improve their image in the country.[10]

Still another reason why people manipulate the past has to do with the need to justify or to validate a present desire. Essentially, the basic form it takes is to say, "Well, our great American forebears did it, so why can't we?" For example, people who wanted to end Prohibition during the 1920s and early 1930s often pointed out that George Washington or James Madison or Thomas Jefferson or someone else equally respectable liked to drink. I have seen letters inquiring whether Patrick Henry did not, in fact, serve as a bartender at a tavern near his home, and if it was good enough for Patrick Henry, it ought to be good enough for us.[11]

In the case of our own New York, when the state was near bankruptcy in 1967, there was a desire to begin a state lottery. Many people opposed that on moral grounds, so historical research was done; and it was found that lotteries had, indeed, occurred in the colonial period: lotteries to raise money to found secondary schools, King's College (which eventually became Columbia University), and so on. Once again, if it was o.k. for our colonial ancestors, it ought to be o.k. for us.[12]

The last reason I will offer to explain why people manipulate the past has to do with fulfilling very deeply felt personal or psychological needs involving sentimentalism, personal ambition, notoriety, and so on. In 1928 a woman named Wilma F. Minor was a young, ambitious

10. Mills to Solon J. Buck, July 6, 1926, Buck Papers, Minnesota Historical Society, St. Paul (hereafter MHS); Budd to Abbott, August 11, 1926, president's letter book, Great Northern Railway Company Records, MHS. For more on the excursions, see "The Upper Missouri Historical Expedition," *Minnesota History*, 6 (1925), 304–8; and "The Columbia River Historical Expedition," ibid., 7 (1926), 242–52. Abbott was an editor of *Outlook*.

11. George W. Bright to Lyon G. Tyler, April 7, 1933, Tyler Papers, Group 2.

12. *New York Times*, January 22, 1967, p. 44.

Figure 27. Ralph Budd (right) receiving a peace pipe from Yakima Indian Chief Menninick, as General Hugh L. Scott looks on during the Great Northern Railway historical expedition to the Columbia River, 1926. Courtesy of the Minnesota Historical Society.

journalist living in San Diego, California. She wrote to the editors of the *Atlantic Monthly* that she had found a lot of love letters that passed between Abraham Lincoln and Ann Rutledge. (As most of you know, the pair was supposed to have had a youthful courtship, but there has never been a shred of surviving documentation for that.) Edward Weeks and Ellery Sedgwick of the *Atlantic Monthly* were fascinated. Eventually, Wilma Minor sent in 227 typed pages of love letters and various other supporting documents. There were all sorts of reasons why the staff of the *Atlantic Monthly* should have been suspicious, but they weren't suspicious enough. One month before the first installment appeared, an advertisement announced "Original Love Letters"; in the first issue, "Lincoln, the Lover" was the great title; finally, "The True Love Story" was proclaimed all over the country. If Wilma Minor was ambitious for recognition as a journalist, she was also a rather strangely romantic personality. Carl Sandburg and Ida M. Tar-

bell examined these documents and said they believed them authentic, but archivists and editors like Worthington C. Ford and Lincoln scholars like Paul M. Angle were nonbelievers. Ultimately, of course, the documents turned out to be forgeries. They were forged simply because Wilma Minor was very eager to make a name for herself.[13]

CAROL KAMMEN: In less dramatic ways, local historians and local communities also manipulate the past, sometimes consciously and sometimes unknowingly. Chambers of commerce are among the most interesting users of historical fact—and sometimes of historical fiction. Just look at the advertising that circulates about America's hometowns. History is used to make a place look good, or to make a town sound interesting in order to draw tourists to two-story outhouses, or to attract new residents or—most important—potential investors. I have never seen a chamber of commerce flyer that noted a bank failure or stressed that there was malaria in that locality. Promotional literature tends to overlook any unpleasantness in order to enhance the town, and history is a prime way of doing this. In such instances history is used selectively; the positive is emphasized.

Historical house museums often manipulate the past by portraying a static view of what a house would have looked like, whereas most houses that were *homes* were organic units: they grew, they were altered, they took shape variously, people moved things around. Very few people in 1840 ordered complete roomfuls of ready-made furniture, but today we see a house that looks totally put together. Thomas Jefferson's Monticello is simply the grandest and most elaborate example of a house that was actually in constant transition. Jefferson was always pulling off one wing, putting on another, or altering great portions of the house. Today Monticello is displayed as a completed, serene period piece. I think historical house museums are one area where we should look to see if we are not portraying a past that is a bit too tidily put together, just as outdoor museums tend to portray a clearer, calmer, more settled past than actually existed. The pigs and the cattle that once roamed our streets, leaving piglike and cattlelike remains, are carefully sequestered behind fences. Yet I have some

13. For the advertisement and editorial reactions, see *Atlantic Monthly,* 142 (November 1928), 33; and 143 (February and April 1929), 288, 516–25. See also Don E. Fehrenbacher, *The Minor Affair: An Adventure in Forgery and Detection* (Fort Wayne, Ind., 1979), a pamphlet published by the Louis A. Warren Lincoln Library and Museum.

wonderful documents written in 1820 by a man who commented that he hated to sit behind certain people in church because they always came through the cow pasture, and he was offended by the "element of cow adhering to their feet."[14] Our past is not as clean and neat as we often portray it.

There has also been a selective collecting of material in our local archives. Many of them portray, or have documents that portray, a past accommodating the archivists' own idea of what the past was all about. Once upon a time historical societies sought particular types of documents and papers and artifacts: those of "important" people, of the old families, neglecting at the same time the "unimportant" remains of nonimportant people. This attitude has become institutionalized in some archives so that blacks and members of ethnic groups and "ordinary people" do not think of a historical society as having any interest in or relevance to their lives. In many cases that has been true. A major shift in this attitude can certainly be seen in the Minnesota Historical Society book *They Chose Minnesota* (1981), which is a celebration of the ethnic diversity of the past of this state. There are other state books somewhat like it. This new affirmation of our pluralistic past, however, is a relatively recent phenomenon.[15]

We also manipulate and somehow emasculate the past when our historical societies display artifacts such as farm, shop, and kitchen implements as art objects rather than as tools that had a function. Lovely hand-hewn wooden rakes are things of great beauty to collect today, but their historical significance is embodied in their function. I am a strong critic of historical societies that display farm tools but never explain how they were used.

The past is manipulated by something I call censorship, although perhaps that word sounds a bit too strong. There is a subtle curtain of silence that a community draws around particular topics—an absence of documentary material on certain episodes, a lack of memory about certain subjects. There is an attitude that says local history is for our pleasure and for our benefit, but it is not something that ought to rake up the past.[16]

14. S. J. Parker, quoted in Carol Kammen, ed., *What They Wrote: 19th-Century Documents from Tompkins County, New York* (Ithaca, 1978), 12.

15. On archival collecting, see Lydia Lucas, "The Historian in the Archives: Limitations of Primary Source Materials," *Minnesota History*, 47 (1981), 227–32.

16. Peggy Korsmo-Kennon, Waseca County Historical Society, and Deborah L.

This censorship on the part of a community is not unique. Local historians themselves tend to censor the topics they look into. As an integral member of a community, the local historian frequently accepts its views and values, sometimes adopting a community "line" about certain events. To go against this may be self-defeating and jeopardize access to future sources. I am saying not that we must wash dirty linen in public, but that we must look at the whole past and not just those parts that make us feel good.[17]

I think we manipulate the past by viewing local history as a progression, a steady march from wilderness to settlement to present civilization to civic good, without a misstep along the way. There are various elements in our past that I think we have to acknowledge. By looking selectively, we ignore the totality of the truth of the past, seeing it in such a way that progress for the common good is never doubted and never thwarted. I don't know about your communities, and I know that Minnesota is a progressive state, but the communities I have studied have taken a lot of missteps along the way, and it is important for us to look at those as well as at the progress.

There is no party line in local history. It should include the past of the well-located merchant and the ne'er-do-well peddler, of the prosperous farmer and the laborer or tenant on a poor hillside farm; of community leaders and community failures; of the ill, the down-and-out, the sick, and the criminal; of the late comers as well as the firstcomers. Now, I too love the first-comers—first settlers are interesting, and many people in my town can name the first three families who arrived there. But I think those people who settled later are also important; they, too, had to leave behind old lives and search out new prosperity. It seems to me that we have to look at the history of hostility to strangers as well as those instances of community cooperation. The plurality of the past is our concern, as is the comparative history of communities: reasons why one community did well and why another seemed to stagnate. We are at last growing away from Richard Dorson's characterization of all local history as "old tomes [which] all told one rigid, undeviating story. They began with a reference to Indians and the wilderness topography; hailed

Miller, MHS, suggested an episode in Blooming Prairie that aptly illustrates this problem: see Harold Severson, *Blooming Prairie Update* (Blooming Prairie, Minn., 1980), 233, and *Minneapolis Tribune*, October 22, 1981, p. 3B.

17. This problem is discussed briefly in John W. Caughey, "The Local Historian: His Occupational Hazards and Compensation," in *Pacific Historical Review*, 12 (1943), 1.

the first settlers; noted the first churches, the first schools, the first stores; devoted a chapter to the Revolution and the local patriots; swung into full stride with the establishment of the newspaper, the militia, the fire department, and the waterworks; rhapsodized about the fraternal lodges and civic organizations; recounted the prominent citizens of the community, and enumerated famous personages . . . who had passed through . . . and rounded off the saga with descriptions of the newest edifices on Main Street."[18]

In addition to the ways we have manipulated the past to create the present, I want to look at the important problem of how the present shapes the past. The interests of a historian writing a town history in 1879, for example, were very different from those of a historian writing about that same community in 1900, 1939, or 1981. Historical concerns shift, and while we may consult some of the same evidence, our interest in that evidence is altered by time. In my copies of the three county histories that deal with the area where I live,[19] there is on the back flyleaf of each something I call my Anti-Index. This is not a list of charges against those earlier authors. I am not saying, "Hey, you didn't deal with that. I gotcha on this one." Rather, I am trying to judge what things I look for in these books that an earlier author had absolutely no interest in. The Anti-Index is a gauge of my current historical interests and a barometer of the changes in historical fashion. The earliest county history I use was written in 1879, the second in 1894. Both of these are aptly characterized by Dorson's description and embody all of his topics. The third is a town history that appeared in 1926. It is a business record of my community, with all the business starts—but there is never a failure mentioned. I find it interesting because it reflects the optimism of the 1920s. I frequently look for failures of businesses, but one never finds them in those old promotional histories. My Anti-Indexes also contain topics such as women and demographic questions and philanthropy; sometimes one finds mentions of ladies' aid societies and of charity, but I look in vain for ways in which communities dealt with those massive problems where many people needed help. I look for the status of leaders and leadership in the old histories, and these are not mentioned.

18. Dorson, *American Folklore & the Historian* (Chicago, 1971), 149.
19. D. H. Hurd, *History of Tioga, Chemung, Tompkins and Schuyler Counties, New York, with Illustrations and Biographical Sketches of Some of Its Prominent Men and Pioneers* (Philadelphia, 1879); John H. Selkreg, ed., *Landmarks of Tompkins County, New York* (Syracuse, N.Y., 1894); Henry E. Abt, *Ithaca* (Ithaca, 1926).

My own interests reflect changes in historical thinking about the past that have occurred over the last twenty years. And they help me to see more clearly what the questions of the 1980s actually are. By asking new questions about the past, we are creating a different history from that produced by earlier writers.

MICHAEL KAMMEN: During the 1920s and 1930s a number of American writers interested in our past, such as Charles Beard, Constance Rourke, and Bernard De Voto, "discovered" that we have been a nation of mythmakers. It became commonplace to insist that there was something peculiarly American about not perceiving properly the distinctions between history and myth while dignifying many of our myths as acceptable history. On the eve of World War II, however, when people began to be more aware of myths, there was such a powerful need for a reassertion of national self-confidence that such prominent figures as the poet Stephen Vincent Benét and many other writers came to feel that a nation's folklore, its legends—the mythology that they had described—played a very important role in sustaining the nation's belief in its value system and would be absolutely crucial in the war against Fascism. Consequently, although you can find recurrent charges about the United States being a nation of mythmakers, after World War II there was a reinforcement of this tendency in quite a different direction from what one would have expected. Treasuries of American folklore and mythology began to appear.

I would like to make a related point: Carol and I have been talking about deficiencies and inadequacies on the part of Americans in misunderstanding or misusing the past, but it is a universal phenomenon; I think we ought to take a moment to bring that into perspective. In English history something called the myth of the Norman Yoke has been very important. The theory, which began to emerge in the seventeenth century, is that before 1066 the Anglo-Saxon inhabitants of Great Britain lived as free and equal citizens who governed themselves through representative institutions. Then along came William the Conqueror (then known as William the Bastard), who established the tyranny of an alien king and landlord. But the people did not forget the rights they had lost and fought continuously to recover them—with varying degrees of success. That myth was central to both popular and scholarly thought in England for a very long time.[20]

20. See Christopher Hill, "The Norman Yoke," in *Puritanism and Revolution* (New

You will notice that while speaking of abuses of the past in this country—specifically the rivalry between Italians and Scandinavians for primacy as explorers—I very carefully avoided the subject of the Kensington Stone, about which you know far more than I do. My impression from reading the literature is that the stone is indeed a forgery and that it was made in the late 1880s just as people were anticipating all the hullabaloo that would culminate at Chicago in the great Columbian Exposition of 1893. One interesting aspect is that people constantly tried to draw upon the expertise of Norwegian, Swedish, and Danish runologists. Those authorities were consulted, but they were never very helpful. Perhaps they were, as they usually said, just too busy; nevertheless, my impression from Erik Wahlgren's very good book on the Kensington Stone is that in their heart of hearts the Scandinavian runologists really did not want to spoil the belief that, in fact, their explorers had arrived first. In any case, if you look at a wonderful book called *The Golden Horns,* a study of Norse mythology in Sweden, Denmark, and Germany in the seventeenth, eighteenth, and nineteenth centuries, it becomes very clear that misuses of the past were just as strong abroad as any of the abuses that we have talked about today.[21]

Finally, our topic is not even a phenomenon peculiar to industrialized societies. We know from the work of anthropologists that among so-called primitive societies, when there is a major change of dynasty—that is, when one family line comes to an abrupt end for some reason such as a coup d'état or a childless ruler—all the genealogies get rewritten, and no one is in the least embarrassed about this. It is the most natural thing in the world for such societies to rewrite their genealogies to accommodate and comport with the new royal family. My point is that we may be guilty of sins of omission and of commission with respect to using the past to shape and create the present, but there is nothing unique about our doing so.[22]

York, 1964), 50–122. See also J. G. A. Pocock, *The Ancient Constitution and the Feudal Law: A Study of English Historical Thought in the Seventeenth Century* (Cambridge, 1957).

21. Wahlgren, *The Kensington Stone: A Mystery Solved* (Madison, Wis., 1958), esp. 72, 121; Theodore C. Blegen, *The Kensington Rune Stone: New Light on an Old Riddle* (St. Paul, Minn., 1968), 109–25; John L. Greenway, *The Golden Horns: Mythic Imagination and the Nordic Past* (Athens, Ga., 1977). See also Lawrence M. Larson to Guy Stanton Ford, November 12, 1935, Ford Papers, University of Minnesota Archives, Minneapolis.

22. Contemporary Communist regimes are especially heavy-handed in this regard. See the brilliant novel by Milan Kundera, *The Book of Laughter and Forgetting* (New York, 1980). Kundera is a Czech writer living in exile in Paris.

CAROL KAMMEN: We have commented about misuses of the past, but I would like to look very briefly at four ways that local history is of value to our communities. One is recreational: local history is really a lot of fun, both for the individual and for the community. It adds to our enjoyment of knowing where we are and having a sense of connection with place, a not inconsiderable quest among people who move so rapidly and so much as we do. On the personal level, it helps people to set roots in communities. The pursuit of local history is also social; its activities are often shared, creating a bond for the people involved. Local history is concerned with the environment; it reaffirms the value of our land, our architectural history, our towns and our cities. It is a concern with our environment that we hold in trust for the future and that helps us to place value upon some of the things we do.

Most of all, local history is educational. It teaches about the particularities of place; it is the laboratory where we study the relationship of one town to another, to a state or region, or even to national history; and it is a means of learning and applying historical methods, of using critical skills and deductive reasoning, of making judgments, of seeking answers from a mass of contradictory and confusing sources, of learning to sort the important from the trivial, and of seeking themes and patterns. Knowledge of local history demands of its practitioners that they sift and evaluate what they know, select the gold from the dross, and seek the truth wherever that search may lead. It requires us to arrange our knowledge and articulate it for other people—education both for ourselves and for our communities.[23]

MICHAEL KAMMEN: One of the problems that I think we have to deal with involves the relationship between the researching, the writing, and the presentation of authentic history—history as true as we can make it—and the values of a democratic society. A lot of the evidence that I have seen, emerging from several centuries of history in this society, suggests that in the minds of many people there has been a tension between the ethos of a democratic society and writing honest history, because people want their history to be comfortable. They want a history they can live with, one that reinforces the beliefs they already have. This was a major issue in the 1920s when so many of the

23. See Victor Skipp, "Local History: A New Definition and Its Implications, Part 2," in *Local Historian,* 14 (1981), 392 (a quarterly formerly titled the *Amateur Historian* and published in London).

textbooks were being challenged. James Truslow Adams, perhaps the most widely read American historian of his day, demanded: "If democracy rejects the truth, will it slowly retire again, as in the Middle Ages, to the quiet cell of its cloistered votary?" He went on to assert that "the influence of democracy in the long run upon intellectual life has yet to be determined, and there rests upon the more cultured elements among the public a very genuine and solemn obligation."[24]

We can go too far, however, in trying to democratize the past. My favorite example of that occurred in 1936 when a group of journalists and professors at Columbia University decided to rewrite the Declaration of Independence because there were too many complicated sentences and polysyllabic words. Thomas Jefferson had not used language sufficiently accessible to the "common man." So they rewrote it in simple language that any idiot could understand—while Jefferson rotated in his grave at the loss of all that beautiful Enlightenment prose that we so much admire.[25]

Yet there remains the problem of telling communities or societies or nations things that they don't particularly want to hear. The questions are: What are the solutions? What can be done about it? How and why is it important?

In 1904 a dinner was held at the Nicollet House in Minneapolis to honor James K. Hosmer, who was retiring after twelve years as librarian of the Minneapolis Public Library. One of the speakers, William W. Folwell, made a very simple and obvious point, but one that needs to be brought to our attention again and again: that in a democracy people constantly form opinions in order to make choices about the future. They need a historical basis on which to do so. Therefore good history, true history, authentic history, is absolutely indispensable to a democracy. Moreover, local history is particularly important because, in this context, it enables people to get at the essence of how specific communities reached their present condition. Herbert Levi Osgood, one of the most prominent American historians early in the twentieth century, remarked in an interview that "it is only through the study of local and state history that the real nature of our democratic society can be understood."[26]

24. Adams, "History and the Lower Criticism," 316. See also William E. Dodd, "History and Patriotism," in *South Atlantic Quarterly,* 12 (1913), 116.

25. See *New York Times,* February 13, 1936, p. 24.

26. Folwell's speech, dated January 29, 1904, is in Hosmer Papers, MHS; Dixon Ryan Fox, *Herbert Levi Osgood: An American Scholar* (New York, 1924), 64.

Looking at various commemorative and historical activities in the years since World War II, I note that they have been most successful at the state and local levels. For example, the Civil War Centennial from 1961 to 1965 was in many respects *un*successful as a national event; in local terms, however, it was exceedingly successful. In Virginia, for instance, there were 1,147 different centennial events in which communities could become involved. Obviously, Virginia was something of a special case because so much of the Civil War took place there. But it was true all across the country that the Civil War Centennial and the Bicentennial of the American Revolution energized far more people and interested them in history within their localities than as national phenomena.[27]

CAROL KAMMEN: For a long time, I think, there has been an uneasy relationship between the folklorist and the historian. Their sources and their means of approaching sources are different. But much of what has been accepted as local history in our communities has really been folklore, and it is the folklorist who often knows how best to see this material and how to use it. It is the folklorist who can take a local tradition and show that it is part of a national or even an international motif, for our roots go beyond our own community's founding, beyond the borders of individual community memory. Folklore reveals the "shared" facts of a people, not quite like the facts of historical evidence at all times, but often the basis of popular action and sometimes of popular belief.

MICHAEL KAMMEN: We began with a definition, or clarification of a definition, and we shall end with one. The word that I want to call to your attention is "nostalgia," because it has become a kind of buzzword. We read a great deal about it; we hear a great deal about it in the media; and I think it is a word that has become trivialized. It has undergone a kind of banalization. What has happened is that the original meaning has been lost sight of, with unfortunate results. Coined by a Swiss physician in the late seventeenth century to describe a physiological condition, "nostalgia" did not mean a simple longing for the past. It had to do instead with longing for the particularity of place, longing for *home*. Nostalgia was a condition diagnosed among soldiers

27. See Robert G. Hartje, *Bicentennial USA: Pathways to Celebration* (Nashville, Tenn., 1973), chap. 4.

who languished and wasted away when they were far from their native land.[28] If we go back to the original meaning, I think we can achieve a reaffirmation of state and local history, as well as of history in general, because history has everything in the world to do with a sense of place.

But I would conclude with the point that while nostalgia may or may not be a pathological disease, it does indeed involve the yearning both for a better time and for a beloved locality. Primarily, it involves the need for a sense of rootedness. The poet Allen Tate wrote about this sense at some length. In a charming essay on the southern sense of place, he discussed the desirability of the individual's feeling a sense of roots somewhere. (The irony is that Tate himself, because of personal complexities in his family life, did not know until the age of thirty where he had been born.) I offer Tate's essay as a fine statement of the genuine human need for a sense of place and, therefore, the value of state and local history as a means of understanding what our relationship to a particular place has been and might be.[29]

28. Jean Starobinski, "The Idea of Nostalgia," in *Diogenes: An International Review of Philsophy and Humanistic Studies,* 54 (1966), 81–103.

29. Cf. Tate, "A Southern Mode of the Imagination," in Joseph J. Kwiat and Mary C. Turpie, eds., *Studies in American Culture: Dominant·Ideas and Images* (Minneapolis, Minn., 1960), 99; and Tate, "A Lost Traveller's Dream," in his *Memoirs and Opinions, 1926–1974* (Chicago, 1975), 5–8.

Heritage, Memory, and Hudson Valley Traditions

On April 23–24, 1983, Dutchess County commemorated the tercentenary of its founding by holding a conference in Poughkeepsie, New York, the county seat, titled "Transformations of an American County."

Leadership in planning the conference had been handled by Jonathan C. Clark, associate professor of history at Vassar College, a promising young scholar who died at the age of forty-two, just months before the conference he had so ably organized took place. After an opening luncheon and dedication of the conference to Professor Clark's memory, I presented the keynote address. It is printed much as it was given in order to retain the intimate and collegial tone of the occasion.

Early in the 1930s, during the depths of the Great Depression, researchers at Cornell University and at Cornell's Experimental Station in Geneva, New York, developed inexpensive foods called Milkorno, Milkwheato, and Milkoato. They consisted of whole-grain meal, dried skim milk, and salt. They contained lots of minerals, proteins, and vitamins, and thus cost very little. In February 1933 Governor Herbert H. Lehman and Eleanor Roosevelt visited Cornell and had a Milkorno luncheon: tomato juice, Milkorno, scrapple, cabbage salad, baked apple and cookies, all at a staggering cost of six cents per per-

son.[1] I think that our luncheon today may have been *considerably* tastier, but some would say that we're in a depression once again, which makes that price tag of six cents sound might good!

Be that as it may, I'm very glad to be here and grateful to you for inviting an "outsider" to speak on this occasion. So much so, in fact, that insiders and outsiders will be one of the themes I touch upon in discussing why a local and regional celebration—*this* local celebration, in particular—has statewide and even national resonance.

In the year 1799, David Daggett delivered an oration in New Haven, Connecticut, that bears a charming title: *Sun-Beams May Be Extracted from Cucumbers, but the Process Is Tedious.* I shall try to extract three sunbeams today, and I can only hope that the process won't be too tedious. My first attempt concerns the Hudson River Valley "school" of painters and a certain happy lesson, or sunbeam, that I see in their story. My second involves the nature of memory and amnesia in the Hudson River Valley: what is remembered, what is forgotten, and the implications of both. My third concerns the relationship between local traditions and national heritage, once again with particular reference to the Hudson River Valley. Bear with me, and perchance the process of extracting sunbeams from historical cucumbers may not prove to be too tedious! We shall see.

I have always shared your affection for the Hudson River Valley school of landscape art. One never tires of those beautiful scenes, and in my opinion they have never been surpassed in the subsequent history of American landscape painting. The school is often referred to as the "first school" (meaning the earliest) in the whole history of American art. That is not quite true, of course; nonetheless, you can acknowledge with pride the primacy of an earlier and less famous, yet *also* a Hudson River Valley school. I have in mind those portraits, overmantels, religious scenes, and allegories ascribed to the so-called Schuyler Painter, the Gansevoort Limner, and the *Aetatis Suae* pictures. Many of those portraits, of course, incorporate landscapes in the background, or off to one side. An example, *Pau de Wandelaer* by the Gansevoort Limner (ca. 1725), shows the mid-Hudson, its mountains, and a single-masted sailing vessel with fore and aft rig.[2]

Some of the religious paintings are wonderfully naive, though per-

1. Morris Bishop, *A History of Cornell* (Ithaca, 1962), 464.

2. Robert G. Wheeler and Janet R. MacFarlane, *Hudson Valley Paintings, 1700–1750, in the Albany Institute of History and Art* (Albany, N.Y., 1959), 20.

Figure 28. The Finding of Moses, unidentified limner in the Albany area, ca. 1740. Collection Albany Institute of History & Art.

haps "innocent" would be a better word. I have in mind *The Finding of Moses,* for example, done by an unknown artist in Albany during the first quarter of the eighteenth century (Figure 28). Six uncorseted lovelies are reaching out to little baby Moses, whose basket seems to be not so much caught in the bulrushes as it is simply floating on Rondout Creek or the Esopus. Three of the six full-bosomed creatures are almost unseemly in their dishabille. But the painter has carefully inscribed "Exodus 2V–3" in the left foreground to remind us that Pharaoh's daughter and her handmaidens had, after all, gone to the river to bathe. Still, it seems droll to envision fleshy Egypt in the middle distance, with the Hardenberg Hills as a backdrop.[3]

3. Ibid., 37.

So much for the *first* Hudson River school. It was indeed the first American school; but exemplars will primarily be found in public galleries and homes along the valley, and aficionados of these works are primarily local people plus a few professional specialists. The *second* Hudson River Valley school is a different matter, however, because it has truly become a cherished part of our national aesthetic heritage. The landscapes of Thomas Cole, Asher B. Durand, Frederic E. Church, Jasper F. Cropsey, and many others are prized by collectors and art museums throughout the country—indeed, throughout the world. On October 25, 1979, I was heartbroken when Sotheby Parke Bernet knocked down *Figures on The Hudson River,* a brilliant October scene by Jasper Cropsey, for $16,000. In that very same sale *The Icebergs,* by Frederic Church, went to a Texan for a cool $2.5 million. I would have been content with Cropsey's luminous vista of the lower Hudson, but it was just a bit beyond my budget.[4]

One aspect of the second Hudson River school that interests me especially is that a number of its prominent members really were not residents of the valley. Like me, they were outsiders who found themselves attracted to the valley: its vistas, its foliage, its people, its boats—even its cows and sheep. Precisely because they were outsiders, they helped to create a national school and a national style that was, nonetheless, place-specific. Take George Inness, for example. He was born in 1825 on a farm just two miles from Newburgh, but his family moved to New York City while he was still an infant. In 1829 they moved again, this time to a country home outside of Newark, New Jersey, where Inness spent his boyhood. At the age of sixteen he got a job with two map engravers in New York City. Then he studied with a French landscape painter in the city, and in 1845 he set up his own studio. He sketched for a while at Pottsville, Pennsylvania, where his elder brother lived, and then began a truly peripatetic career: short periods of residence in Italy, Brooklyn, France; a move to Boston in 1859; five years in Medfield, Massachusetts, where he painted some of his greatest scenes. After the Civil War this restless man moved to Eagleswood, New Jersey, went back to Rome for four more years (1871–75), returned to Boston, to New York City once again, and finally, in 1878, settled in Montclair, New Jersey, where he spent most of his remaining sixteen years.

In 1870, however, after Eagleswood and before Rome, he painted a

4. Sotheby Parke Bernet sale catalog 4290, *American 19th and 20th Century Paintings, Drawings, Watercolors and Sculpture* (October 1979), nos. 25 and 34.

large oil titled *Landscape, Hudson Valley,* which now hangs in the Cincinnati Art Museum (Figure 29). It's a fascinating picture. Inness's emphasis is upon the valley itself rather than the river. Some sun is breaking through an overcast sky. Locomotive-like puffs of steam stream from the chimneys of three small homes located on the edge of a hillside in the foreground; farmsteads as well as a village are rather indistinct in the middle distance. The painting has a mystical quality, but not because Inness has chosen to romanticize the Hudson Valley of his nativity. Quite the contrary, his theme is as elusive on canvas as it must have become in his life by 1870. At the age of forty-five he seems to have been invoking some memory of his origins. There is no machine in this garden, no locomotives like his more famous *Lackawanna Valley* of 1855, or a locomotive roundhouse located like an omphalos in the center, or a field of stumps in the foreground. The Lackawanna Valley was being shaped by the hand of man, whereas *Landscape, Hudson Valley* is inhabited but remains rustic. The vast sweep of the valley, with a limitless horizon, is viewed from a bluff on the lower edge. Inness had come home, yet he acknowledged his true situation, that of an affectionate outsider.[5]

The mysterious haze that he imposed on this Hudson Valley scene—a haze of memory, of time filtered through distance and clouds—may be constrasted with still another painting by Inness called *New England Valley,* handsomely displayed for sale in the April 1983 issue of *The Magazine Antiques* (p. 723). Here the landscape is much sharper, each grove of trees stands out more clearly, and we are entering the unspecified valley behind a lone woman whose purpose in heading for the pasture and cattle in the middle distance is known only to her. The high bluff and rocky outcropping appear *across* and above the valley. They merely define one distant boundary of it. We are, as I have noted, *entering* the valley, invited as it were by the farm woman who is preceding us. In *Hudson Valley,* by contrast, one feels more like the mature Moses: permitted to observe the promised land from above and afar but not to enter it. The viewer remains very still. Only his eye moves, drawn by a broad bend in the river, back and back and back to the hazy horizon, to a vast yet finite horizon of memory.

5. *Landscape, Hudson Valley* appears in John K. Howat, *The Hudson River and Its Painters* (New York, 1972), fig. 63. *Lackawanna Valley* appears in Barbara Novak, *Nature and Culture: American Landscape and Painting, 1825–1875* (New York, 1980), fig. 84.

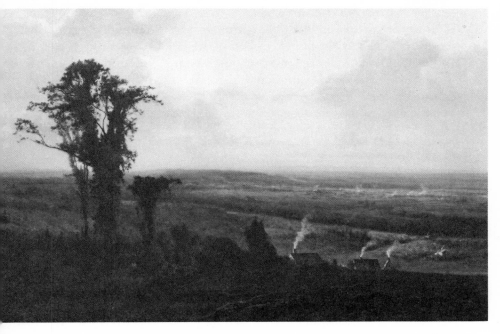

Figure 29. Landscape, Hudson Valley, by George Inness (oil on canvas, 1870). Cincinnati Art Museum, Bequest of Frieda Hauck.

(I recall with great fondness a two-week trip that I made in July 1972, while researching *Colonial New York—A History,* up and down both sides of the Hudson, from Tappan and Tarrytown at the southern end to Fort Edward and Glens Falls in the north. I considered myself an empathetic outsider then, as I do once again today, approaching the valley with an active historical imagination.)

Although we speak of the Hudson Valley "school," each of those great artists had his own angle of vision, his own reason for recapturing some aspect of the landscape and its past. Thomas Cole wanted to comprehend awesome, sublime aspects of nature and sought to define the romantic Americanness of the valley, in contrast to his more controlled Roman landscapes, often with ancient ruins. John Quidor enlivened the folklore of the Hudson Valley by using Washington Irving's tales as points of departure for such fantastic confrontations as *The Return of Rip Van Winkle* (1829) and *Anthony Van Corlaer Brought*

into the Presence of Peter Stuyvesant (1839).[6] Jasper Cropsey recorded the shifting of seasons in the valley with exquisite faithfulness to each burnished or fallen leaf.

We need to consider the *entire* school if we are to savor the fullness of man's experience with nature and history in this valley. Nor can we ignore the less famous, "naive" artists of the valley; their identification with it may have been the strongest of all because it was their *primary* identification. *The Hudson Valley, Sunset,* a mid-nineteenth-century landscape by Thomas Chambers in which a dirt road gives way to the foreshortened river itself, reminds us that Dutch explorers and English navigators of the seventeenth century called the Hudson, quite literally, their "road."

Then we have the varied blues and greens of *Marlborough from New Hamburg,* by the self-trained folk artist Clinton W. Clapp (1831–1915). Born and raised in the Town of Wappinger, he left in 1845 to study mechanical engineering at New York University and the City Mechanical Institute. Unlike the peripatetic George Inness, however, Clapp came home in 1852, became president of a bicycle-wheel manufacturing company and the local historian for Poughkeepsie newspapers. He prepared a chapter on Wappinger for Hasbrouck's *History of Dutchess County.* A century ago, in 1883, he began to paint with oils. Sailing his steam-powered yacht down Wappinger's Creek to its mouth at New Hamburg, he noticed a fine view of Marlborough, entrepôt of the local raspberry industry, which every day sent berries by steamboat to New York City. We cannot see the berries in this quaint scene; but the steamboat is at the wharf, white sidewheel and black smokestack ready to carry those berries down to Gotham.[7]

The second aspect of heritage and memory that I want to mention has to do with our tendency to forget as well as to remember. Since the beginning of this century, for example, New Yorkers have shown a wonderful capacity to celebrate anniversaires, but then to dismiss their historical occasions entirely. The Hudson-Fulton Celebration in 1909, for example, commemorated the tercentenary of Henry Hudson's "discovery" of the river that bears his name, as well as the centennial of Robert Fulton's invention of the steamboat. That celebration was an

6. Located resectively in the National Gallery of Art, Washington, D.C., and the Munson-Williams-Proctor Institute, Utica, New York. See Bryan Jay Wolf, *Romantic Re-Vision: Culture and Consciousness in Nineteenth-Century American Painting and Literature* (Chicago, 1982), 131–67.

7. Howat, *The Hudson River and Its Painters,* 163, fig. 55.

important landmark in our cultural history for many reasons, among them the first major exhibition of American decorative arts, held at the Metropolitan Museum of Art in New York City, a show that provided the genesis for the American Wing of the Met, which opened in 1924 and so richly displays objects characteristic of material culture in the Hudson Valley.[8]

That eventful tercentenary, honoring the history of discovery and technological innovation in New York, was followed in 1914 by an obscure event called the Commercial Tercentenary of New York. Its memorial booklet explained: "The year 1614 is a red-letter year in the history of the State of New York; for it was the year in which the duly chartered commerce of the Hudson River began; the year in which the first ship was built in these waters; the year in which the first fort was built by the Dutch traders in the Hudson Valley, and the year which produced the first definite cartographical knowledge of New Netherland."[9]

I would venture the guess that virtually no one today knows about that tercentenary, even though it became a kind of prototype for comparable commercial anniversaries. In 1941, for example, Dun & Bradstreet celebrated its one hundredth birthday in New York by publishing a volume titled *The Sinews of American Commerce.* The president of Dun & Bradstreet proudly sent it to clients and other influential persons, explaining that it gave "the intimate story of the development and the evolution of credit in the irresistible progress of a vigorous people."[10]

In 1926 New York state observed the tercentenary of the founding of New Netherland: special exhibitions were prepared and appropriate publications appeared, such as a bibliography relating to the history of New Netherland and several one-volume histories of New York, 1626–1926. Two years later the 300th anniversary of the Dutch Reformed Church in America was observed, with special homage to Jonas Michaëlius, the first dominie to arrive in New Netherland. In

8. Michael Kammen, "The Rediscovery of New York's History, Phase One," *New York History,* 60 (1979), 388–94; Kammen, *Colonial New York—A History* (New York, 1975), 92–93, 109, 148, 258–63, 291.

9. [Edward H. Hall], *The Commercial Tercentenary of New York, 1614–1914: Containing a Brief History of the Beginning of the Regularly Chartered Commerce of New Netherland and the Permanent Settlement of What Is Now the State of New York* (New York, 1914), 66.

10. A. D. Whiteside to Dixon Ryan Fox, October 15, 1941, Fox Papers, Schaffer Library, Union College, Schenectady, N.Y.

1936 a Long Island Tercentenary took place; four years later some of the towns on the eastern end of the island, such as Southampton and Southold, settled by Puritans who had crossed Long Island Sound from New England, celebrated their tercentenaries.[11]

Each of these occasions stimulated a certain amount of public interest, and several of them even generated publications of enduring value. Nevertheless I am impressed—or perhaps I should say depressed—by our tendency to forget even what we have re-remembered. You will not be surprised to learn that, sometimes at least, it is necessary to revive our lapses in order to recapture our heritage. I do not have individuals in mind so much as organizations. In 1935, for example, a resident of Garden City, Long Island, reported that some of those involved in planning the Long Island Tercentenary believed that "the best way to push our celebration" would be "to resuscitate the dead Nassau County Historical Society."[12] Well, yes it *does help* to have a local historical society with a spark of life to it!

I find that Dutchess County in general and Poughkeepsie in particular have a better record than most. Various groups, institutions, and writers have from time to time freshened our memory of the significant state convention that met here from June 17 until July 26, 1788, to consider and ratify the new U.S. Constitution.[13] The New York State Historical Association held its annual meeting in Poughkeepsie on September 15, 16, and 17, 1938, in order to mark the sesquicentennial of New York's becoming the "eleventh pillar" of the new United States. The Dutchess County Historical Society and Vassar College served as co-hosts on that occasion.

You may be interested (or appalled) to learn that the overall cost per person for meals and lodging was $3.50 a day. Those attending could participate in a "pilgrimage" to several of the grand Hudson River mansions in the area: the Roosevelt and Vanderbilt homes in Hyde Park; and Montgomery Place, beyond Rhinebeck, where General and

11. Charles S. Brigham to Victor H. Paltsits, April 20, 1928, Paltsits Papers, New-York Historical Society, New York City; Dixon Ryan Fox to Byron F. Burch, January 3, 1941, Fox Papers, Union College. For the 200th anniversary of the settlement of Cherry Valley, see F. LeVere Winne to Dixon Ryan Fox, February 6, 1941, and Fox to Winne, May 21, 1941, Fox Papers, Union College.

12. Courtney R. Hall to Dixon Ryan Fox, November 28, 1935, Fox Papers, box 1, New York State Historical Association, Cooperstown, N.Y.

13. Linda Grant De Pauw, *The Eleventh Pillar: New York State and the Federal Constitution* (Ithaca, 1966), 187–254; J. F. Baldwin, "What Poughkeepsie Celebrates," *New York History*, 20 (1939), 133–41.

Mrs. John Ross Delafield explained "the history of the house and its famous occupants, the Livingston family."[14]

On September 17, a date observed as Constitution Day beginning in 1919, preliminary speeches were made by George V. L. Spratt, the mayor of Poughkeepsie, and Frederick H. Bontecou, state senator from the twenty-eighth district. Dixon Ryan Fox, energetic president of Union College and of the New York State Historical Association, abbreviated his remarks because Governor Lehman was present and President Roosevelt was also waiting to deliver his address by radio from Washington. As Fox observed to the crowd in downtown Poughkeepsie, most of them had surely attended to hear Lehman and F.D.R. supply "some fresh interpretation of our present political life and its tendencies." Fox was sagacious; undoubtedly, he did the right thing. Still, it seems at least a *bit* bizarre that on this historical occasion a distinguished historian of New York state and of American political culture during the later eighteenth century felt that he had to truncate his remarks because the audience had *really* assembled to hear two nationally prominent figures speak about current events.[15]

Yes, I do appreciate that under these particular circumstances, F.D.R. was no ordinary American president. He was, in Felix Frankfurter's words, "the Dutchess County American," a marvelous appellation, in my opinion, and one that Frankfurter concocted in January 1939 in his first letter to Roosevelt after the president had named him to the Supreme Court.[16] I'll have more to say in a few moments about the Dutchess County American.

First, however, I want to finish my point about memory and am-

14. *New York History*, 19 (1938), 113–15, 229, 232, and 20 (1939), 4. *The Historical American Building Survey*, "List of Structures Recorded in Southern New York State District" (April 15, 1934), included four structures in Dutchess County: Trinity Church in Fishkill, the Dutch Reform Church in Fishkill, the Glebe House in Poughkeepsie, and the Abraham de Peyster (or Newlin) House in Tioronda, south of Beacon. This list is in Fox Papers, box 5, New York State Historical Association. See also William Nathaniel Banks, "Edgewater on the Hudson River," *Antiques*, 121 (June 1982), 1400–1410. Edgewater is located in Barrytown, north of Rhinebeck along the east bank of the Hudson.

15. The six-page typescript of Fox's talk is in Fox Papers, box 3, New York State Historical Association. Fox's books included *The Decline of Aristocracy in the Politics of New York, 1801–1840* (New York, 1919), and two on which he was working at the time: *Yankees and Yorkers* (New York, 1940); and *The Completion of Independence, 1790–1830* (New York, 1944), with John A. Krout.

16. Frankfurter to F.D.R., January 30, 1939, quoted in Michael E. Parrish, *Felix Frankfurter and His Times: The Reform Years* (New York, 1982), 278.

nesia. If the Poughkeepsie Convention of 1788 provides a good example of a historical event that has remained relatively vivid, Mehitabel Wing Prendergast provides us with an instance of a wonderful woman, truly an actress in the drama of revolutionary history, who seems to have been forgotten even in the annals of Dutchess County. Although Mehitabel is my favorite heroine in all of colonial American history—not just New York, but *all* of colonial America—she does not seem to be mentioned in James H. Smith's bicentennial *History of Duchess County, NY, with Illustrations and Biographical Sketches of Some of Its Prominent Men and Pioneers* (1882). Nor does she appear in the *Commemorative Biographical Record of Dutchess County, New York, Containing Biographical Sketches of Prominent and Representative Citizens, and of Many of the Early Settled Families* (1897), nor even in *County at Large,* by Martha Collins Bayne (published in 1937 by the Women's City and Country Club with Vassar College).

Some of you may know all about Mehitabel Wing Prendergast; but believing, as I truly do, that she should not be overlooked by *anyone,* allow me for just a moment or two to slip into the role of Peechy Prauw, the local historian and drinking companion to Wolfert Webber, who tells those tales in Washington Irving's *Tales of a Traveller.*

It's a complicated yarn, but here's the essence. William Prendergast led a tenants' revolt in these parts during 1766. He surrendered to a regiment of royal grenadiers in the little town of Fredericksburg (now Patterson), and they marched him directly to Poughkeepsie and then onto a Hudson River sloop bound for New York, where he was imprisoned. Meanwhile, a Poughkeepsie grand jury indicted him for high treason, and he was brought back to a packed courtroom in Poughkeepsie on August 6, 1766, to stand trial. Mehitabel entered with him; and as the attorney general introduced damaging evidence against William, Mehitabel, a twenty-eight-year-old Quaker, maneuvered eloquently as his advocate. The Poughkeepsie correspondent for the New York *Gazette or Weekly Post Boy* explained to readers that, "solicitously attentive to every particular and without the least Impertinence or Indecorum of Behavior, sedately anxious for her husband she never failed to make every Remark that might tend to extenuate the Offence and put his Conduct in the most favourable point of view[,] not suffering one Circumstance that could be collected from the evidence or thought in his Favour to escape the Notice of the Court and the Jury." When the attorney general asked Justice Horsmanden to have Mehitabel removed from the courtroom, the judge responded

that she was not creating a disturbance, "nor does she speak unseasonably."

"Your Lordship," the exasperated prosecutor replied, "I do not think that she should speak at all, and I fear her very looks may too much influence the jury."

He was wrong, as it turned out, because the jury found William guilty. The required sentence? "High treason against his Majesty—Friday the twenty-sixth day of September—to be hanged by the neck until you are dead."

Even as the crowds of angry, sympathetic farmers followed William back to the Poughkeepsie jail, Mehitabel swung into action. She had one last desperate recourse. Despite Quaker constraints, she borrowed her sister's best dress—a pretty white one with blue stripes—mounted a horse, and galloped eighty miles to see Governor Sir Henry Moore in Fort George. As she dismounted, Mehitabel pleaded for an interview, and she got it. She explained the desperate cricumstances of William and their fellow tenant farmers, and she clarified his limited role and his true intentions in the populist protest. According to Wing family tradition, her arguments were so persuasive "and her looks so utterly appealing" that water came to the eyes of Governor Moore. Wiping away his tears, he told her, "Your husband shall not suffer."

Moore wrote a reprieve for Prendergast and allowed Mehitabel to draft the petition for a royal pardon. Satisfied that every legal technicality had been attended to, she then galloped the eighty miles back to Poughkeepsie, flourished the governor's reprieve, and prevented William's execution. Six months later the long awaited letter arrived from the prime minister himself, Lord Shelburne: "I have laid before the King your letter of the 11th Oct. recommending W. Prendergast who was sentenced to death for treasonous Practices and Riots committed in Dutchess County, to the Royal Mercy, and his Majesty has been gratiously pleased to grant him his pardon, relying that this instance of his Royal clemency will have a better effect in recalling these mistaken People to their duty than most rigorous punishment."[17]

The coda to this complicated tale goes on and on. Let it suffice to say that Mehitabel and William Prendergast lived happily ever after—pretty much. He died in 1810, and she survived him by eighteen

17. I have relied on Carl Carmer, *The Hudson* (New York, 1939), 89–99; and Irving Mark, *Agrarian Conflicts in Colonial New York, 1711–1775* (New York, 1940), 146–50.

months. Perhaps every school child in Dutchess County knows the whole stirring saga; but if—perchance—not, then surely there's some work to be done on your local history chapbooks. The Prendergasts, but mostly Mehitabel, are what History ought to be all about.

Having talked about a local legend who may have been insufficiently honored in her own land, let me now turn to a very different aspect of heritage, memory, and Hudson Valley traditions. I have in mind the gradual, hesitant, but irrepressible process whereby Hudson Valley traditions have come to be recognized as part of our *national* heritage. In one sense that development began with Washington Irving, of course; but the process has been slow, retarded by the vagaries of regional rivalry, inadequate means of communication and transportation, and so on. During the past sixty years, however, the particulars of *your* history have become part and parcel of *our* history. The transformation has been a fascinating one, and I am able to share several phases of it with you because of research that I have done at archives in Cooperstown, Schenectady, and Pocantico Hills, near Tarrytown.

Let's go back to the Dutchess County American. In March 1938, when the annual meeting of the New York State Historical Association was being planned for Poughkeepsie, Roosevelt declared to Dixon Ryan Fox "my deep personal interest in the early history of New York State." Earlier, in 1923, F.D.R. had published pertinent essays in *De Halve Maen,* quarterly magazine of the Holland Society of New York. In July of that year he wrote to Fox at Columbia:

> I should much like your judgment on the possibility of a publication or series of publications on old Dutch houses, portraits, etc. in New York State and vicinity. . . . In regard to the question of cooperation I am inclined to believe that other organizations might be glad to work with us—for instance, here in Dutchess County the Dutchess County [Historical] Society would, I am sure, assist us, and there are two or three people in this neighborhood who I think would be entirely willing to help us gather data, photographs, etc.

Fox responded constructively by sending, as a model, a form used by the Colonial Dames of Connecticut in recording information about historic homes. "With the multifarious demands upon your time" [Fox added]

> I suppose it will be difficult for you to give very much attention to such an historical adventure, but I am sure all societies of the hereditary patriotic type will be heartened by your lively interest in such a concern.

There is a great deal of energy and intelligence in the membership of these organizations that is anxious for direction in serviceable employment. I have been struck as an outsider [here's that theme once again!] with the wistfulness of some of the leaders in search of something appropriate to do.[18]

To make a long story somewhat shorter, the guidance of Fiske Kimball, a prominent architectural historian then teaching at New York University, was sought; and he offered many helpful suggestions that lifted the professional qualities of the project by enlisting expert advice. Following Kimball's suggestion, Fox stressed to Frederic R. Keator, a moving spirit behind the project, that "it is clearly desirable to have real research enter into the collection of data rather than oral tradition, unsupported by documentary evidence."[19] The outcome, eventually, was the publication in 1929 of *Dutch Houses in the Hudson Valley before 1776*, by Helen Wilkinson Reynolds, with an introduction by Governor Franklin Delano Roosevelt.

Phase Two in the nationalization of Hudson Valley traditions came during the later 1930s when a batch of well-written books and essays appeared, including *The Hudson* (1939) by Carl Carmer, and "The River That Flows Both Ways" (1940) by Remsen D. Bird. The latter was partially serialized in the *Hudson River Magazine,* a journal that began in 1937 and bore the subtitle "A Monthly Mirror of Life along the Hudson." Carroll Osborn had established it in Hudson, New York, at the age of twenty-two. Osborn explained his enterprise to Dixon Ryan Fox in 1940:

Concerning itself with the story of local institutions, activities, personalities, history and folklore, the Hudson River Magazine's regional theme rivals in interest the reading appeal of a daily newspaper. . . . But I am not content with my means of developing the magazine's theme or of spreading its story before the million and a half Hudson Valley people, without the support of influential valley residents who appreciate the desirability of promoting our *regional values*.[20]

18. Roosevelt to Fox, March 18, 1938, Fox Papers, Union College; Roosevelt to Fox, July 9, 1923, and Fox to Roosevelt, August 8, 1923, Fox Papers, box 8, New York State Historical Association.

19. Kimball to Fox, August 9, 1923, and Fox to Keator, August 15, 1923, Fox Papers, New York State Historical Association; William B. Rhoads, "Franklin D. Roosevelt and Dutch Colonial Architecture," *New York History,* 59 (1978), 430–64.

20. Osborn to Fox, November 18, 1940, Fox Papers, Union College.

Fox, in turn, commended the magazine to Carl Carmer, observing that "the whole enterprise is just about the kind of thing you and I approve,—the sectional magazine, rich with the flavor of the locality. The Hudson River now as a social unit passing somewhat into history, it is very desirable that the history itself be kept alive."[21] When Osborn wrote to Fox a few months later to request a "guest editorial," he recommended as one possible point of departure a remark by a recent speaker that "the character of our people made Hudson Valley society a stabilizing force in the nation." Fox cheerfully picked up on this suggestion and sent Osborn "a little piece" in which he embroidered what by then had become one of his favorite themes:

Nothing is more necessary in American sentiment than the defense of regionalism. Loyalty to one's homeland, by birth or adoption, now in no way diminishes our loyalty to the American nation as a whole. . . . With everybody listening to national net-work radio, looking at the same motion pictures, reading chain newspapers, we are likely to forget the special factors of our local environment which make us different, or should make us different from other people. We cannot have a truly rich national culture without cherishing a rich variety within it.[22]

In 1941, when Fox wrote those words, a transformation had already begun that would gradually complete the process whereby traditions of the mid- and lower. Hudson River Valley came to be acknowledged—without any dilution of the particularities and peculiarities of those traditions—as an integral part of the national heritage. In 1939 the Tarrytown Historical Society sought the support of John D. Rockefeller, Jr., in restoring what was then called Philipse "Castle"— now Philipsburg Manor—into (symptomatic phrase) a "historic shrine." Dr. Hugh Grant Rowell, energetic president of the Tarrytown Historical Society, explained to the media that "Williamsburg has proved highly successful as covering the glamor of the South. It is proposed to restore St. Augustine, Florida, to represent an earlier period. Yet the Tarrytowns, with the story of the North, are just as rich in lore, and, in my opinion, have a richer historic background than

21. Fox to Carmer, December 4, 1940; Fox to James E. Leath, December 4, 1940, *ibid.*
22. Osborn to Fox, January 16, 1941; Fox to Osborn, March 11, 1941, *ibid.*, with a typescript of Fox's four-paragraph editorial attached. *Hudson River Magazine* ceased publication in May 1941.

either of the other communities—and no Northern restoration has [yet] been attempted."

What followed during the next quarter-century, from about 1940 until the mid-1960s, is a fascinating story that really requires a chapter all to itself: a story involving historic preservation; the rewriting of certain pertinent state laws; a vigorous public relations campaign; and a lot of support from the region, from particular communities, and from such indispensable individuals as John D. Rockefeller, Jr. Mr. Rockefeller took Dr. Rowell's bait, and I can assure you that that represented a remarkable achievement on the part of Dr. Rowell. I have read through many boxes of Rockefeller's correspondence. Believe me, a lot of people and organizations sent him ingenious proposals for ways in which he could benefit mankind in general, or at least their pet projects in particular, by the simple act of signing his autograph on a slip of paper that we, in our culture, call a check. Rockefeller was very good at saying "no"; but he said "yes" to Rowell, and by 1940 the Sleepy Hollow Restorations were under way.[23]

I would be neither original nor profound if I proclaimed to you that money means power. Nevertheless, it is endlessly fascinating to find new illustrations of the adage. In 1944, for example, at a time when Mr. Rockefeller began looking ahead to the public opening of Philipse Castle, he realized that it would help to establish the restorations as a going concern if historical societies could charge admission to their properties. According to New York law at that time, they could not. J.D.R., Jr., contacted Governor Thomas E. Dewey and proposed that they meet for lunch to discuss the problem. Dewey said fine, how about the Hotel Roosevelt? Oh no, said Rockefeller; in his apartment at 740 Park Avenue "we would be quite by ourselves." That occurred on February 29 (yes, 1944 was a Leap Year). On March 8, J.D.R., Jr., sent Dewey a packet of photographs of the restoration work in progress and thanked the governor for his "kindness in looking into this matter and advising how the interests of the enterprise could best be safeguarded." Three days later Rockefeller followed with another letter:

> I have been thinking of forming at an early date a non-profit corporation to undertake the preservation and restoration of certain historic sites and

23. *New York Times,* April 9, 1939, p. 2; Rowell to Fox, August 15, 1940, Fox Papers, box 6, New York State Historical Association.

buildings in this State. During the past few years there have been brought to my attention several such sites and buildings which seem to me to be of real historic interest and significance and which will be lost to the State and to the Nation as a whole unless some steps are taken to preserve them and make them available for public enjoyment. In this connection, my attention has been called to two statutory limitations upon historical societies organized under the laws of this State. These statutory limitations are: (1) Six acres only can be held in any one locality, tax free. (2) Admission fees cannot be charged.

On April 3, 1944, the county executive of Westchester County recommended to Governor Dewey's legal counsel that the restrictive laws be altered. A few weeks later the state assembly obliged. Thereafter, admission fees could be charged so long as the revenue was used for preservation activities and maintenance of the property.[24]

The successful sequence of events after 1944 must be reasonably familiar to you, though it is important to acknowledge that visitation figures grew only gradually. In 1952 a Temporary Visiting Committee to Sleepy Hollow Restorations, Inc., assessed and praised the work that had been done but concluded that "neither Sunnyside nor Philipse Castle are arousing the interest or attendance they deserve. They are not successfully competing for the time, attention, and support of the educators and the general public which they have earned by their inherent qualities." A visitors' survey conducted in 1959 indicated steady progress, especially by means of tours for school children. However much these visits may have helped to vivify Hudson Valley history for the youngsters, their noisy presence did not always please the older tourists. "We would have stayed longer," one wrote on his questionnaire, "if it hadn't been so crowded with a school tour of jumpy, uninterested small children."

Many visitors seemed more interested in the gift shops—what items were available, and for how much—than they were in the historical restorations. One also finds an unabashed admiration of wealth and social status. A woman wrote from Toledo, Ohio, "I love to see the beauty and artistry of Colonial homes of the wealthier American [sic]. It's wonderful to keep all such shrines preserved for posterity."[25]

24. Rockefeller to Dewey, February 11, 21, and March 8, 1944; Dewey to Rockefeller, March 10, 1944; and Rockefeller to Rowell, February 1, 1944, all in John D. Rockefeller, Jr., Papers, series II (Cultural), box 1, Rockefeller Archive Center, Pocantico Hills, North Tarrytown, N.Y.
25. The report of the Visiting Committee, October 17, 1952, is in the Sleepy

Well, they did, and we are the beneficiaries along with *our* posterity. That same year, 1959, Harold Dean Cater, who four years earlier succeeded Rowell as the director of Sleepy Hollow Restorations, thanked Mr. Rockefeller for the addition of Van Cortlandt Manor. "It is a place of enchanting beauty," he remarked, "where all of us can find roots in the Hudson Valley's past."[26]

I think that we might well chime in with an "amen" to that. As an afterthought, however, we might also want to reflect upon the imperatives of swift travel and the implications of tourism for our historical vistas. "What price progress?" is a tired rhetorical question, but there is a certain poignancy in a note that Dixon Ryan Fox sent to a Tarrytown friend in 1936. Fox expressed regret that he could not participate in the fall pilgrimage of the Tarrytown Historical Society. He requested, however, that his name be added "to any protest which the Society makes as a whole concerning the foolish and useless bridge across the Tappan Zee. Apparently we must all be vigilant to protect the beauty of the Hudson against selfish or misguided invasion."[27]

I don't know how many of you would want to add "amen" to that utterance as well. But while we reflect upon Fox's desire to keep the status quo, and upon the mixed blessing bestowed upon us by bridges, we can be sure that the shades of Thomas Cole, Asher B. Durand, and Frederic Church are saying "amen." I don't think they would be too happy at the sight of the bridges across "the river that flows both ways." On the other hand, they surely would be pleased to learn that Hudson Valley traditions have now become securely part of the national heritage. Memory is supposed to have been the mother of the muses. After three centuries it seems reasonable to conclude that the Hudson River Valley has done well by its muses, and by our memories.

Hollow Restoration Archives at the Rockefeller Archive Center, as is the visitors' survey (box 17). A male visitor from Eastport, Long Island, observed of his docents: "The women who spoke with me about Sunnyside and Philipsburg Manor were well informed, neat in appearance, and above average in class. Keep them that way!"

26. Cater to Rockefeller, July 21, 1959, ibid., box 7.

27. Fox to Leslie V. Case, October 8, 1936, Fox Papers, box 1, New York State Historical Association.

INDEX

Index

Index

Index

Index

Index

Ruegamer, Lana, 171
Rush, Benjamin, 53
Russel, William C., 231
Rutledge, Ann, 293
Rutman, Anita and Darrett, 141

Sage, Henry W., 226, 251
Sahlins, Marshall, 22, 120
Salmon, Lucy M., 59
Salomone, William, 51
Sandburg, Carl, 293
Sapir, Edward: "Cultural Anthropology
 and Psychology," 211n.
Schlegel, Friedrich, 61
Schlesinger, Arthur, Jr., 43, 99n.
 Age of Roosevelt, 37
Schlosser, Christoph, 239
Schorske, Carl, 149
Schouler, James, 27
Schumpeter, Joseph A., 34
Schurman, Jacob Gould, 234
Schuyler Painter, 305
sectionalism. See regionalism
Sedgwick, Ellery, 293
Seeley, Sir John R., 241, 246
Seligman, Edwin R. A., 277
 Economic Interpretation of History, 277
sequence(s), political and historical, 41–42
Severance, Moses: American Manual, The,
 189
Shakespeare, William
 As You Like It, 184
 Tempest, The, 117
Shannon, Fred A., 28n.
Sheehy, Gail: Passages, 209–10
Shepard, Rev. Thomas, 116
Shipps, Jan, 171
Shorter, Edward: Strikes in France, 1830–
 1968, 112
Shotwell, James T., 59, 277
Shy, John, 111
Sidney, Sir Philip, 188
Skinner, Quentin
 Age of Reformation, The, 88
 "Flight from Positivism, The," 8
 Foundations of Modern Political Thought,
 The, 88
 Return of Grand Theory in the Human
 Sciences, The, 9–10n.
slavery, 26, 106, 115, 262
Sleepy Hollow Restorations, Inc., 319–20,
 321
Slotkin, Richard: Regeneration through Vio-
 lence, 117–18
Smelser, Neil J., 21
Smith, Capt. Thomas: Self-Portrait, 73,
 illus. 75

Smith, Goldwin, 244, 245
 England and America, 245
Smith, Preserved: "Place of History
 among the Sciences, The," 7
Smith-Rosenberg, Carroll, 111
social history, 18–19, 26–27
 (1930s), 122
 (1969–74), 111
 (1980s), 113–14
 in cultural context, 131–32
 increasing interest in (1960s–70s), 107
Social Science History, 14
Social Science History Association, 14, 33
Social Science Research Council, 8
social sciences
 (1928–34), 5–8
 (1978–86), 8–13
 historical attitudes in, 20–24, 108–11,
 128
 and History. See History and other so-
 cial sciences
 "value-free," 57
 See also Anthropology; Political Science;
 Psychology; Sociology
Sociology
 crisis in (1970s–80s), 10
 and History, 15, 21–22, 24, 25n.
space (concept), historical treatment of,
 138–39, 139n.
Sparks, Jared, 222, 229, illus. 230, 237
Spence, Jonathan D.: Emperor of China, 32
stability (social)
 as normative, 9
 See also continuity and change, relative
 emphasis on
"Stages of Human Life, The" (Boston
 Medical and Surgical Journal, 1831),
 203 and table, 204
Stages of Life (wood sculpture, ca. 1880),
 205 and illus.
Stages of Man (watercolor), 196–98, illus.
 198
Stages of Man's Life from the Cradle to the
 Grave (watercolor), 198–99, illus.
 199, 204–5
Stansbury, Joseph, 248
Starobinski, Jean, 95
state history. See local history
statistical analysis. See quantitative
 analysis
Steen, Jan: Prince's Birthday, The, illus.
 151, 152
Stephen, Leslie, 240
Steps of Old Age, Ye (engraving, 17th
 century), 205–6, illus. 206
Stevens, Thaddeus, 262
Stiles, Ezra, 136

Index

Library of Congress Cataloging-in-Publication Data

Kammen, Michael G.

 Selvages and biases.
 Includes index.
 1. United States—Historiography. 2. History—Philosophy. 3. United States—Civilization—Historiography. I. Title
E175.K36 1987 973'.072 87-5285
ISBN 0-8014-1924-7 (alk. paper)